VANISHING WORLD

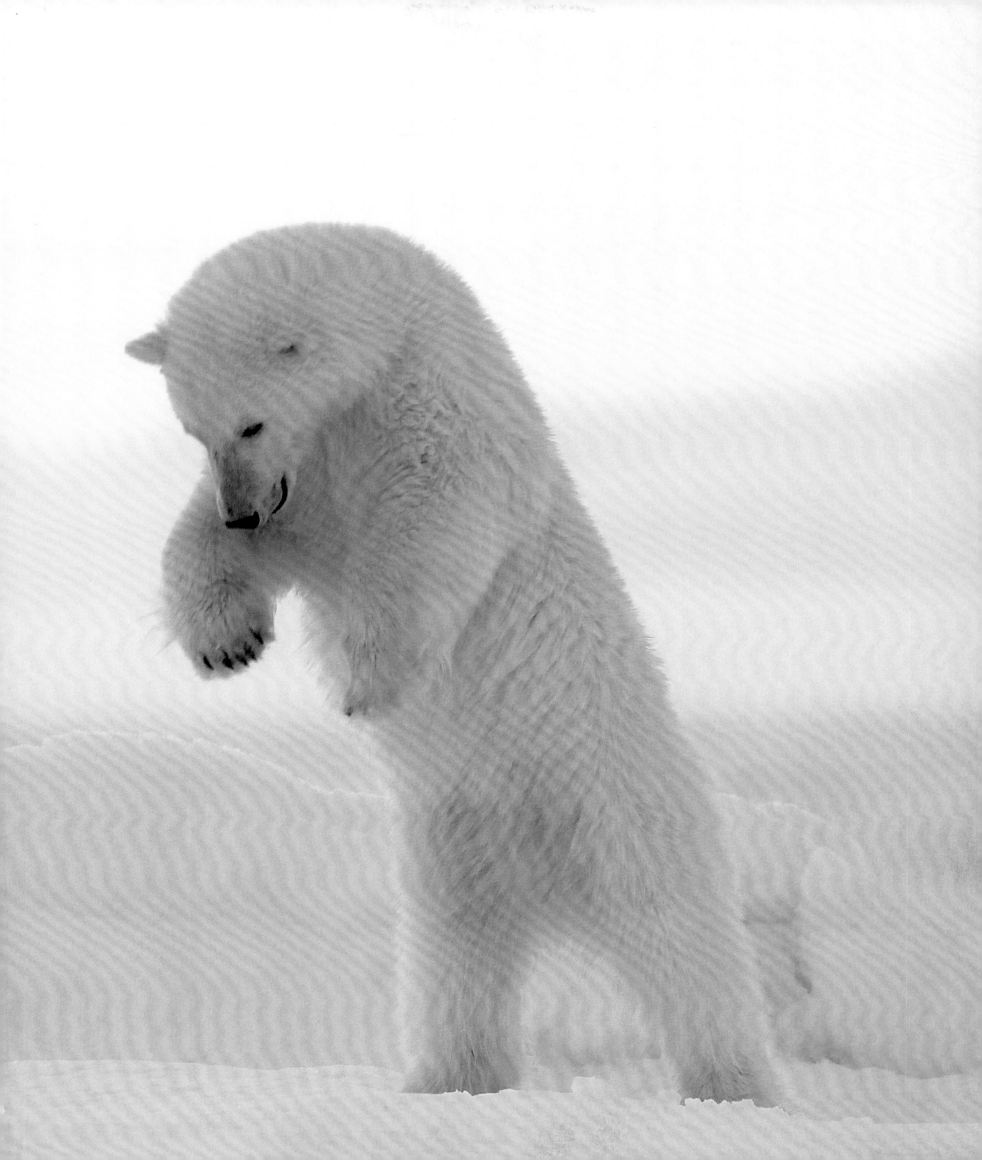

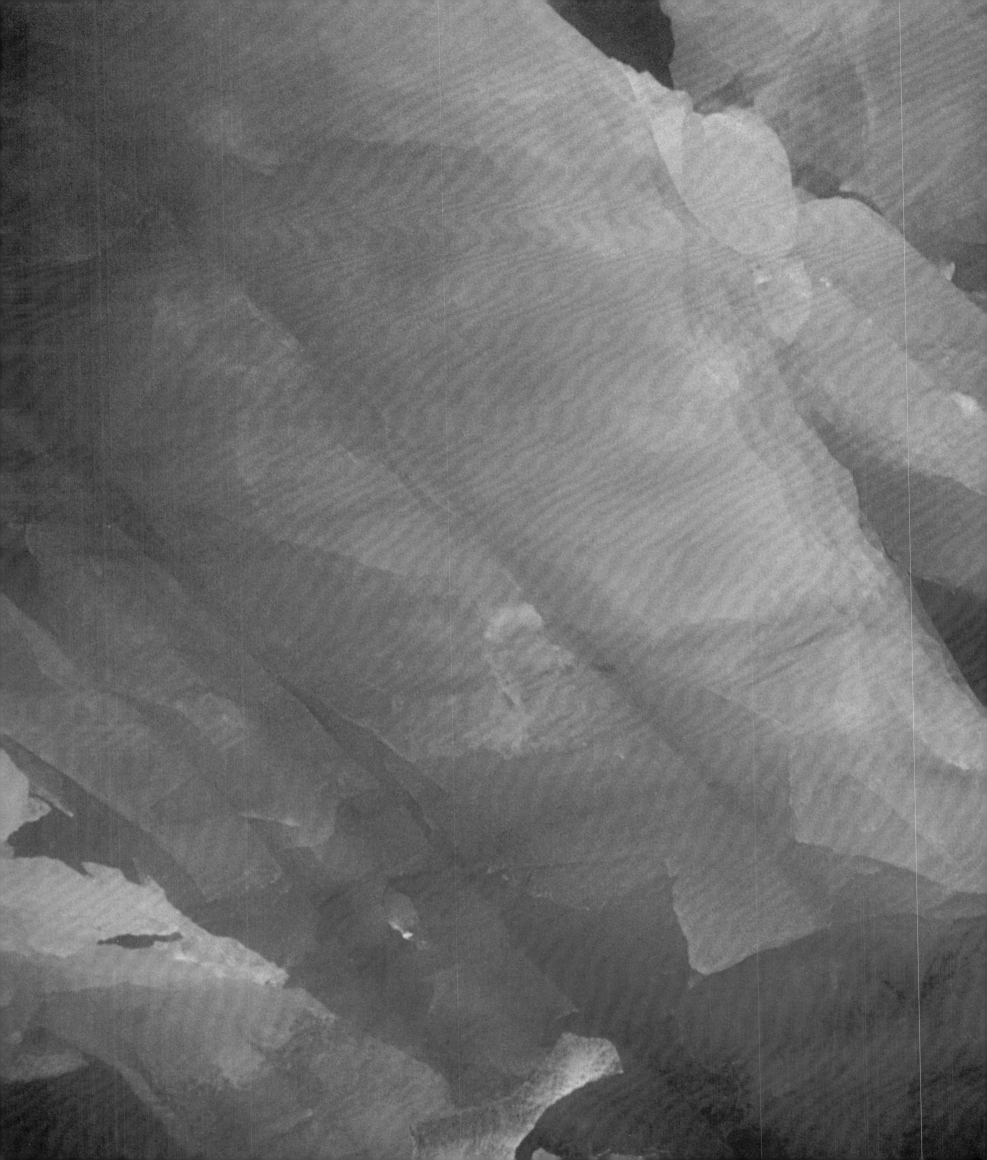

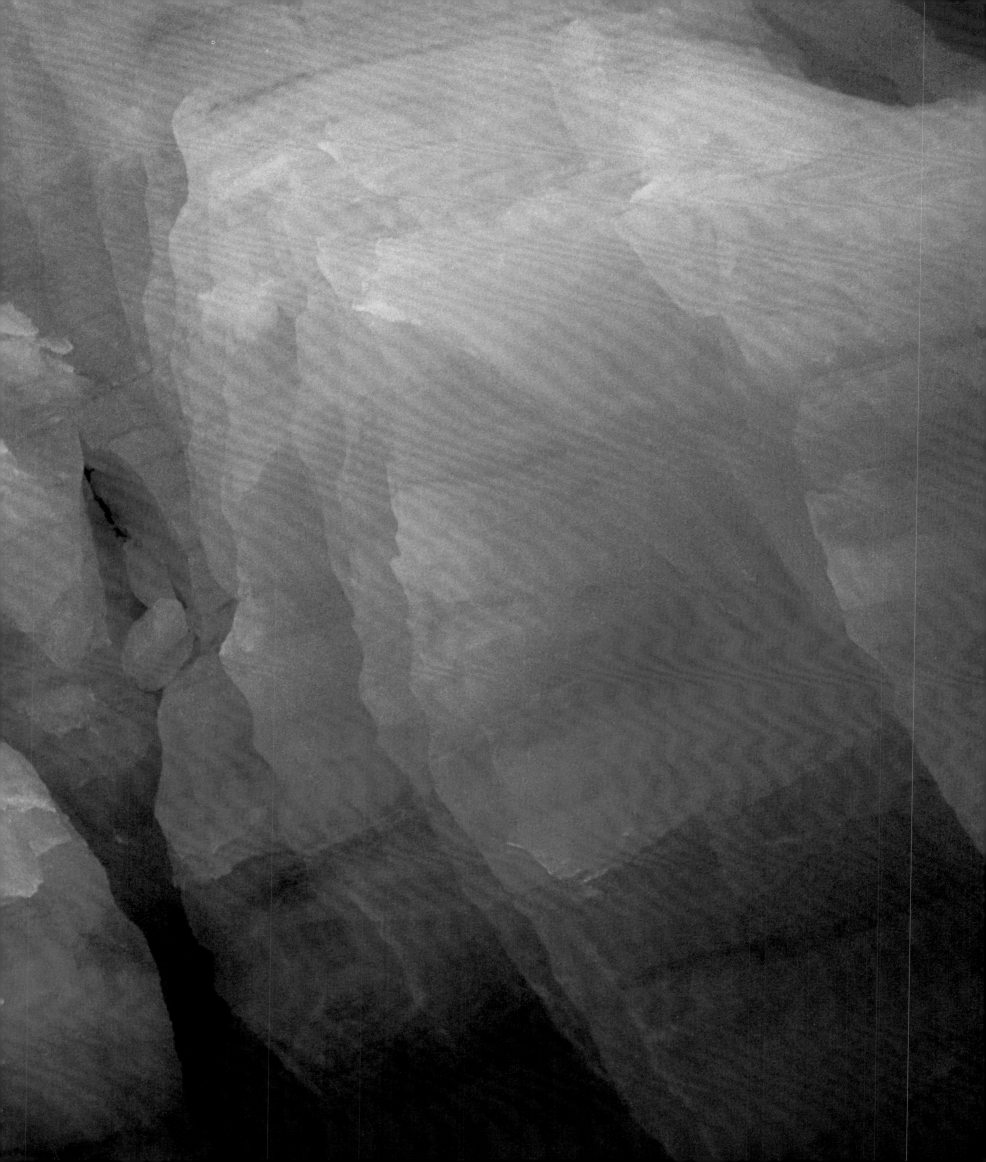

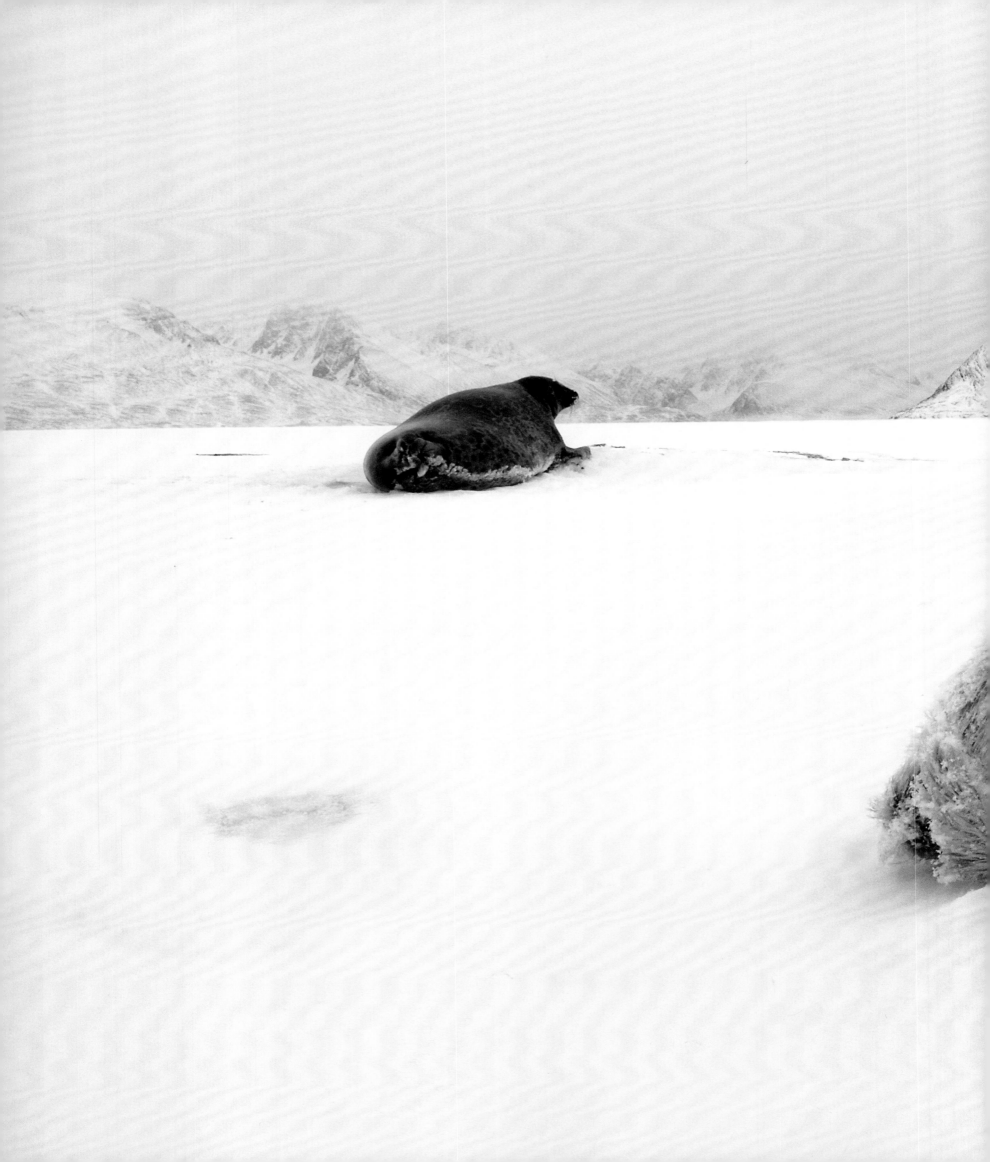

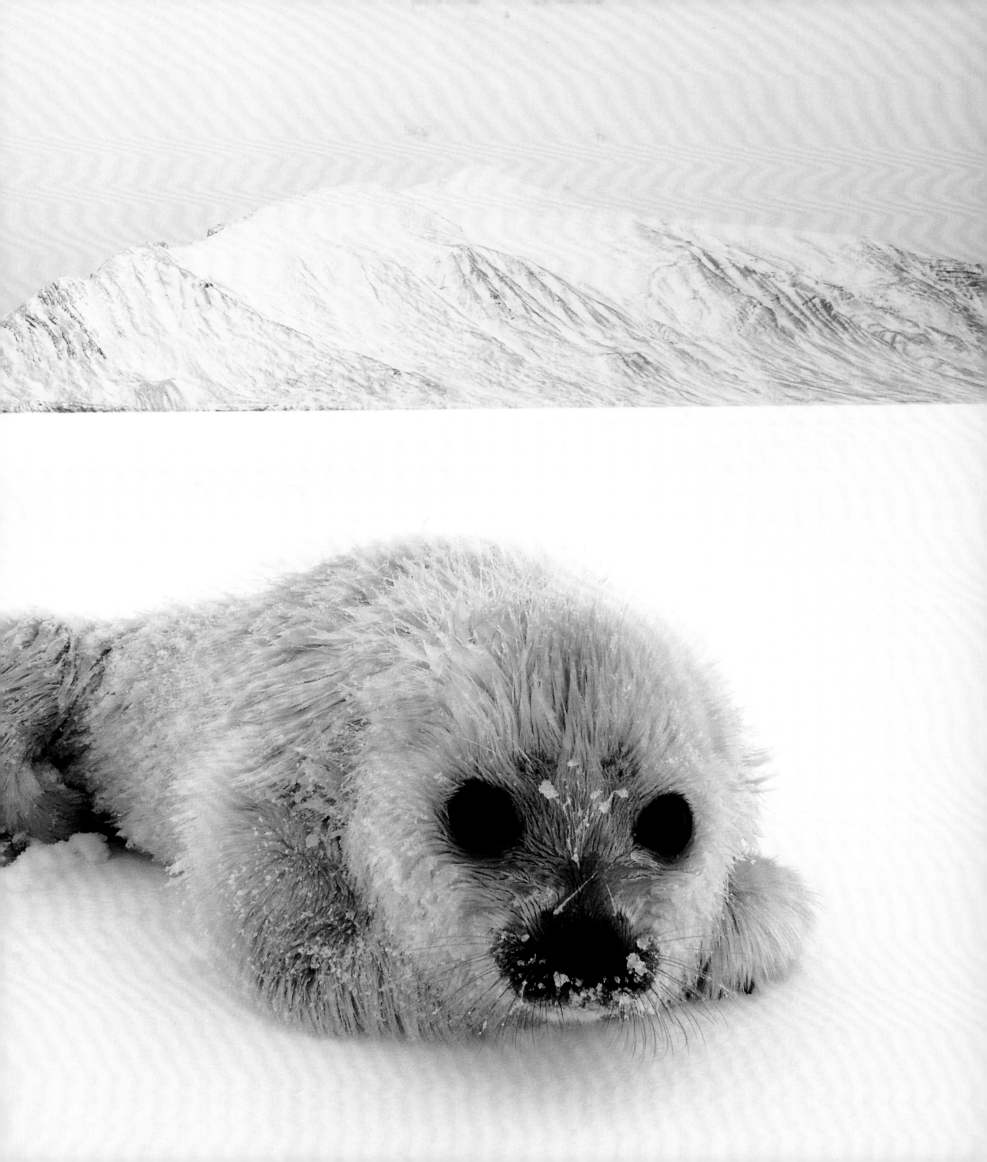

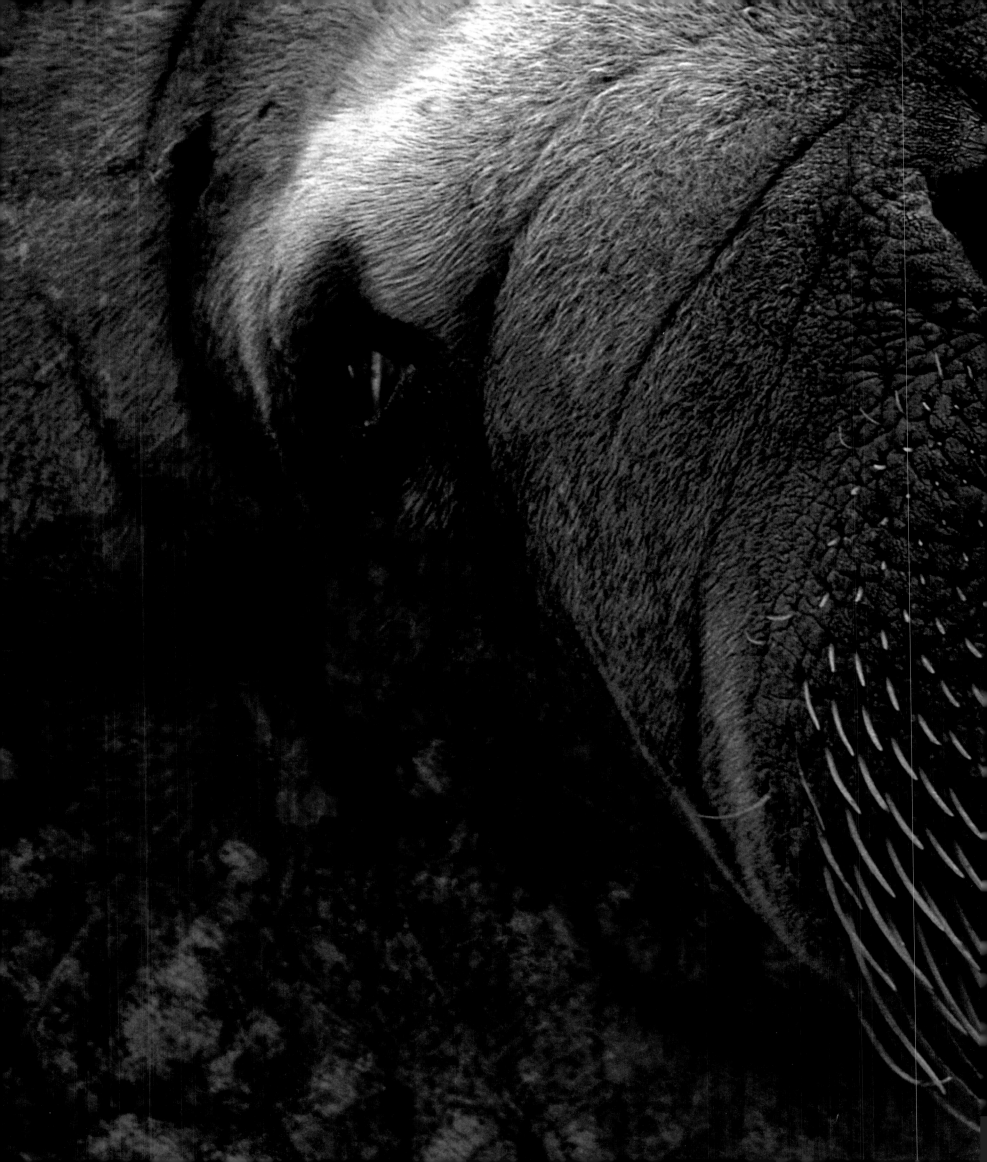

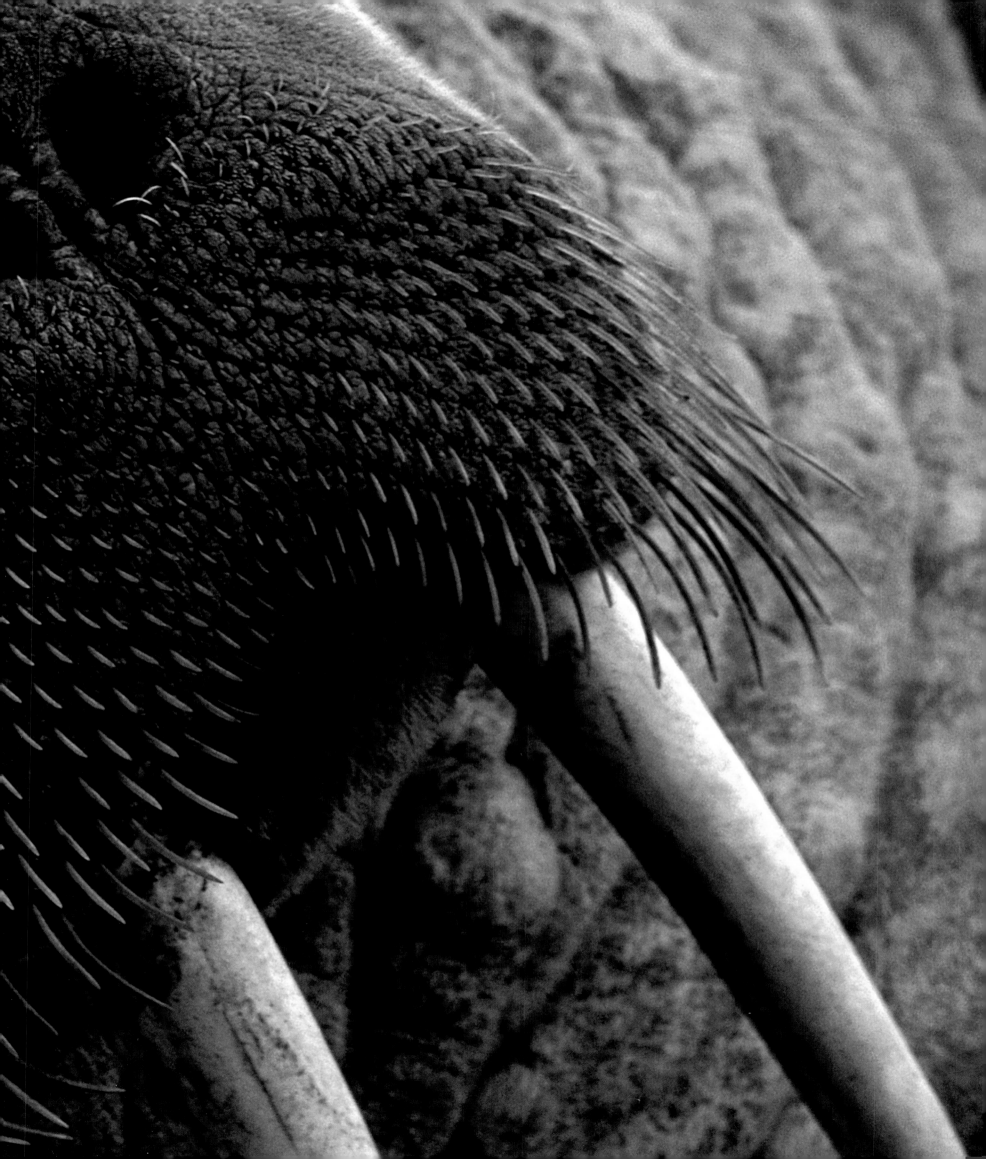

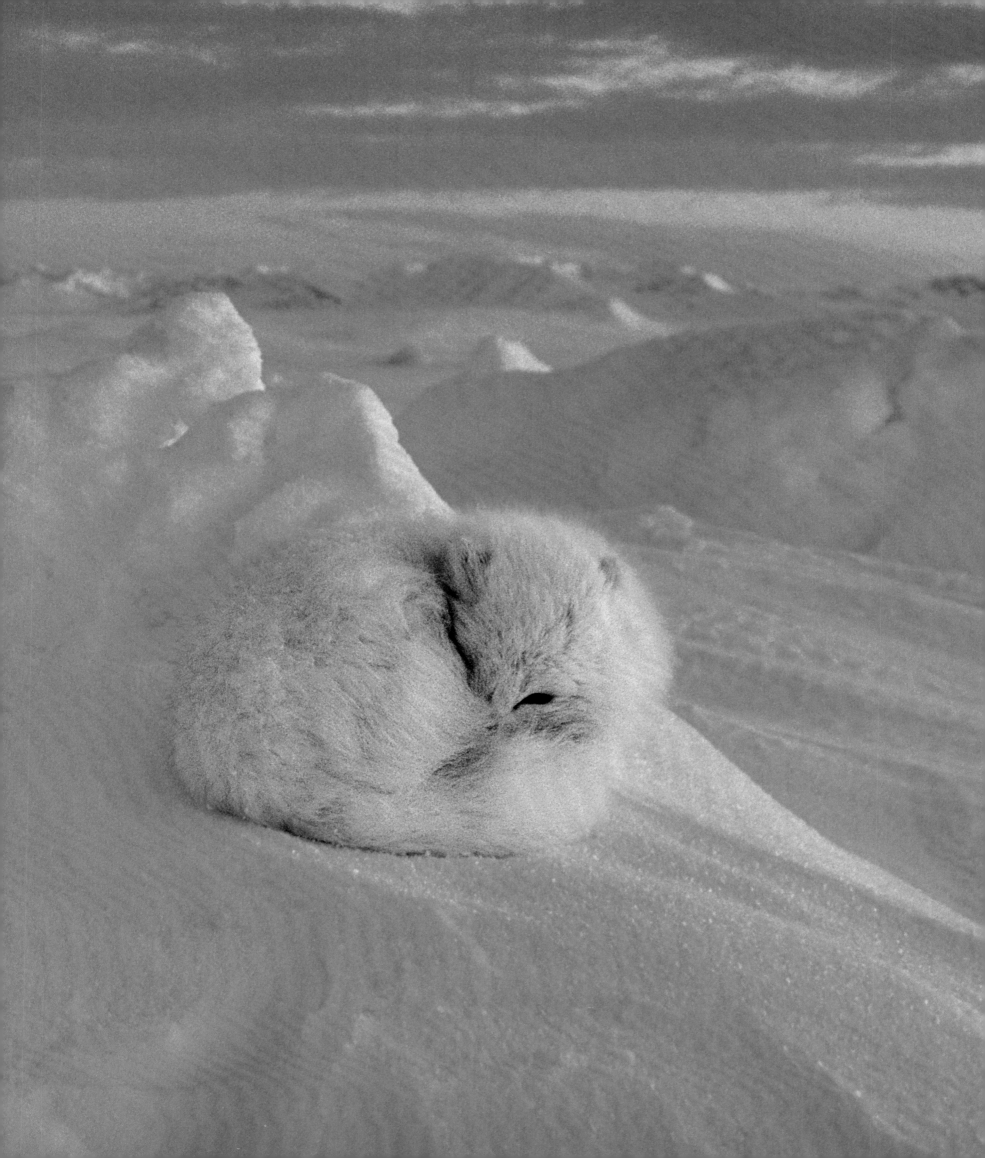

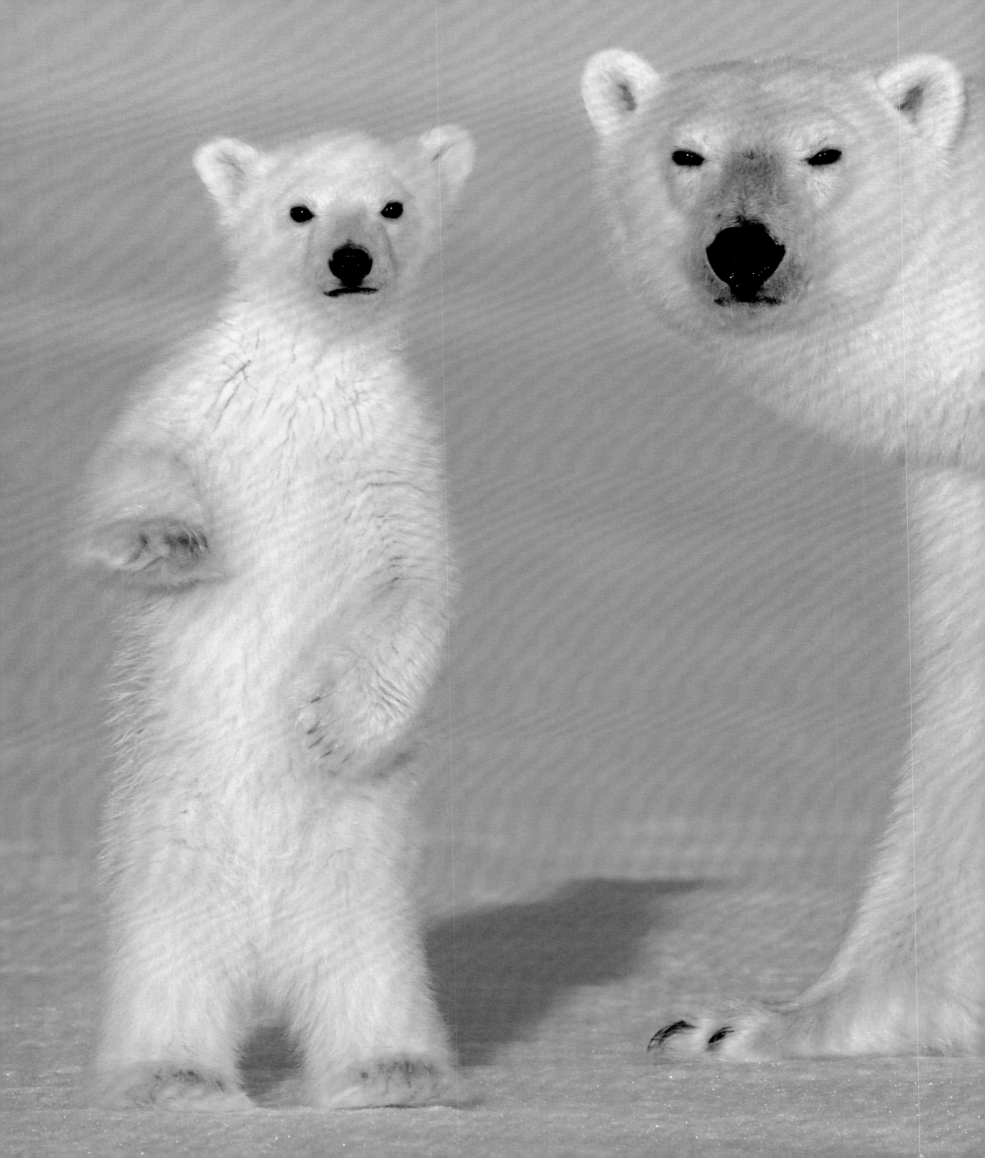

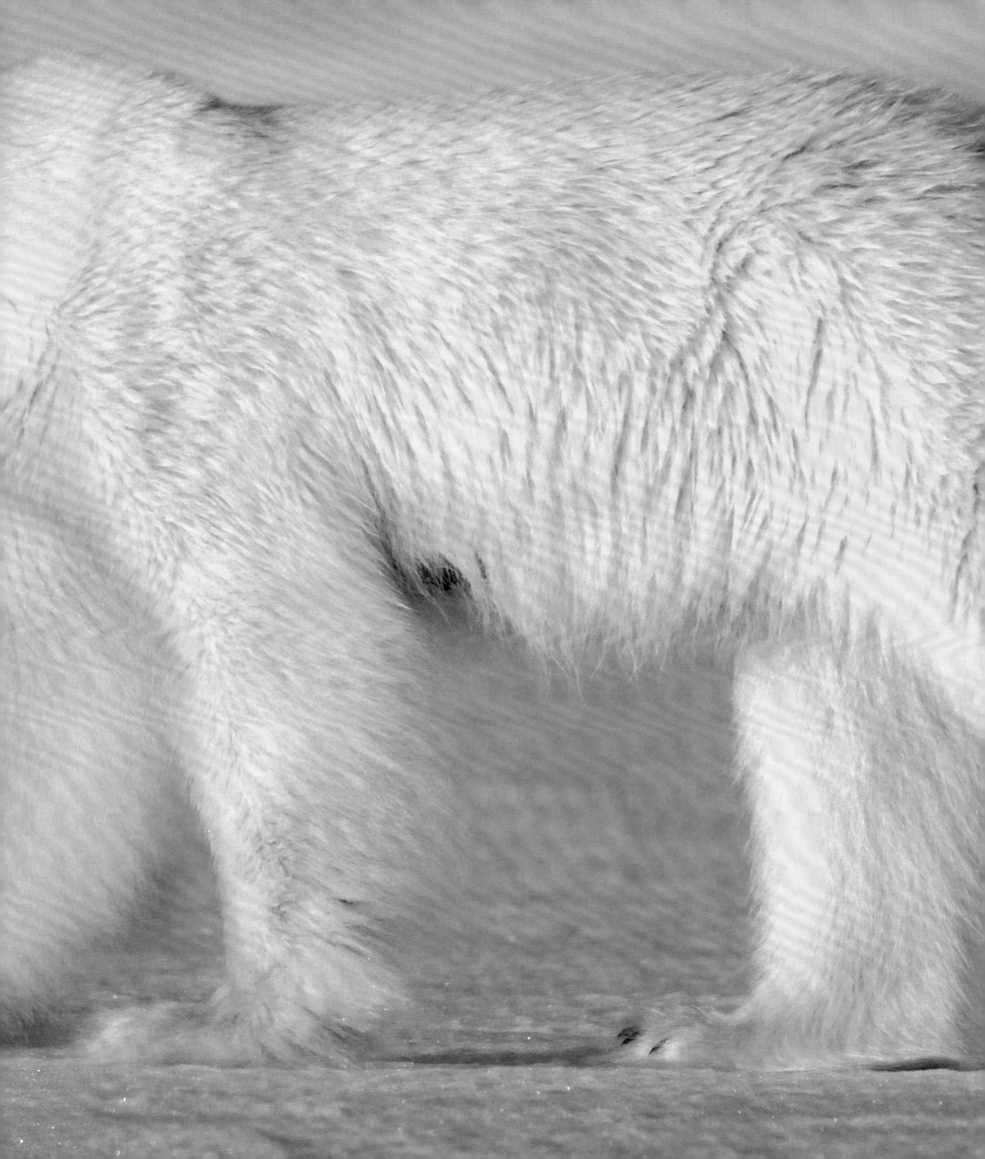

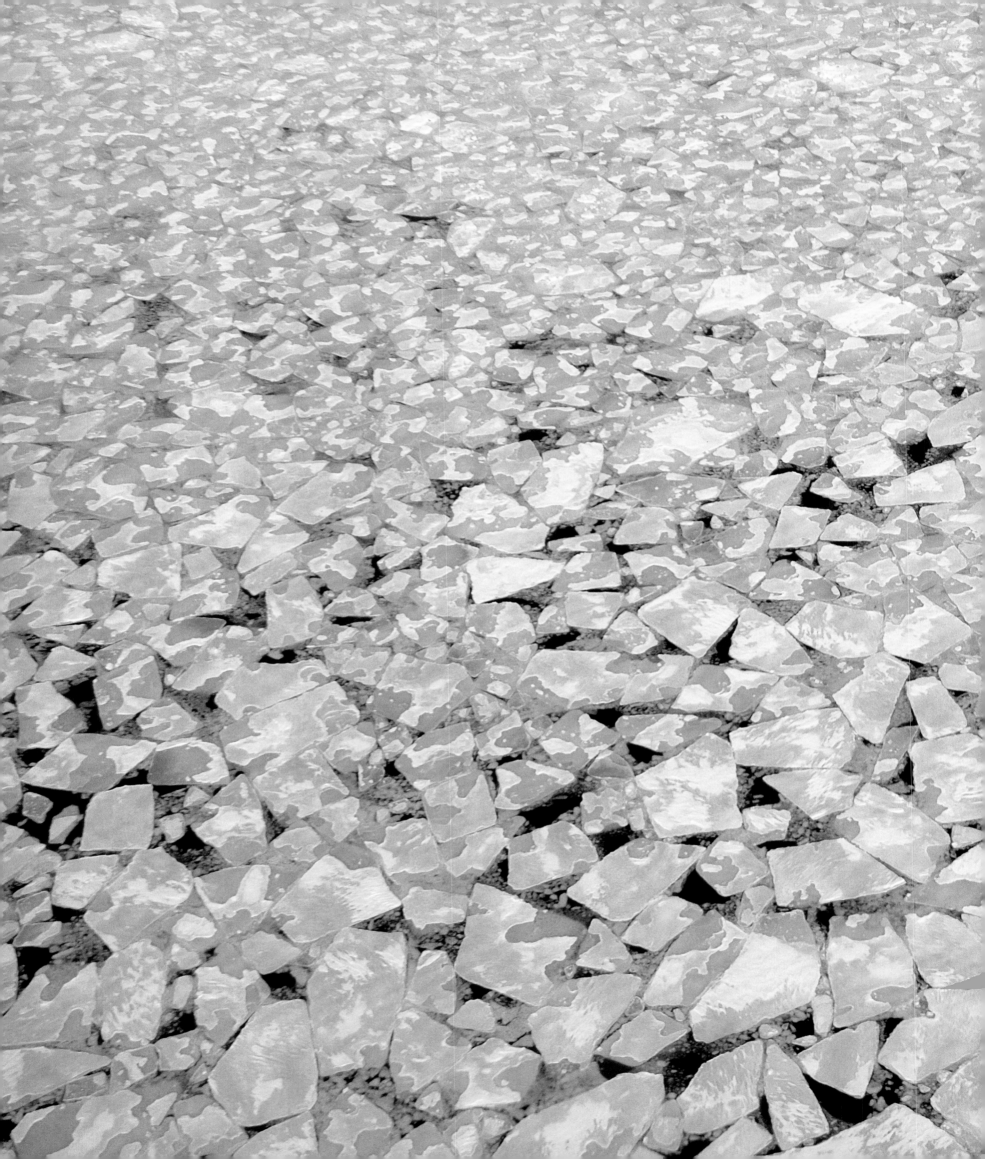

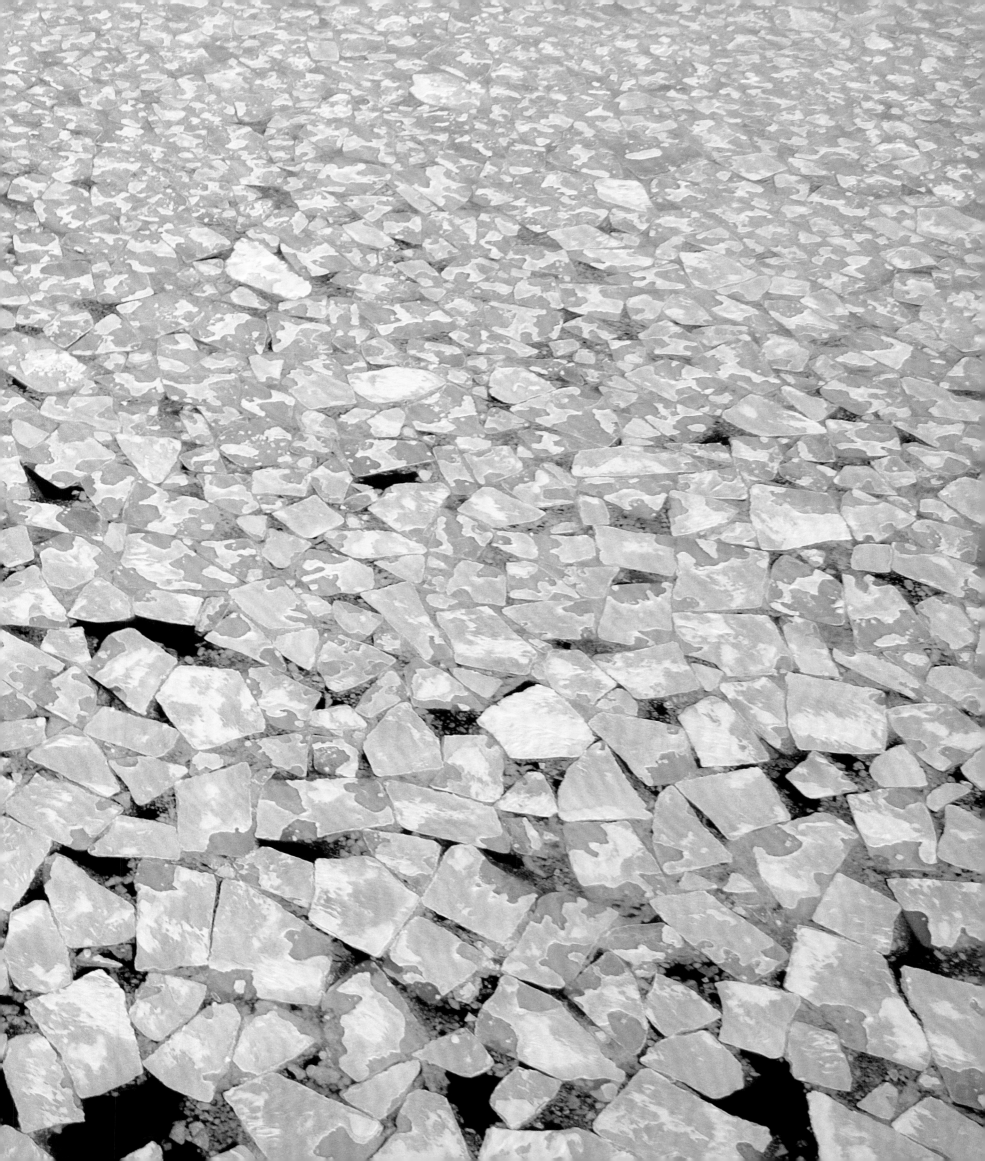

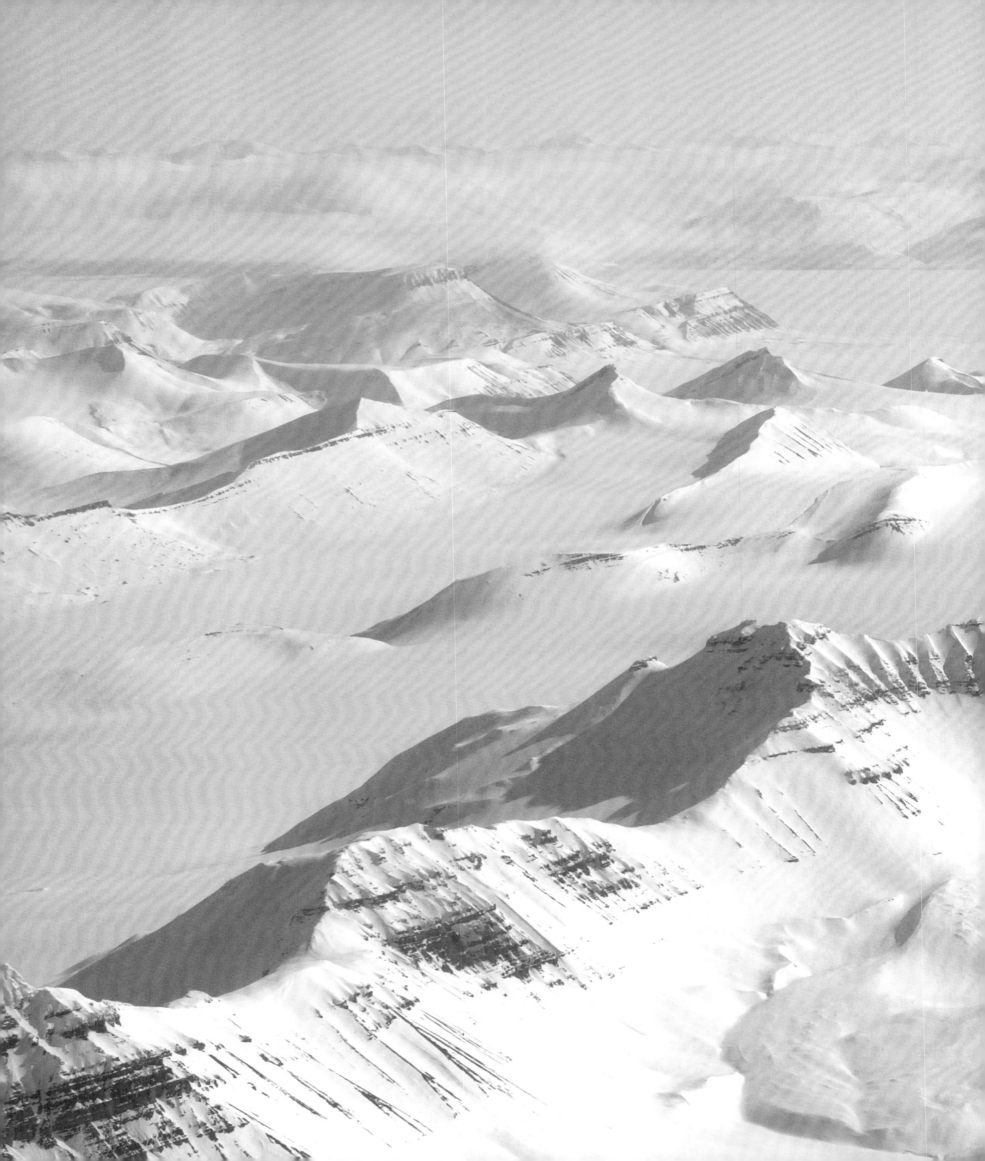

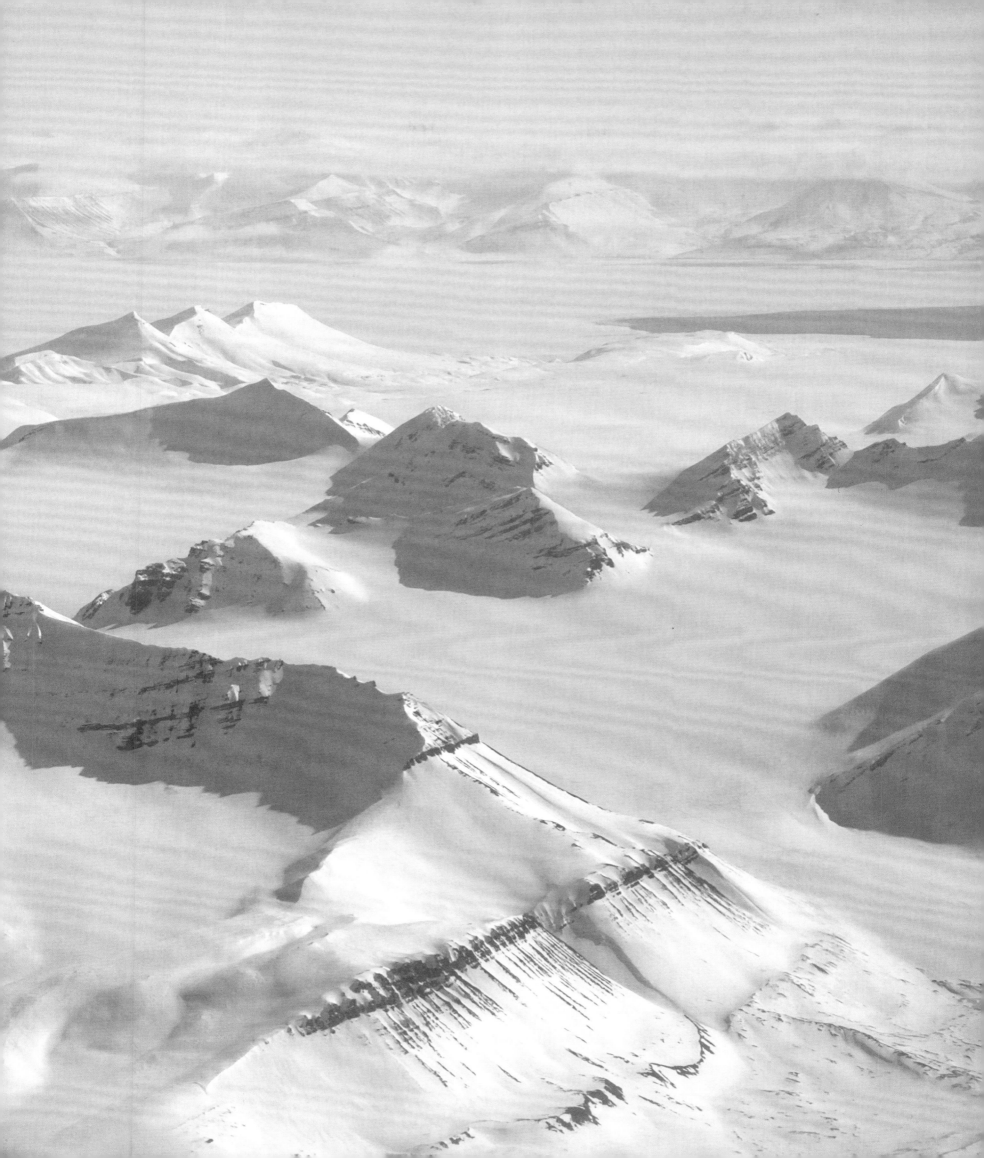

VANISHING WORLD

the endangered arctic

photography by MIREILLE DE LA LEZ

text by FREDRIK GRANATH

ABRAMS, NEW YORK

foreword

There are moments in the history of planet earth that seem more important than others: the emergence and explosion of life in the Cambrian period, the mass extinction at the Cretaceous-Tertiary boundary, and the development of humans as the dominant species on the planet. Superimposed on these events, a set of natural, self-regulating systems has created relative stability around us, allowing complex life to flourish in deserts, forests, and oceans.

We now face another of those important moments. This time, however, it is different. By choice, one species—Homo sapiens—is making fundamental changes to the incredibly complex systems that support all life on earth, something that has never happened before in the 4.6-billion-year history of our planet. Climate change caused by human action is the most serious challenge ever faced by humanity and nature, and it is happening now. Today, the changes are so great that denial is no longer an option—the Arctic is melting.

For the first time in many generations, the eyes of the world are focused on the Arctic. This region is warming several times faster than the rest of the world, and within thirty years may be devoid of ice in summer. Change in the Arctic has implications for us all, as the Arctic plays a critical role in regulating the global ocean and climate systems. As the authors state herein, the Arctic is the "ground zero" of global warming.

However, it is not only the polar bear and walrus that are endangered. The changes to the Arctic will threaten the existence of many of the world's ecosystems as we know them today, including the very basis for many human economies and societies.

But it is not too late to change the current negative trends. With the determination of the world's key decision makers to introduce radical emission reductions, to invest in alternative energy solutions, and to leave attractive—but dangerous—fossil resources such as methane hydrates in the ground, there still is hope for the Arctic and the global climate systems. It is not a matter of lack of knowledge—the solutions are known and must only be implemented. Or, to quote the author of the groundbreaking report "The Economics of Climate Change," Sir Nicholas Stern, "Climate change is the greatest market failure the world has ever seen."

Through the extraordinary images and text of Mireille de la Lez and Fredrik Granath, *Vanishing World* provides an important testimony to the intrinsic values of the Arctic and the immediate threats to these values and to the rest of the world. If we want to maintain a living planet, we have no alternative: humans must live in harmony with nature. Together, let us make that happen in the Arctic.

Dr. Neil T. M. Hamilton, Director, WWF Arctic Initiative

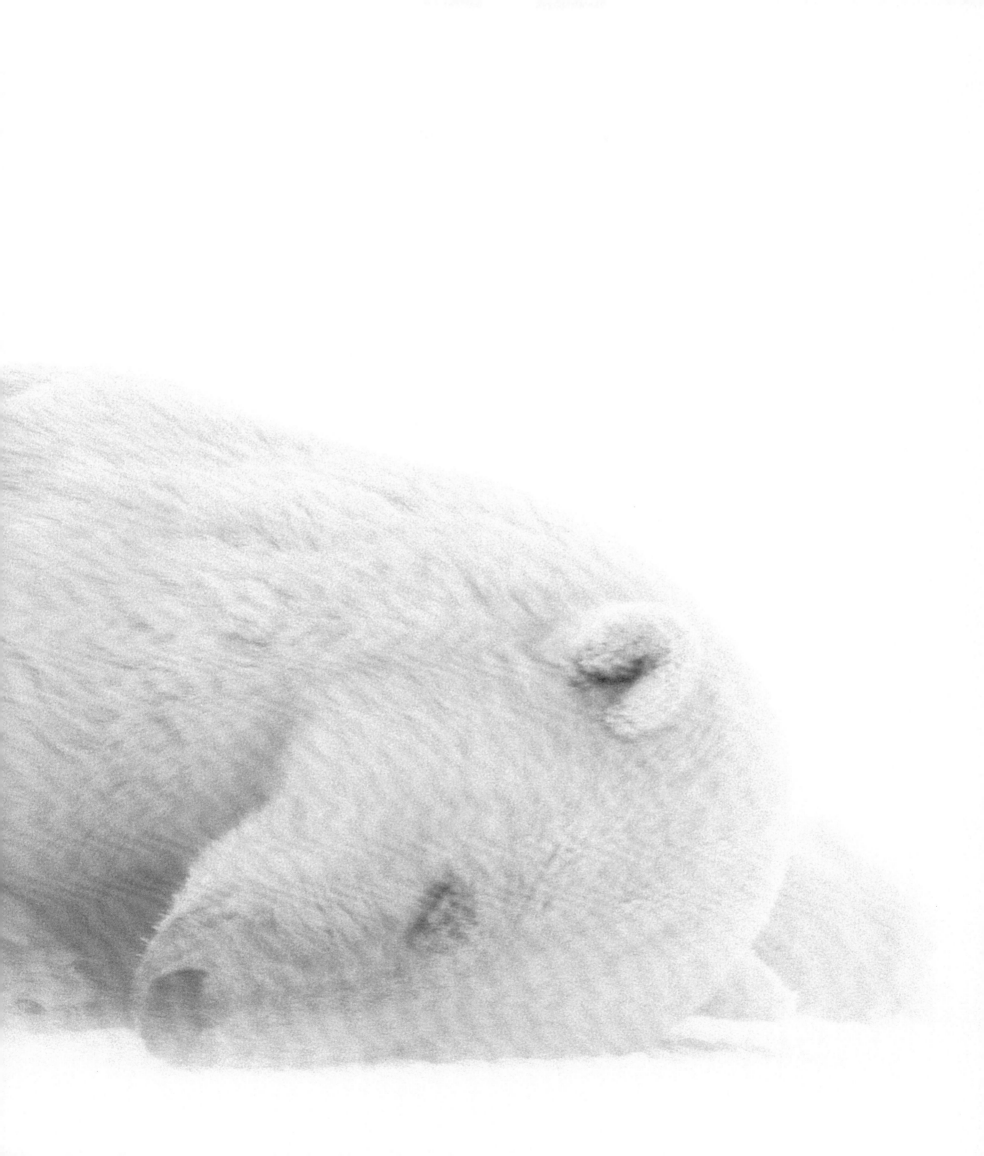

ice

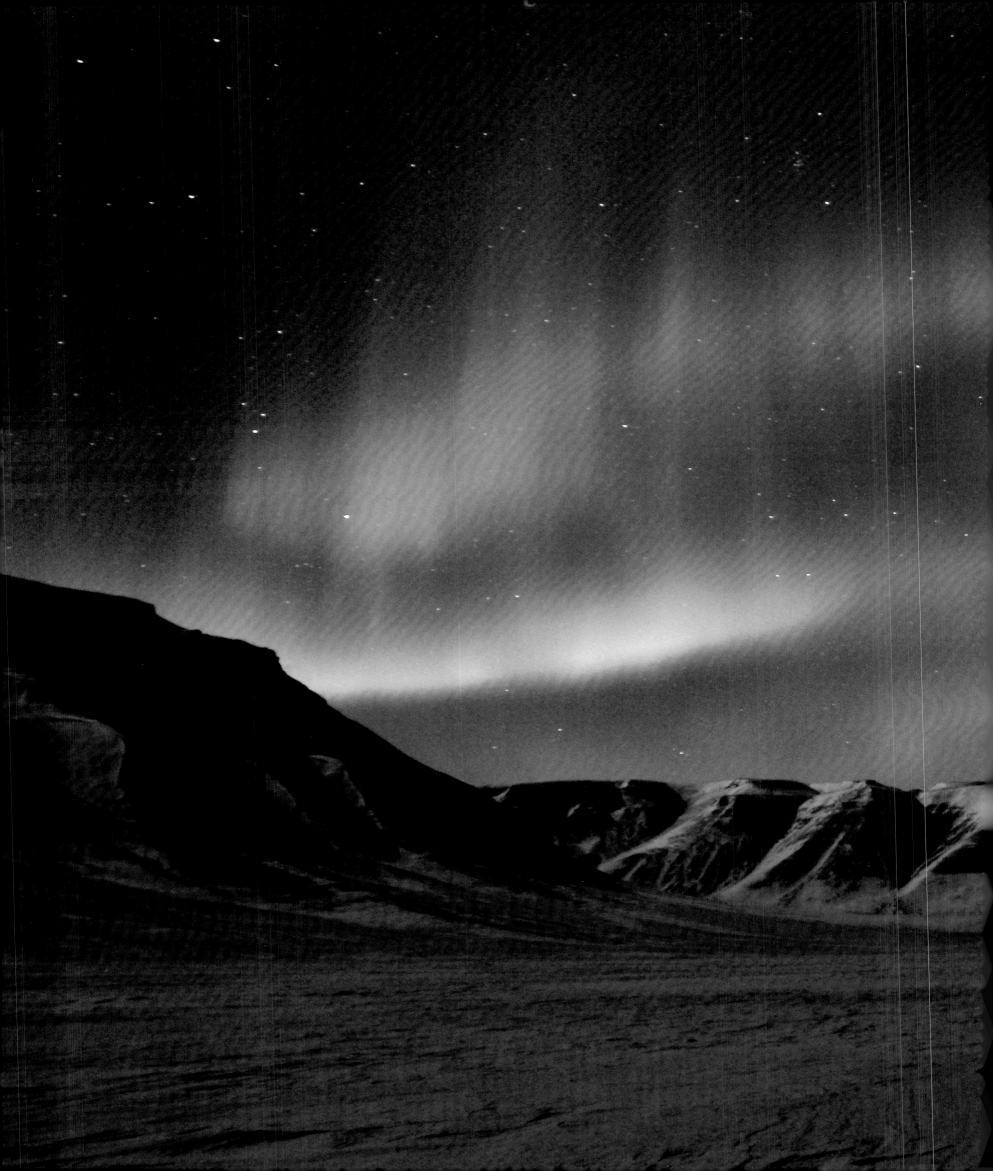

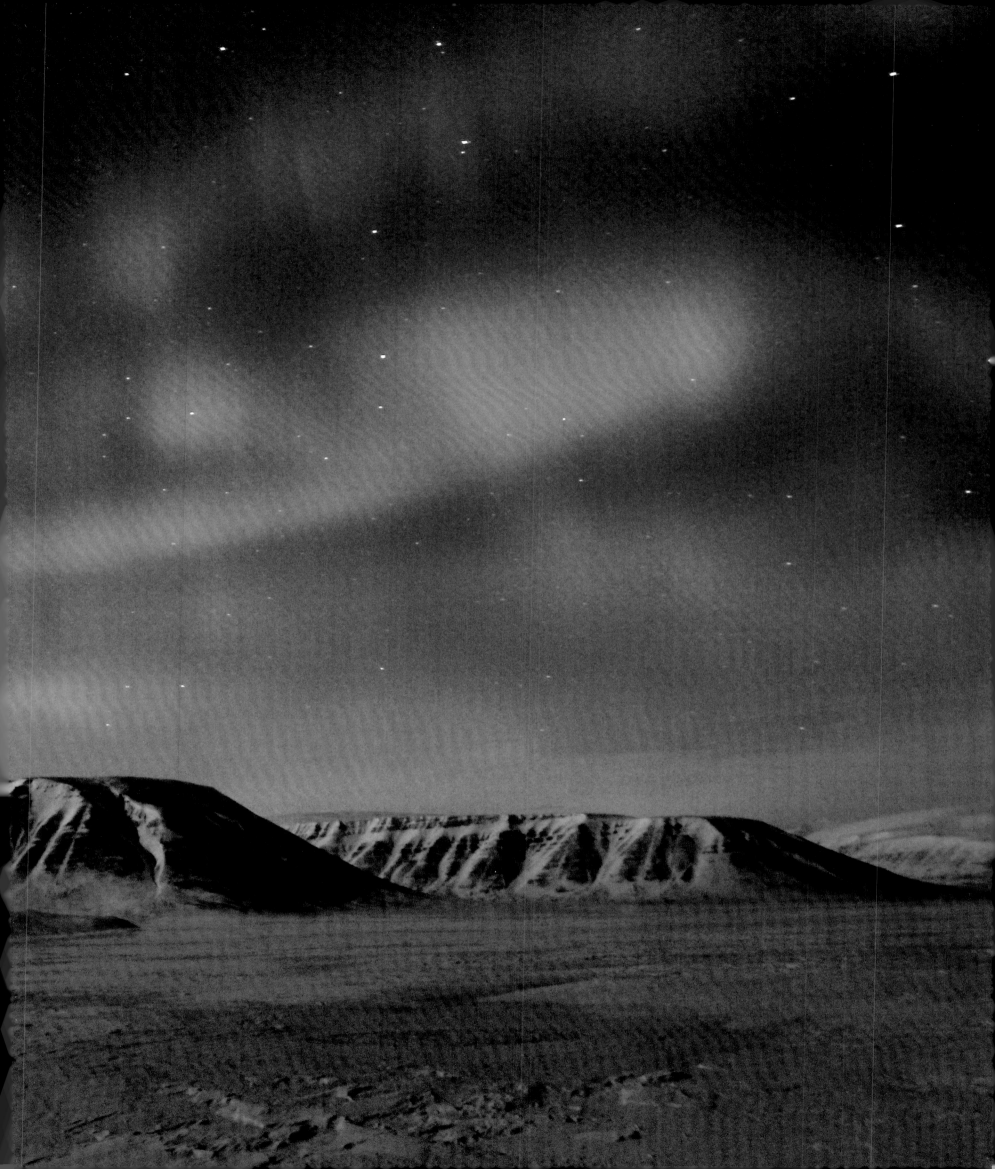

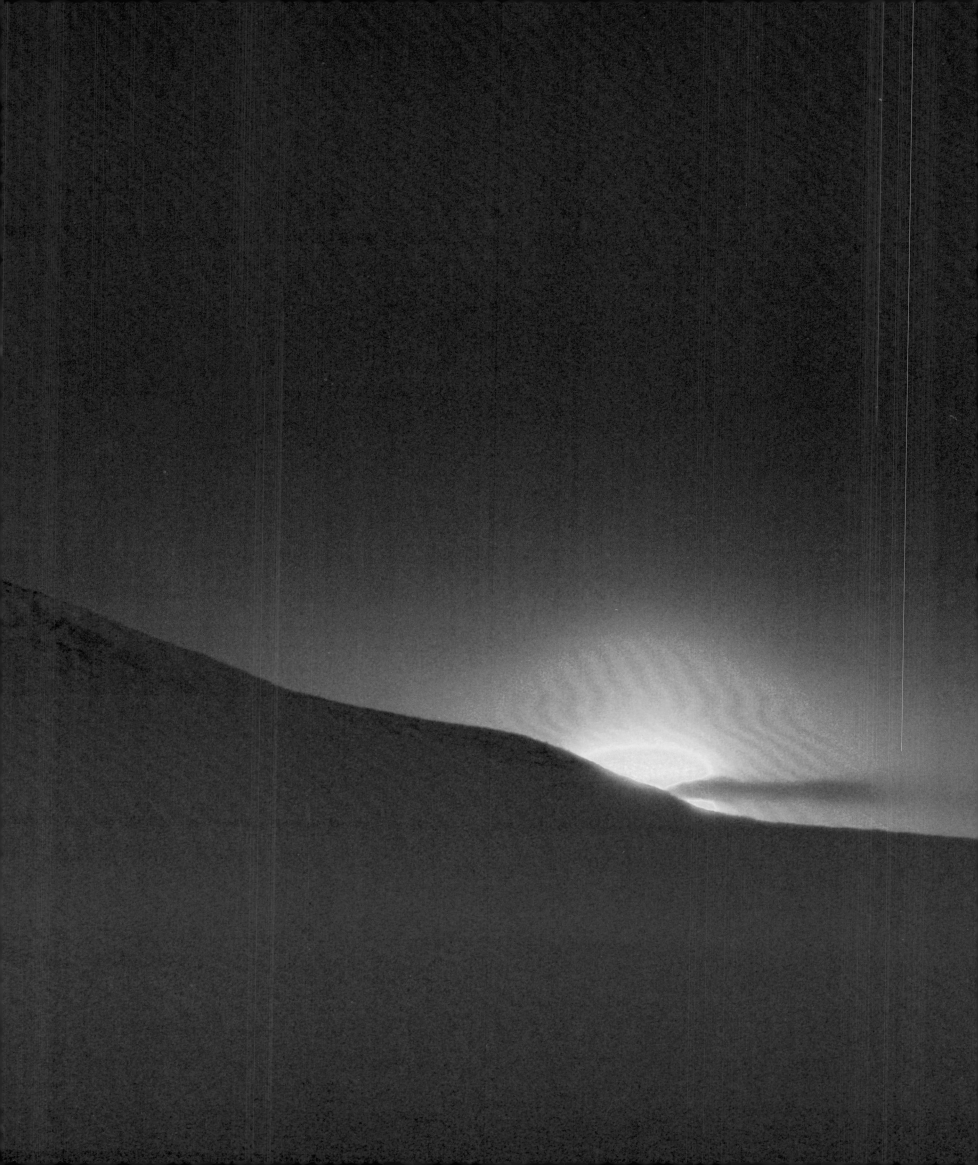

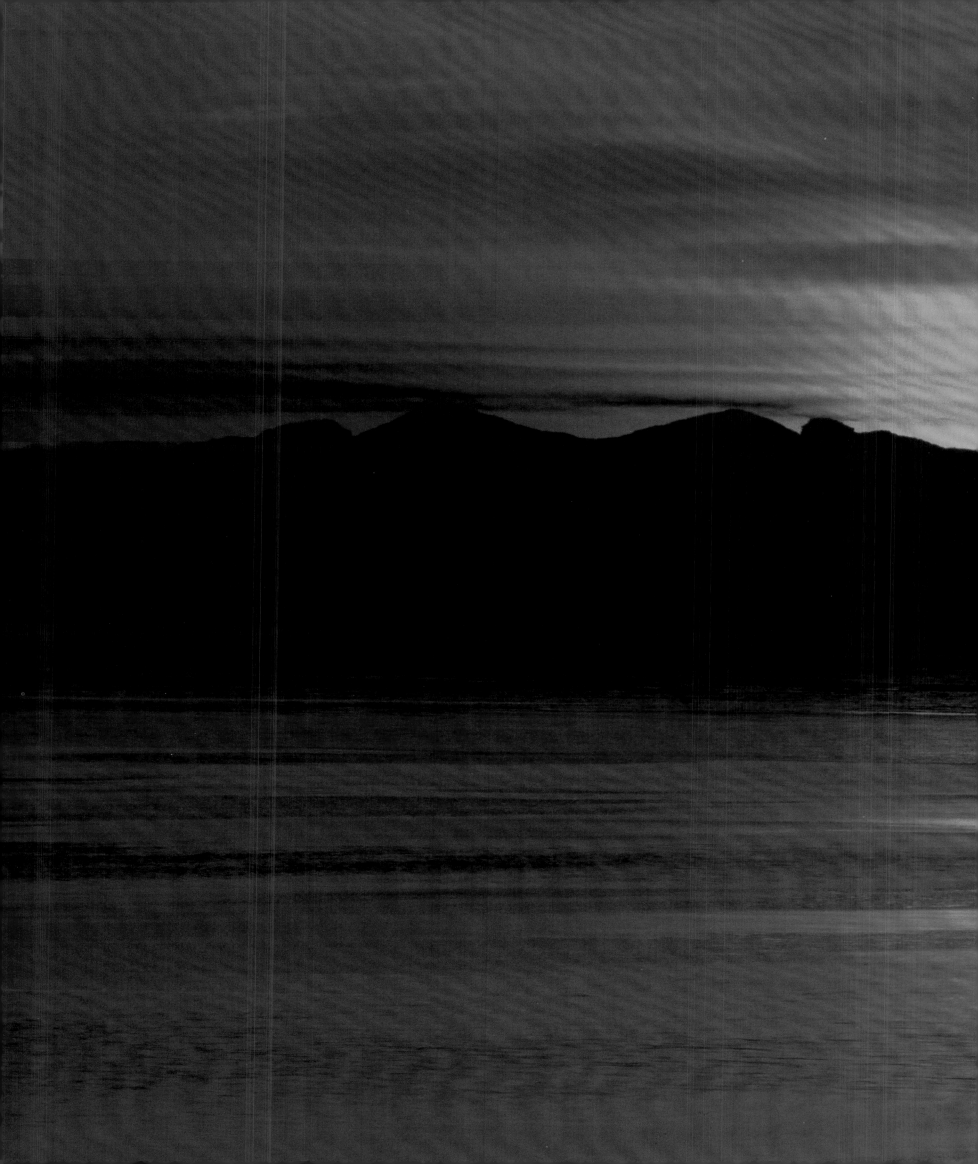

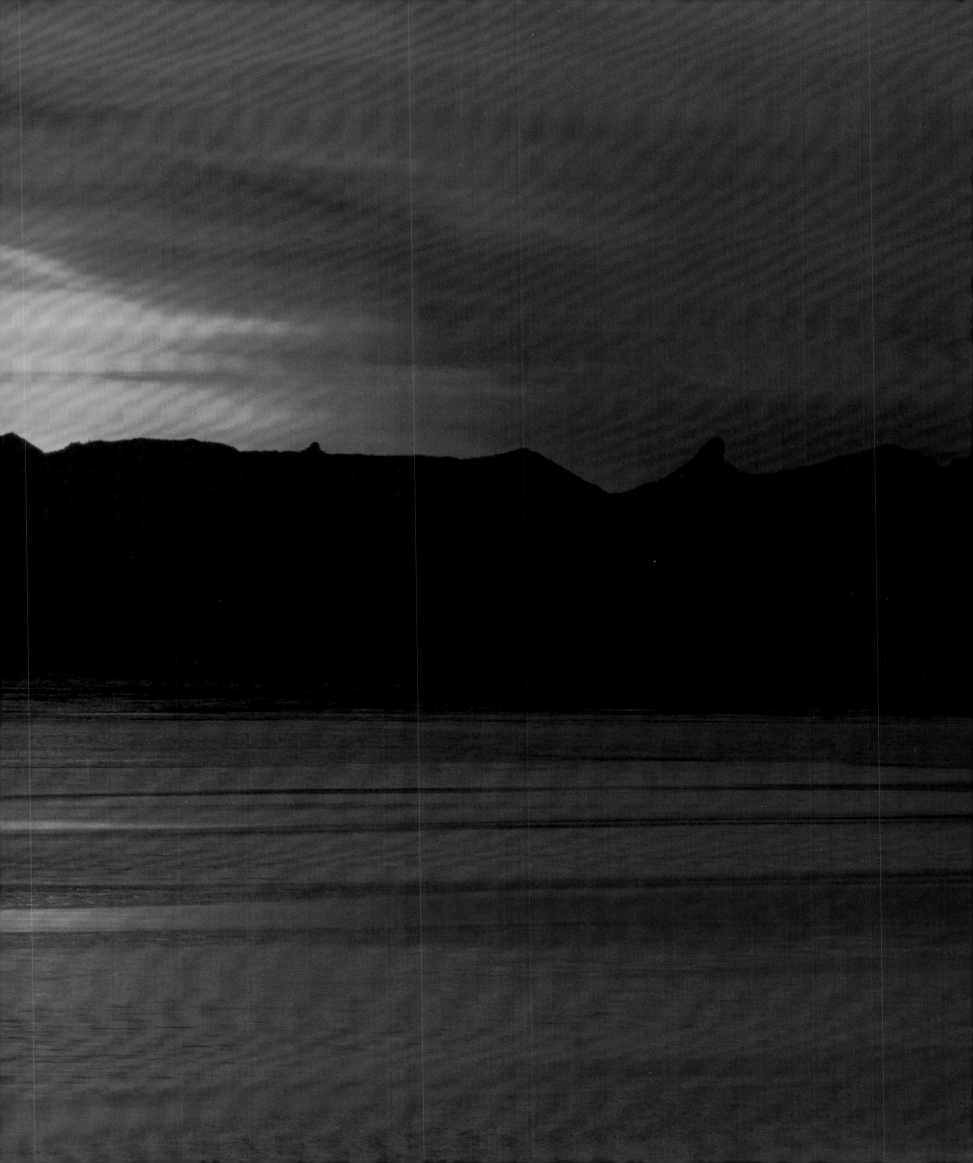

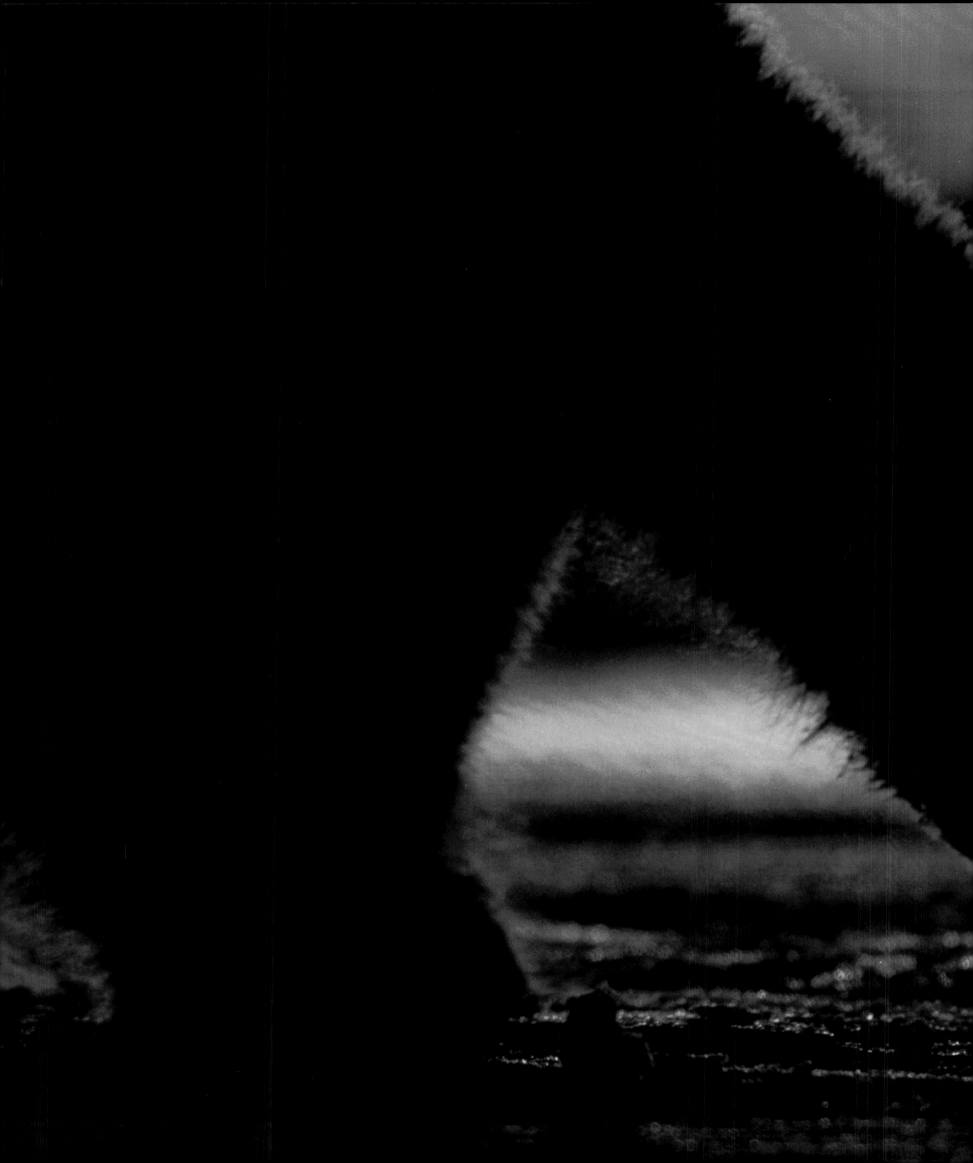

coming out of darkness

Welcome to the top of the world, to the most extreme environment imaginable. A place seemingly as barren and distant as the moon.

Just as the storm settles down, the polar bear slowly awakes and stands up, silhouetted against the red sun rising over the horizon for the first time after months of darkness. With a brief glance over its shoulder, it continues the hunt for food on the pack ice. Here, it is the undisputed ruler, the king of the Arctic.

As our story begins, the world of ice you are about to enter is coming out of darkness. A few months every winter, the polar night reigns over the high Arctic, and the only sources of light are the moon, the stars, and the colorfully iridescent auroras.

But as we arrive, the sun slowly starts to find its way over the horizon. There is a new moon, but the rising sun brings forward color reflections in the snow and ice, shifting from dark blue to pink, violet, and red. It seems an unreal world, but few places are as real as the Arctic.

By this time of year, the ice has expanded southward from higher latitudes, and the polar ice cap once again embraces the high Arctic in its cold arms. When the ice returns, so does the polar bear. It follows the edge of the sea ice as it advances and retreats through the seasons, often wandering hundreds of miles a year.

41

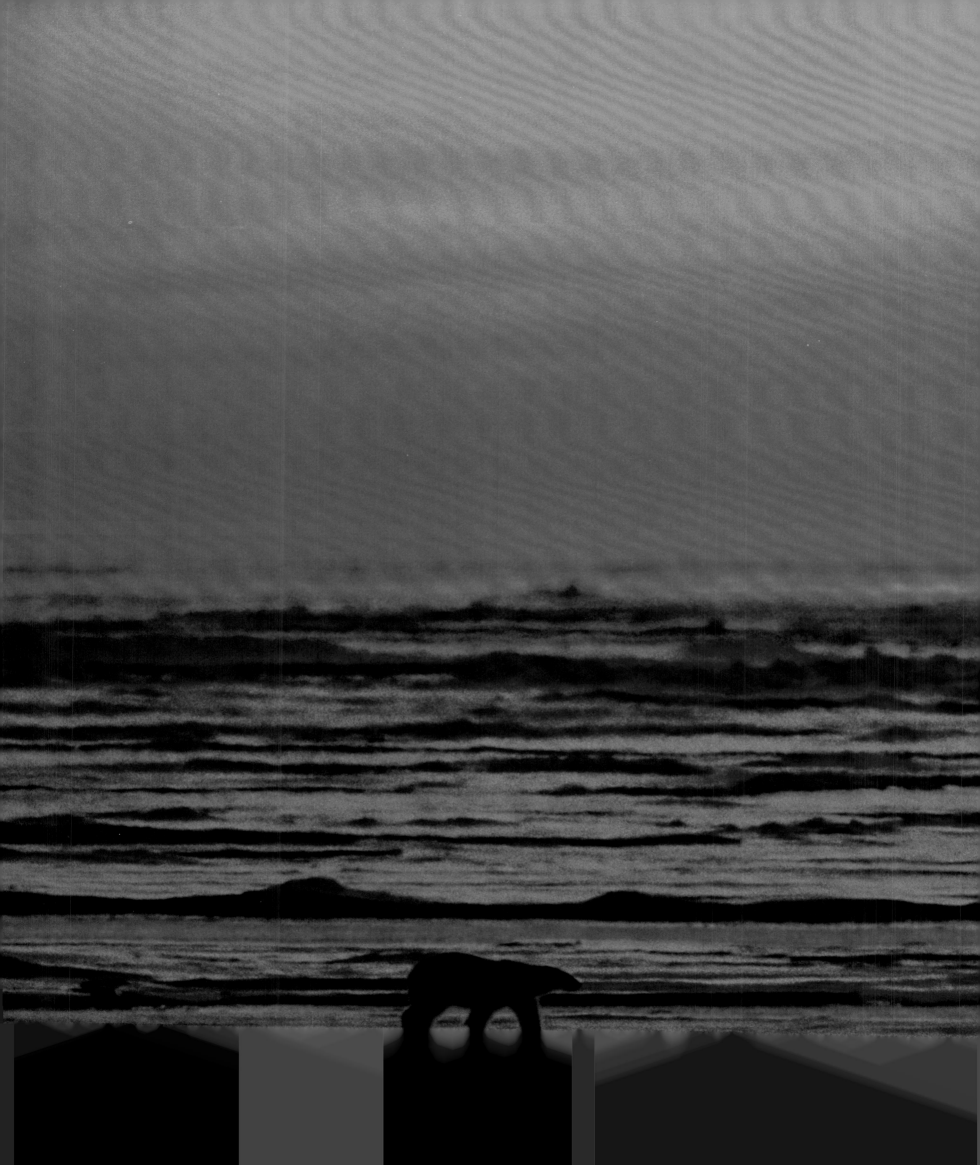

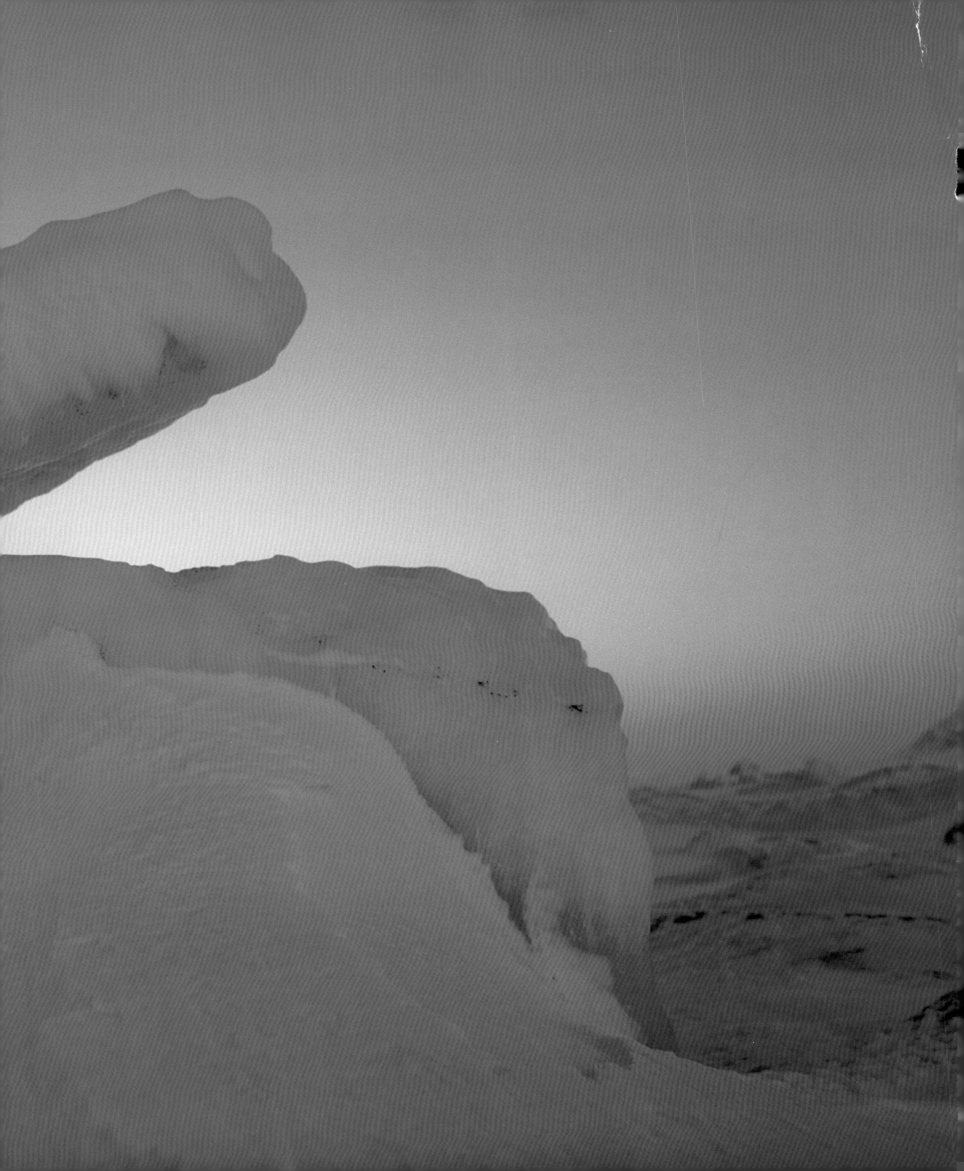

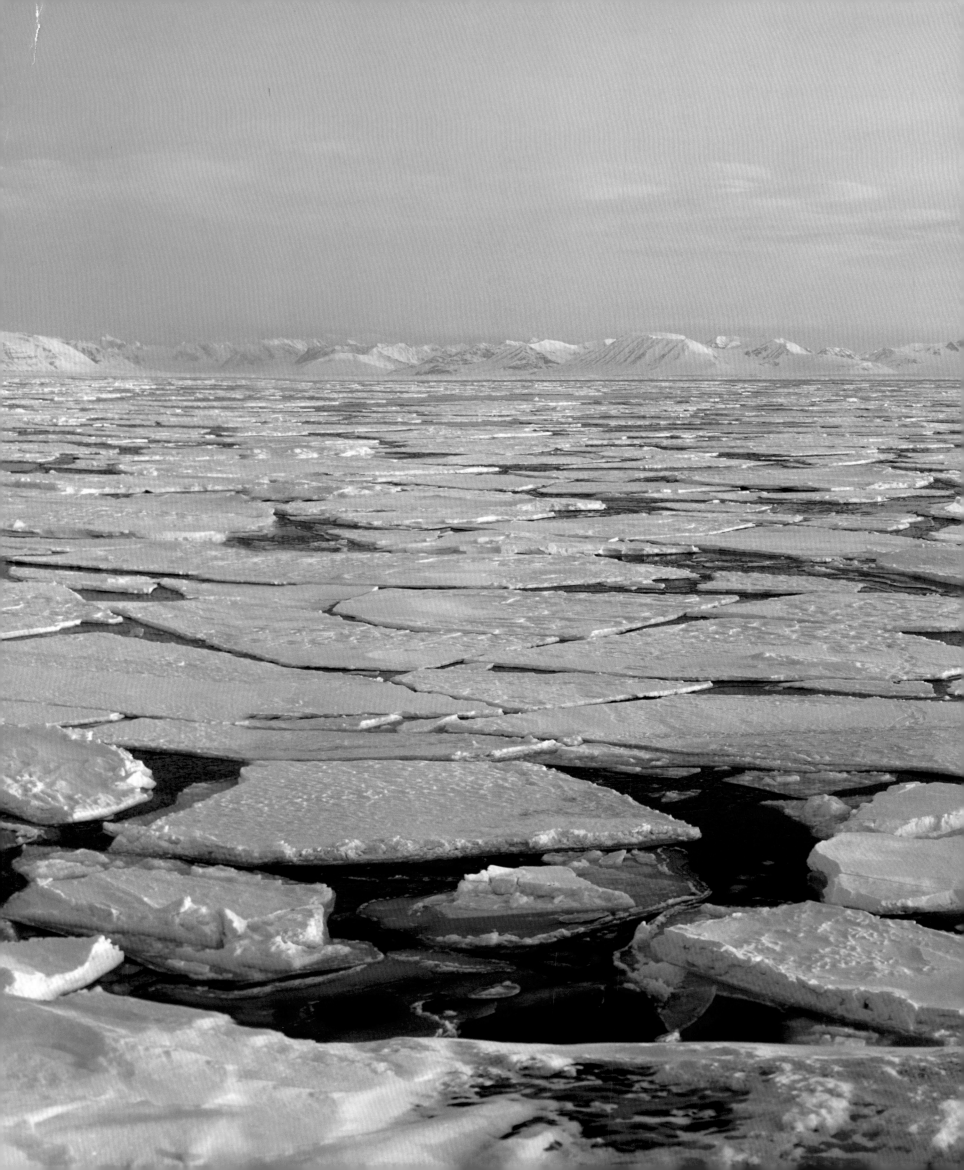

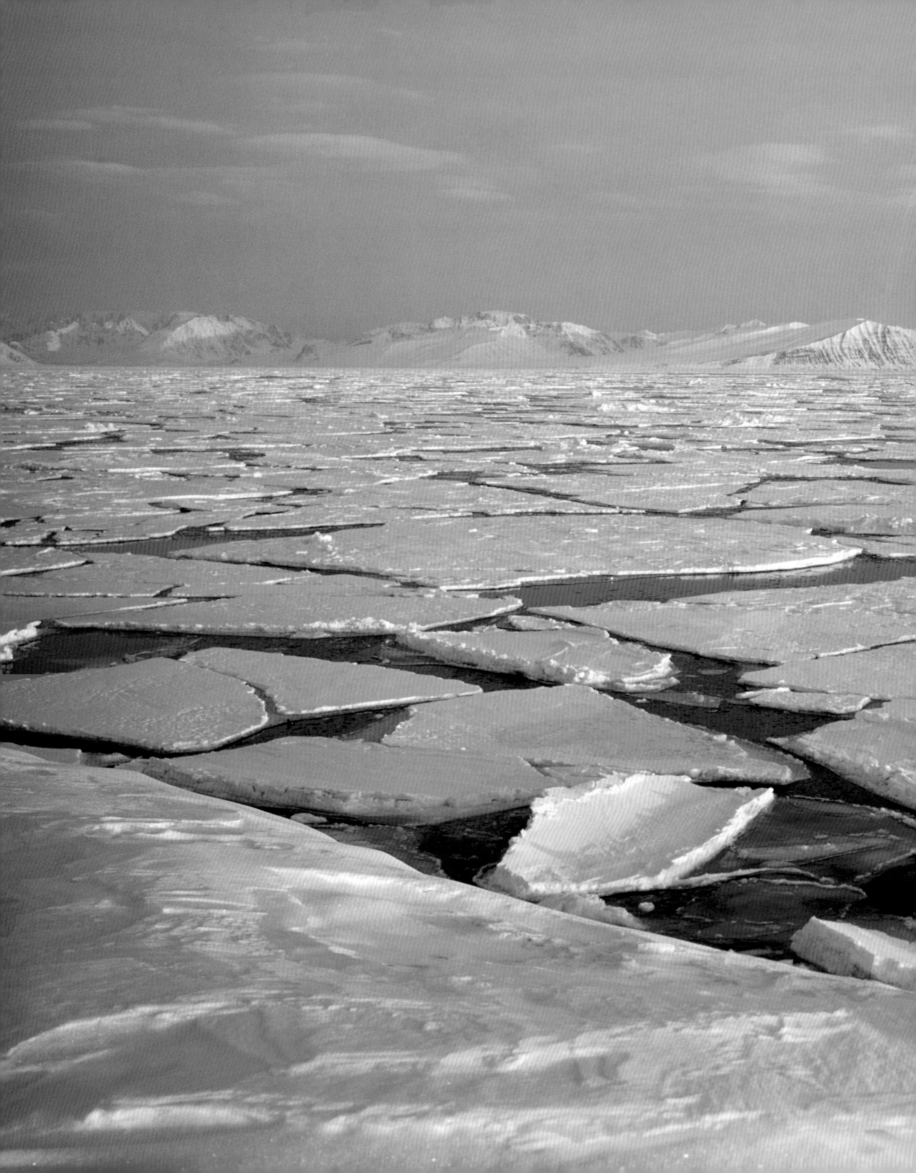

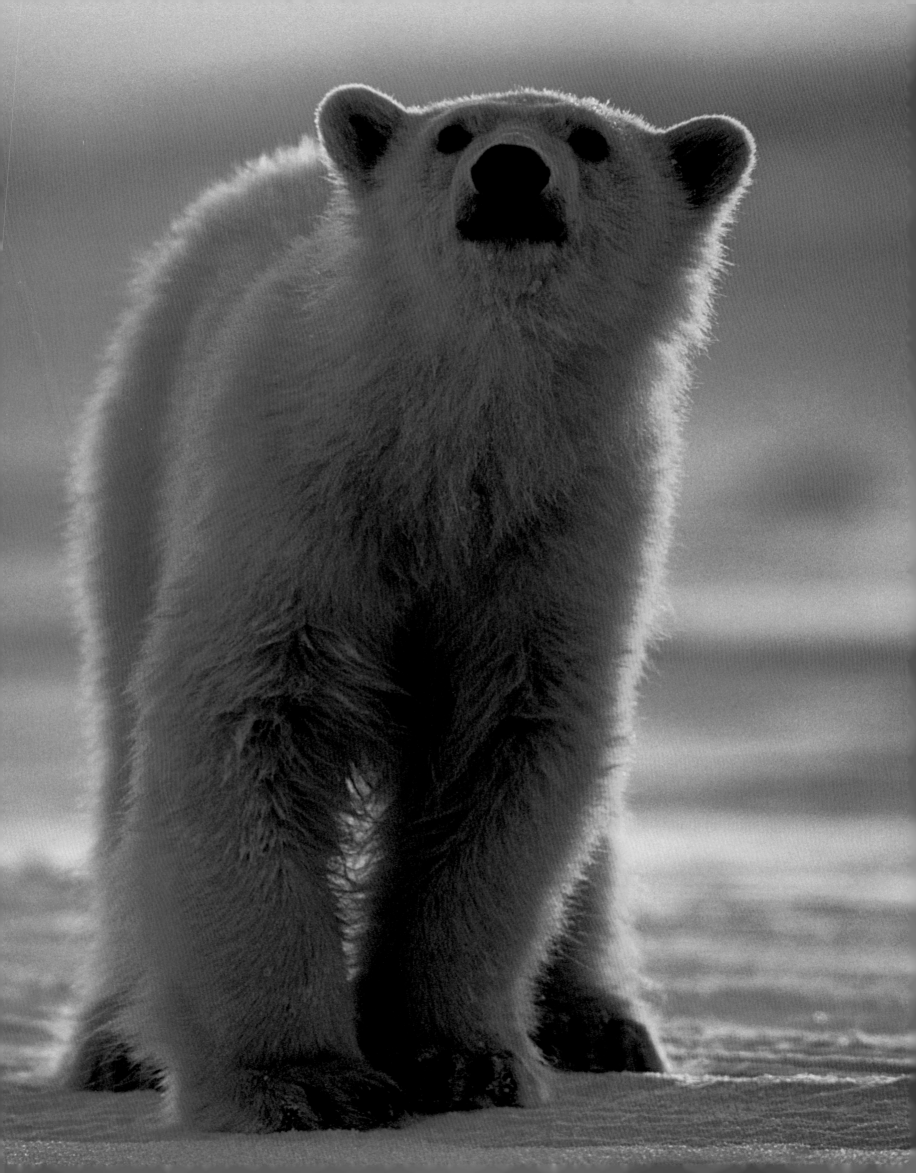

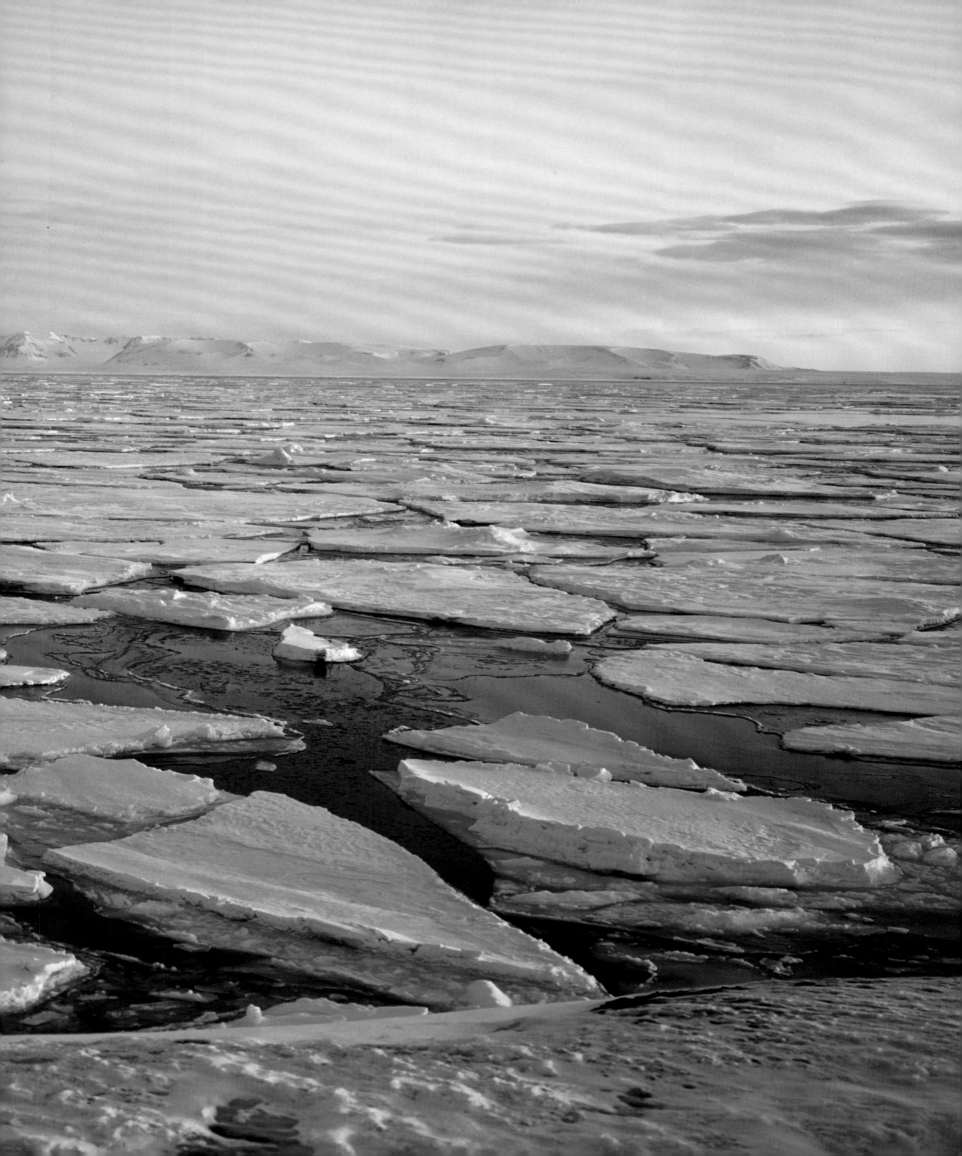

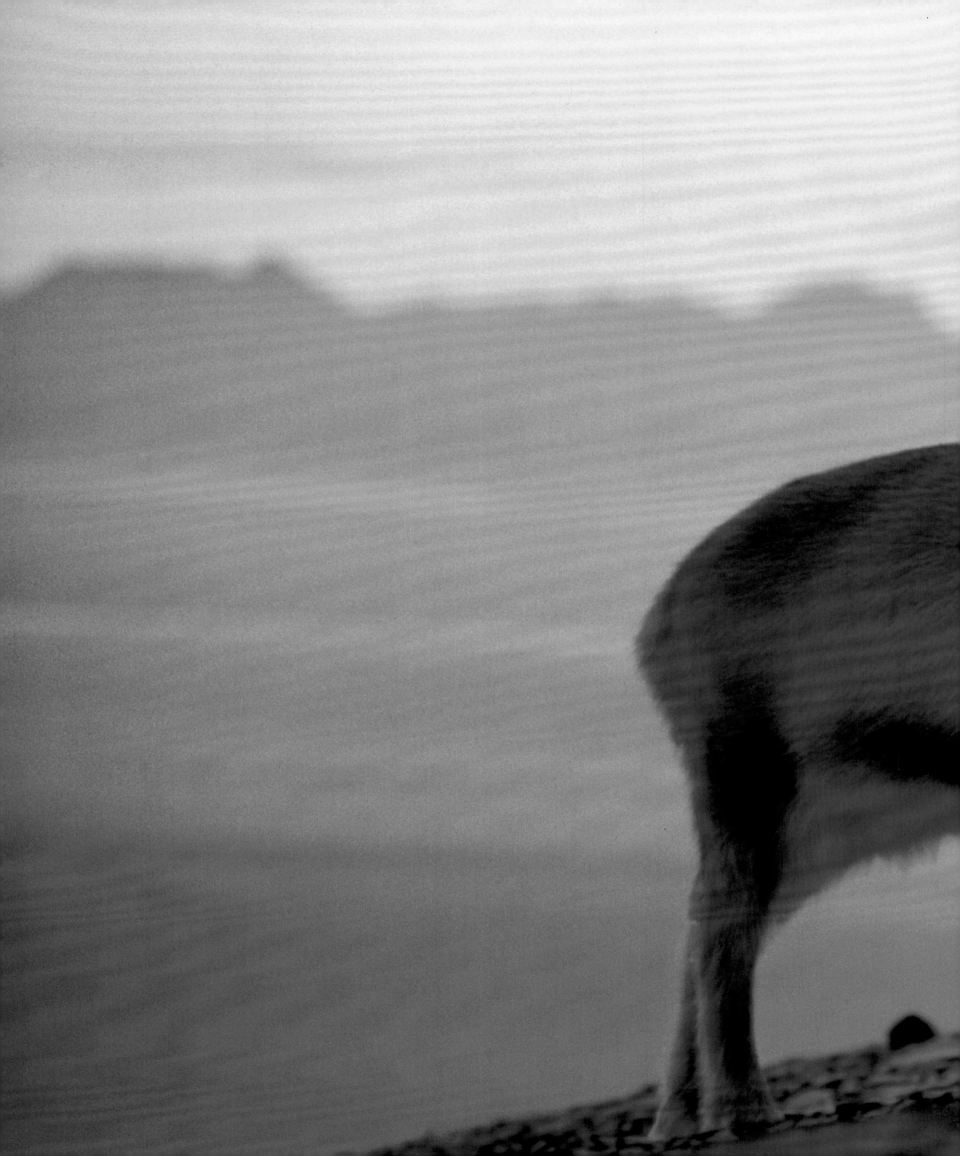

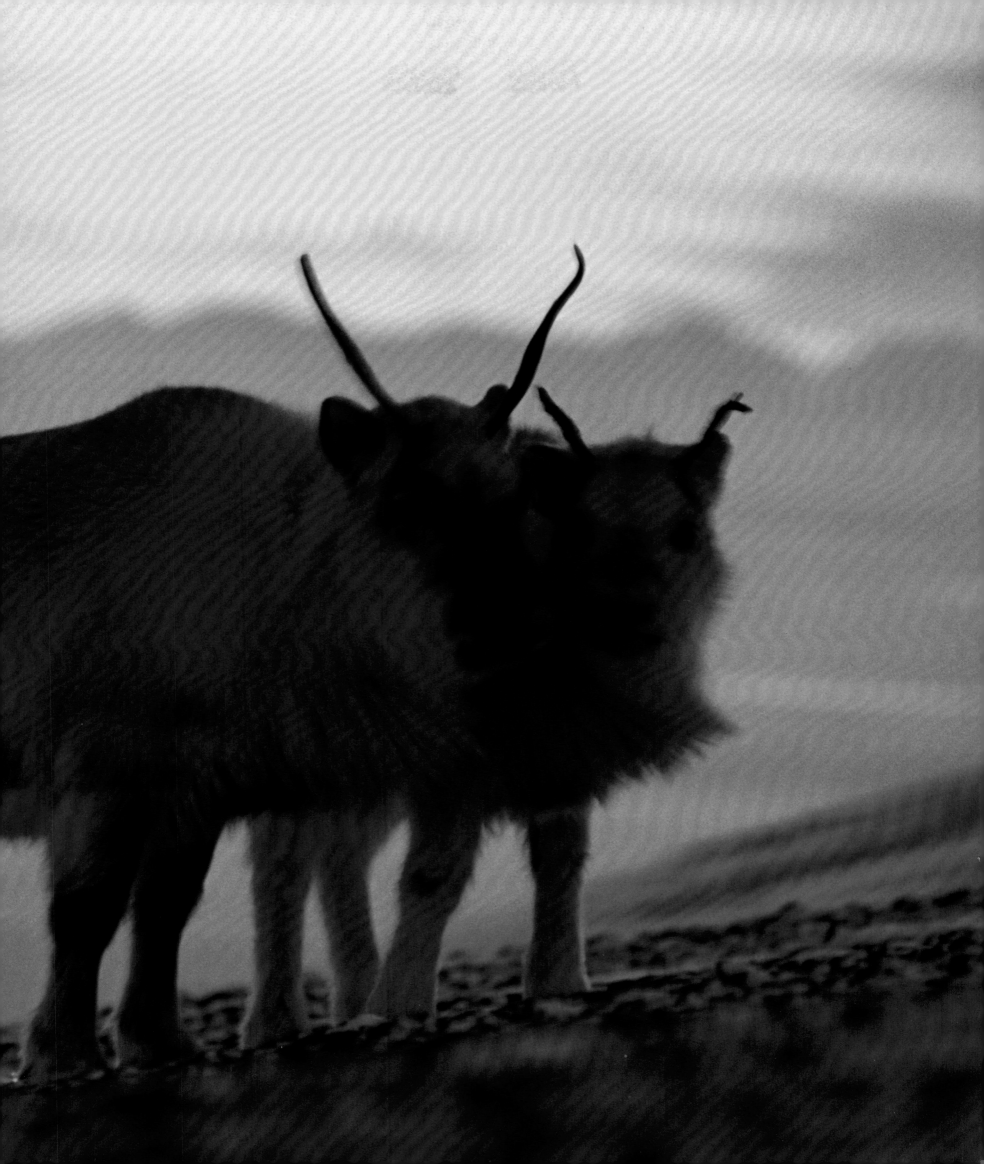

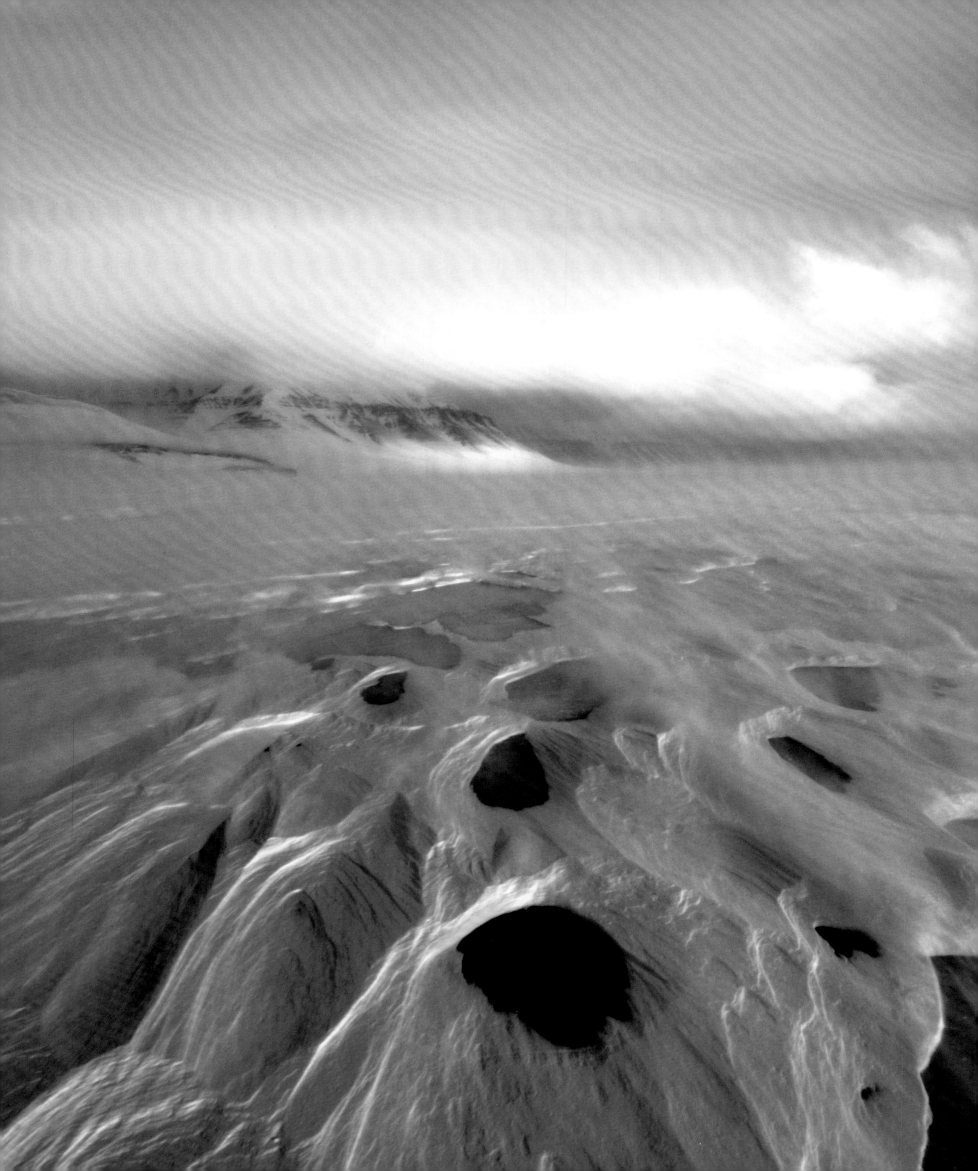

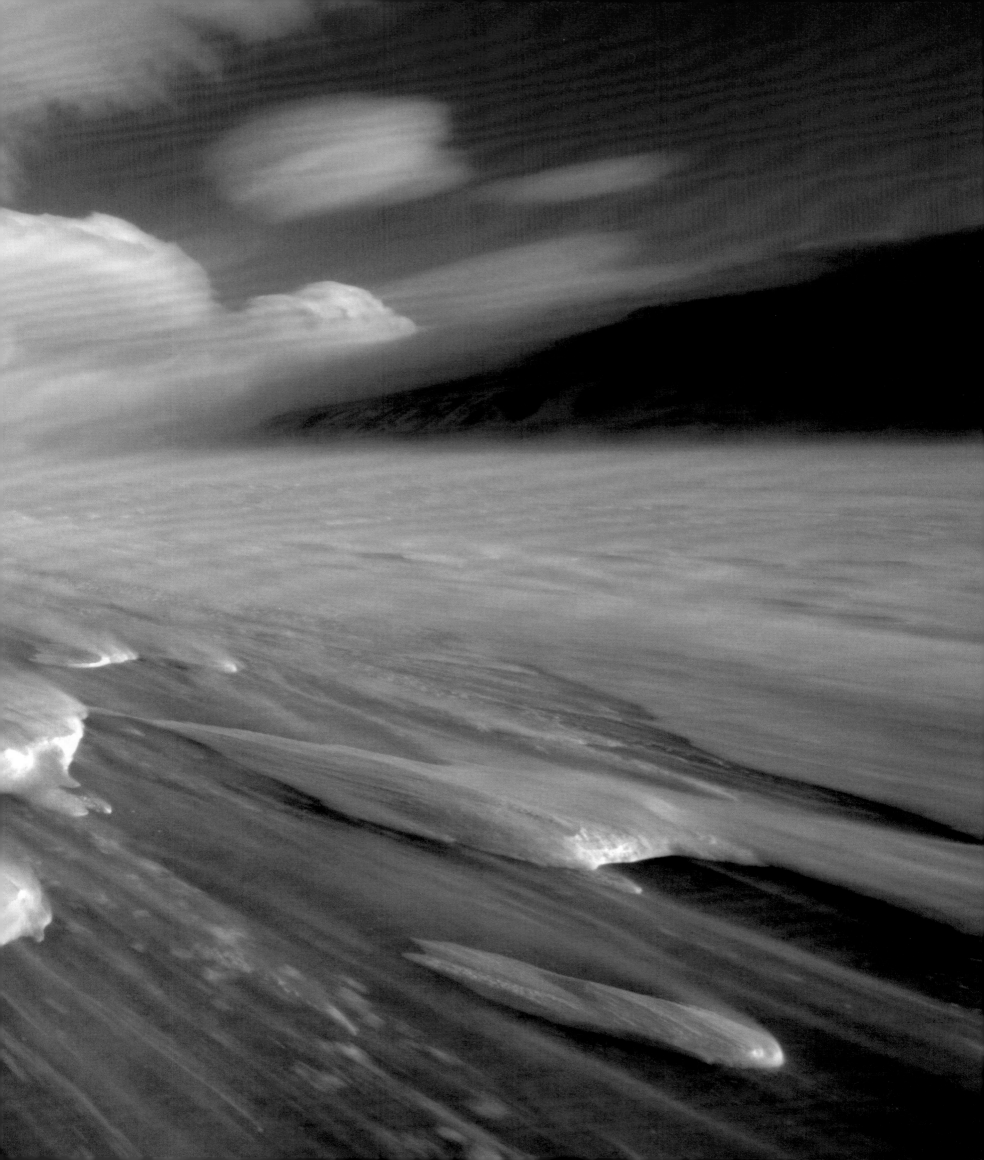

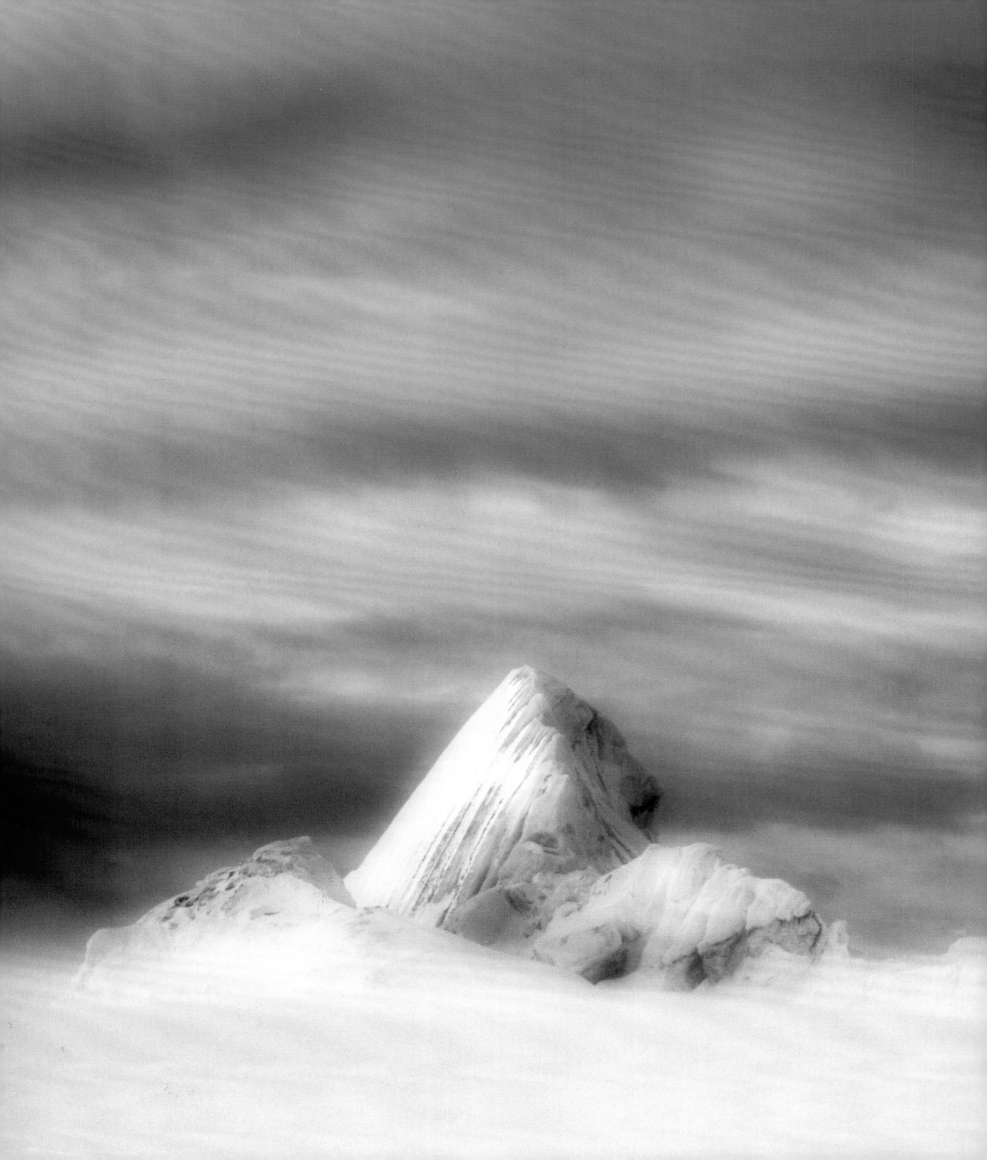

North of us lies a frozen ocean, an infinite desert of ice stretching as far as the eye can see, and beyond. From one continent to another, from one world to the next—and in the middle of it, the ever-drifting ice. The Arctic is water. Frozen and fluid.

This ice cap is the aorta, the main artery, of the Arctic; it is what defines it and gives it life. Like any living entity, it moves, grows, and decays. Driven by wind and ocean currents, the ice is in constant motion. Shaped by seasons and temperatures, it is in constant transformation. It is a landscape with ever-changing scenery. It might seem entirely a world of snow and ice. And it is, but it is so much more still.

It is a white day in the middle of winter; the ice of the north is extended to its fullest reach. It stretches and surrounds the islands and land areas of the high Arctic, offering a bridge, and new grounds, to life that needs it. An amazing floating platform where polar bears and seals get expanded habitat, and animals like the Arctic fox can discover new sources of food. For some, the ice of winter is crucial for survival.

This is the coldest time of year, with temperatures far below freezing. Constant winds make the windchill effect all the more severe. Winter's embrace of the Arctic brings extreme conditions. White skies and white ground, layers of white upon white.

Darkness has left us, and light has begun its arrival. Shades of white replace shades of black. The day becomes longer by the hour, and presently the all-night light of the midnight sun shines once again as the long winter night becomes permanent day.

The sea ice is unpredictable. Some call it the devil's dance floor. When the winds turn, vast areas of thick, solid ice can break up into floes and disappear in the twinkle of an eye, leaving nothing but open water. Chaos can replace order at any given moment. The sea ice of the Arctic gives life, but it can also take it right back.

The world above ours is a world of contrast. A place where life means death, day can be night, and the serene can be the tempest of your wildest dreams.

A polar bear roams the pack ice; the only sound is the whistling north wind. It seems impossible that anything could break the grip of the ice and the extreme cold of winter. But things are changing.

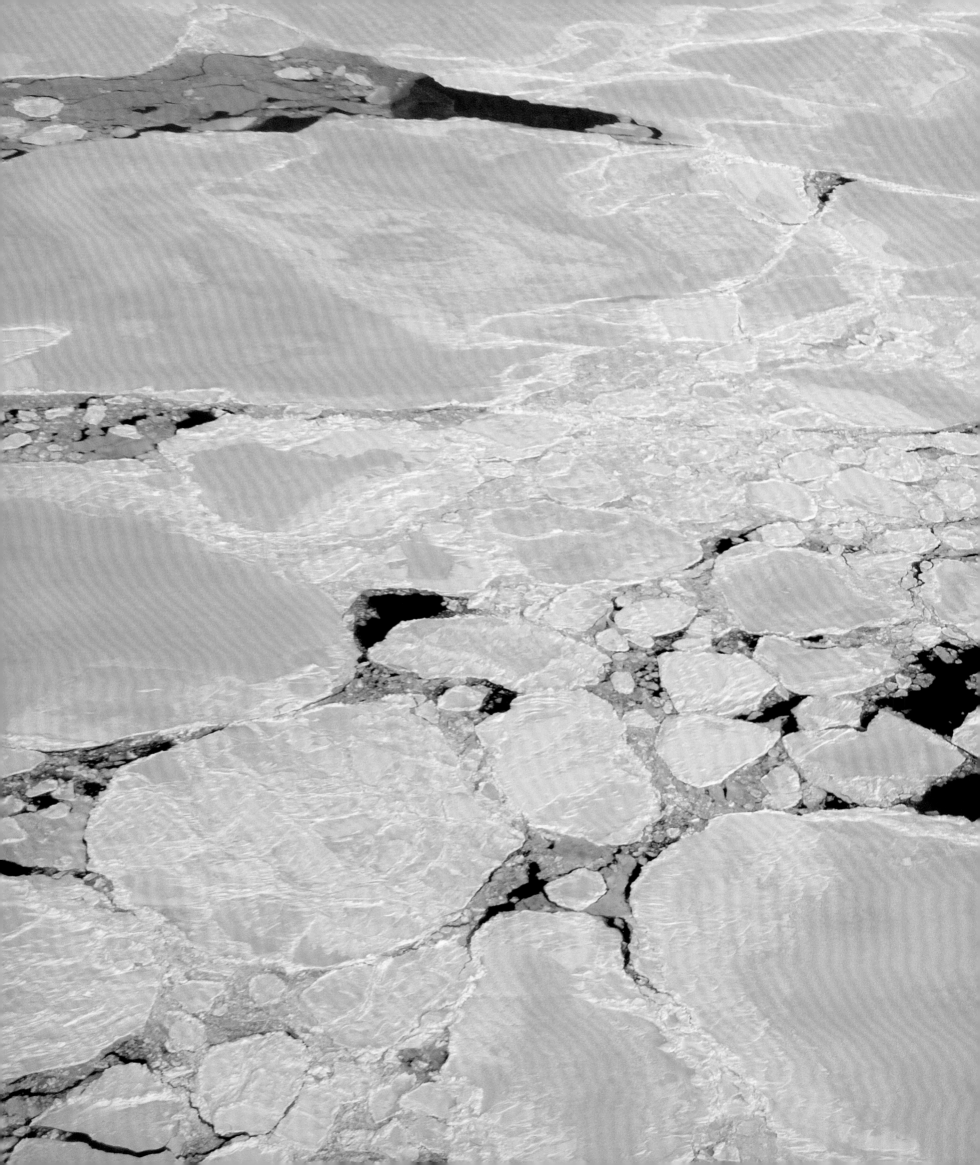

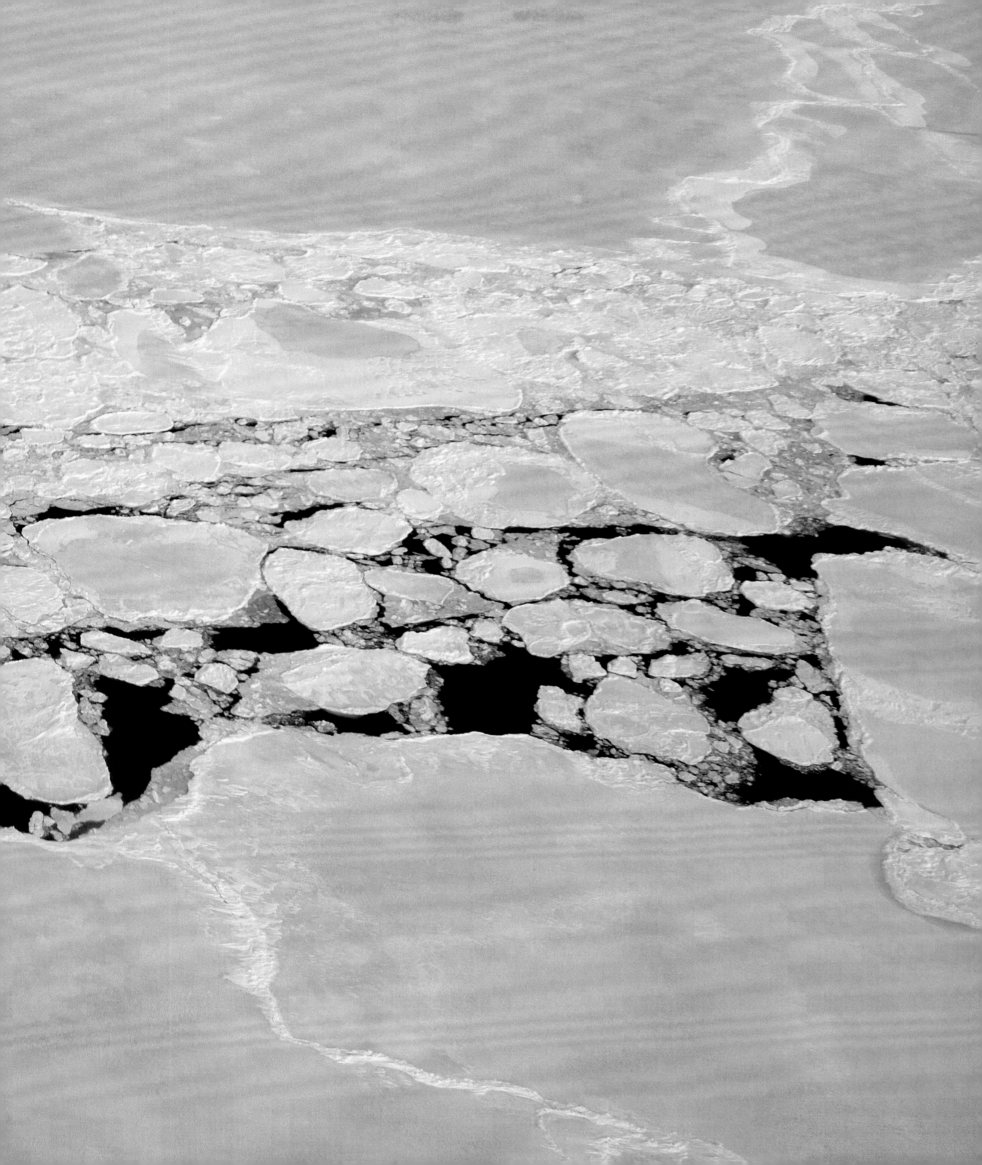

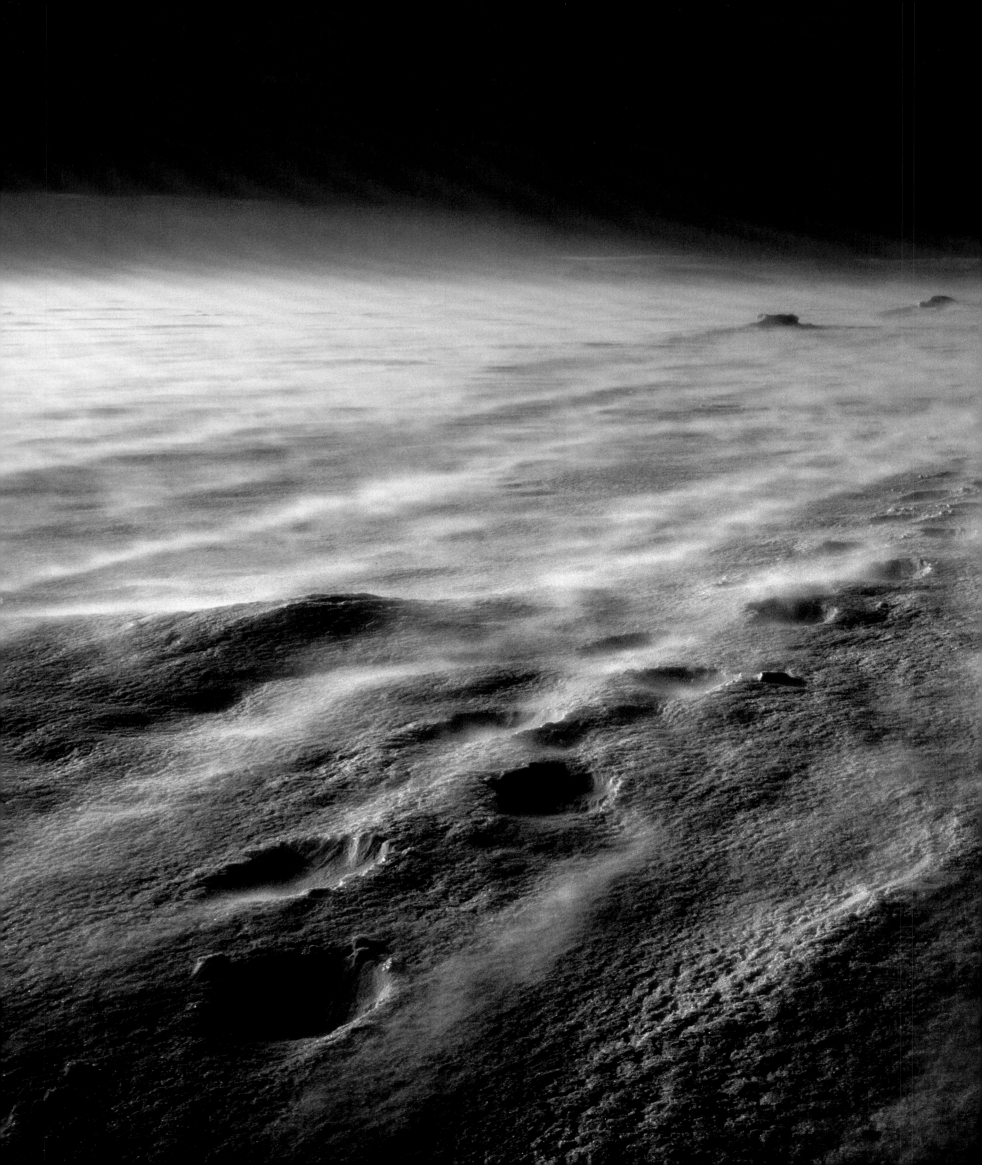

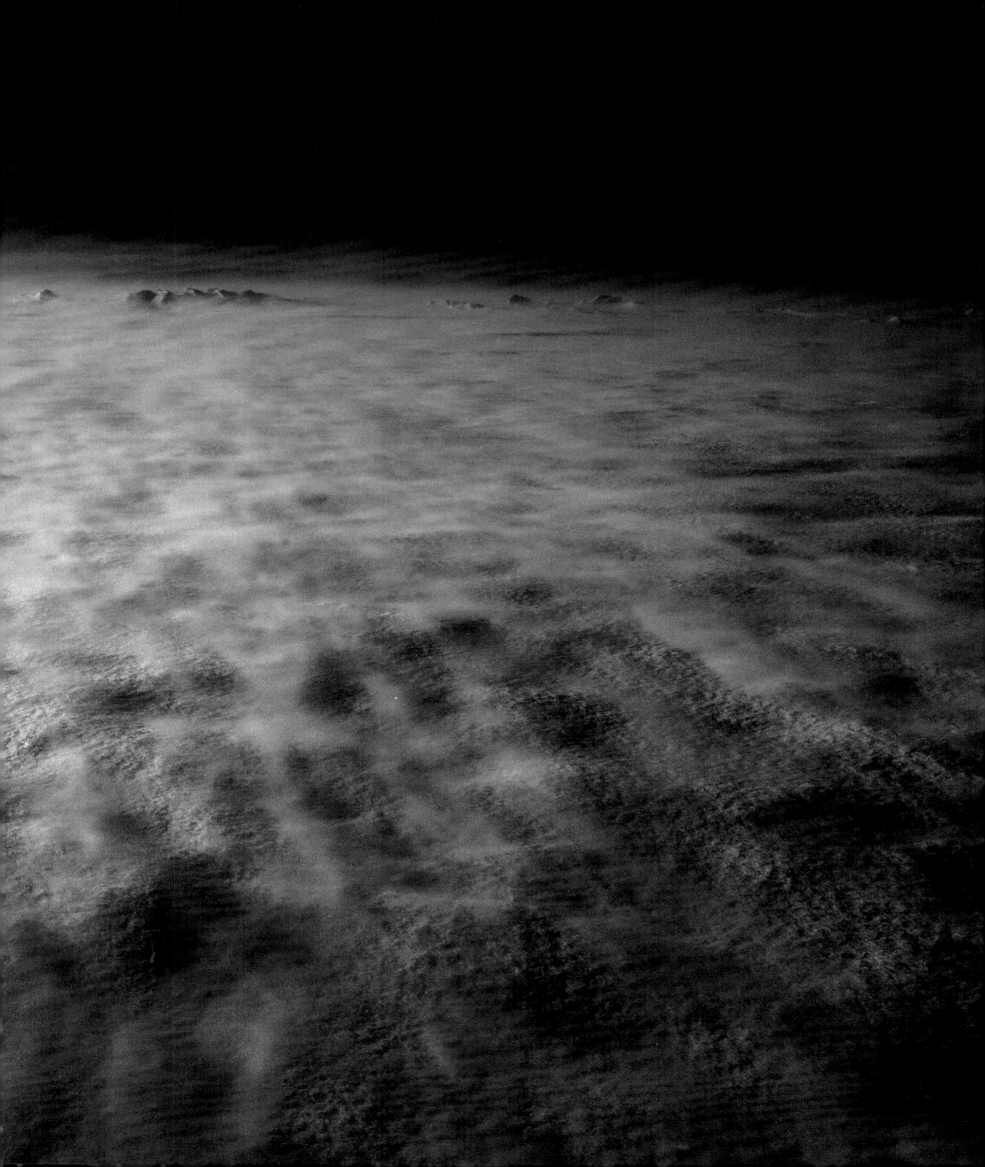

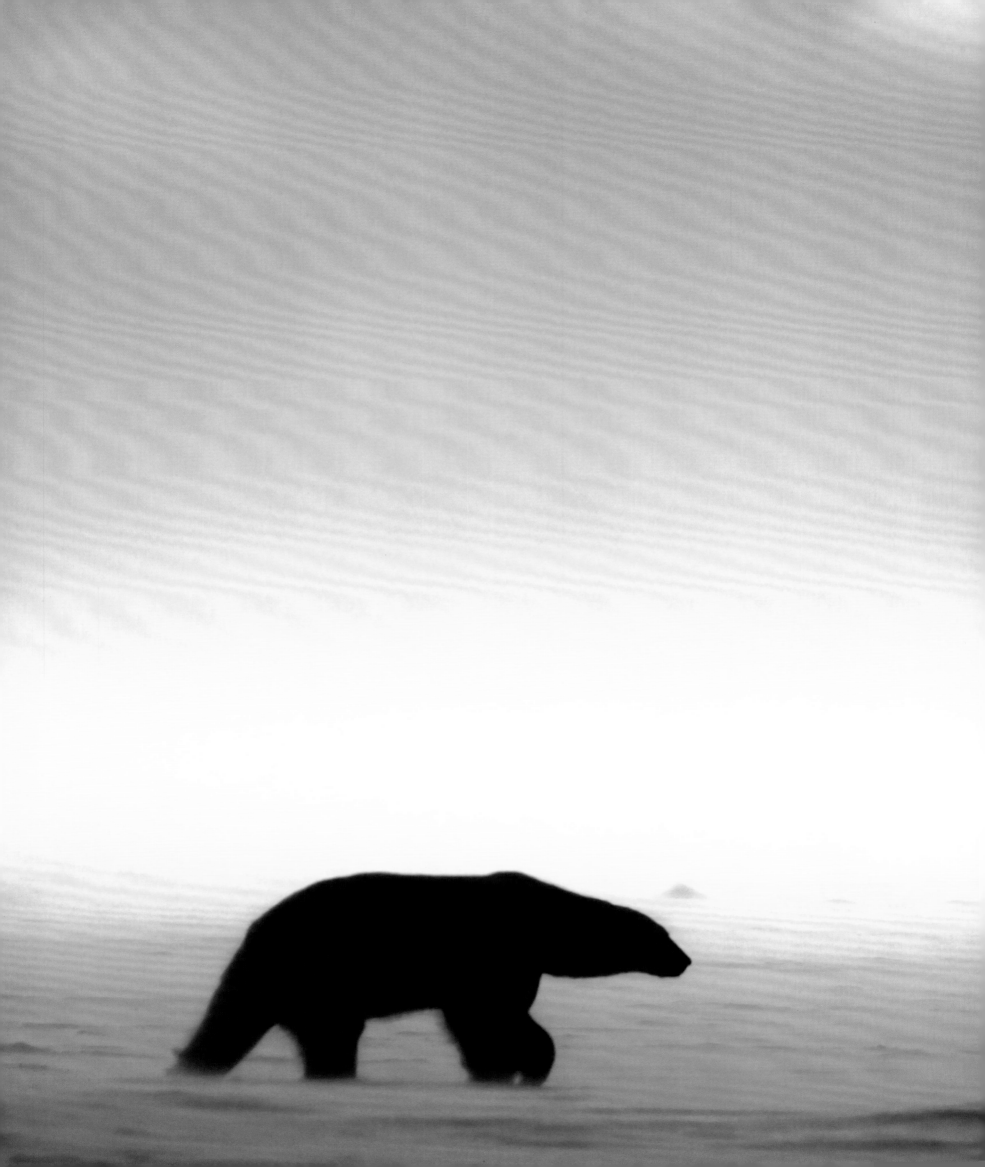

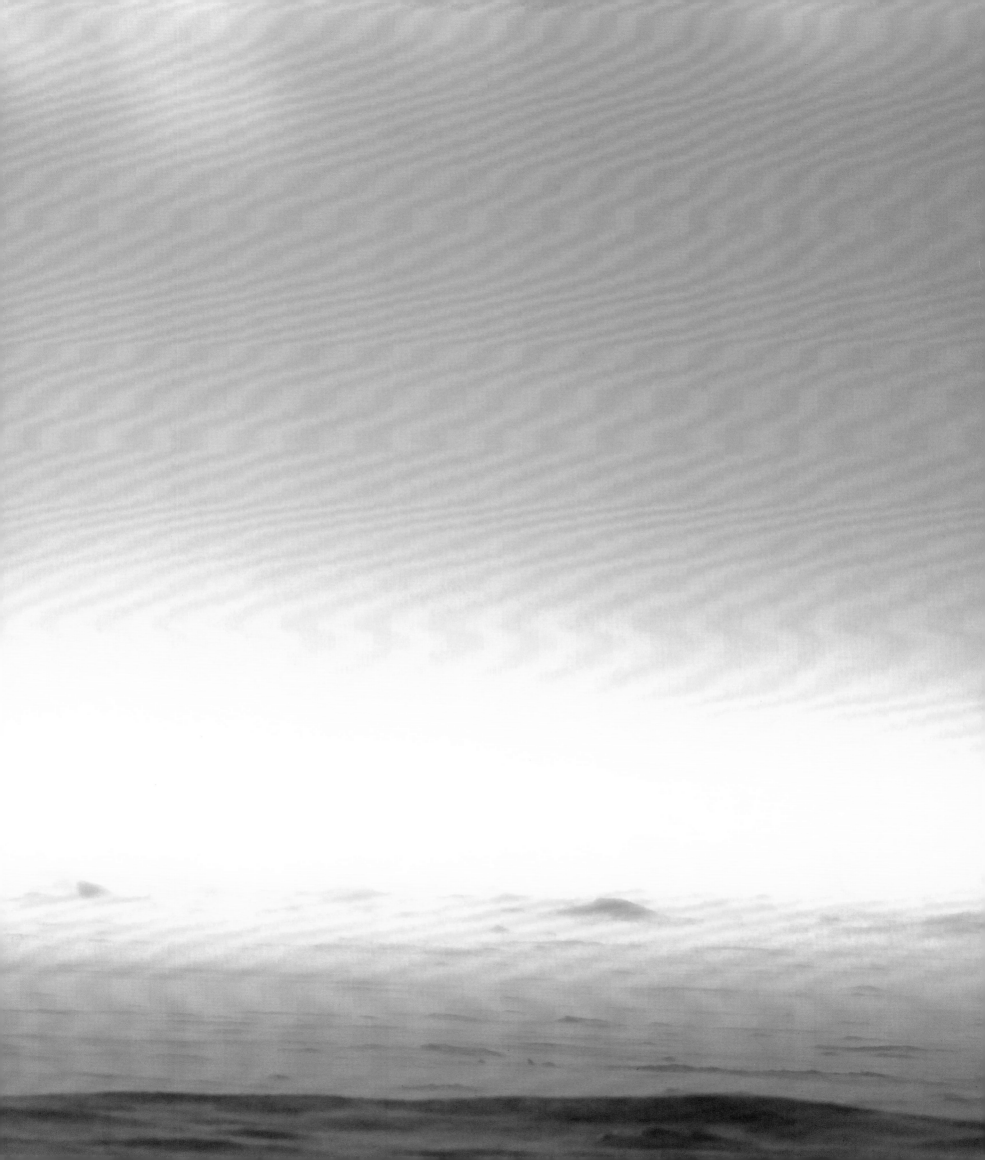

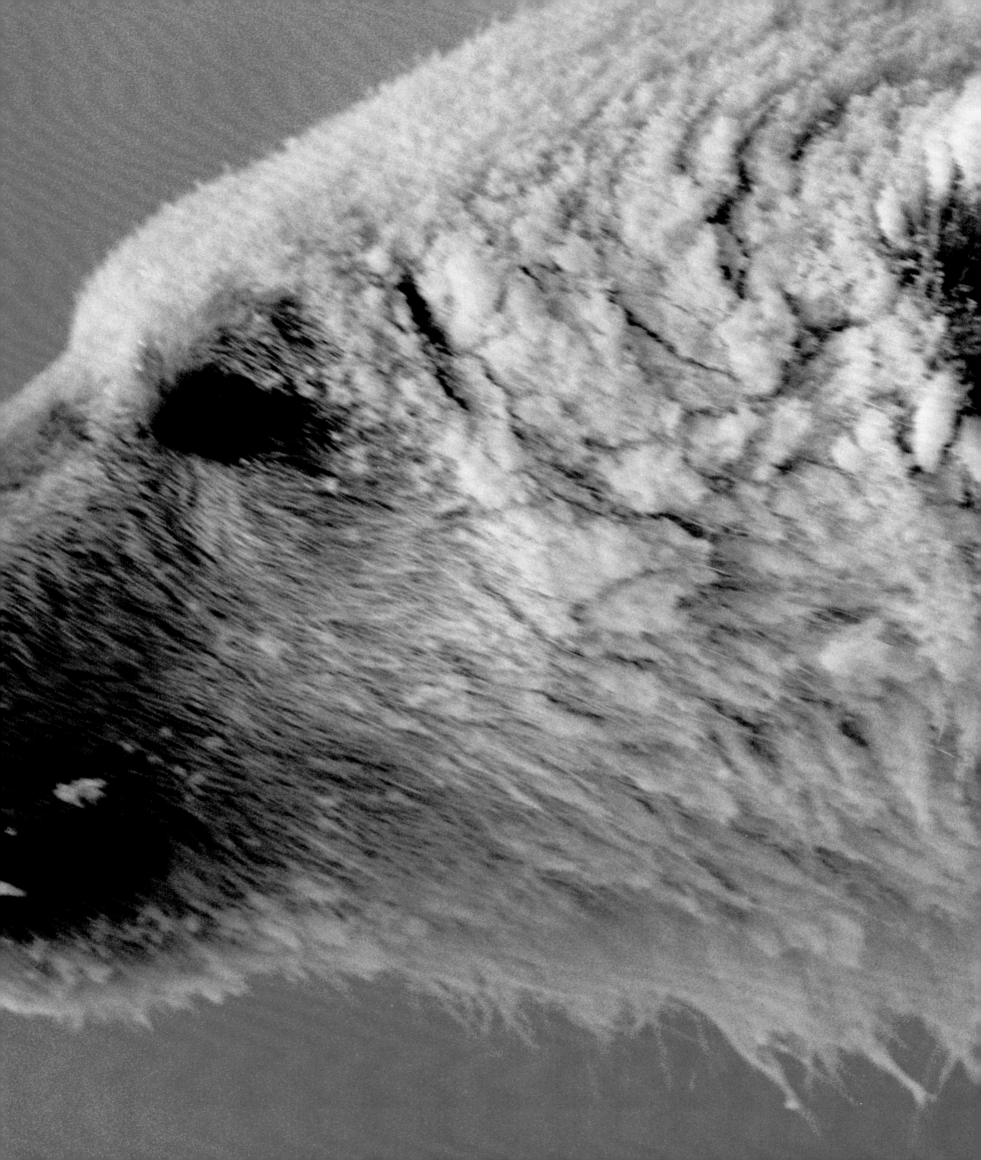

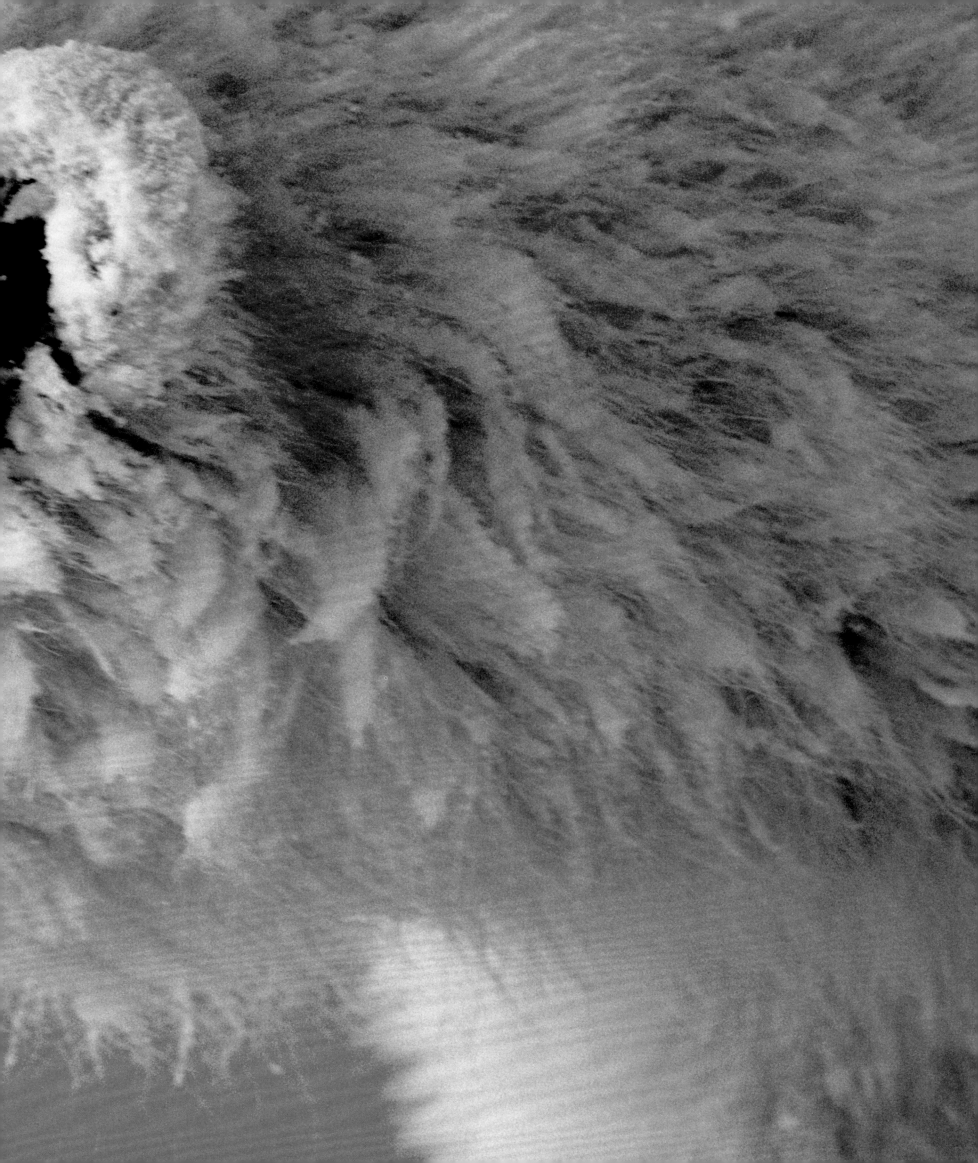

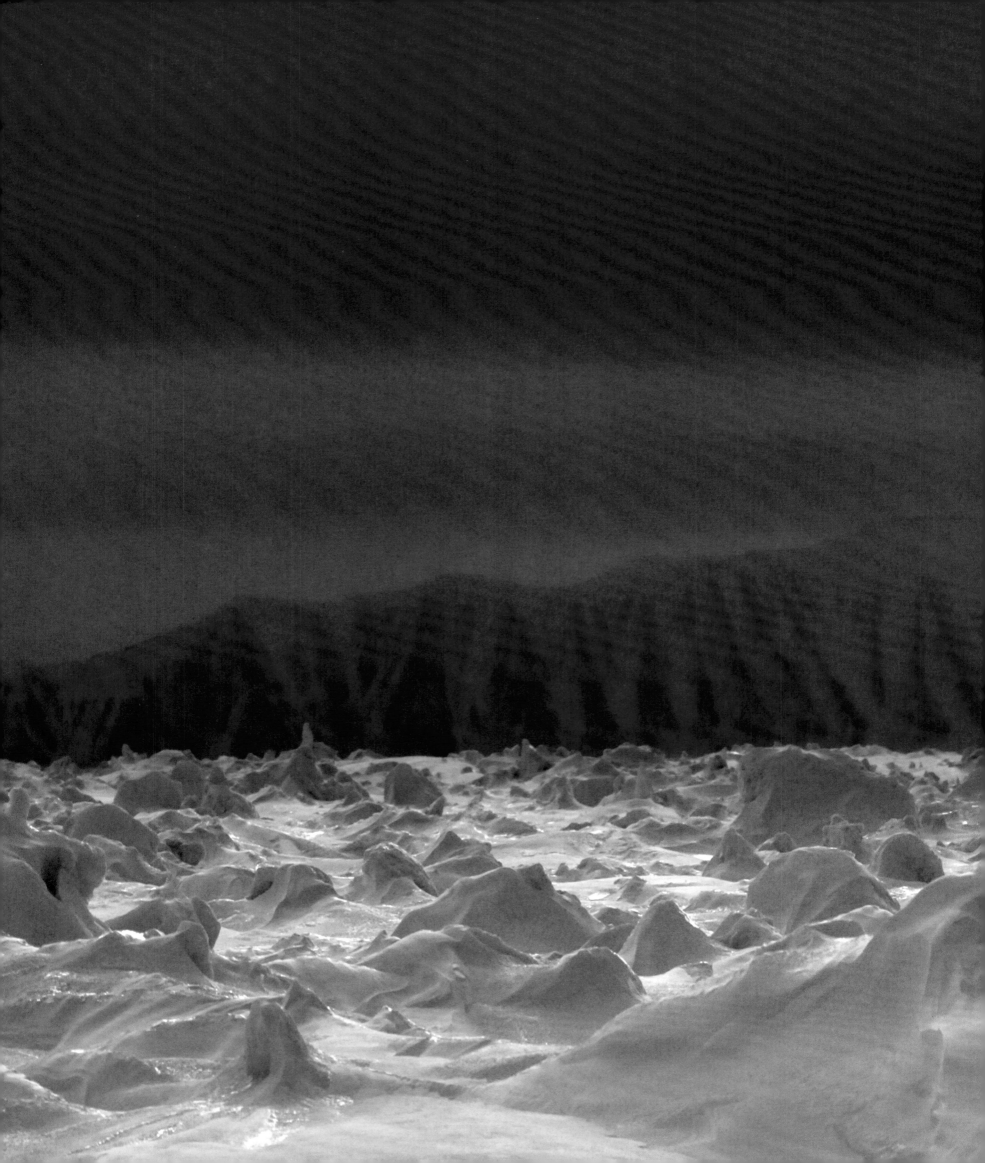

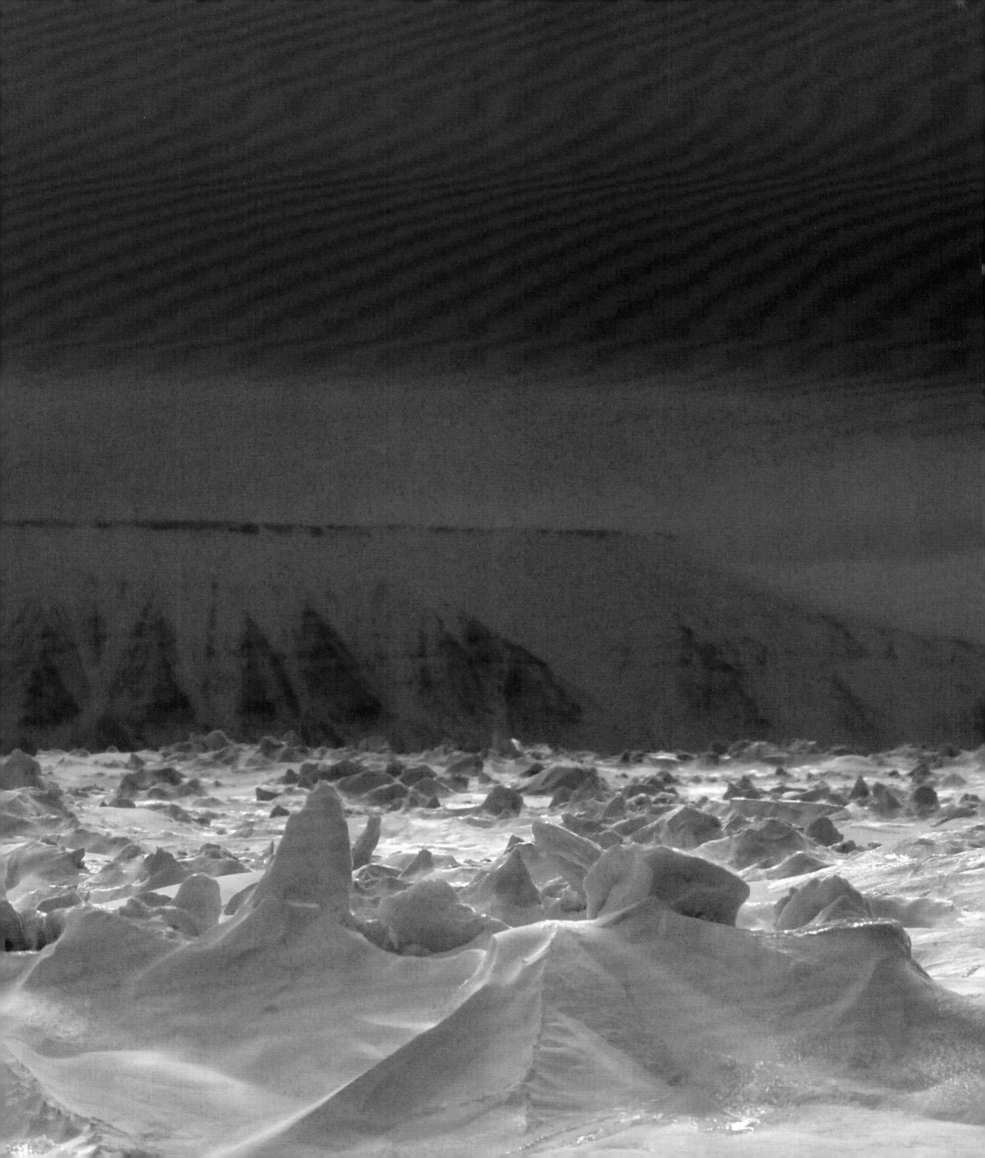

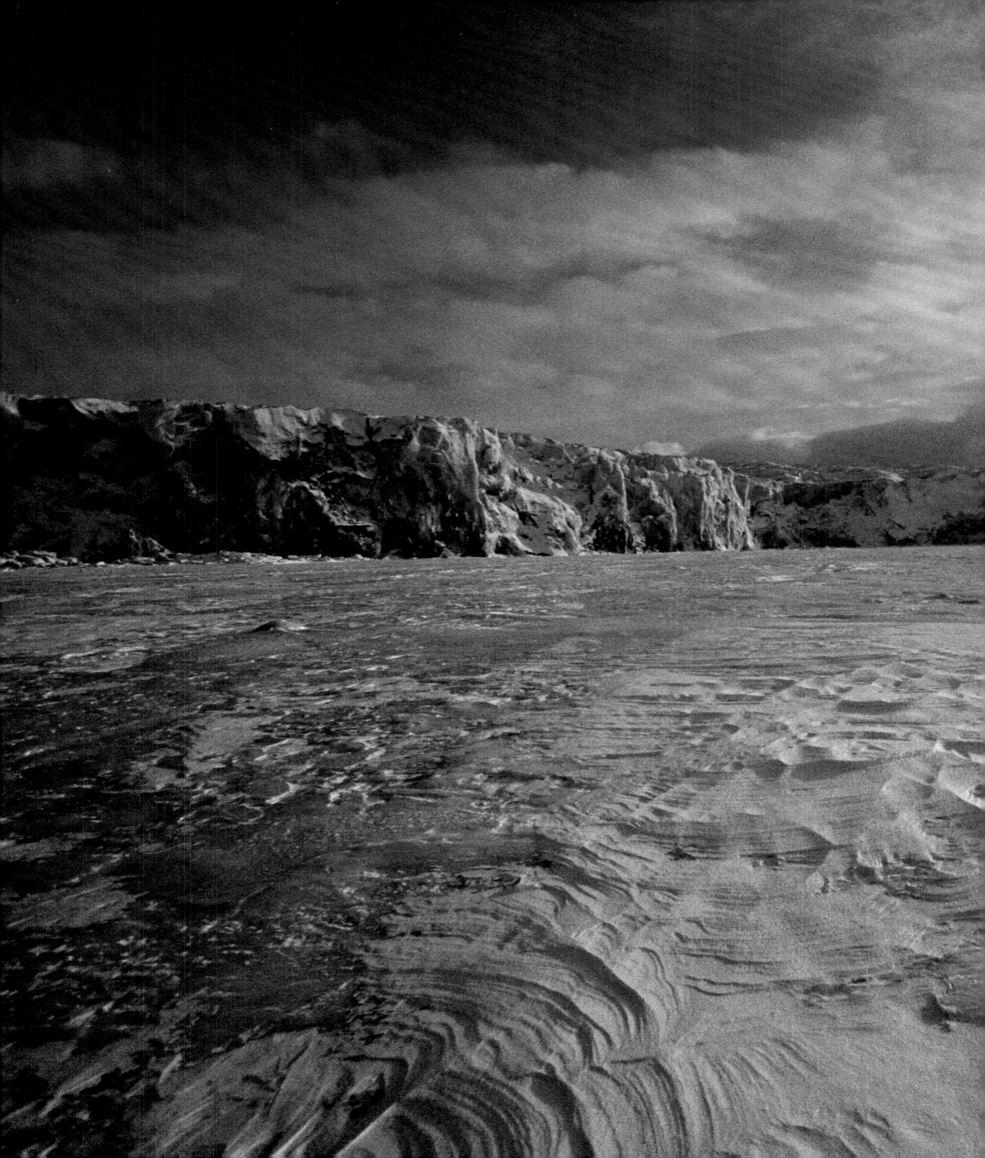

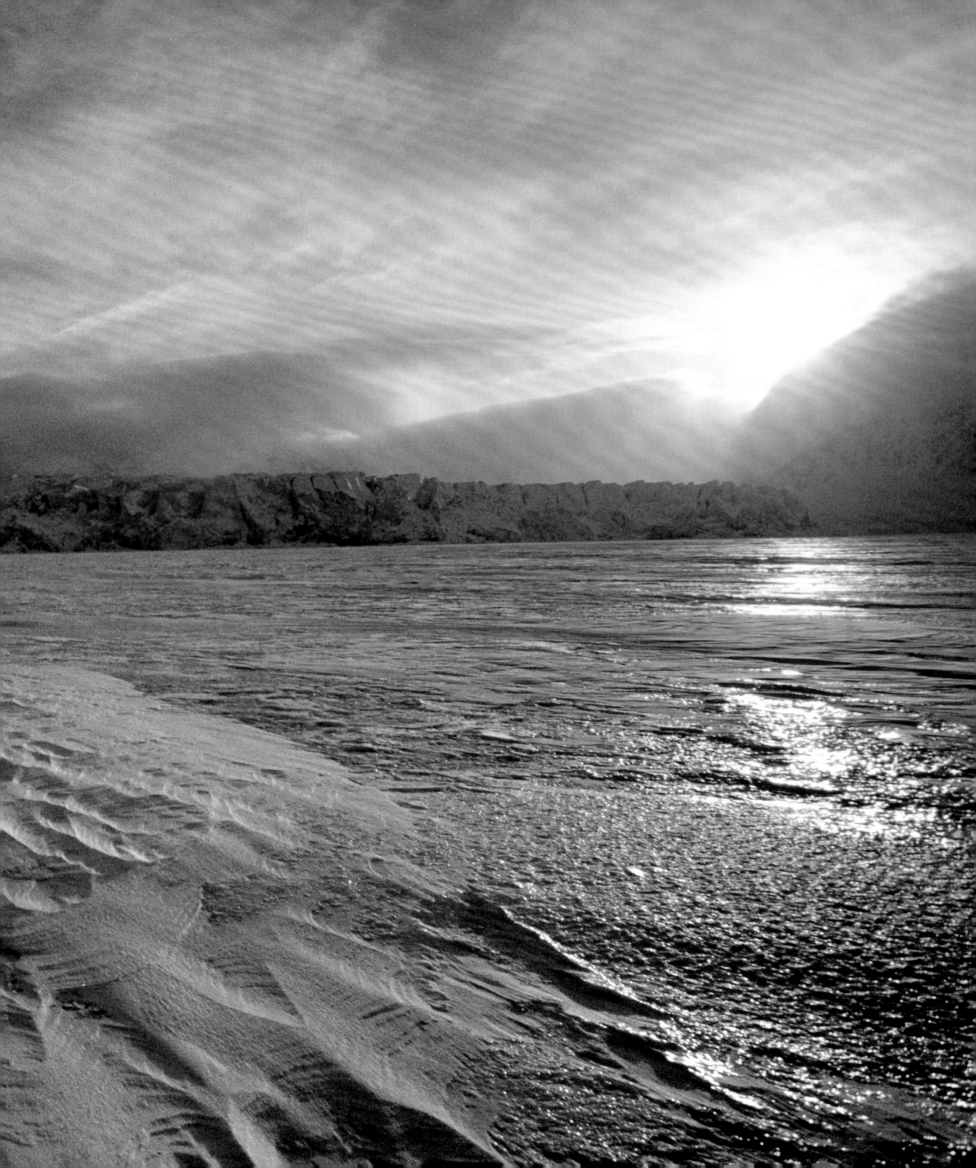

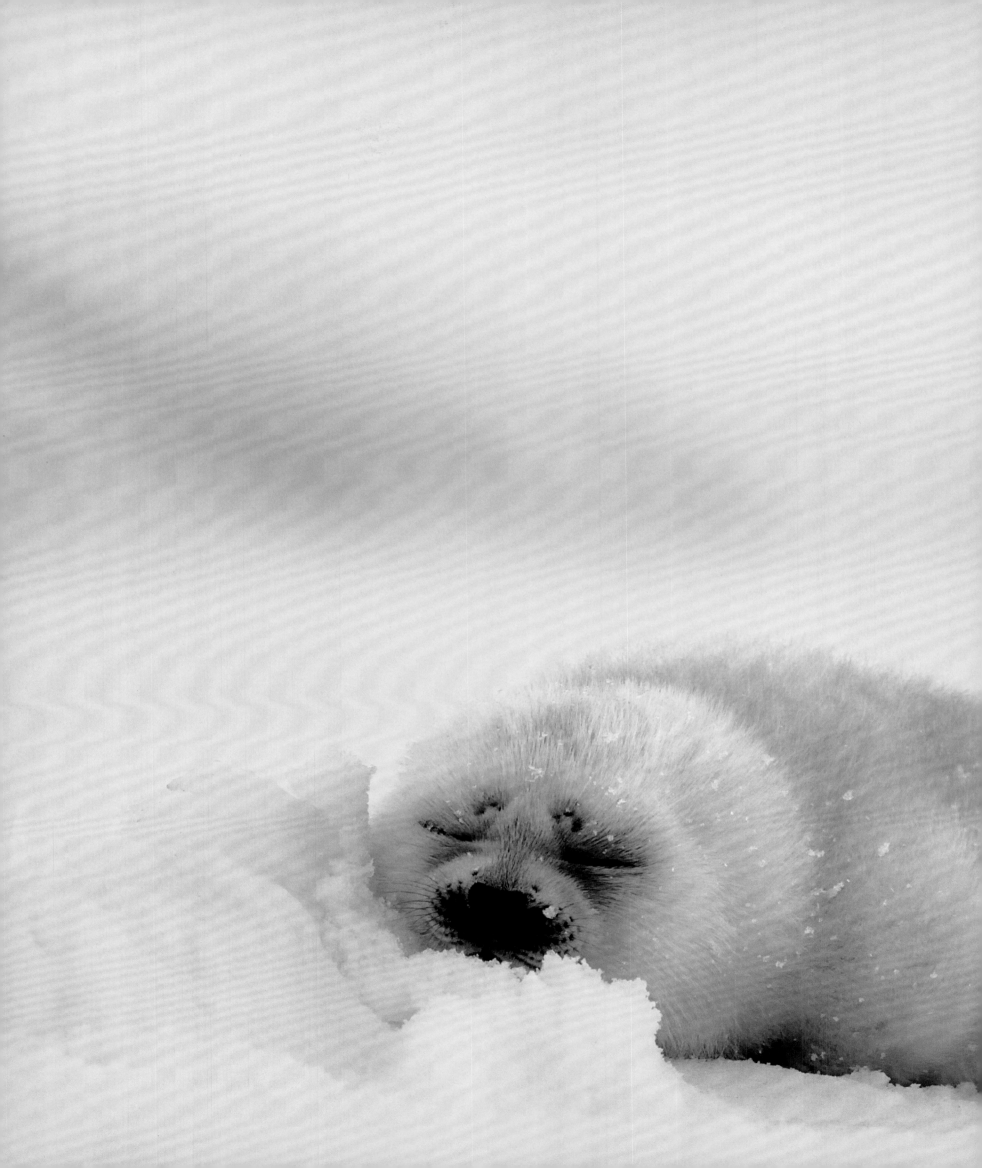

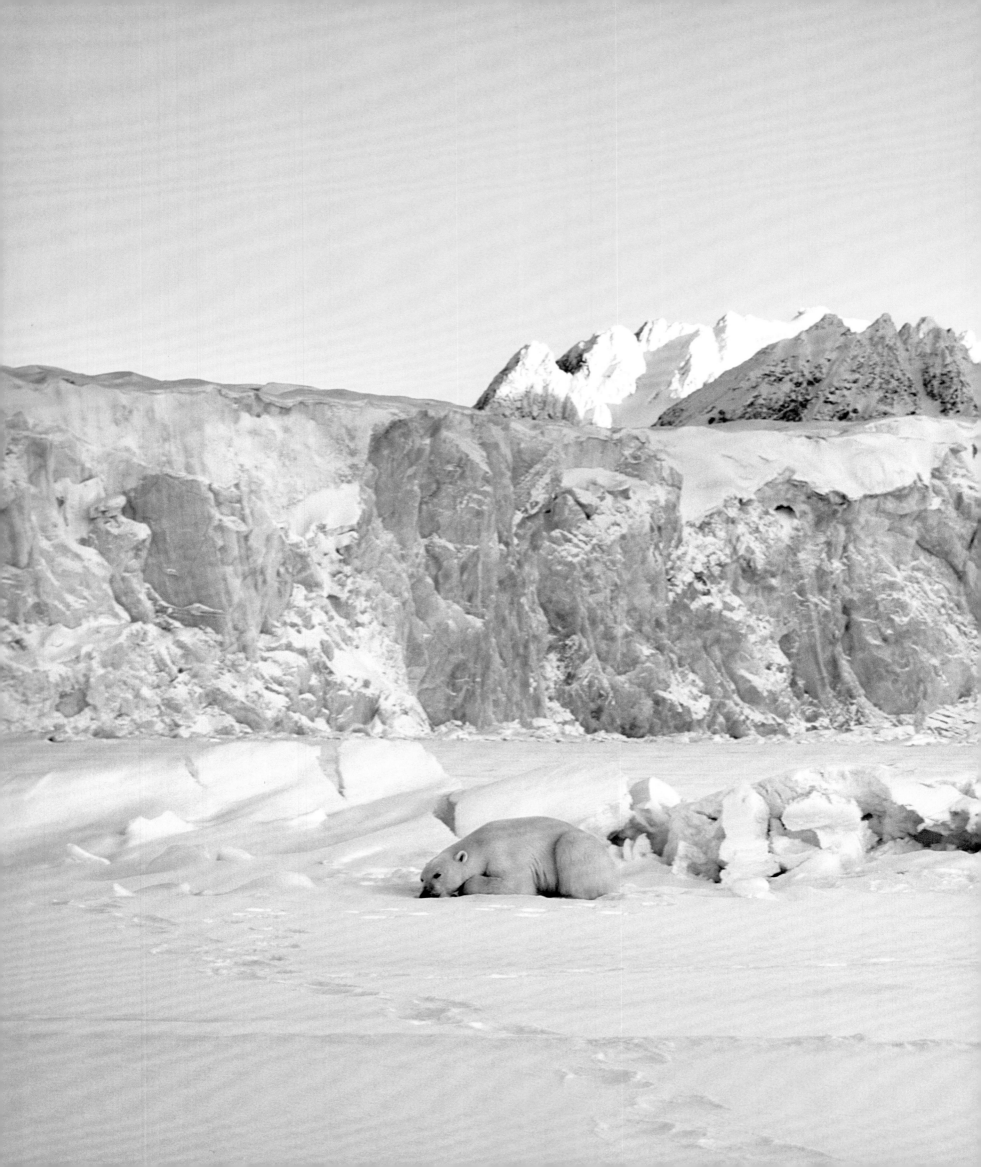

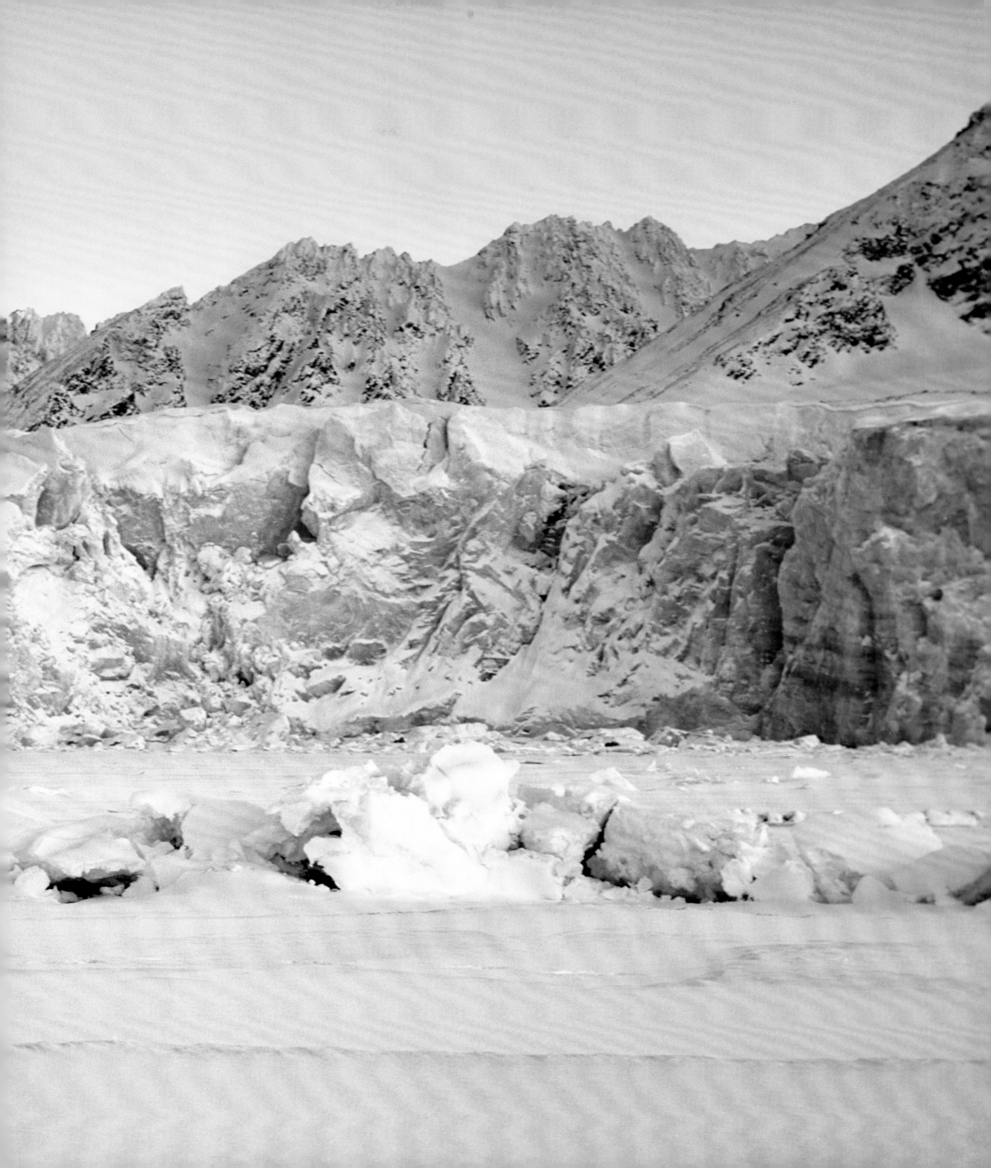

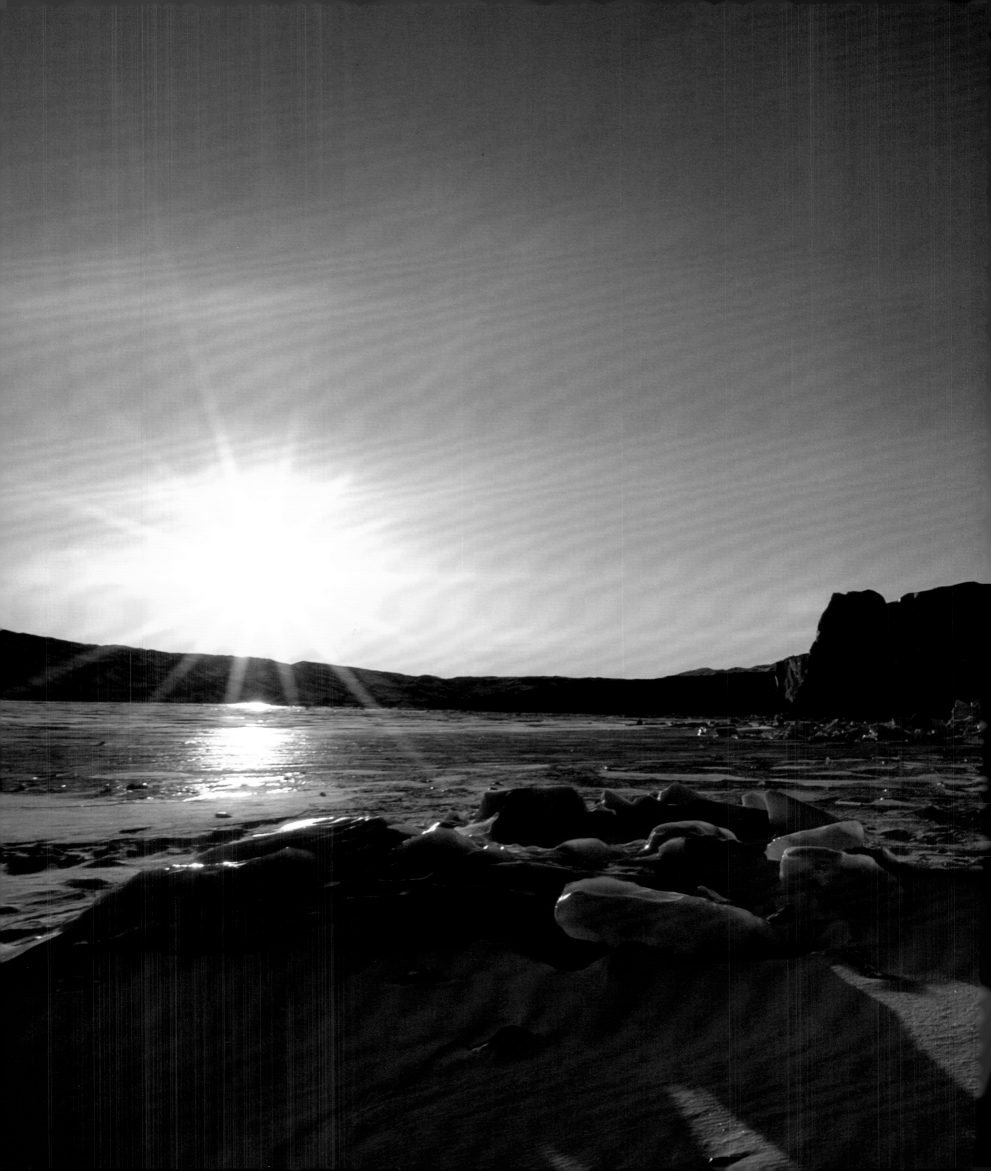

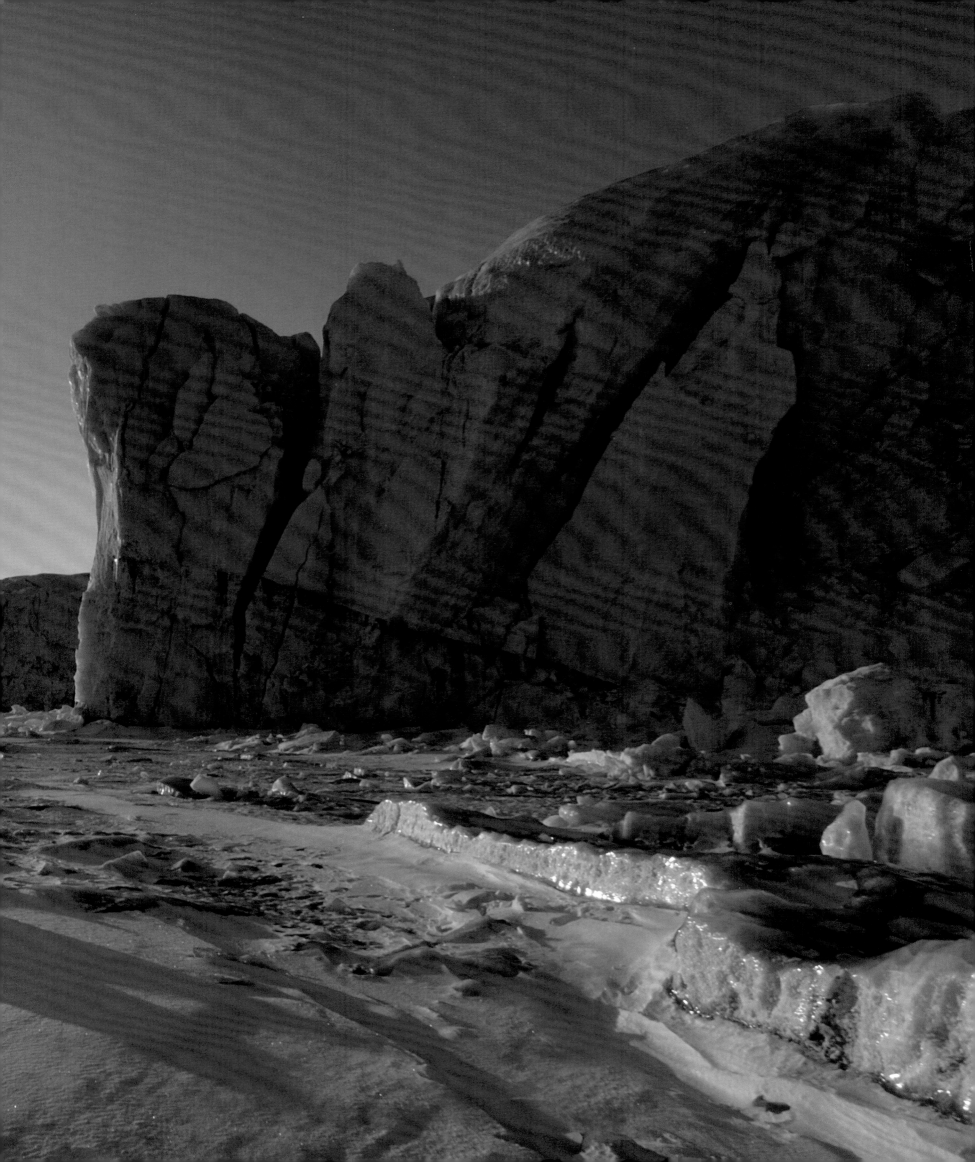

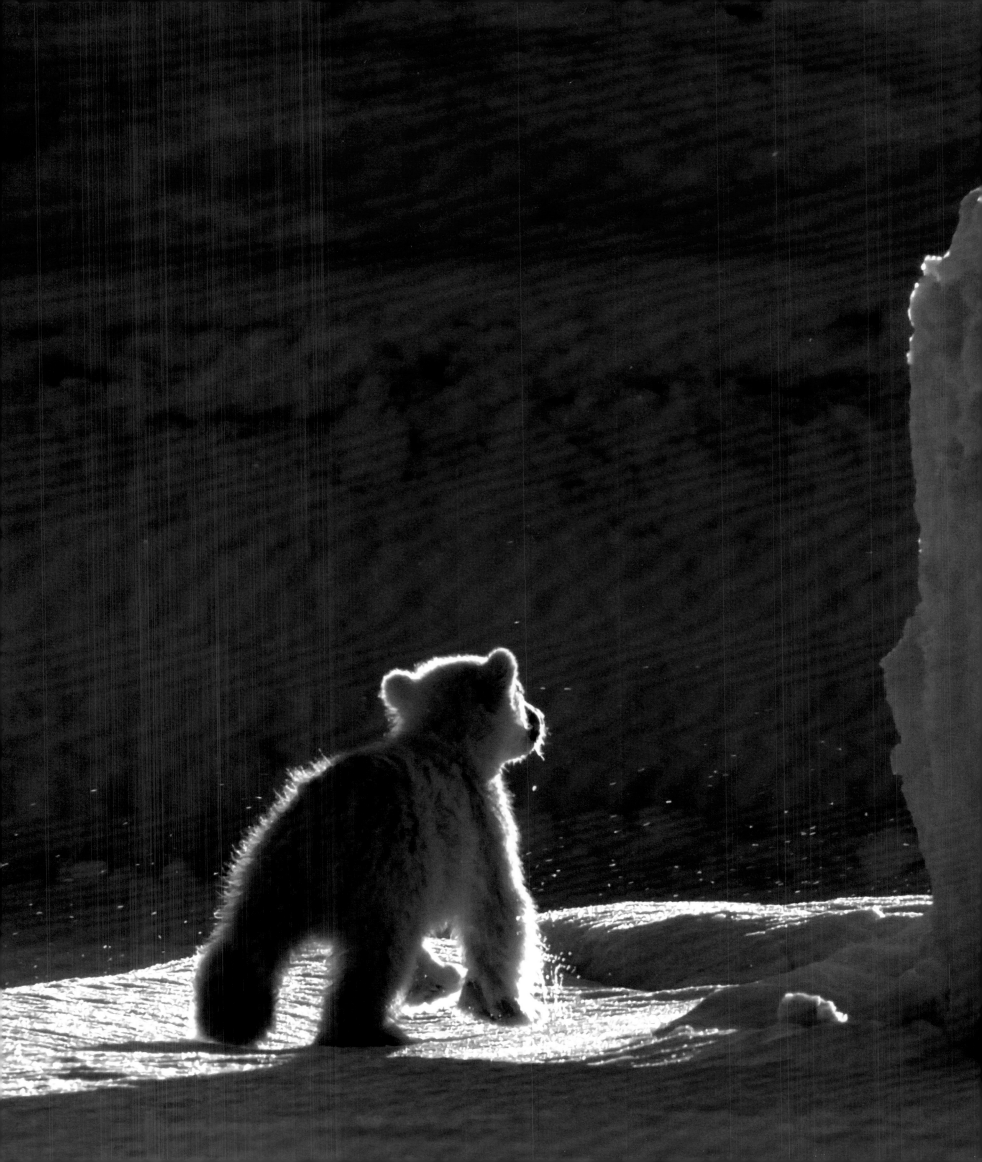

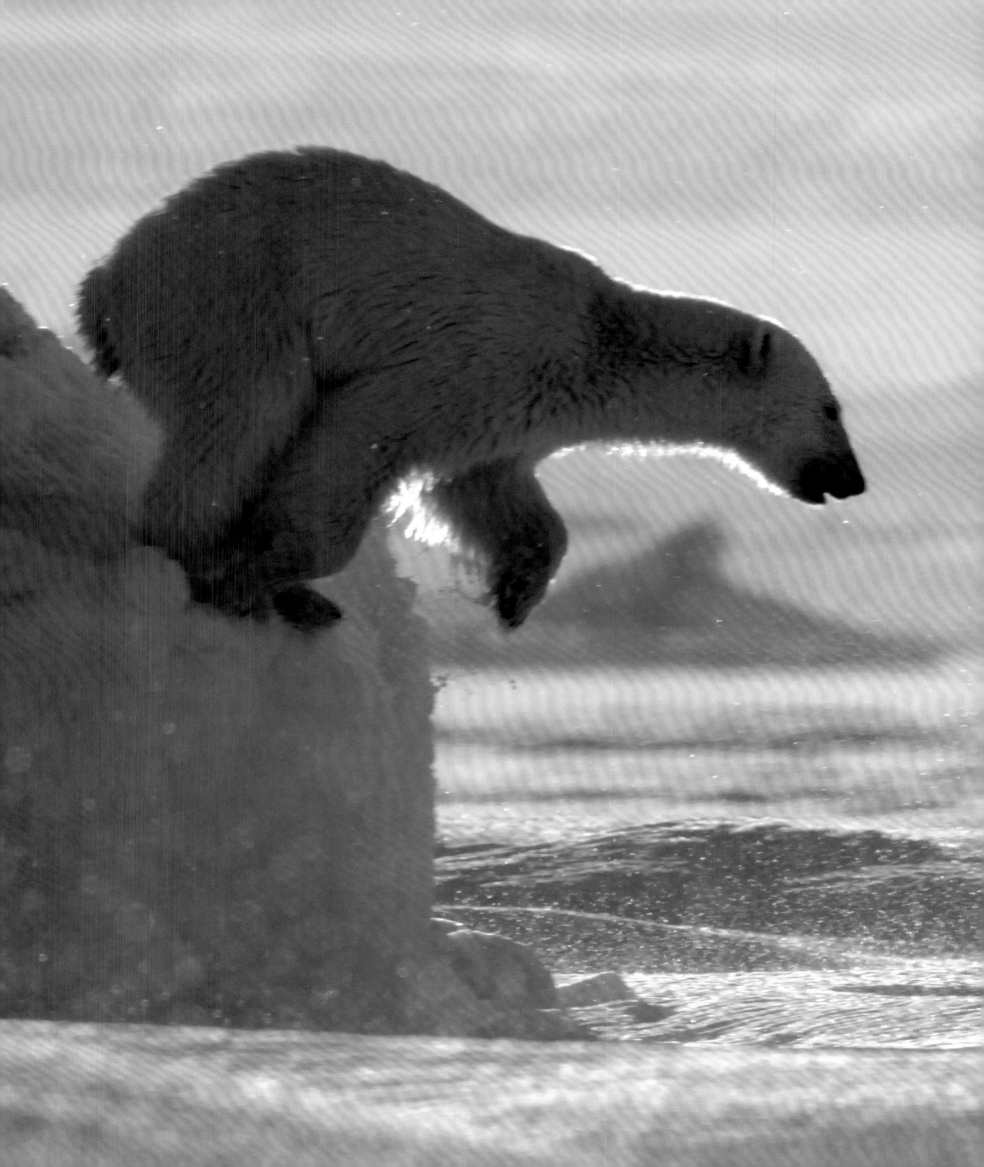

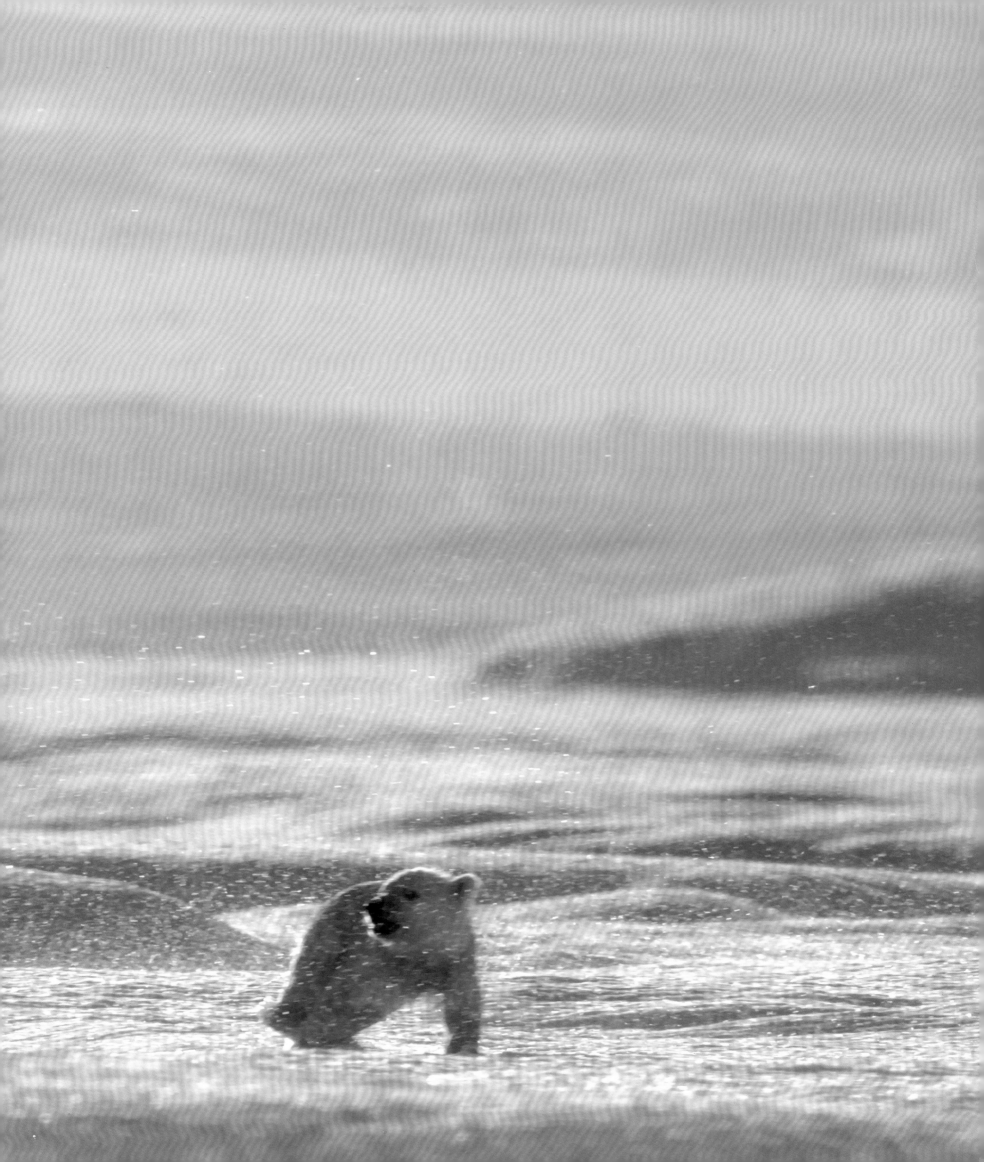

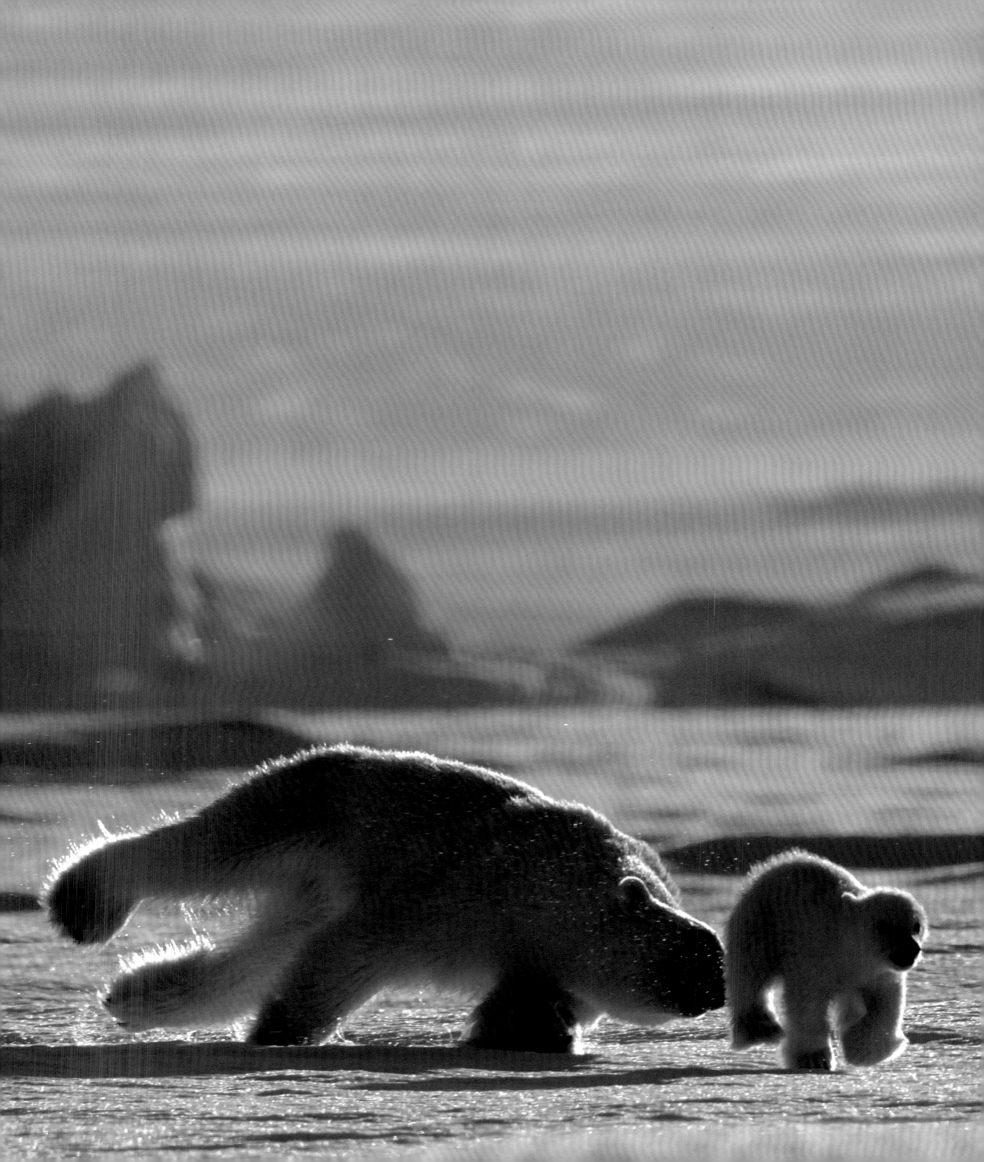

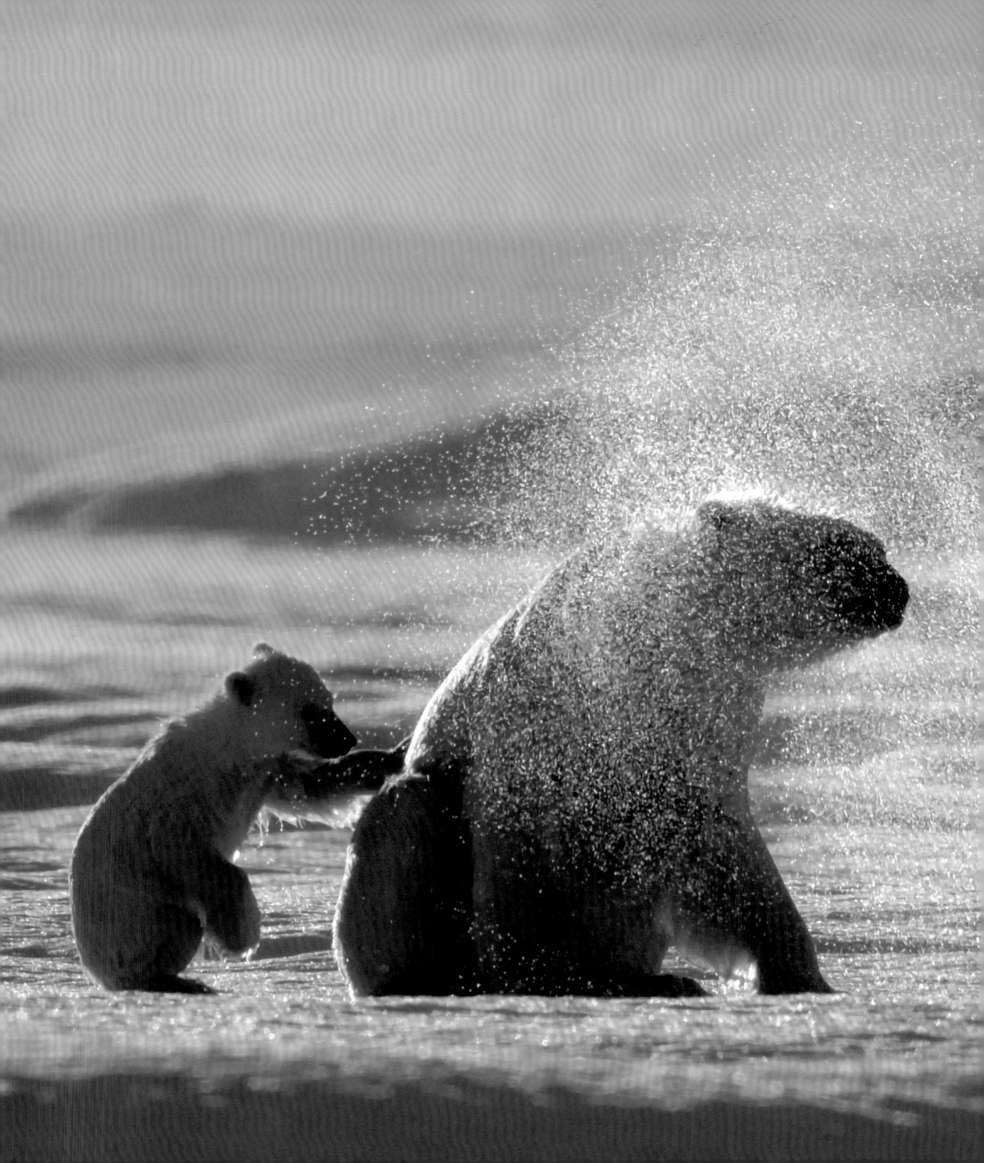

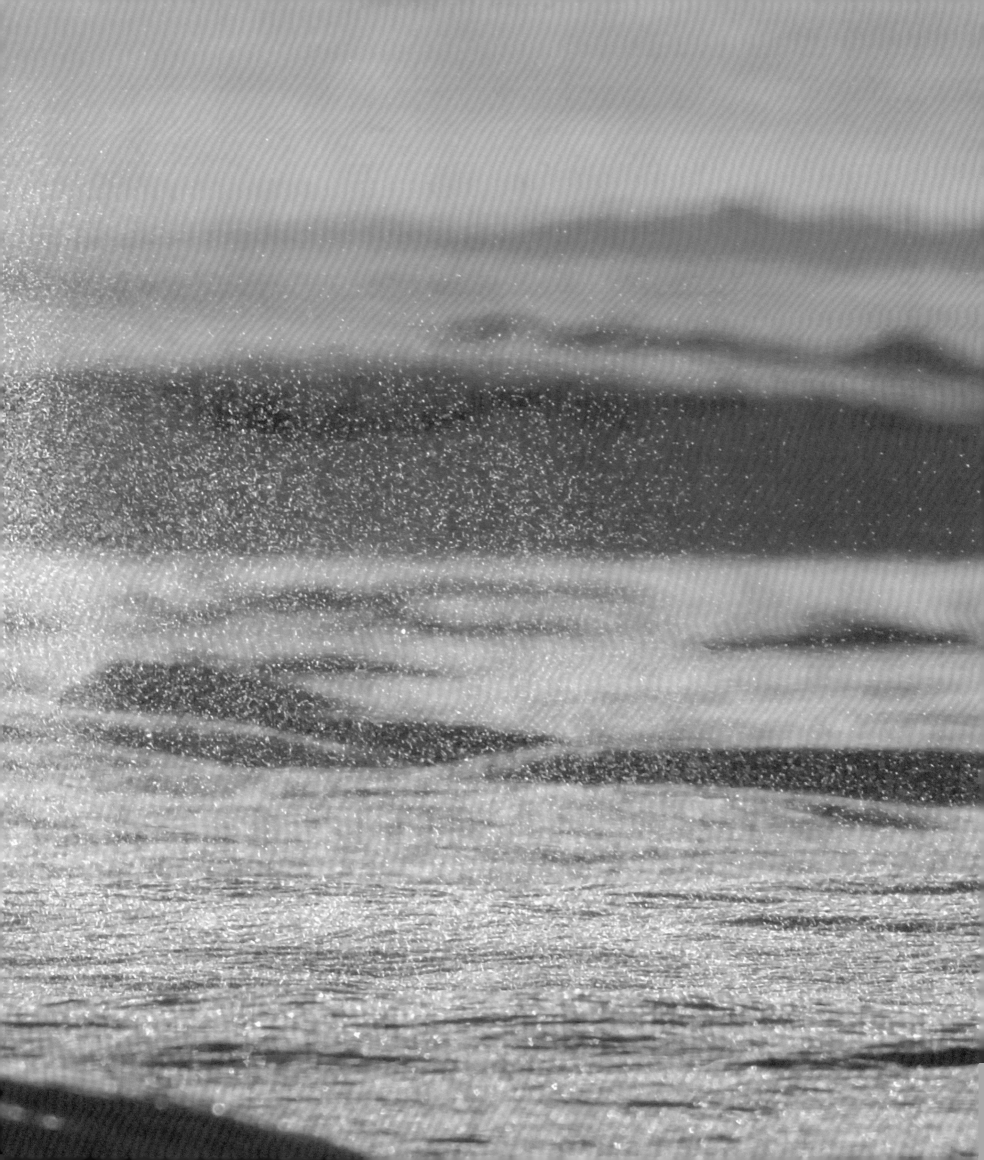

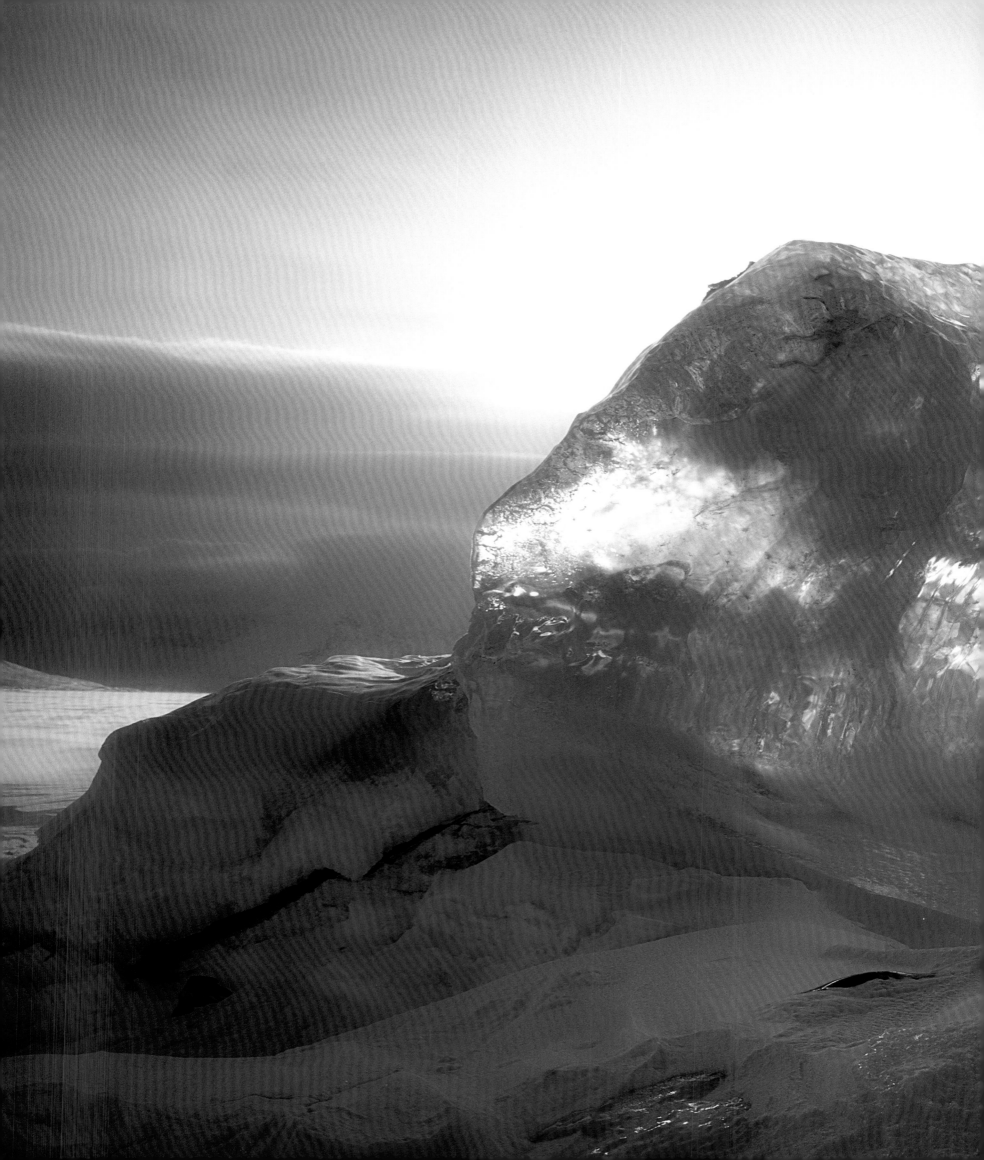

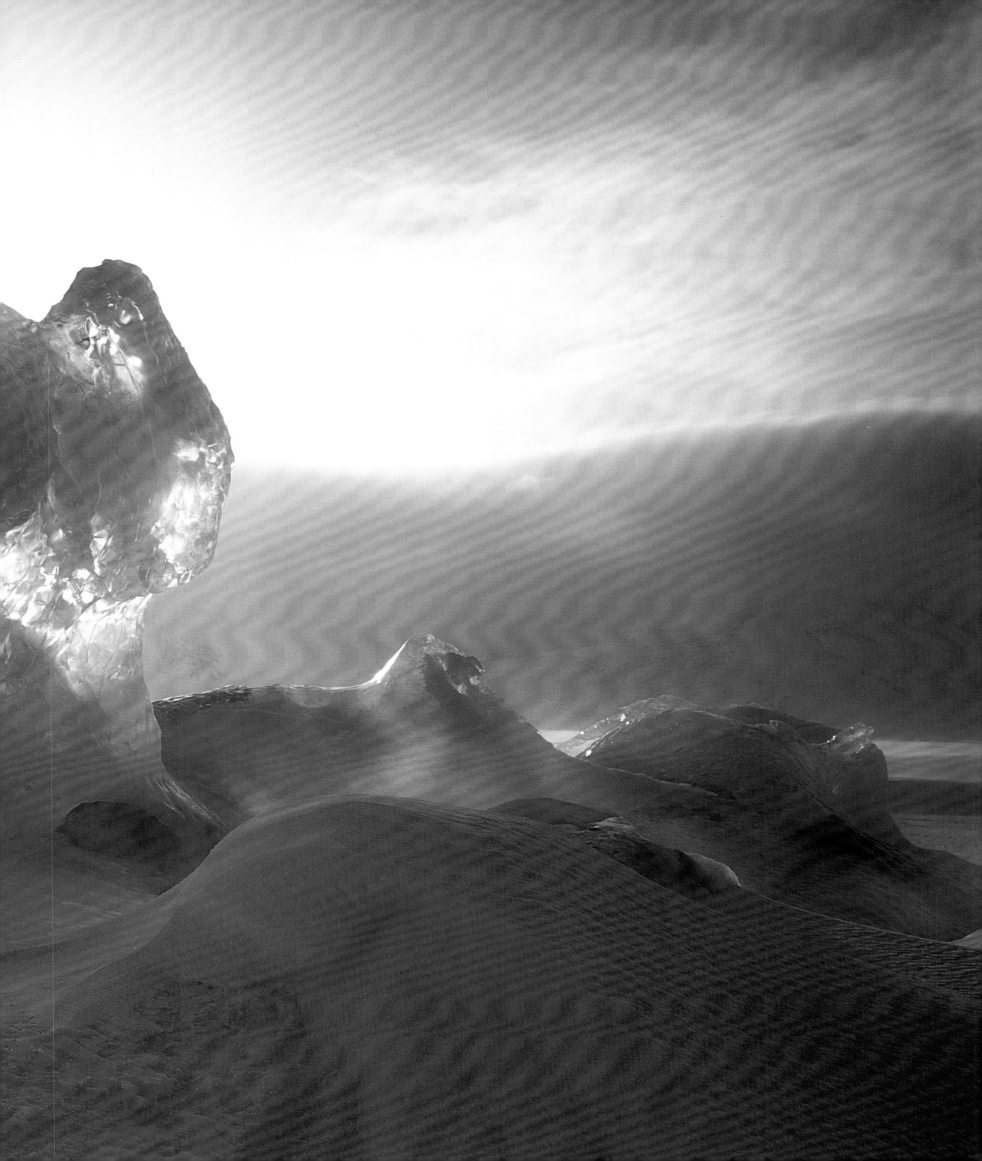

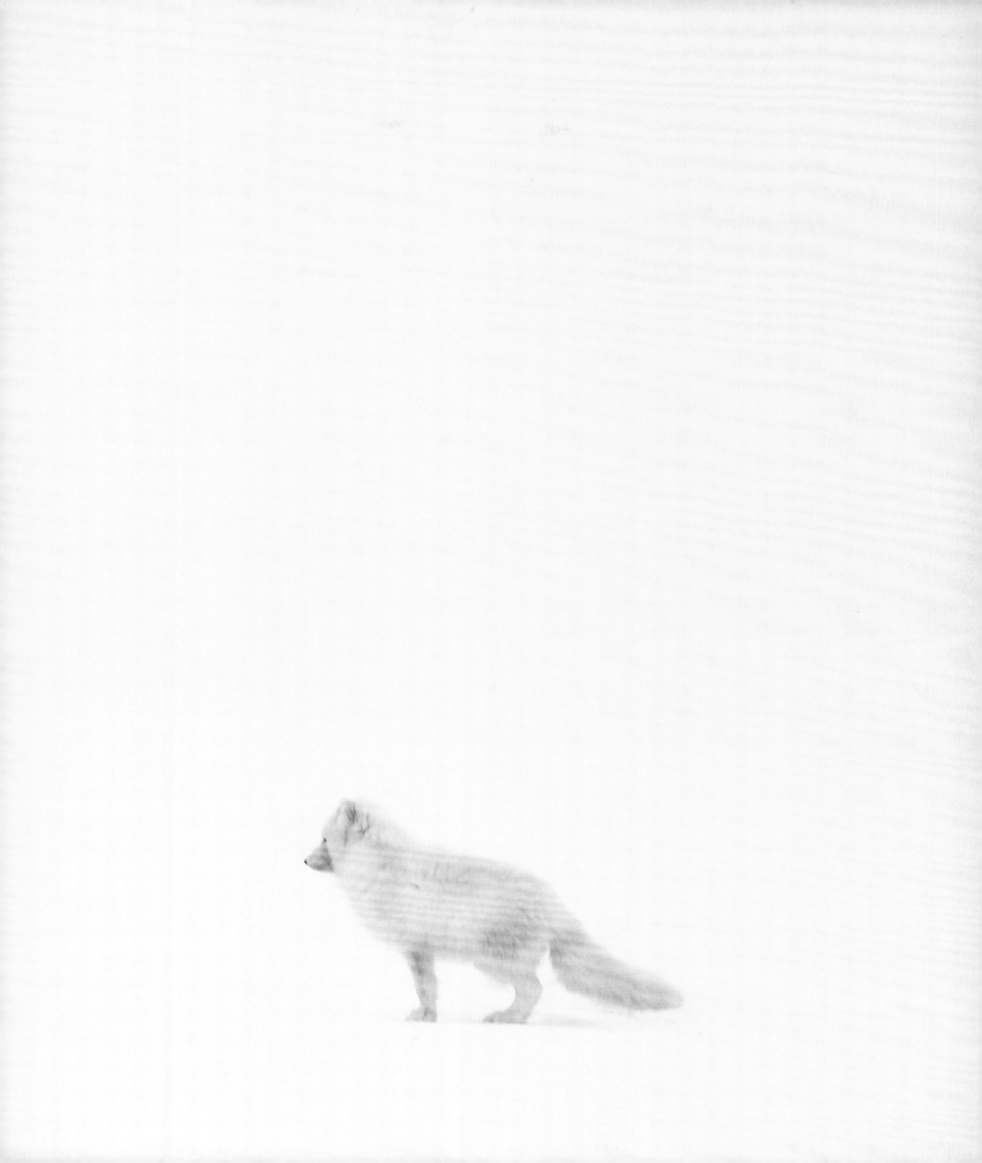

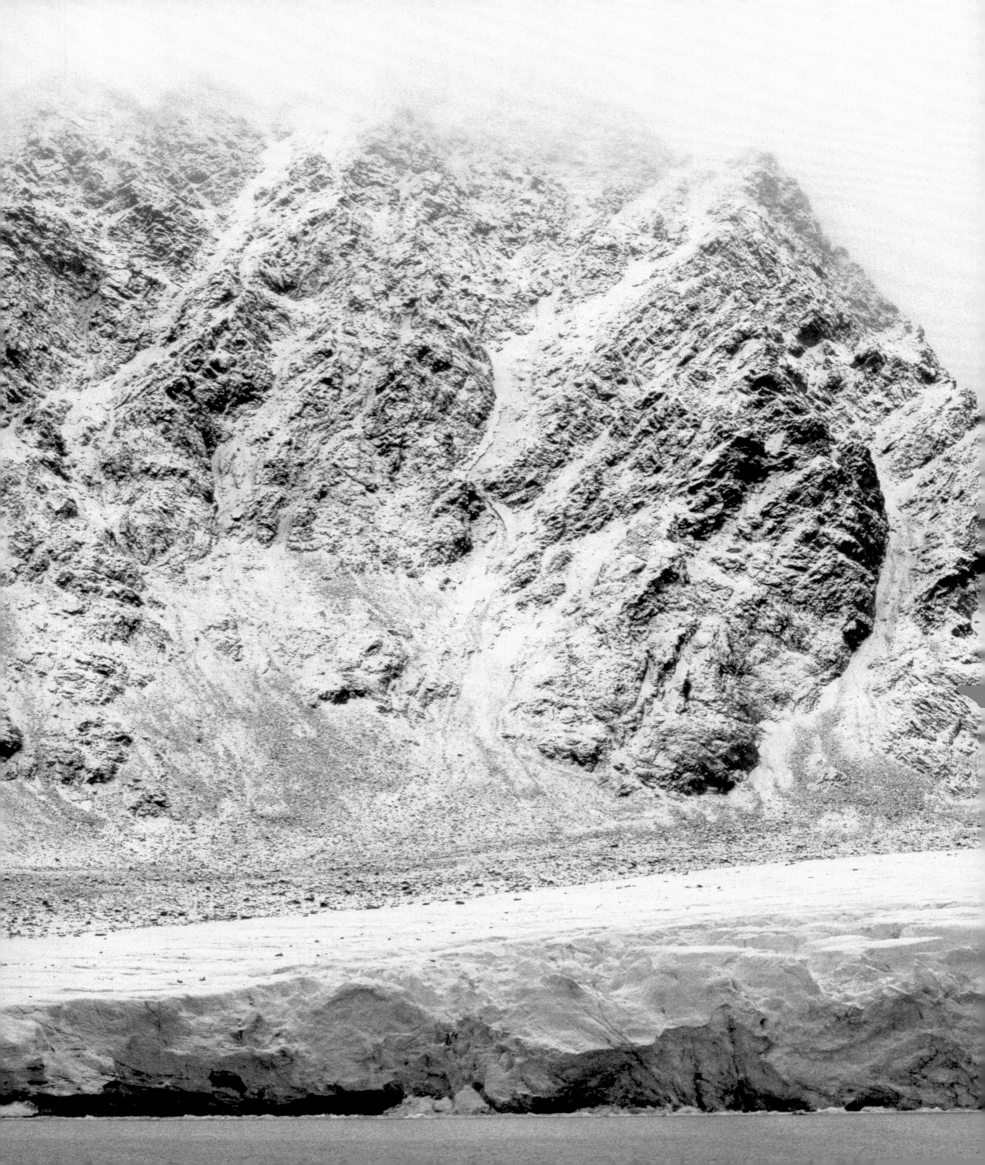

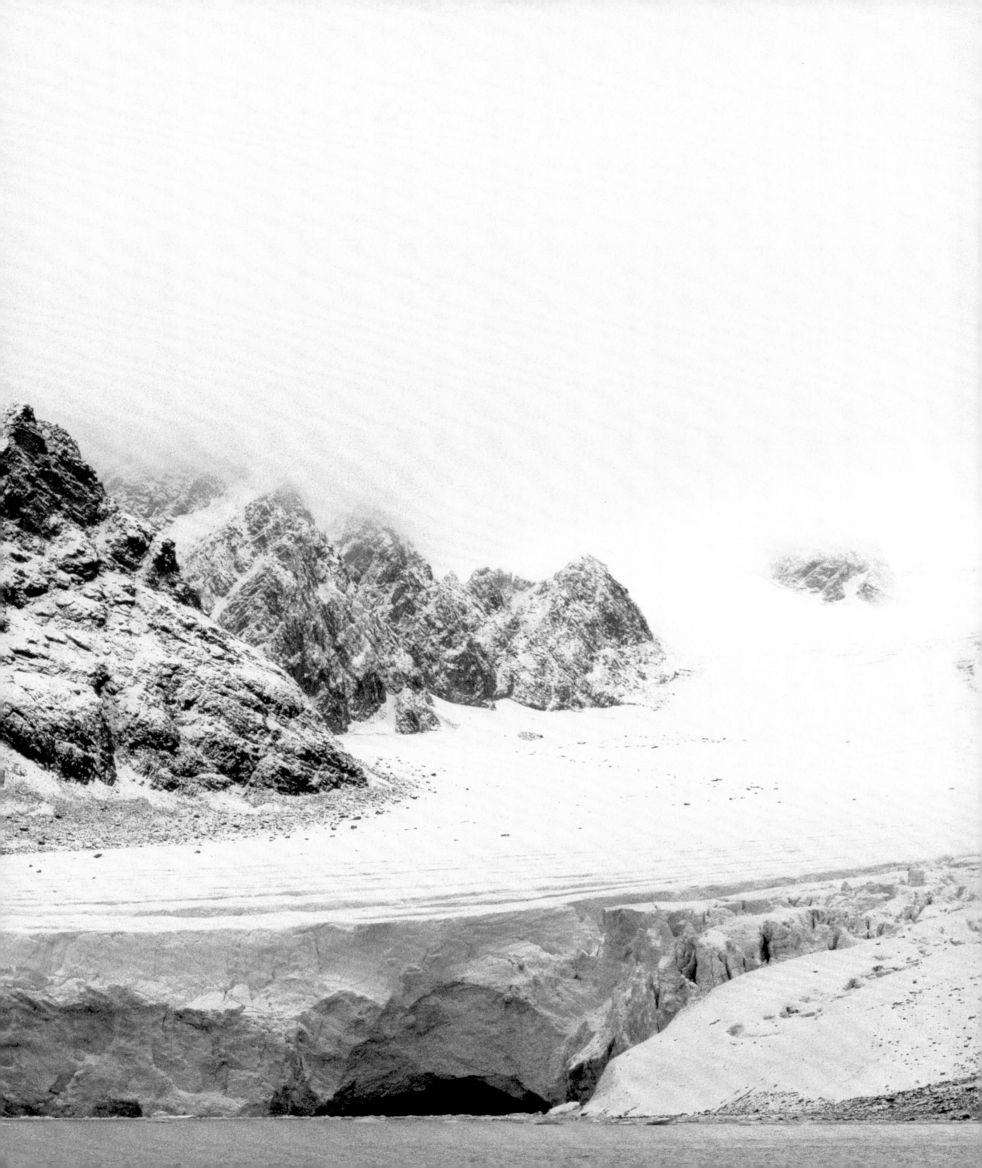

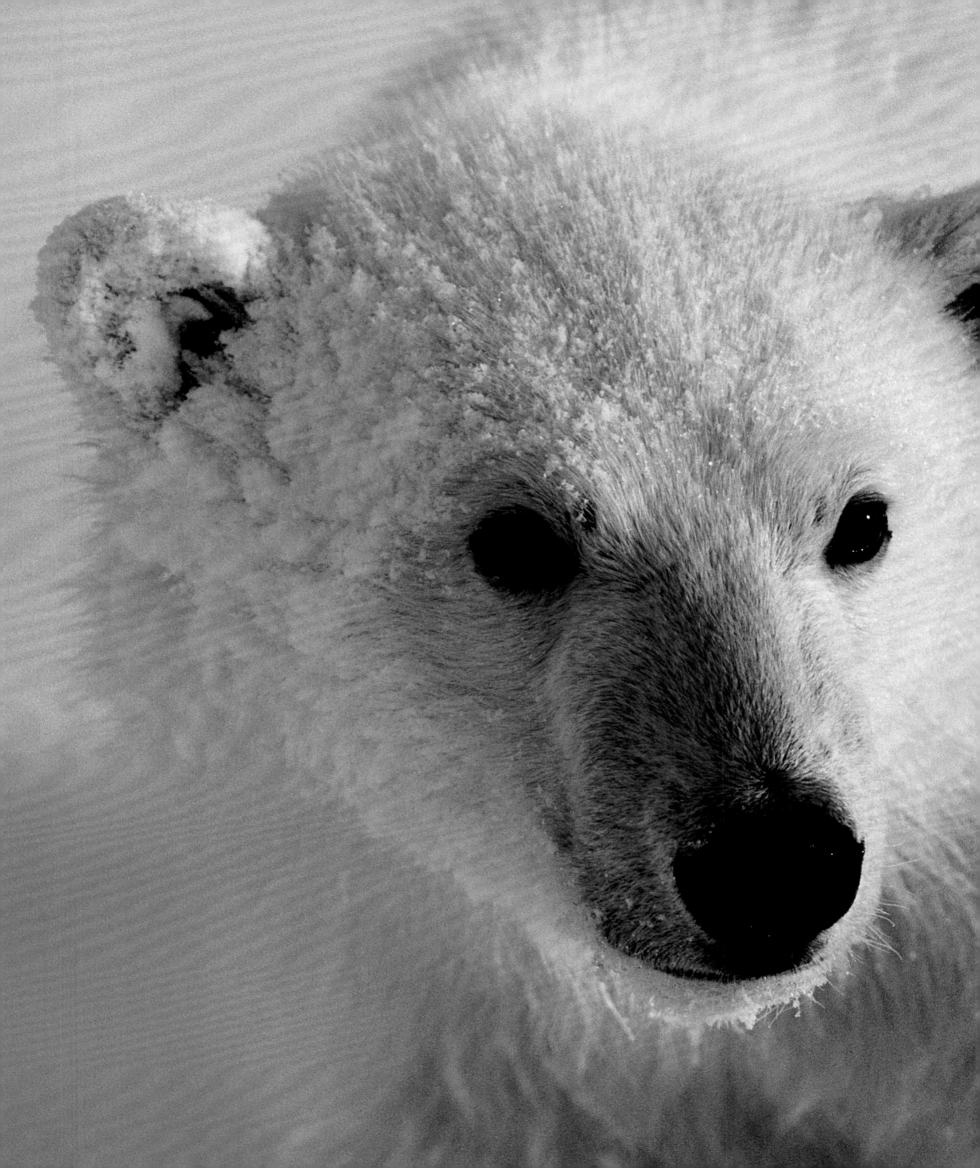

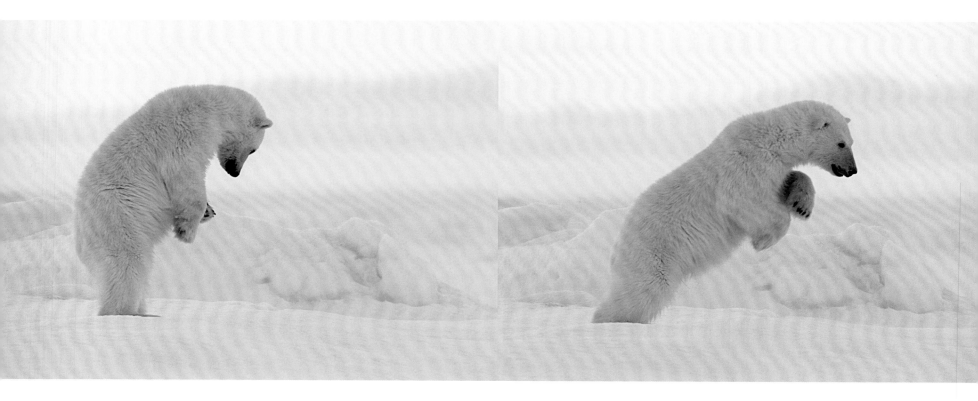

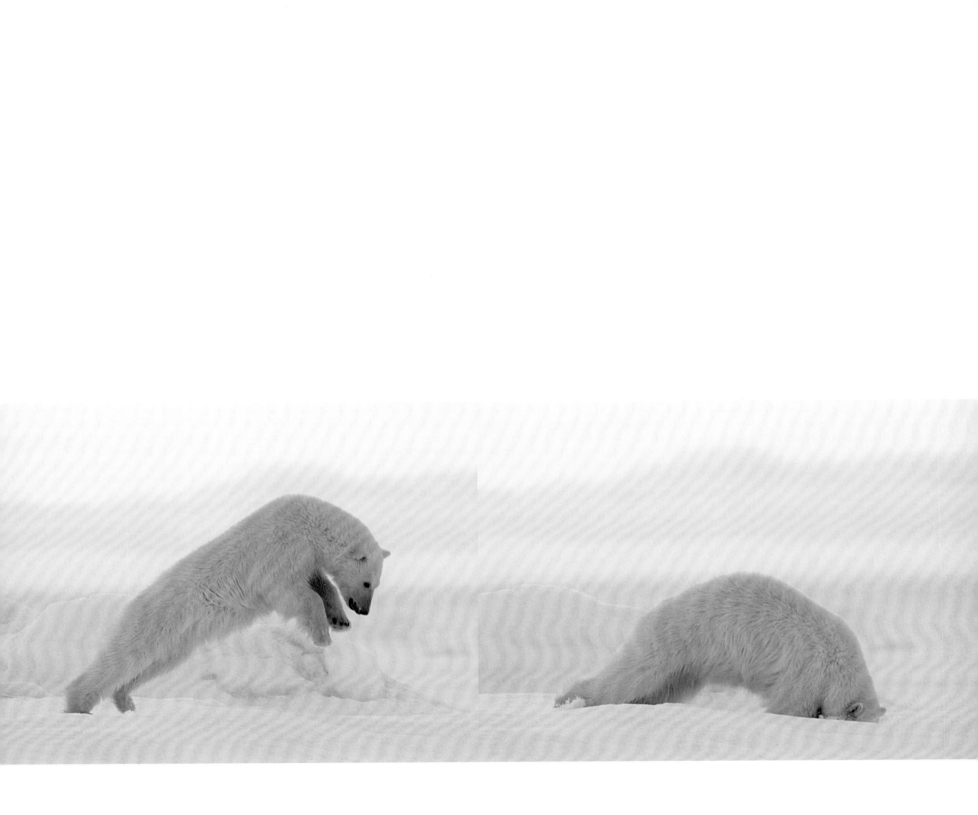

king of the arctic

Topping the food chain, the world's largest land predator wanders its domain, the frozen roof of the Arctic Ocean.

The polar bear lives a solitary life. In a constant search for sustenance, it is endlessly on the move, following the edge of the desolate pack ice. Food is sparse and patience a virtue; the polar bear often goes days without eating.

It stops by a seal's breathing hole. Silent, still as a statue, and with the greatest of patience, the polar bear hovers over the hole. Hours pass as it waits for the wary prey to appear. Suddenly, with explosive power, the bear jumps into the hole, crushing the thick ice that surrounds it. The tranquil bluish white scenery instantly transforms into a scene of blood-spattered carnage, and patience has been rewarded.

The bear finishes its meal. It is very careful about staying clean. After feeding, a bear will devote up to fifteen minutes to cleaning itself. A thorough job is important, as matted and dirty fur is a poor insulator. It washes in the water and then dries itself by shaking off the excess water and rubbing its fur in the snow and against the ice.

The polar bear serves as a distinct indicator of the state of the global environment. Our climate is changing, and the polar bear exemplifies this conclusively. As the sea ice of the Arctic retreats, the polar bear's territory becomes open water—its habitat shrinks and melts away. The king of the Arctic can show us, in a very real way, how global warming is disrupting whole ecosystems.

Evolving from brown bear ancestors some two hundred thousand years ago, *Ursus maritimus*, "the sea bear," has gone through a series of evolutionary changes to adapt to life in an extreme environment. A male polar bear can weigh more than fifteen hundred pounds and grow up to ten feet tall; females are smaller, about half the size of males. The polar bear has no natural enemies—except us, the human being, and the dangers we impose. If there is a permanent end to winter, it will mean the end of life for the polar bear.

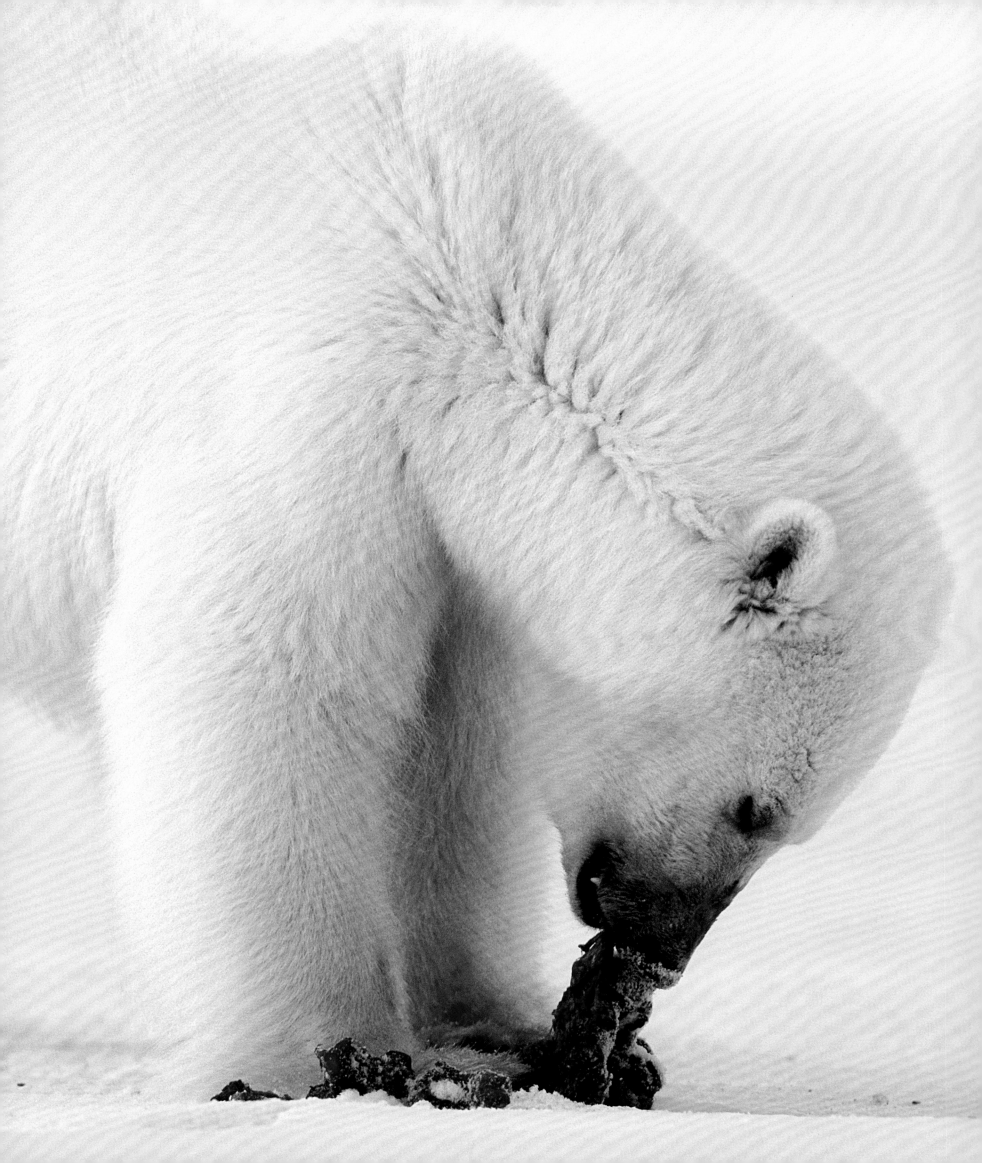

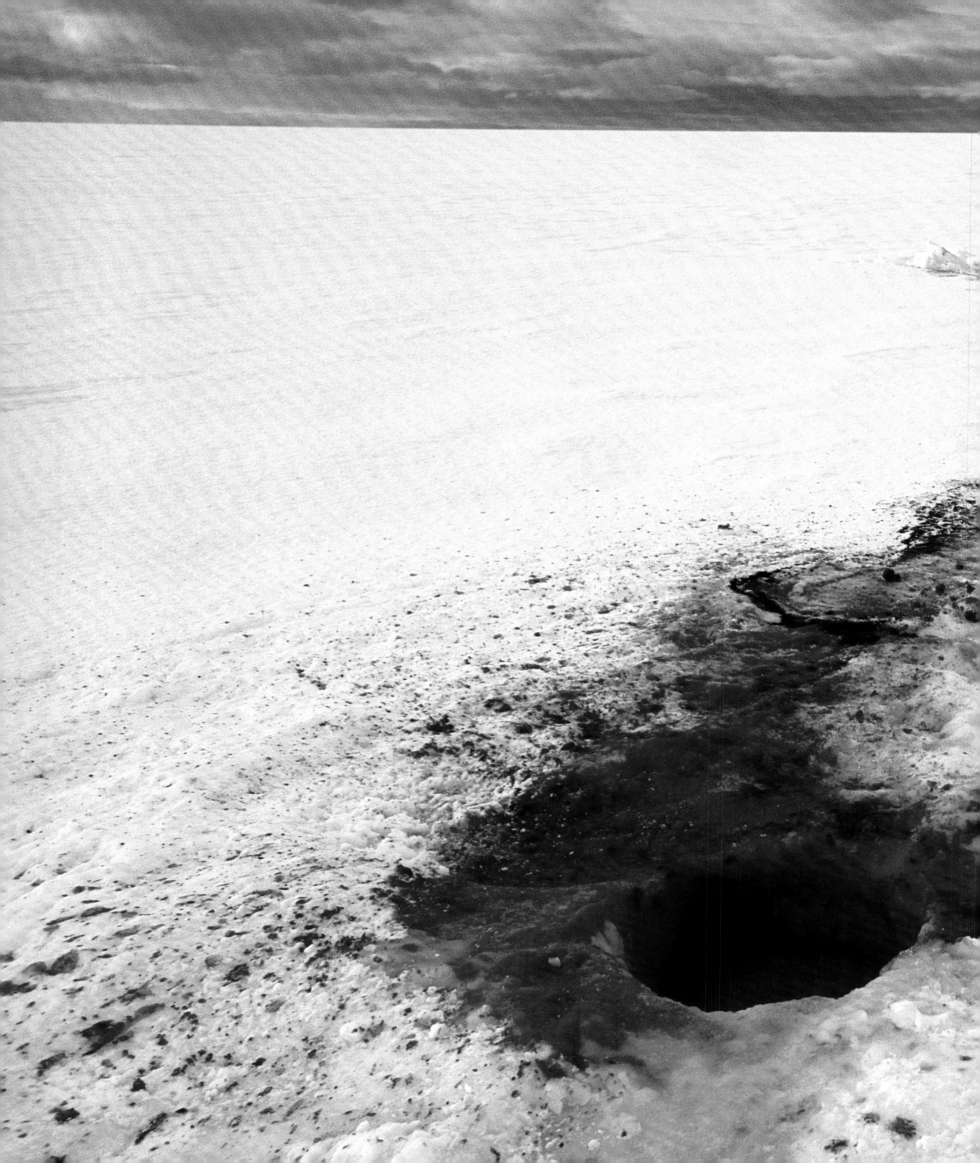

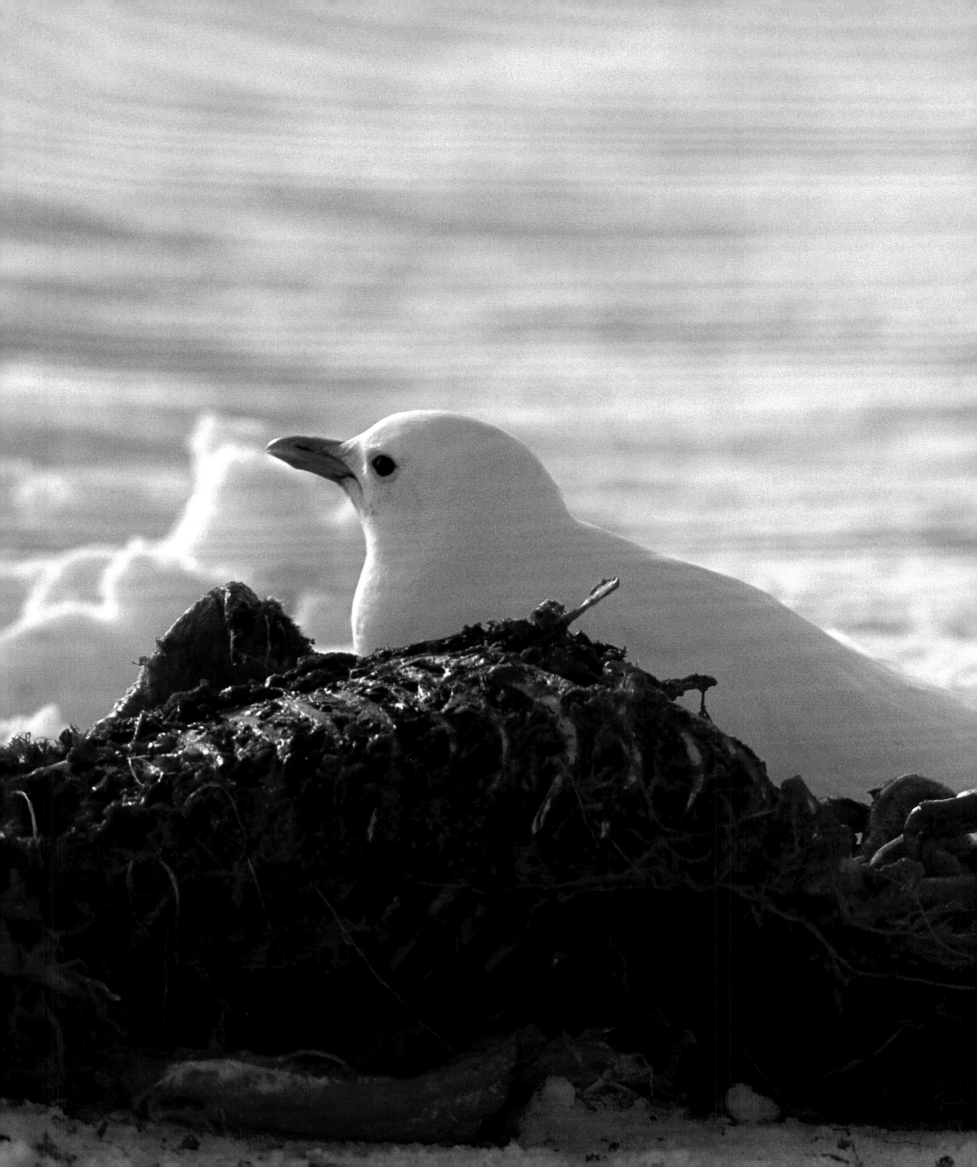

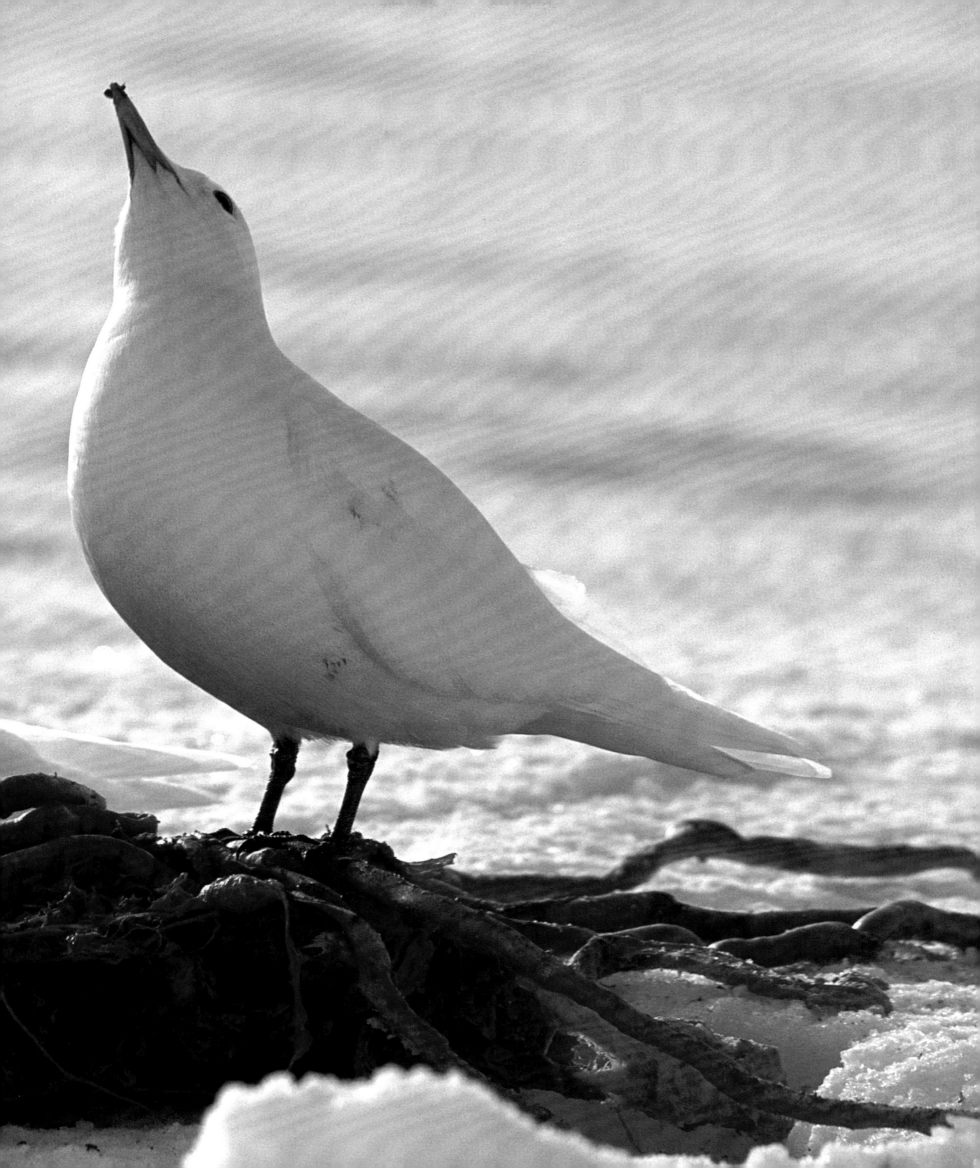

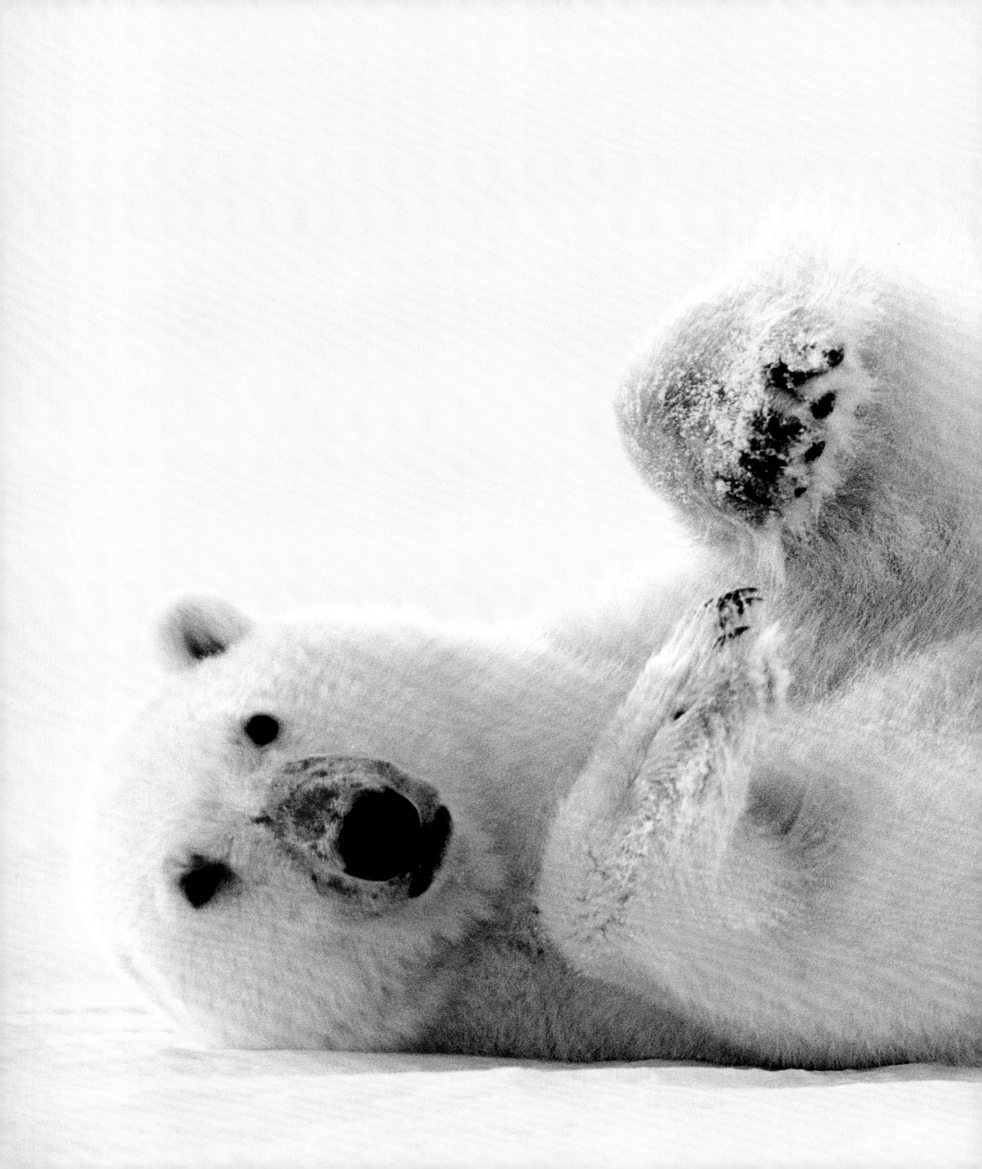

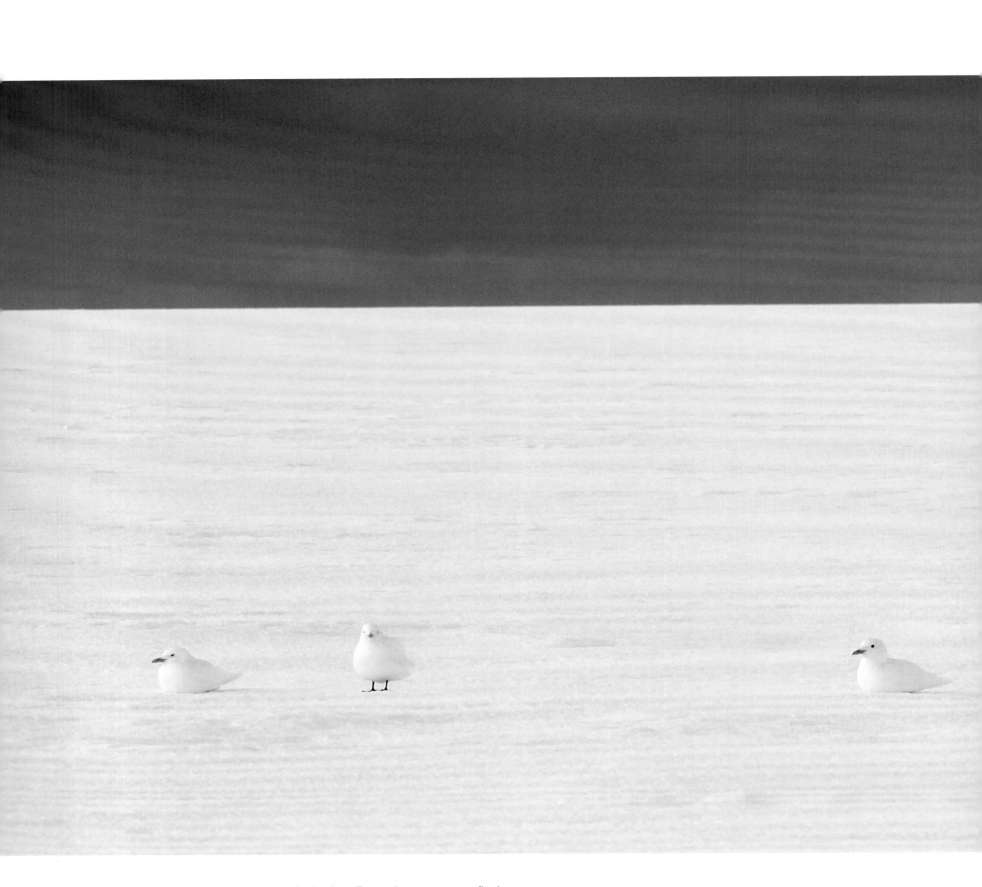

The snowdrift left from the last storm veils the ice. From above comes a flock of ivory gulls. The bird of the pack ice, the ivory gull spends all year in the high Arctic. It is a rare sight, and ornithologists travel from all over the world, from northern Canada to Greenland and Svalbard, trying to catch a glimpse of it.

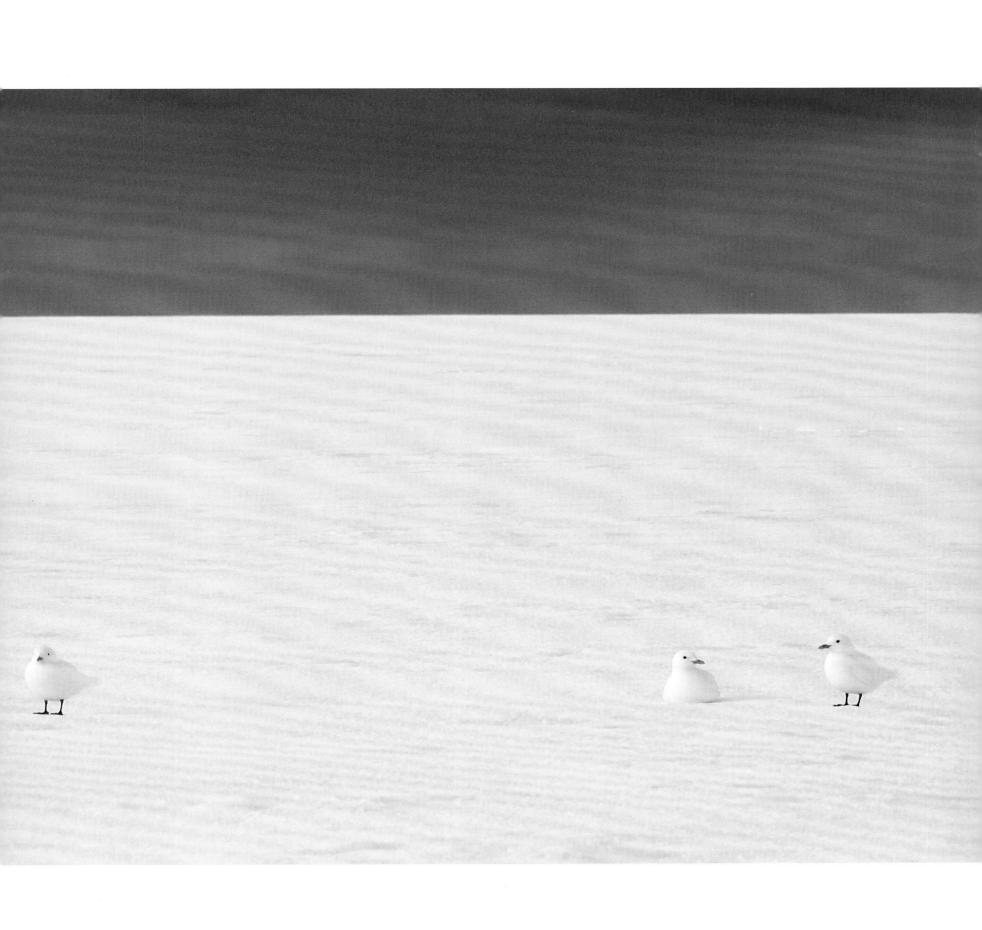

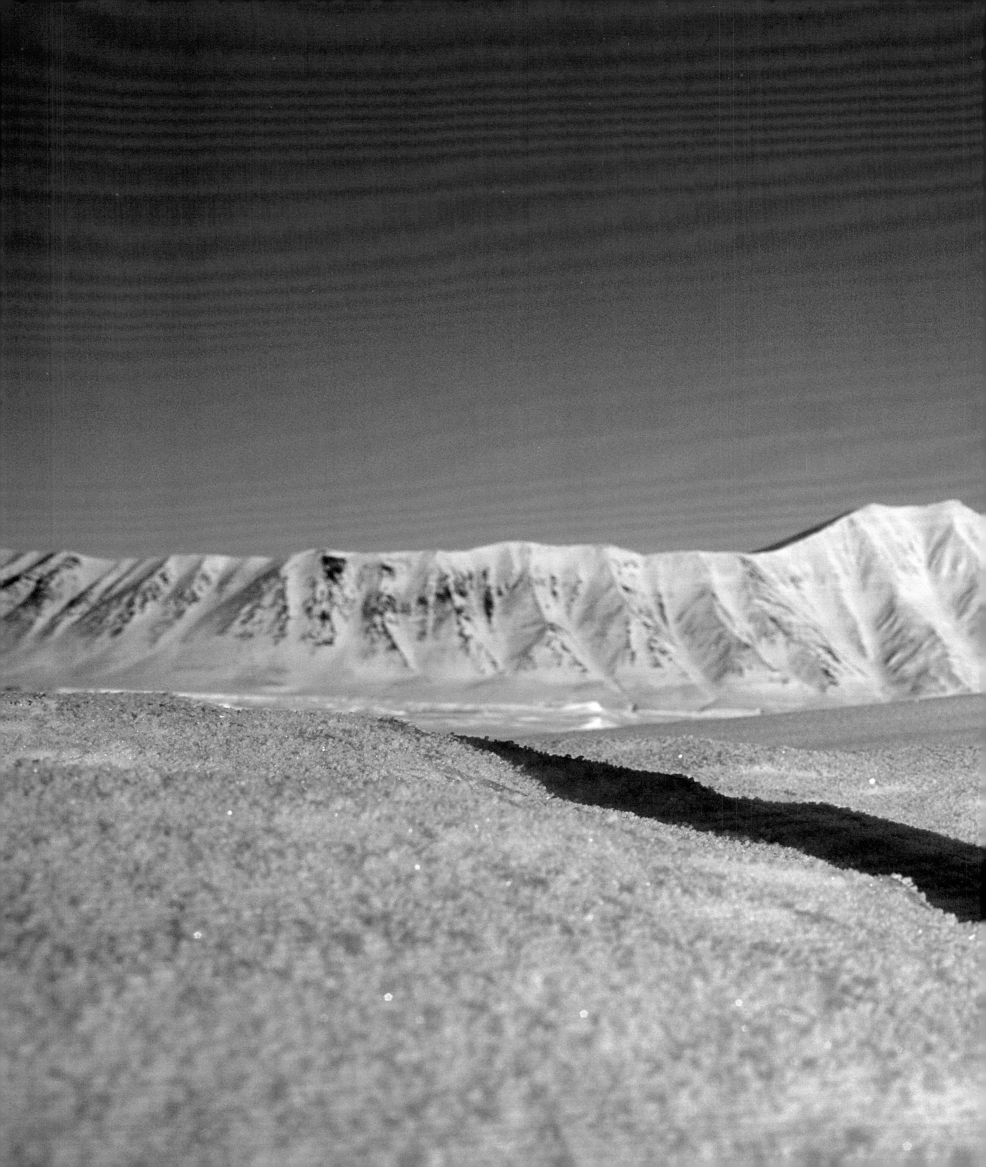

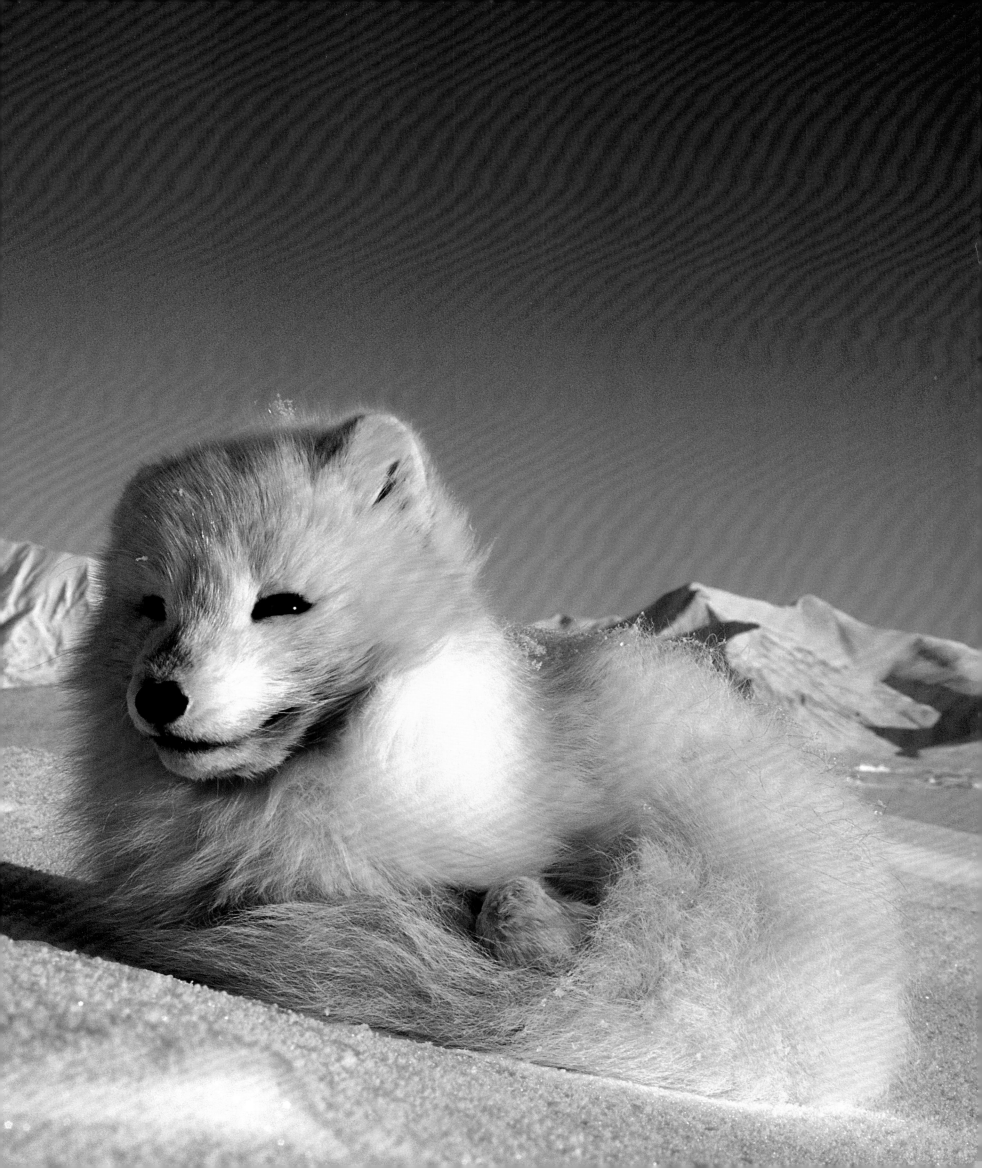

arctic survivor

As the polar bear leaves the remains of its prey, an Arctic fox appears out of the shadows of an ice block. It is midwinter, and food is scarce for the fox; it follows the polar bear through the winter season to feed on leftovers.

The Arctic fox is a scavenger and will eat almost anything it finds. In summer, it is dependent on the birdlife that visits the Arctic. It consumes the birds' eggs and chicks, as well as lemmings and rodents, and builds up a storage of food to last over the long winter. The fox is monogamous, and each pair establishes a territory, or home range, that they return to each breeding season, even after following the polar bear for hundred of miles.

A true survivor, the Arctic fox has evolved and adapted exception-ally well to life in the most frigid extremes on the planet. Its thick winter fur—which turns gray or brown in summer—has the highest insulation factor of all Arctic mammals'.

When the fox has finished eating what the polar bear left of the seal, it hurries away, following the bear's tracks and hoping to catch up. The ice breaks up and shifts, and the tracks disappear.

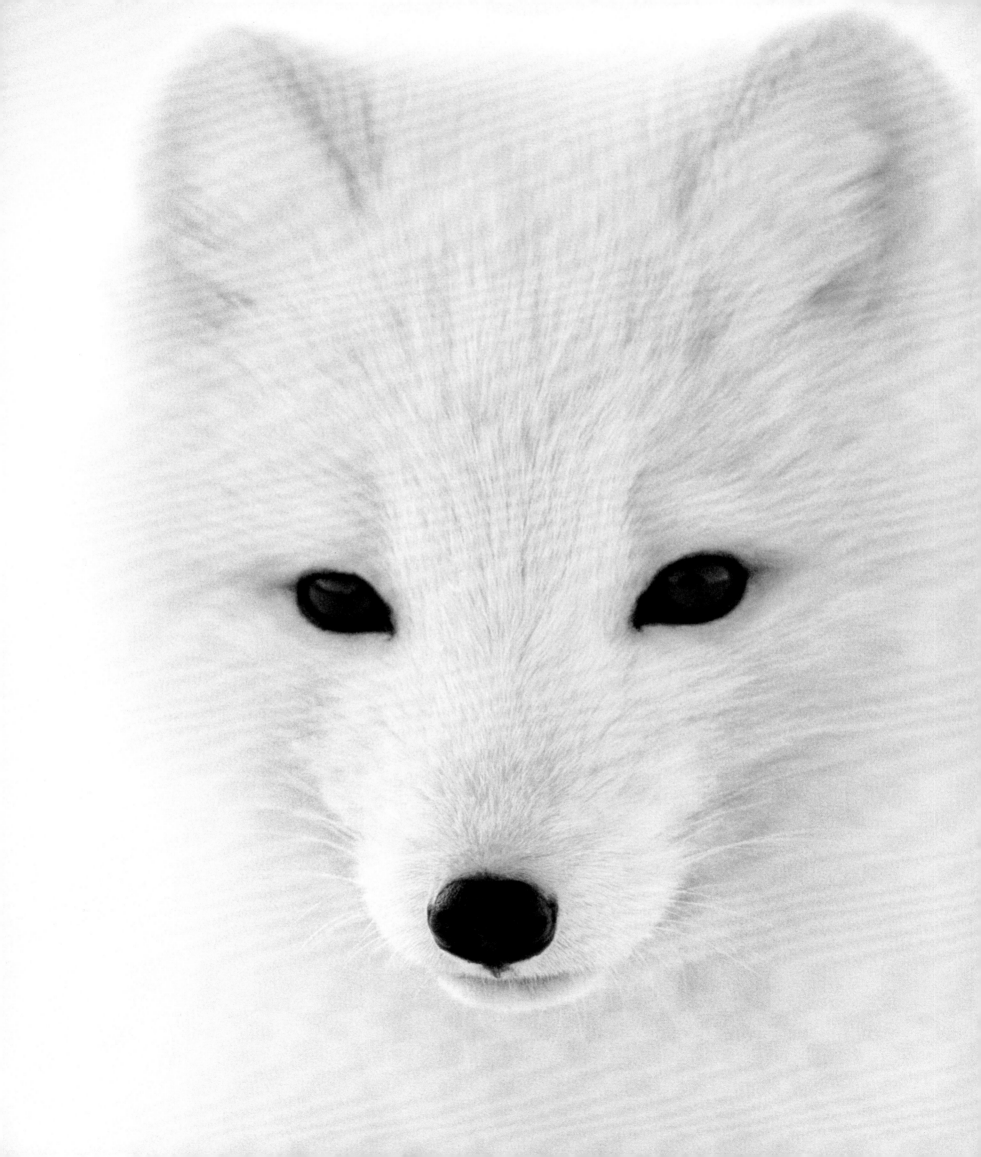

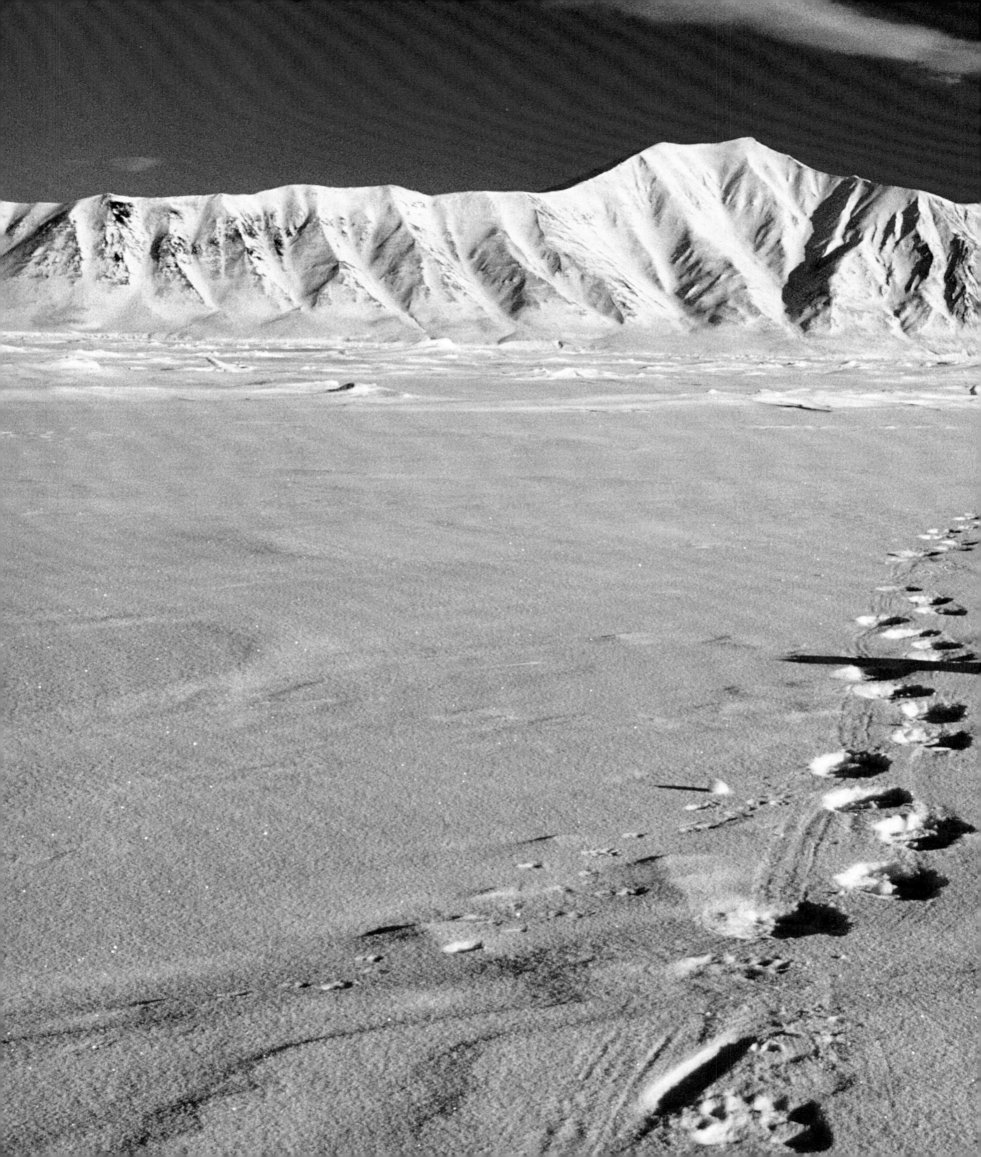

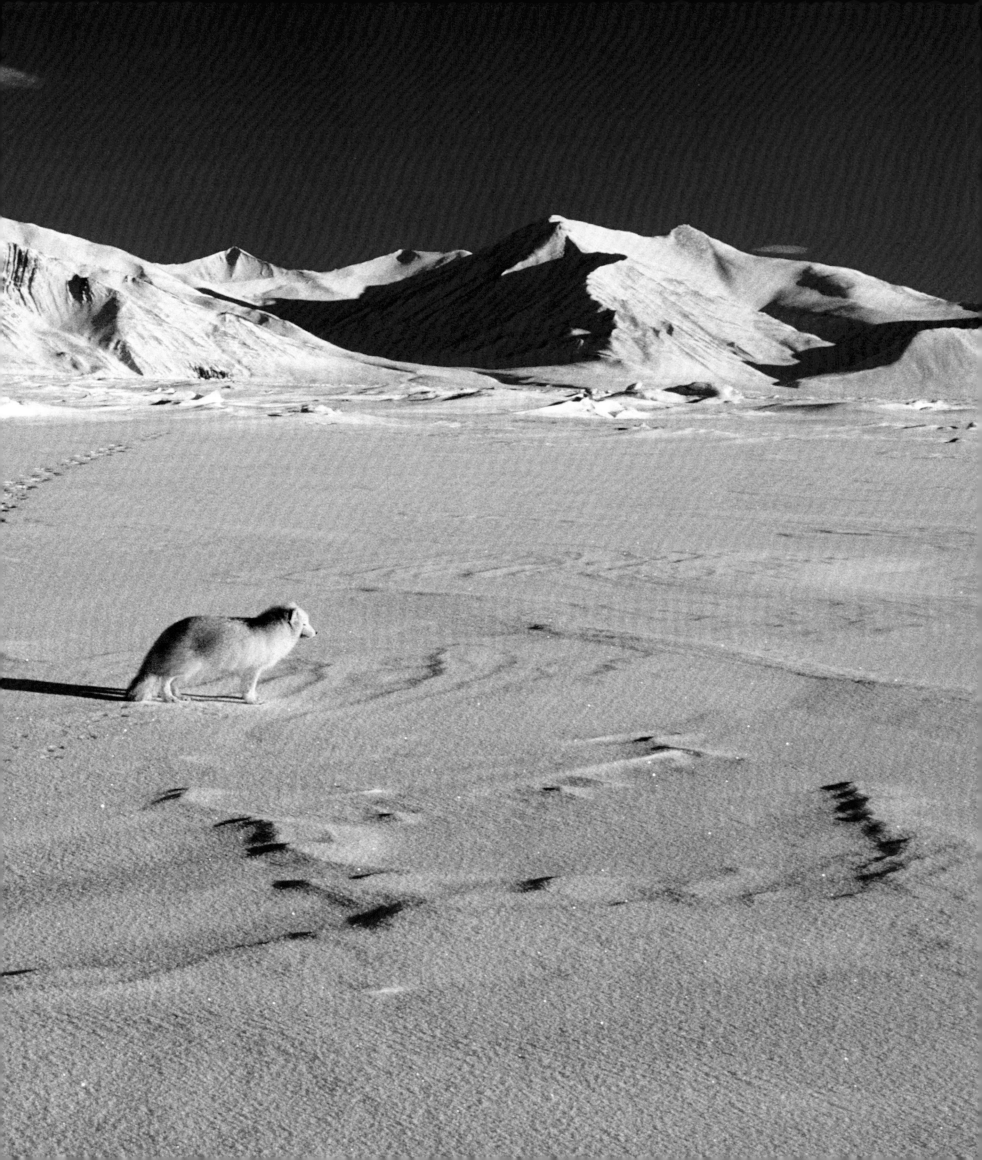

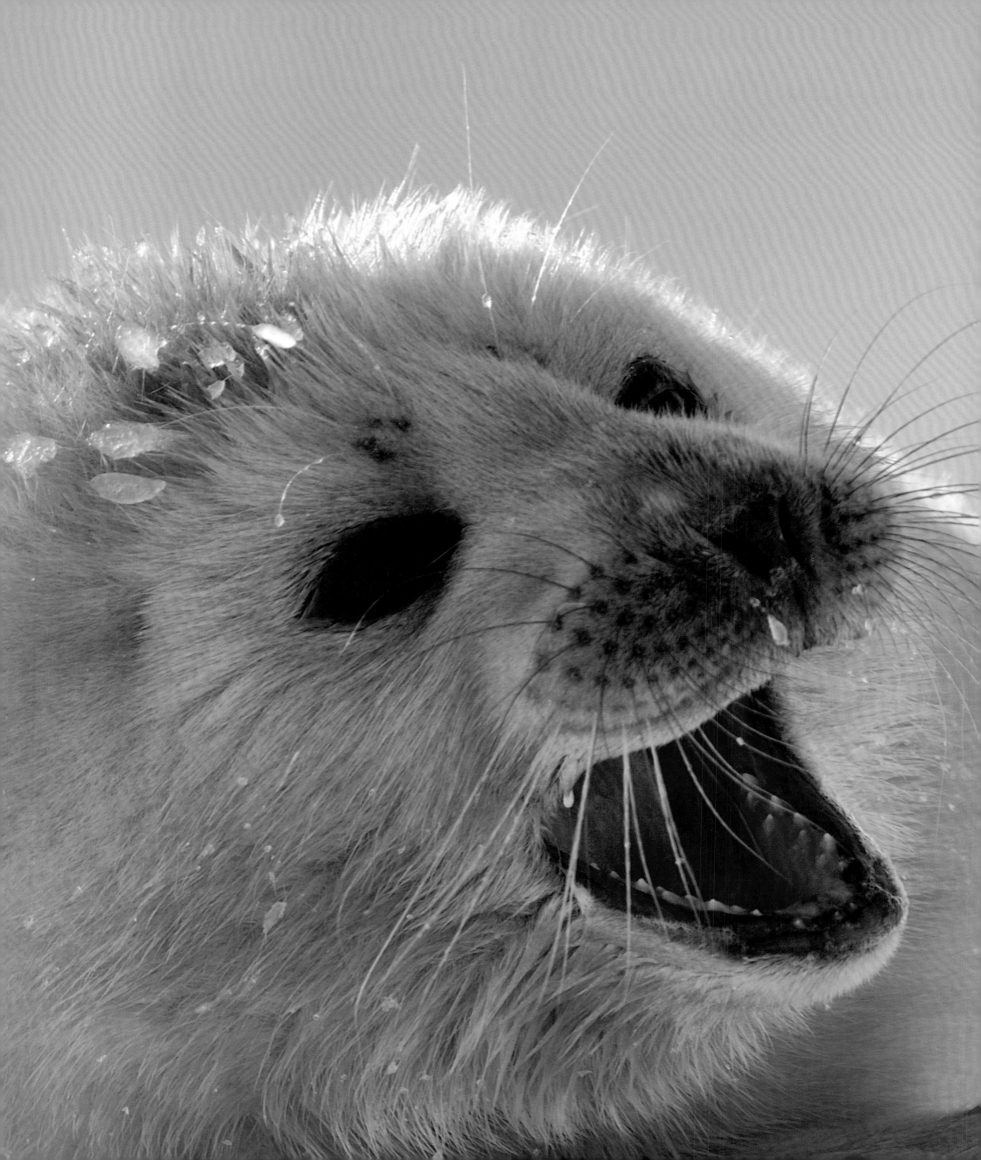

The sea ice of the Arctic is full of life—life dependent on its very exist-ence. The ringed seal often lives in waters completely covered in ice. Using its claws and teeth, the ringed seal keeps holes open in the ice, allowing it to breathe and get out of the water to rest and take care of its young. The seal can keep dozens of these breathing holes open through-out an area in its attempt to avoid predators.

After what seems like an eternity beneath the ice, the seal mother comes up, having fed on fish and shrimp in the cold waters. Her newborn white-coated pup is waiting on the ice; it still hasn't developed enough blubber to swim or survive long in the frigid water.

For twelve days she will nurse her pup, and in that time it will double its body weight. But it is a dangerous life. The ringed seal is the main prey of the polar bear. The bear has an excellent sense of smell and can detect a seal pup lying on the ice from several miles away. Seals often build snow dens on the ice in an attempt to protect their pups, not only from polar bears, but also from Arctic foxes, birds of prey, and the biting wind.

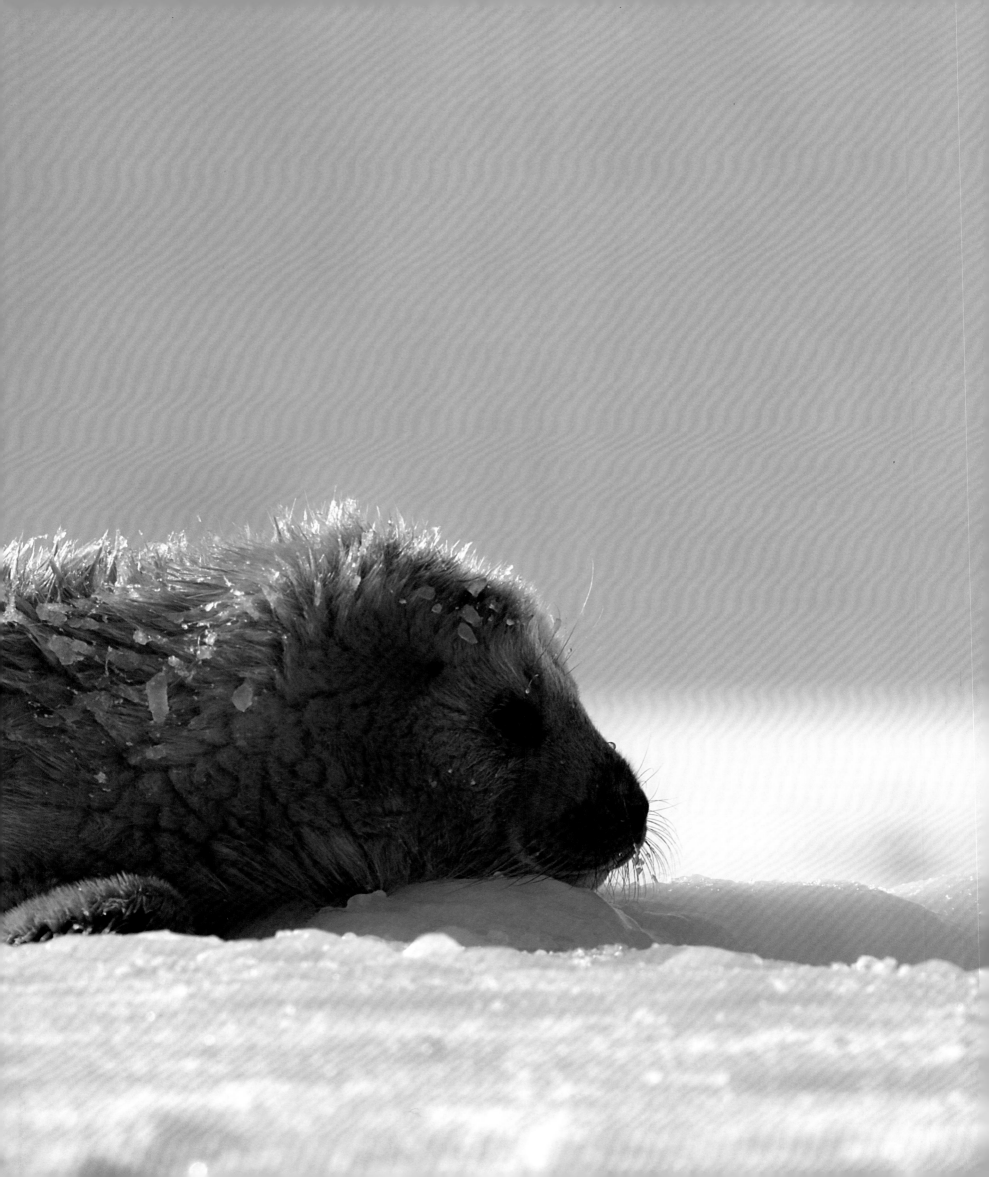

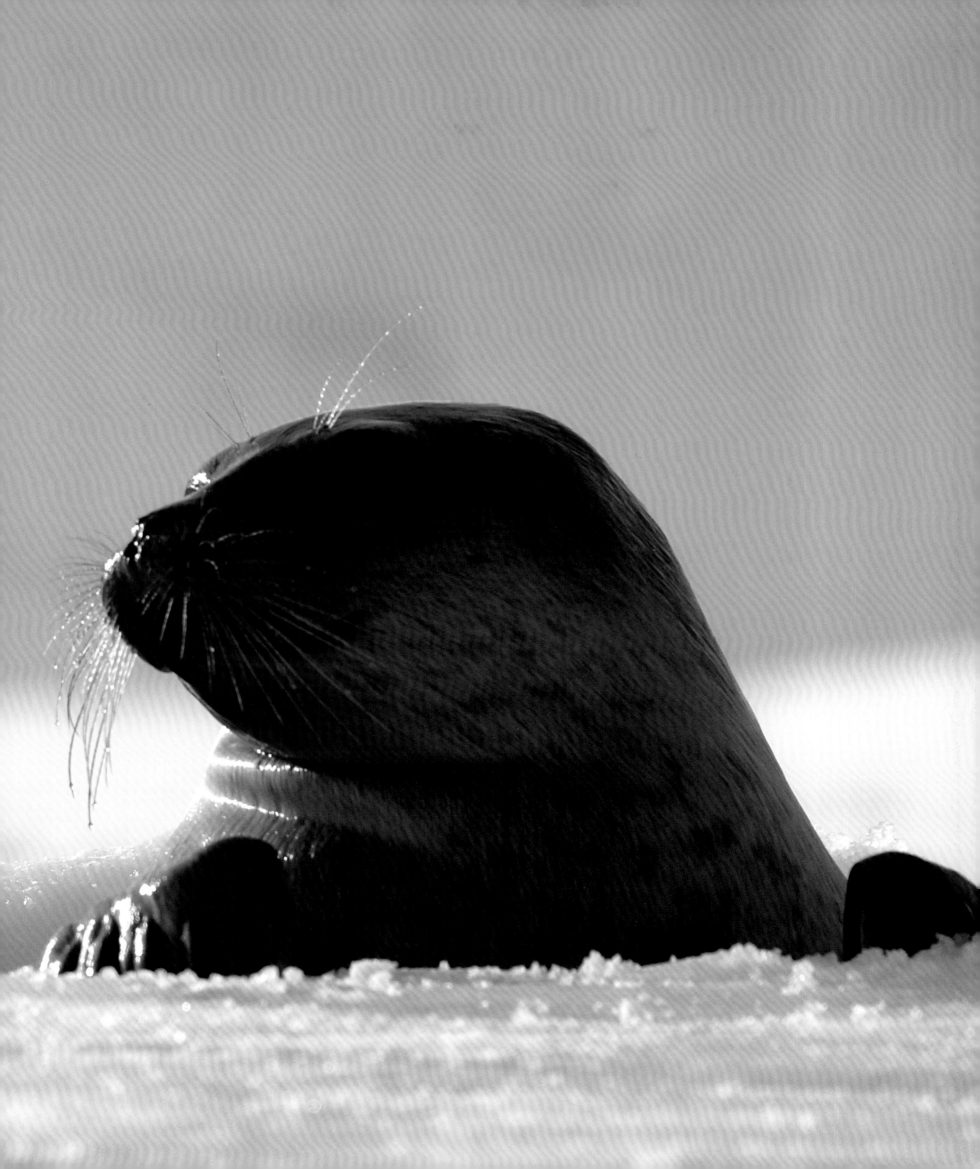

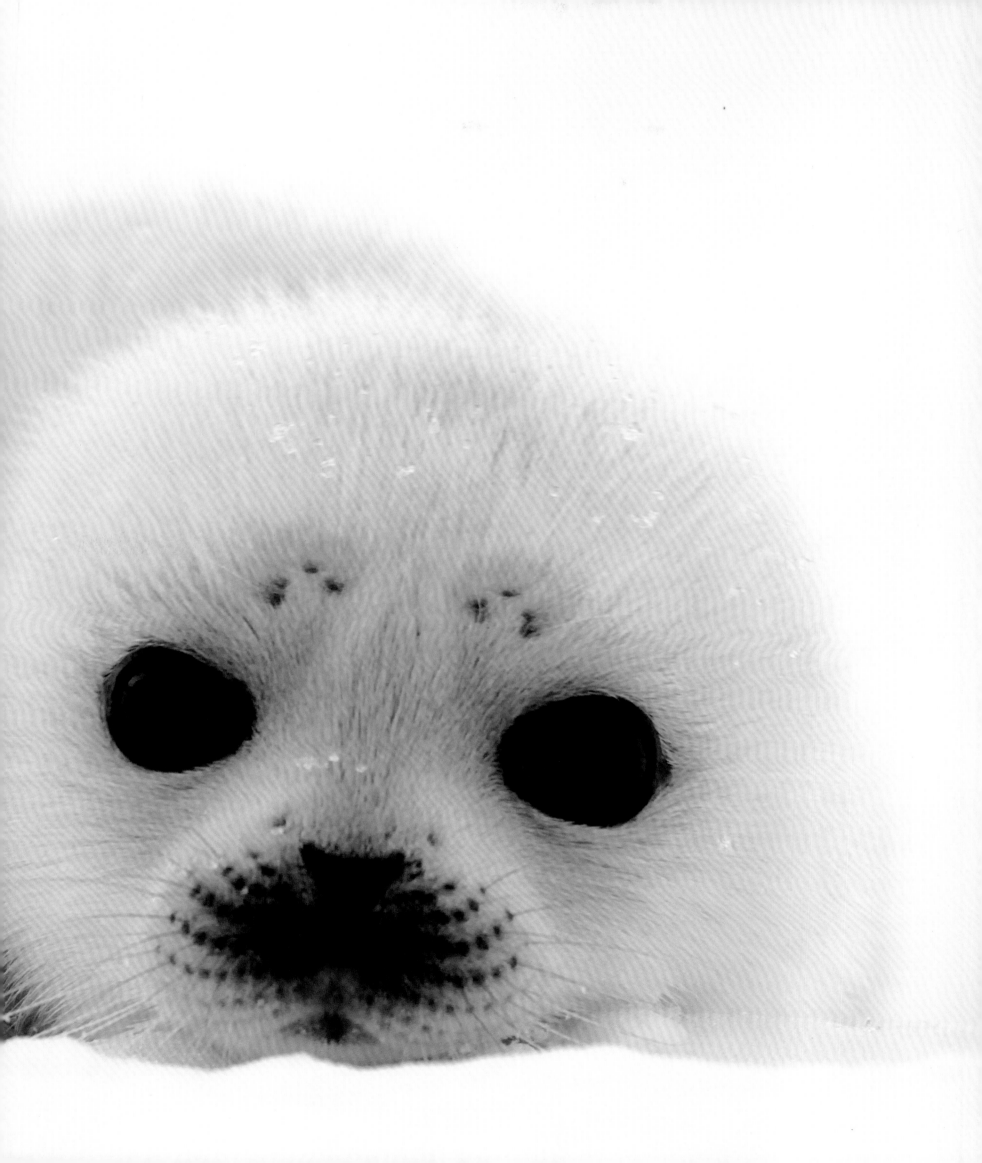

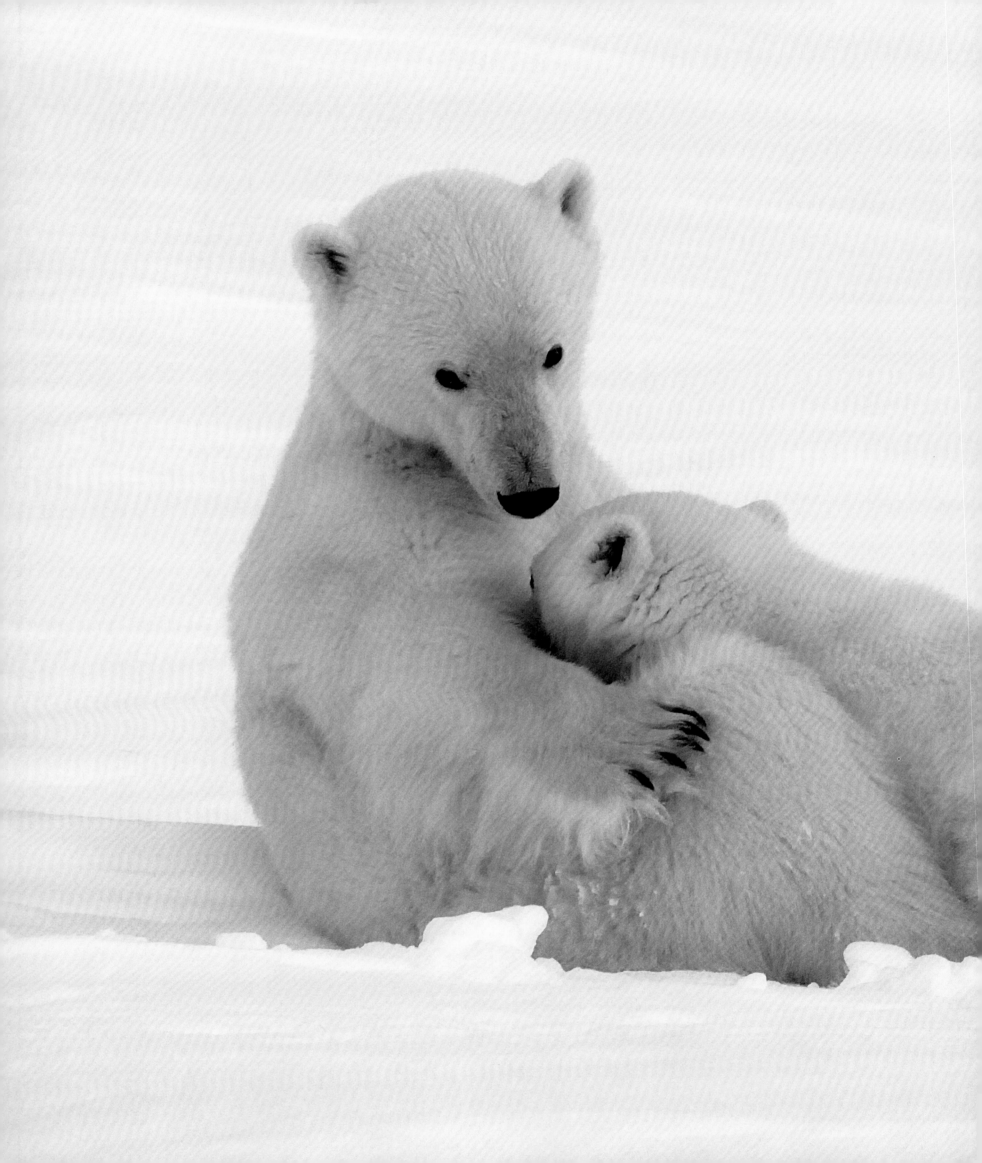

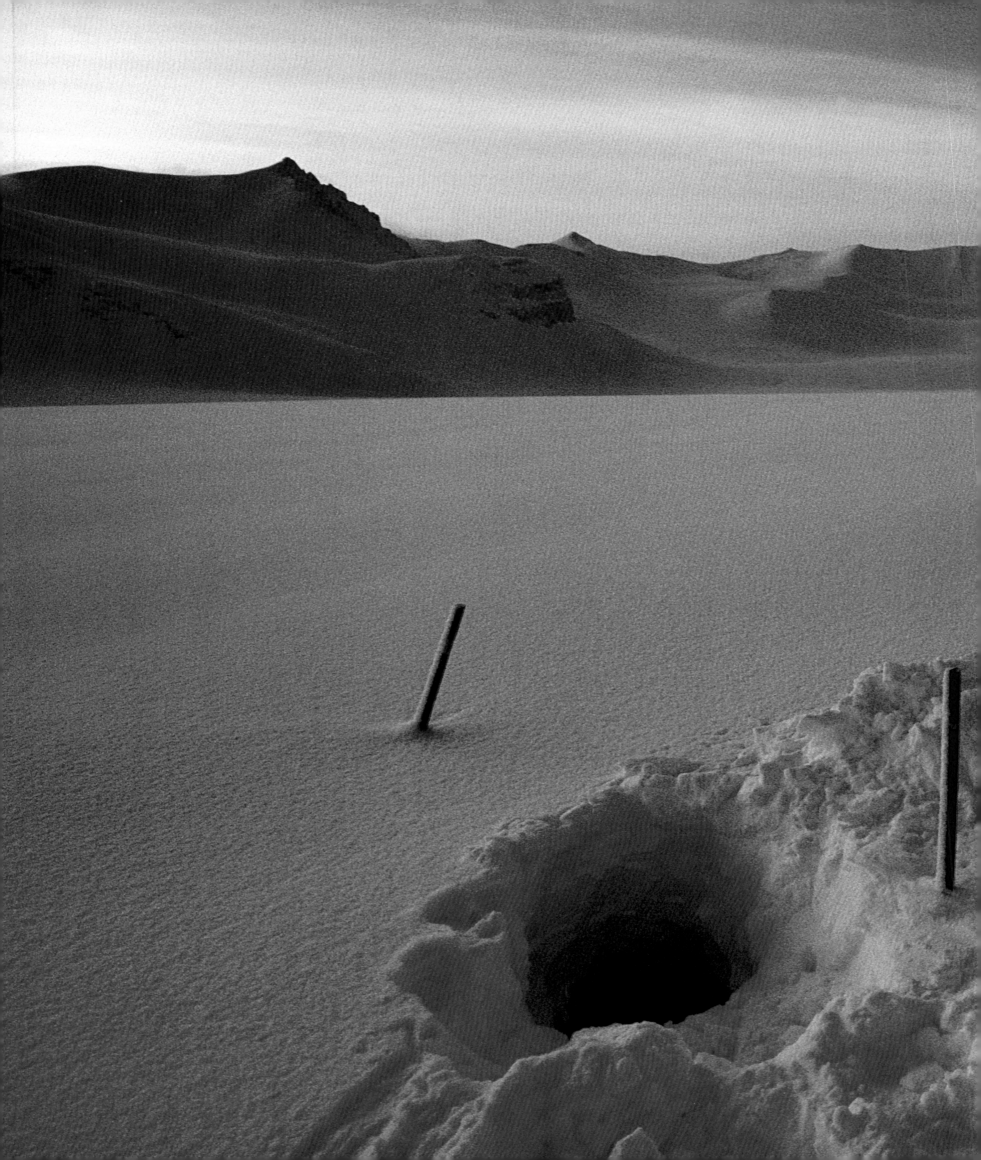

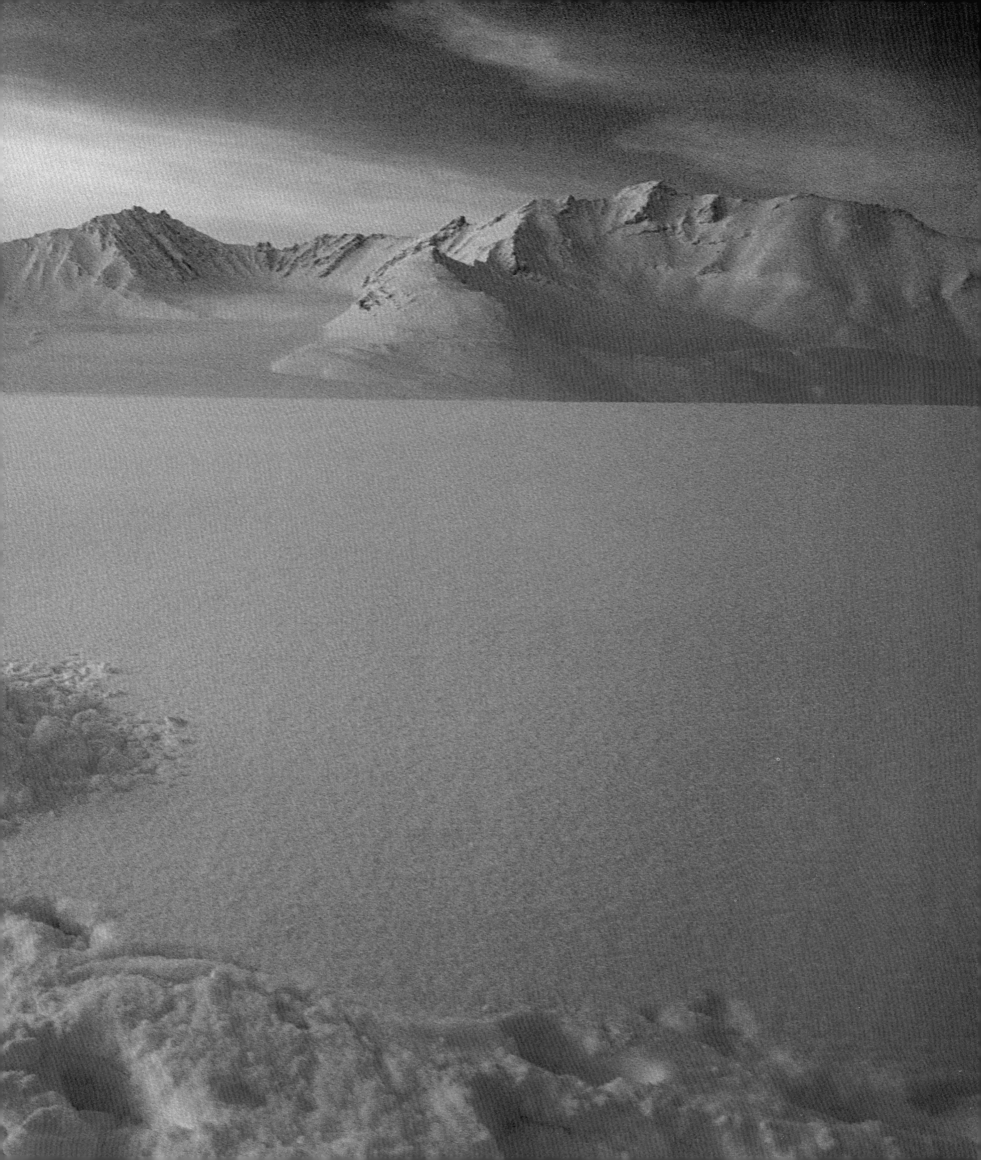

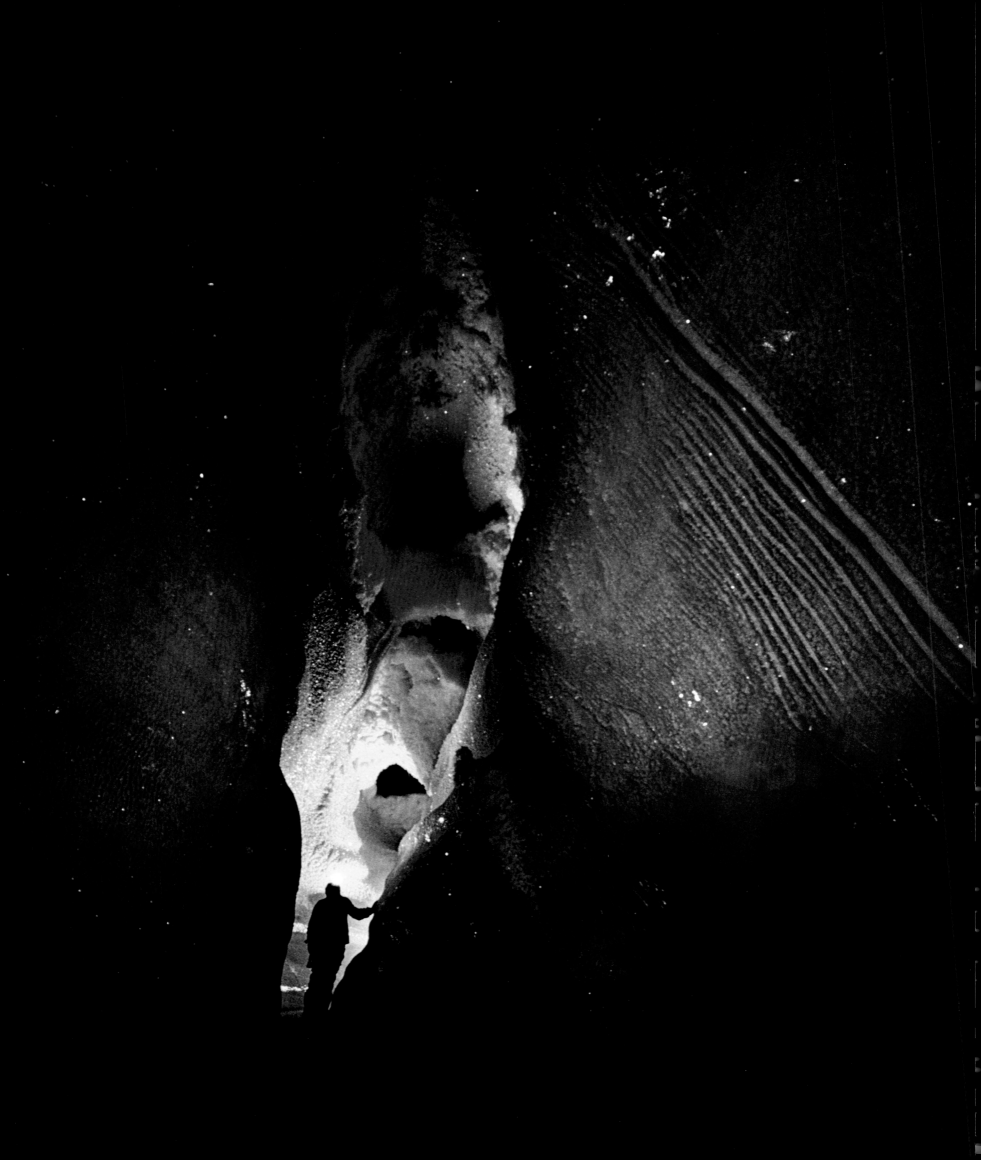

Four hundred feet down in the massive glacier, the ice is several thousand years old. Meltwater has sculpted channels in the blue ice and created an abstract, hidden world. Caves, corridors, and narrow passages run through the ice, with gigantic cathedral-like spaces and stalactites hanging from ceilings and walls. Like the arteries of a heart, these channels transport meltwater through the body of the glacier.

In winter, the glacier is like rock, a jagged mountain lying on land, frozen to the ground. But when summer comes, the glacier and its cover of snow begin to melt, and these channels fill up with rushing water. The glacier starts moving once again, transforming and reshaping. An ancient world of ice waiting to transform.

This ice, this frozen snow and rainfall of past days, offers testimony to our history. It tells stories of the earth before humankind, layer by layer, snowfall by snowfall, down thousands of feet. Old ice, especially on Greenland and in the Antarctic, is a tremendous source of information for scientists. It is an archive of the earth's climate, dating back thousands of years. When we lose our glaciers, we lose our history.

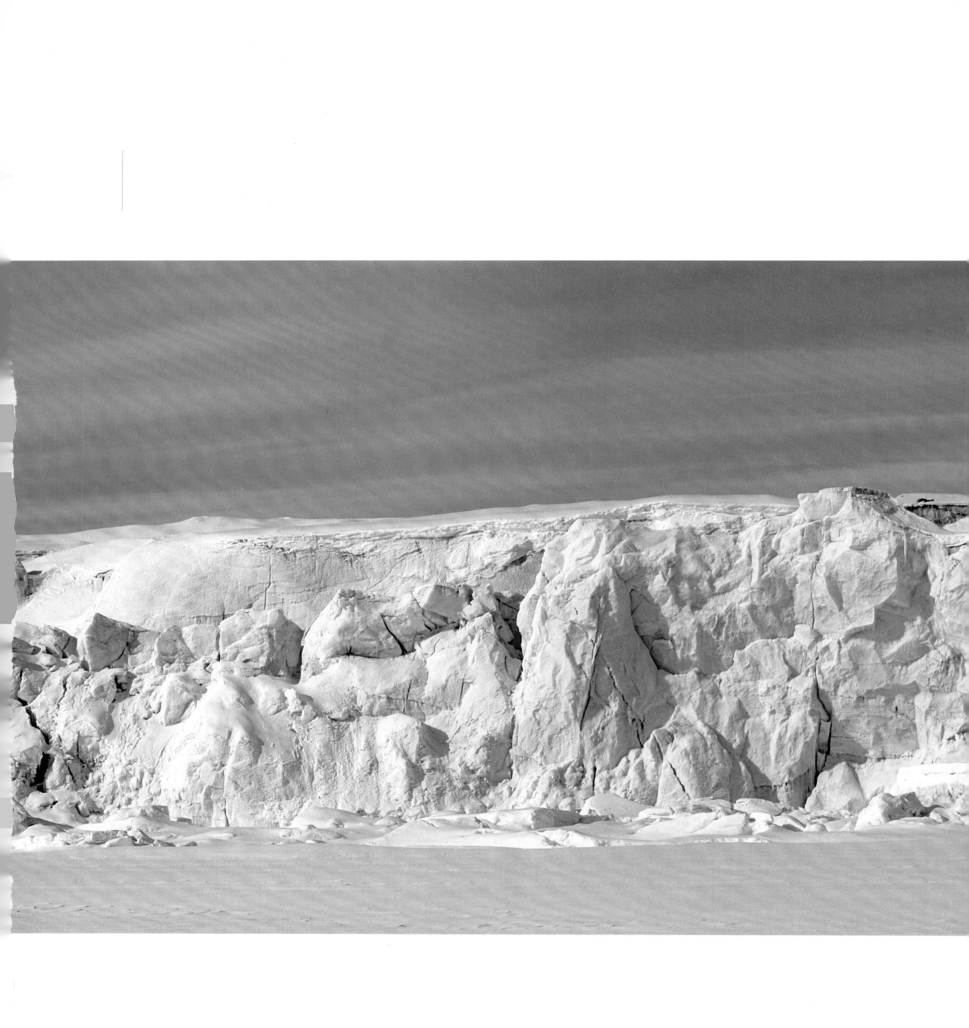

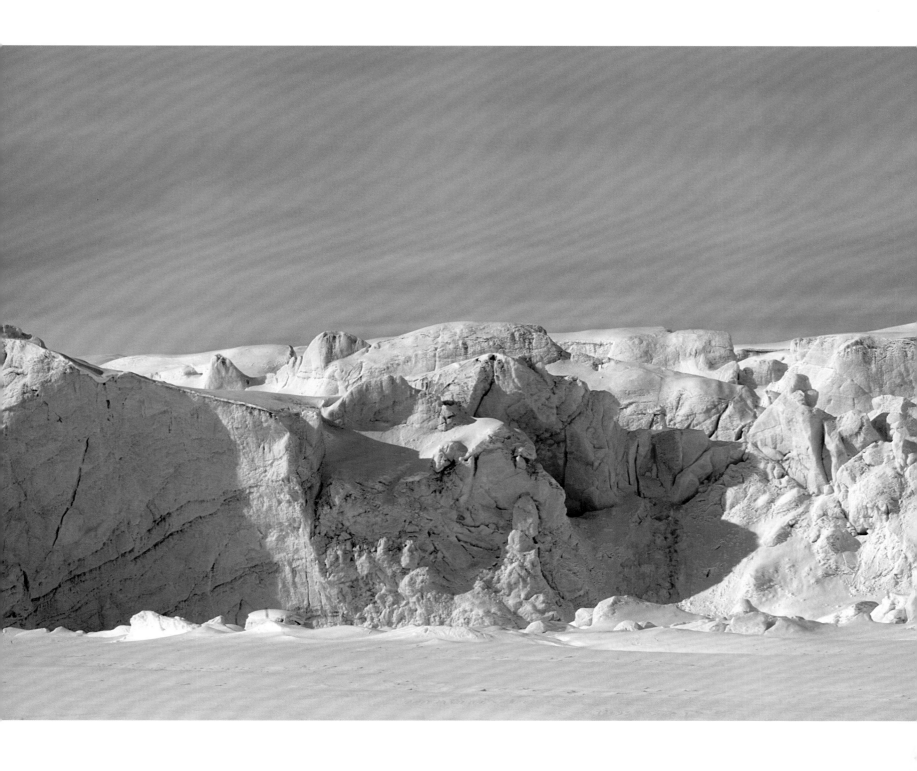

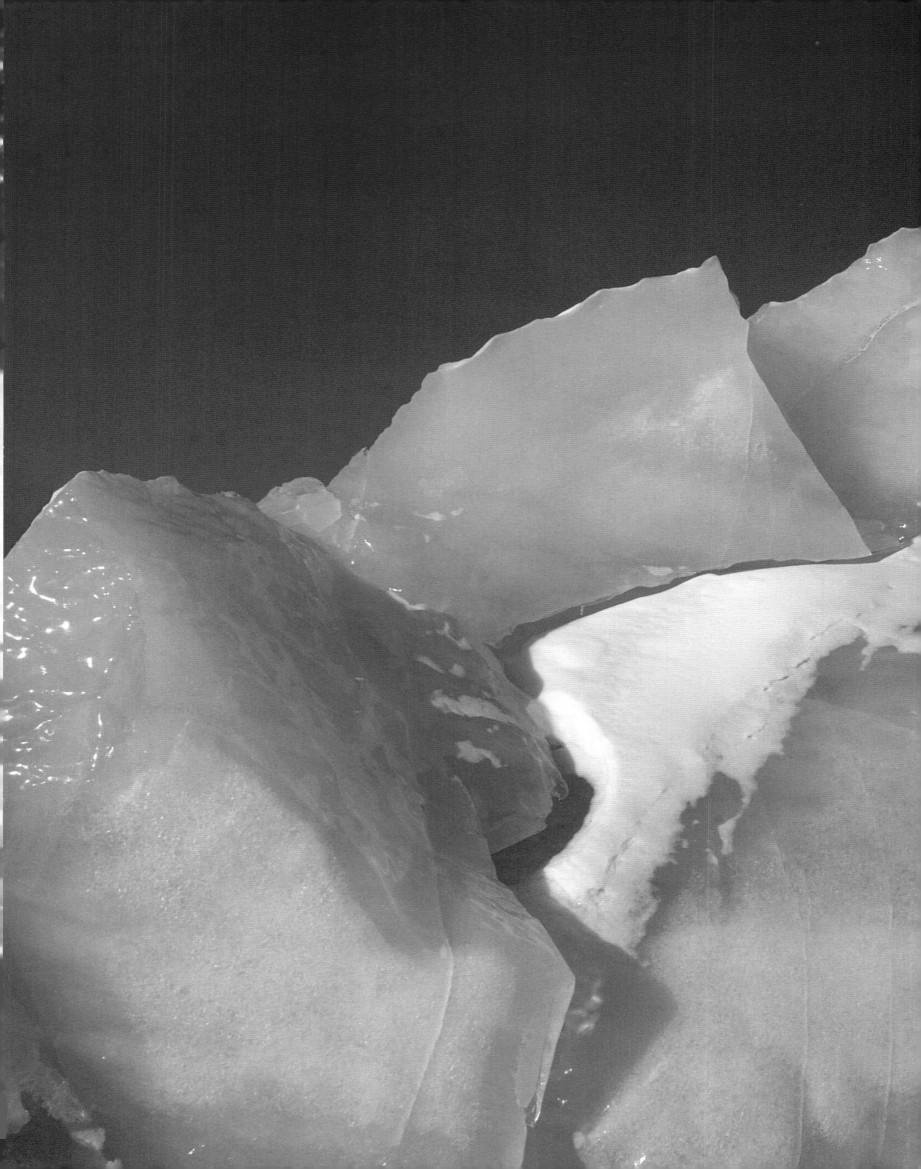

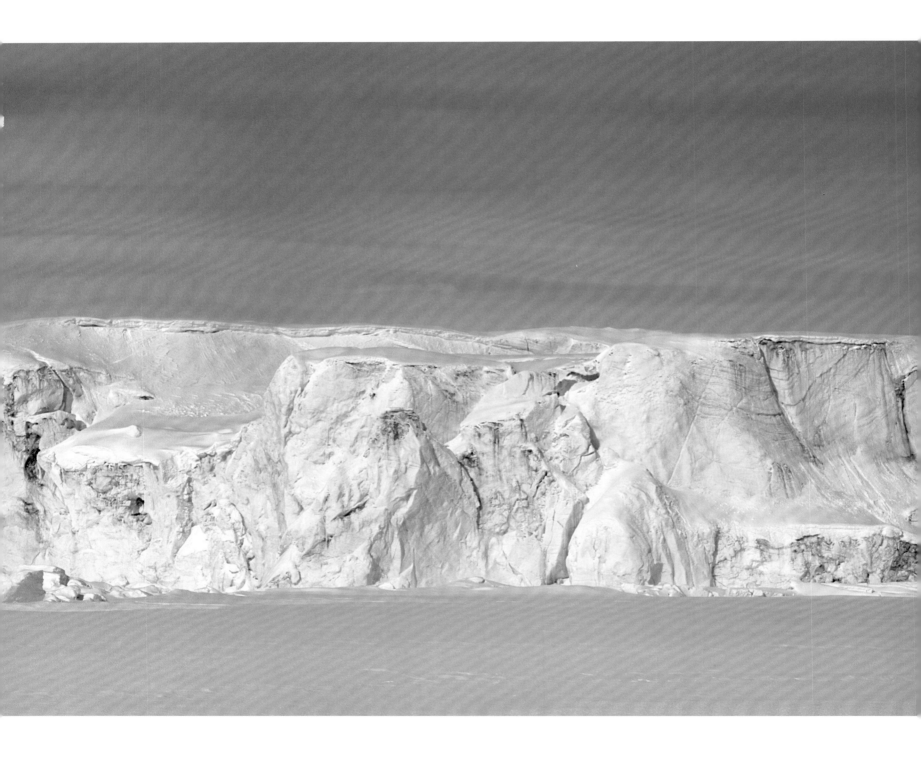

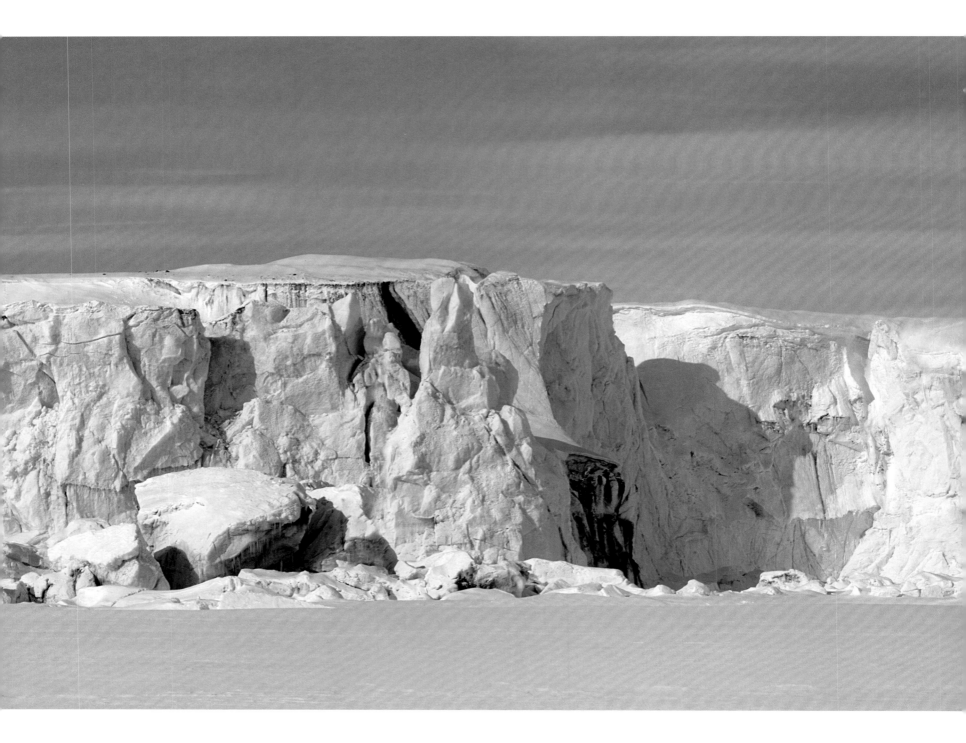

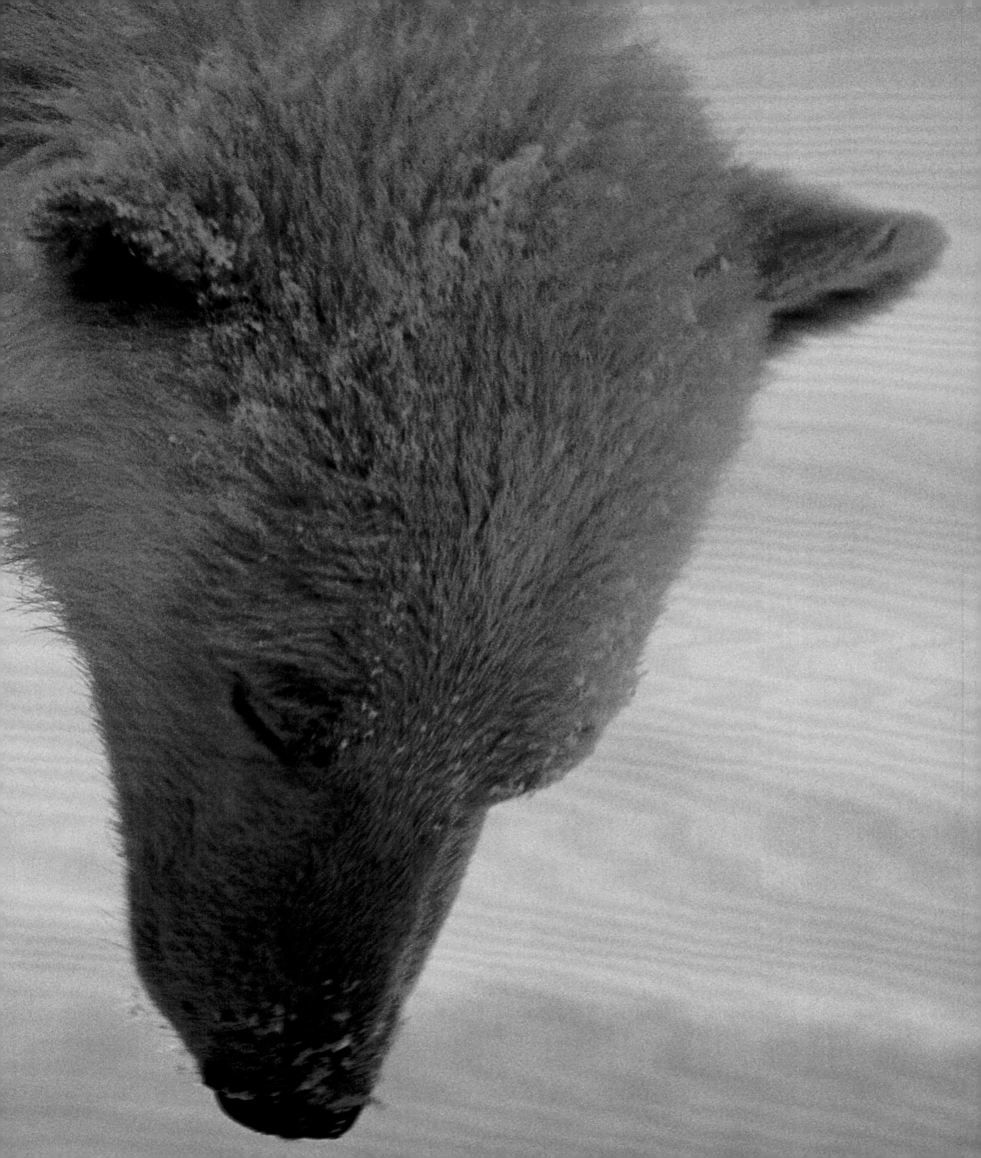

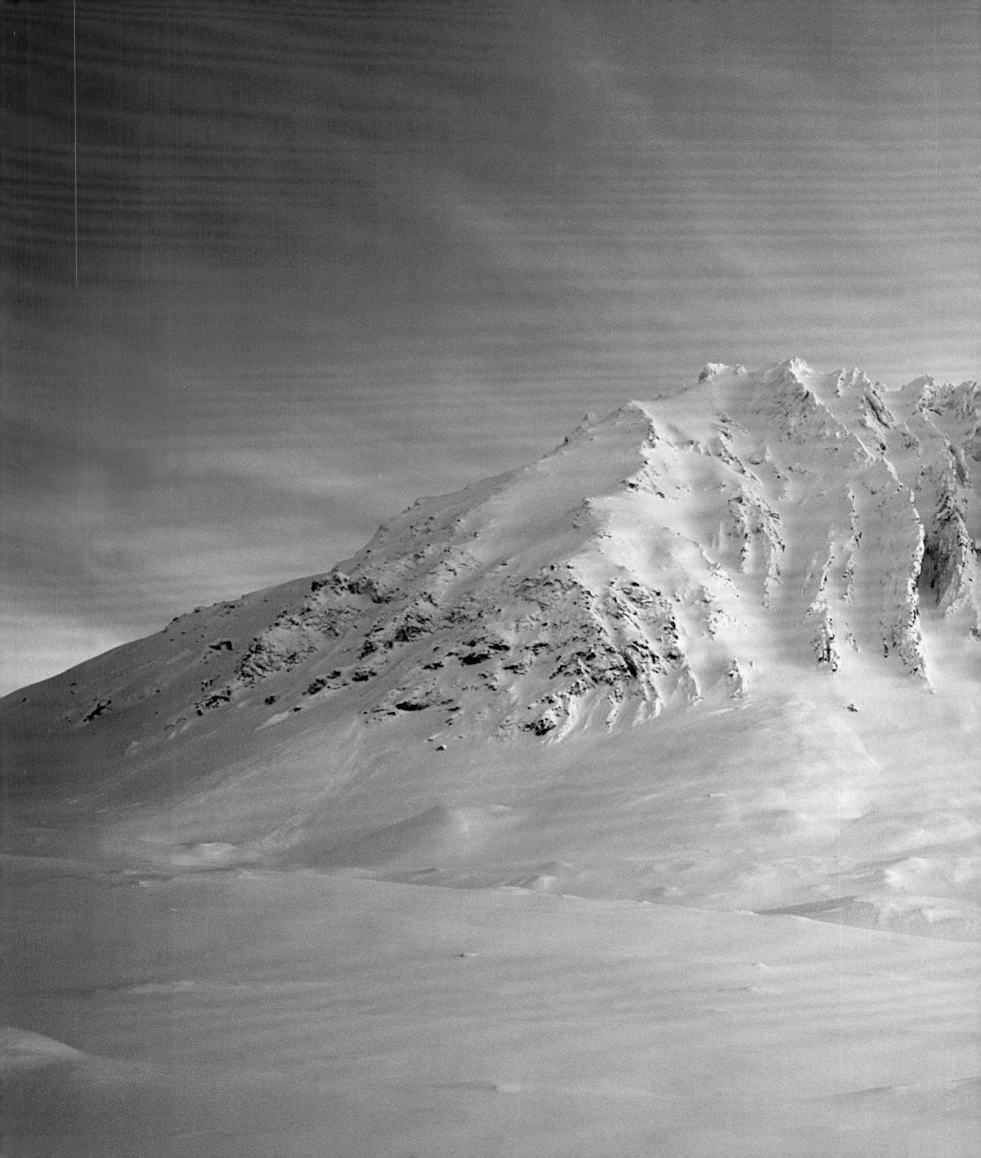

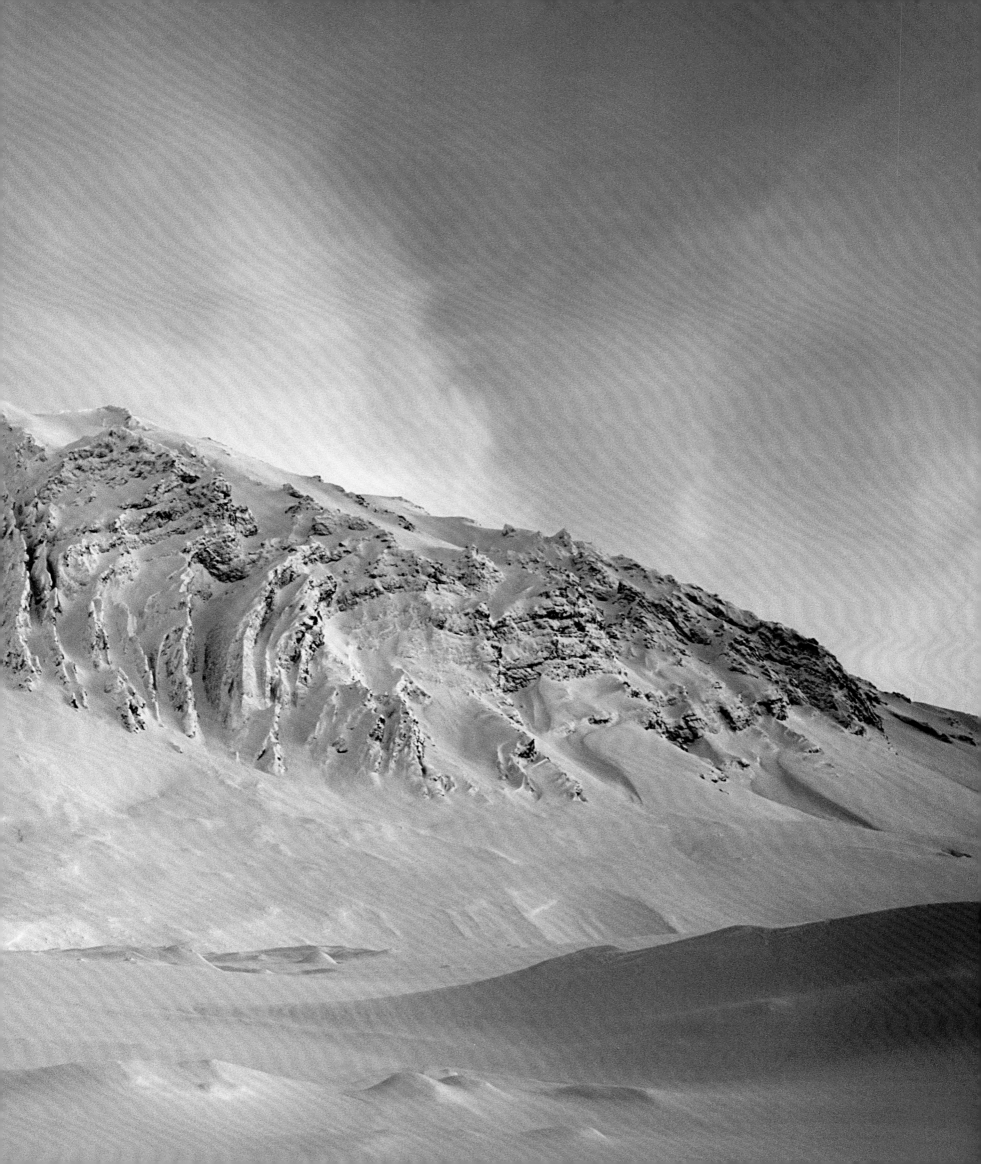

a mother's love

The polar bear spends most of its life on the frozen ocean, but it is also dependent on access to land. In late October, when winter veils the Arctic and the pack ice, a pregnant polar bear goes onto land. On a snowy hillside close to the sea, she carefully seeks out a spot to dig her den. For more than four months, she takes shelter, to give birth and to nurture new life. In the new year, she usually has two cubs. After nursing them in the den through winter, she re-emerges in late March.

After spending a couple of weeks near the den, allowing the cubs to adapt to a new world, she leads them out onto the sea ice. By now she has not eaten for five months, and a desperate hunt for food begins. The journey is slow, with many stops to rest and nurse. Six out of ten polar bear cubs die in their first year, often victims of starvation.

As the mother leaves the den, it is a dangerous time of year—breeding season. An aggressive male bear will not hesitate to kill her cubs in order to mate with her. But a polar bear mother's love is unconditional, and she is very protective of her little ones. To defend them, she will risk her own life.

The cubs follow her every step, mimicking all her moves, learning how to eventually make it on their own. After two years on the ice caring for her cubs and teaching them about survival and life, she is ready to breed again. And the cubs are ready to make it on their own.

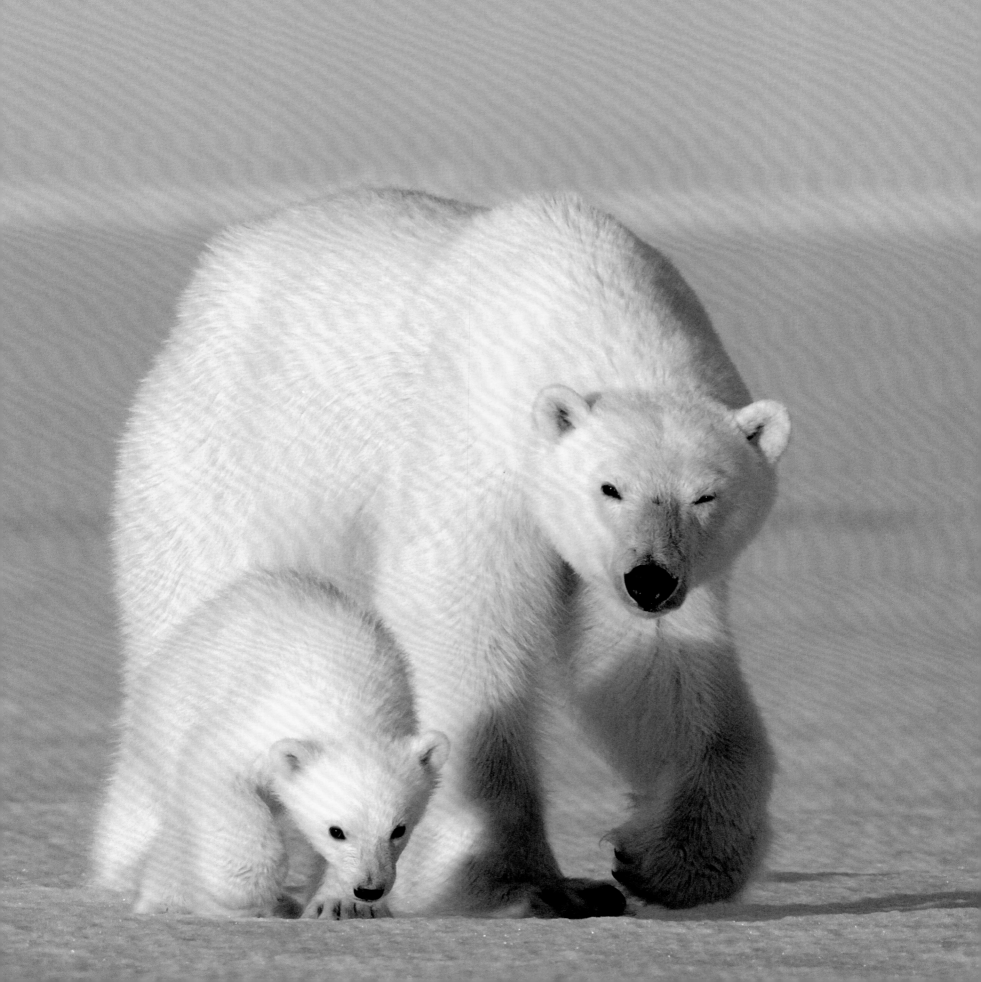

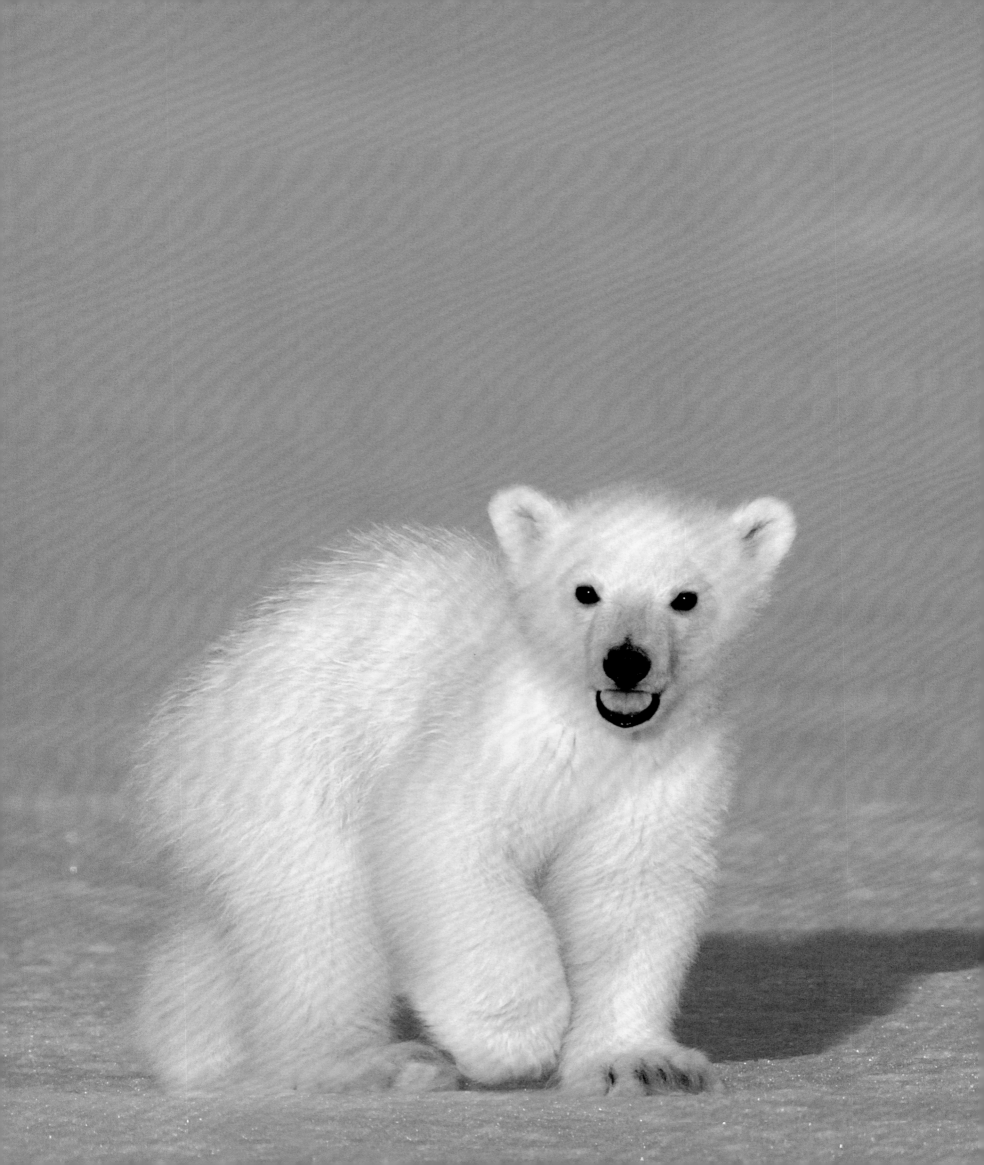

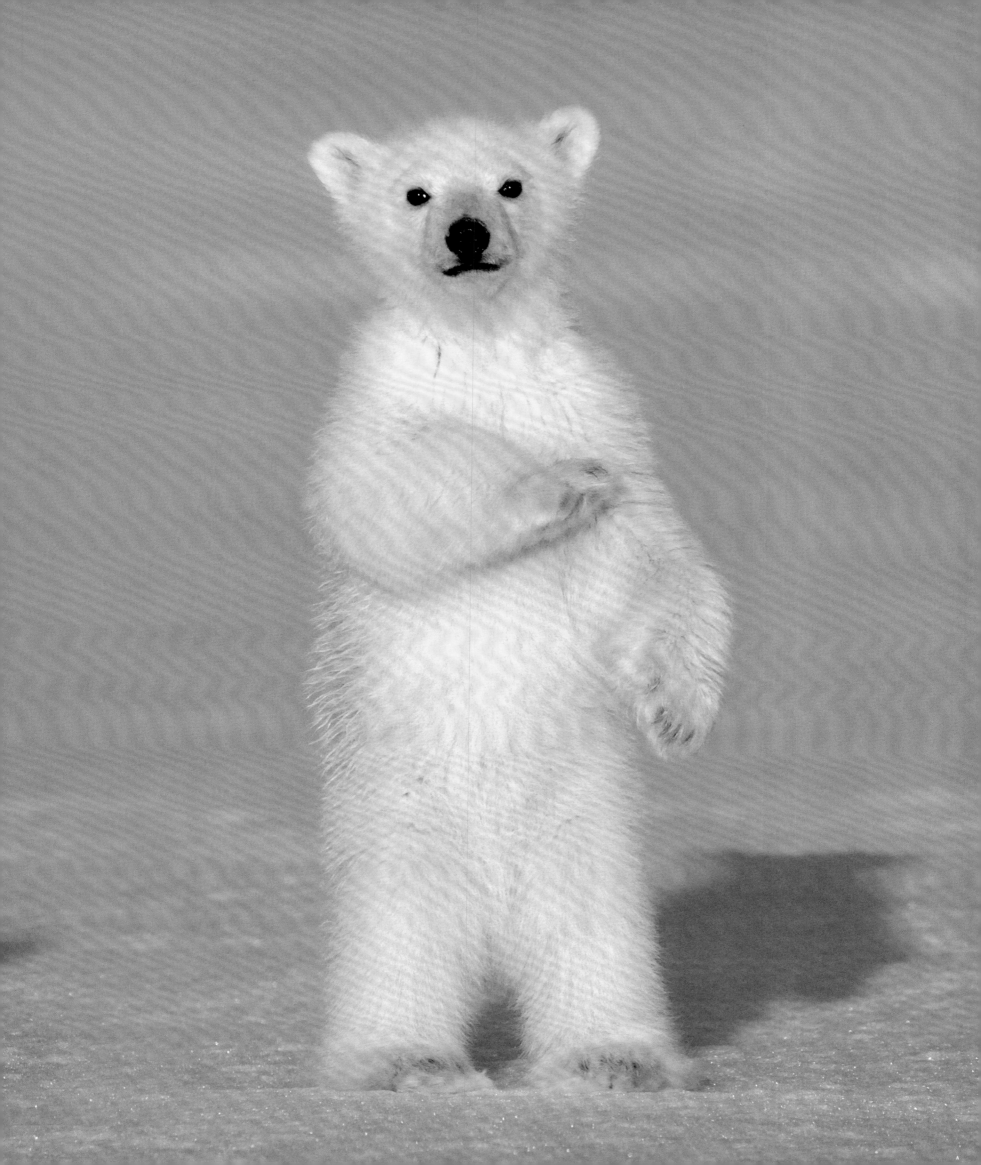

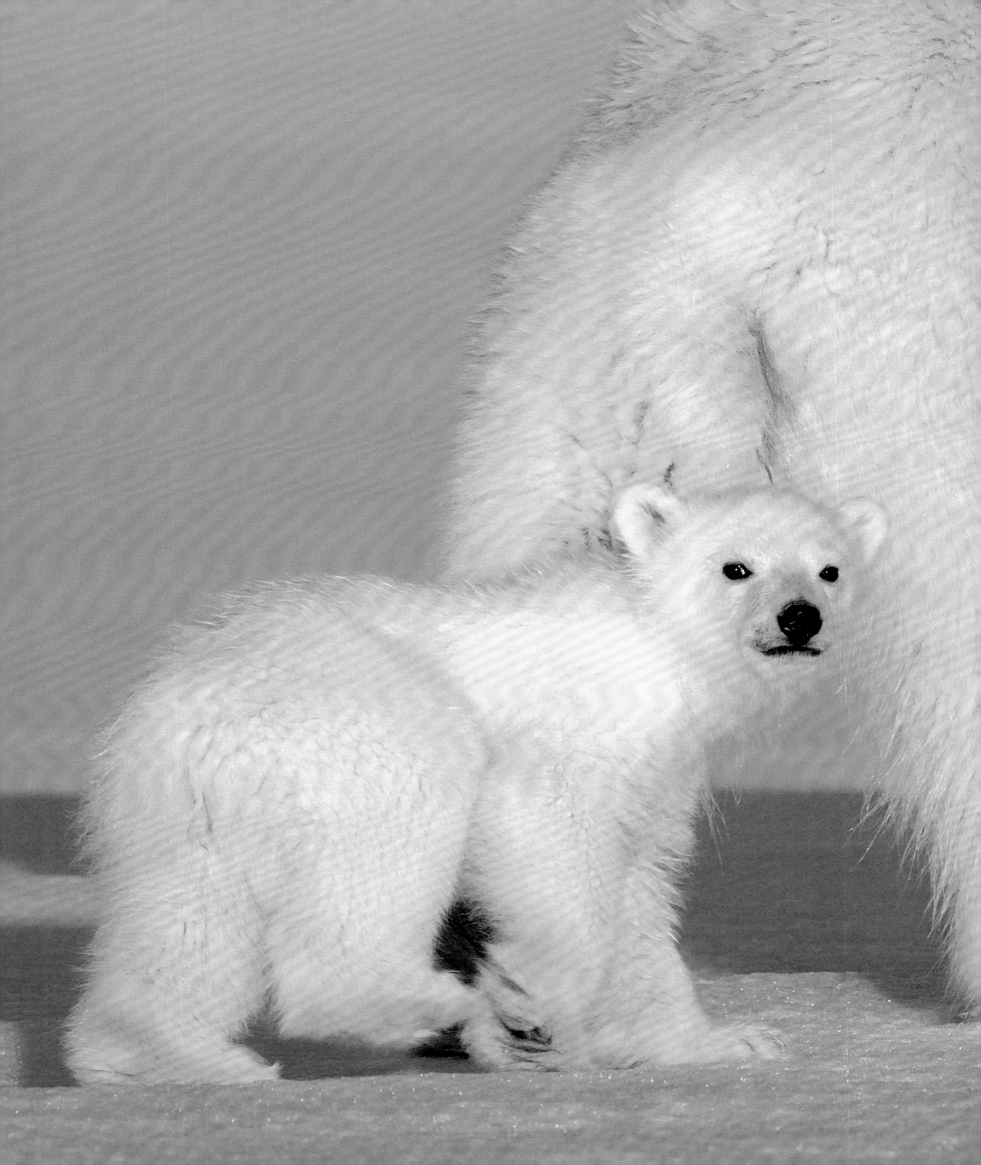

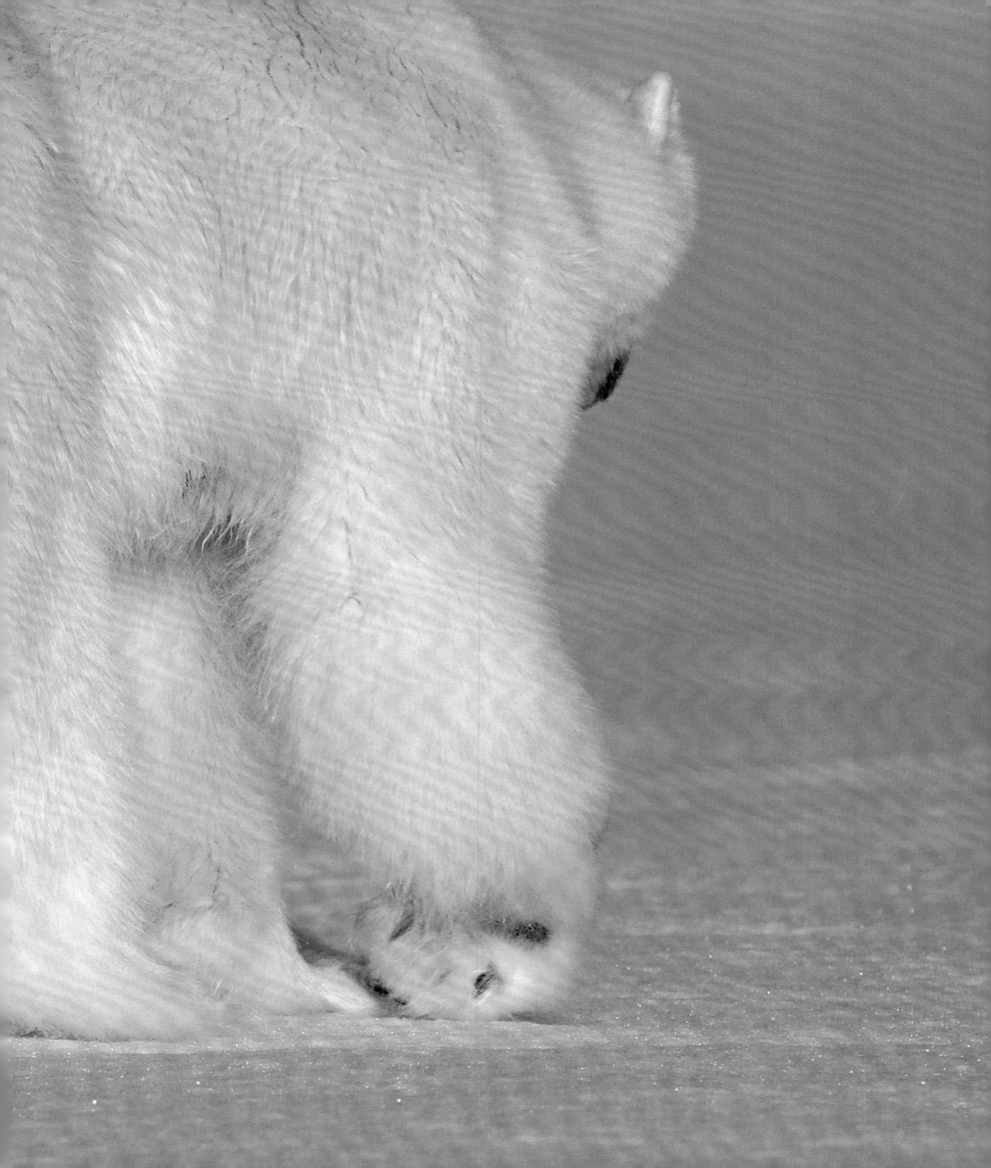

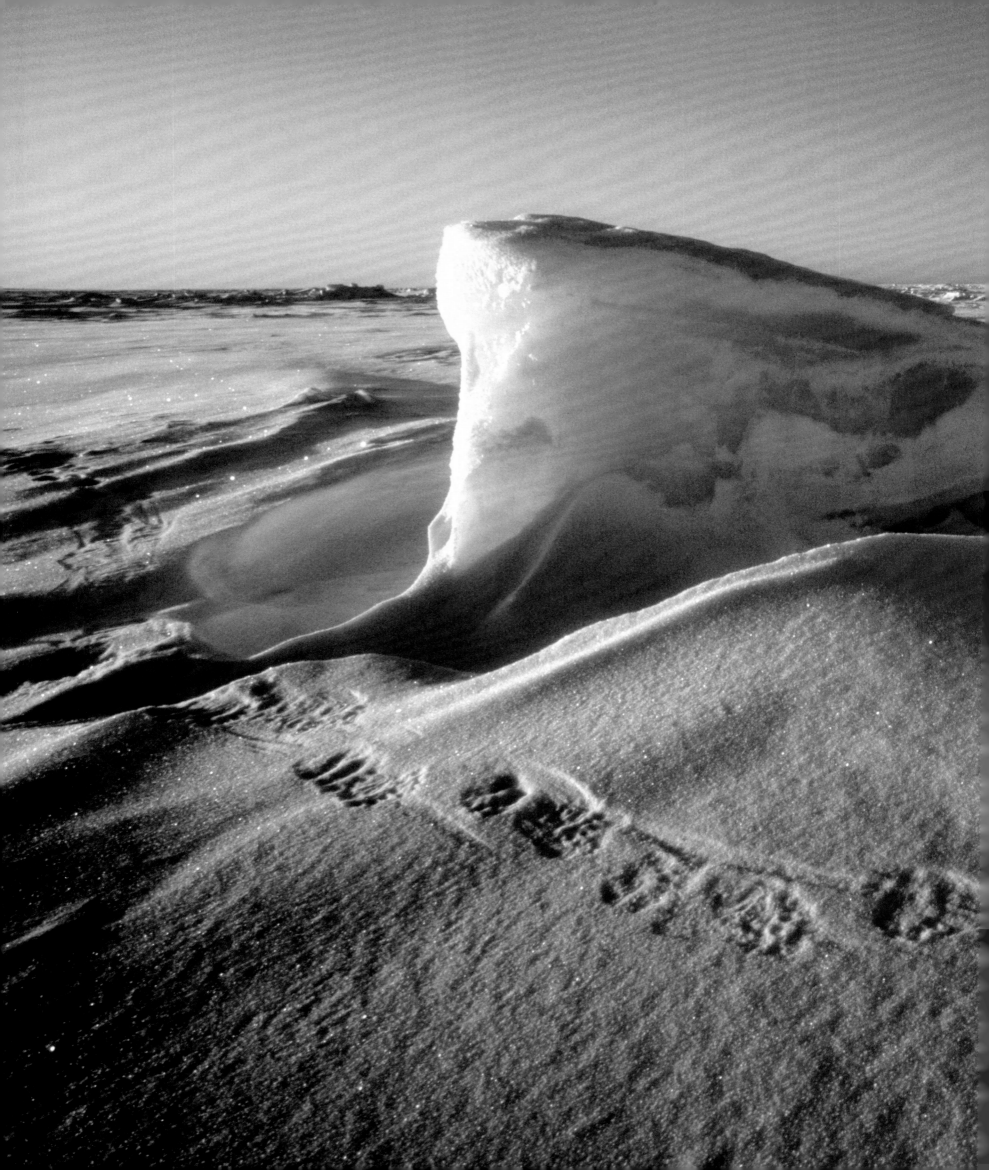

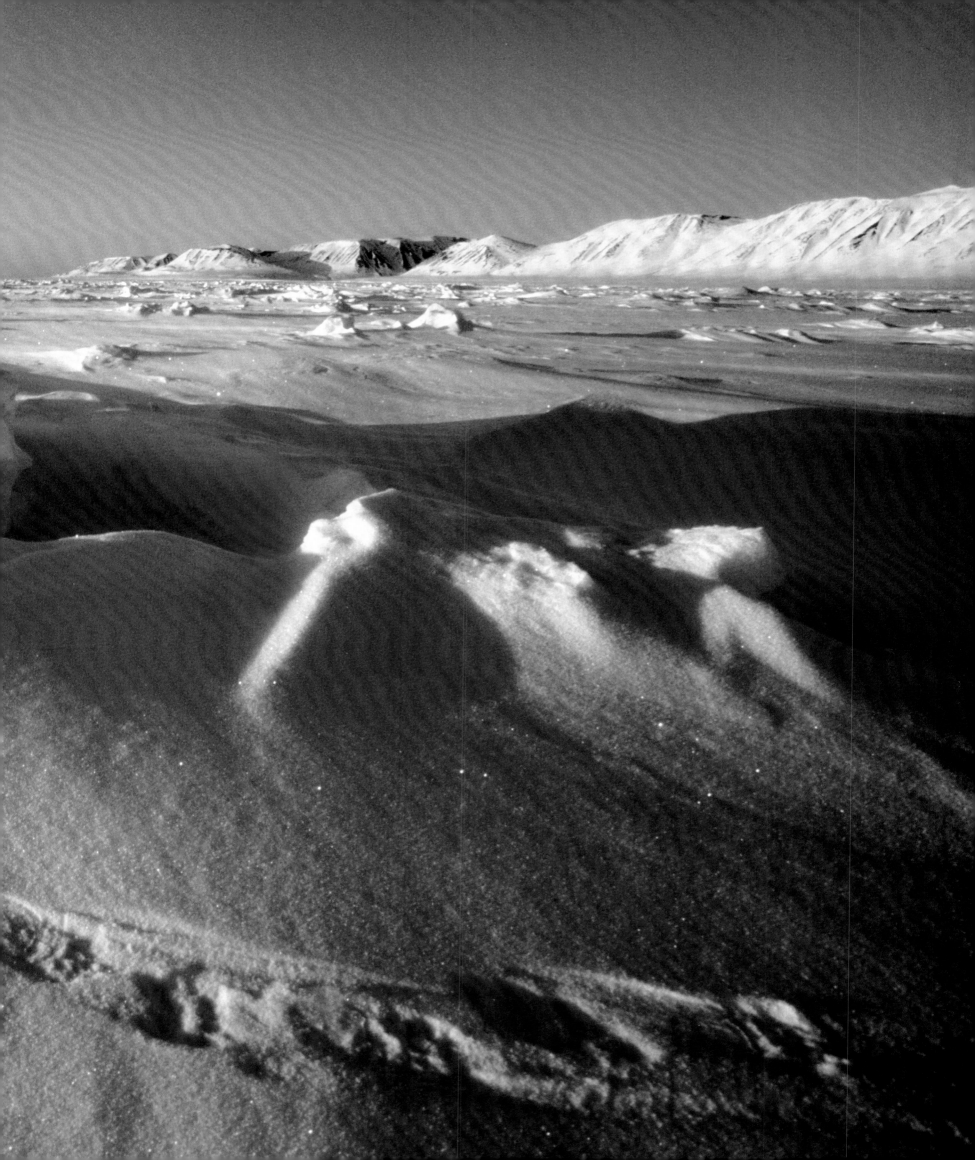

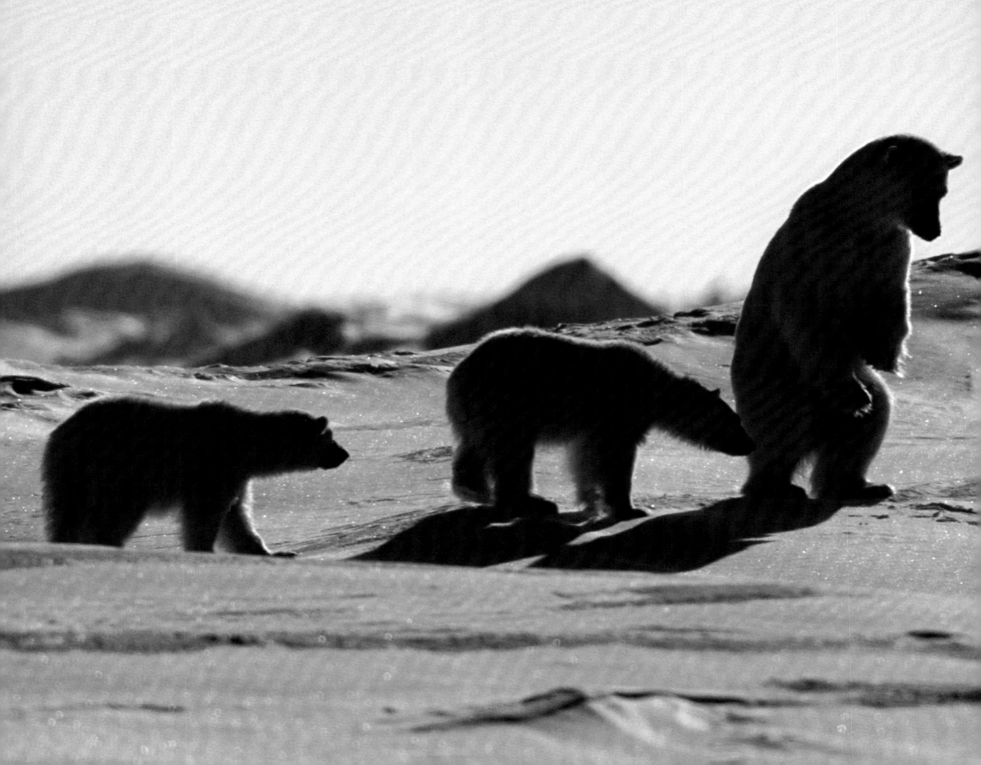

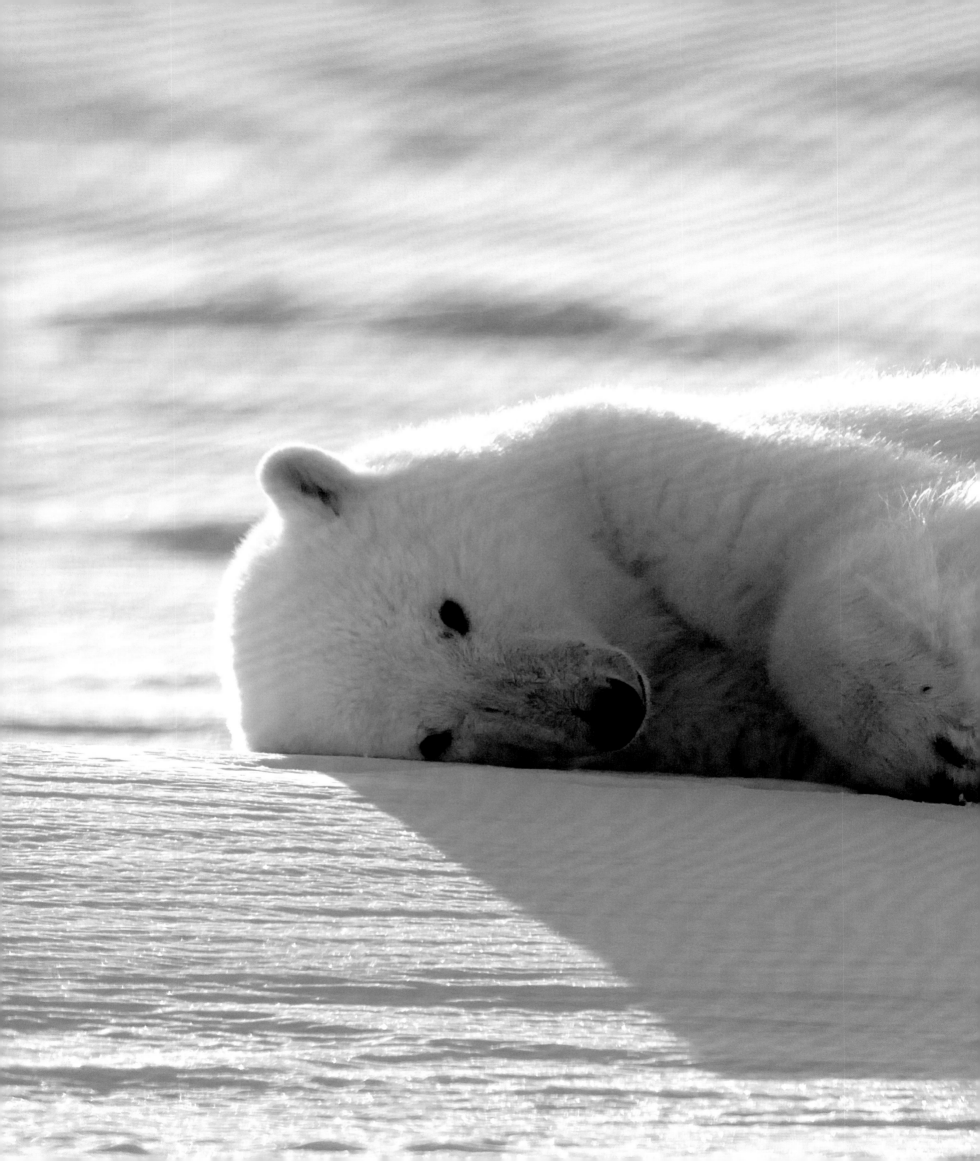

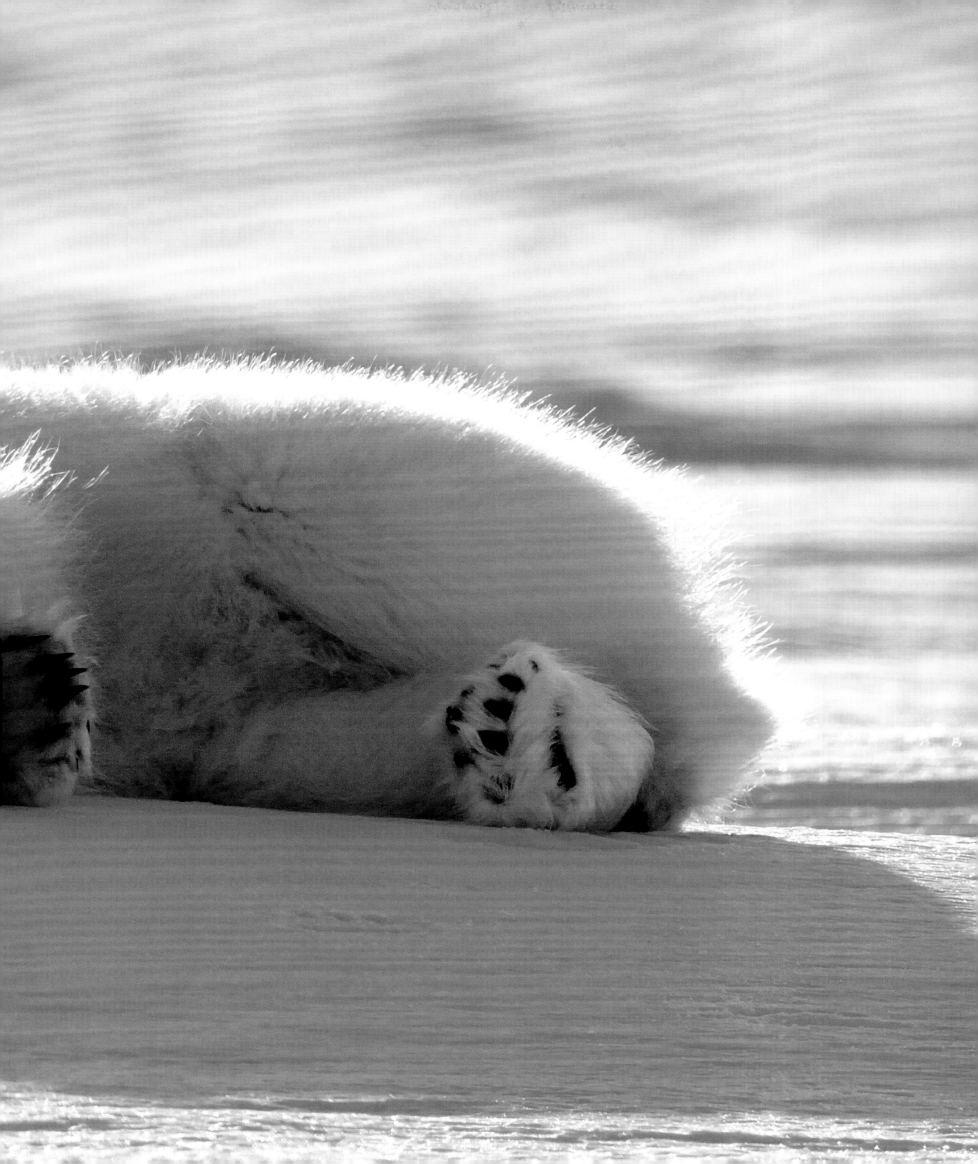

water

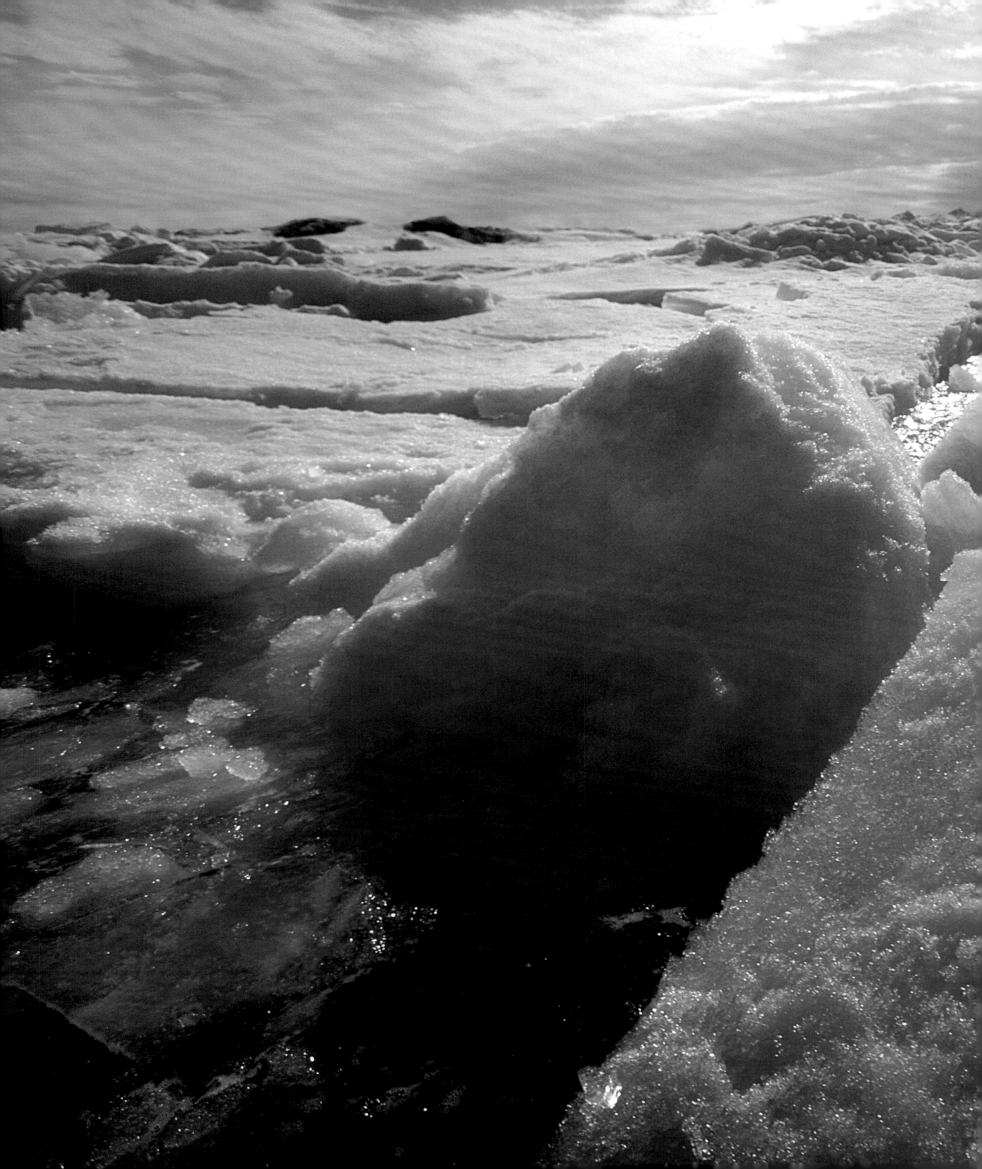

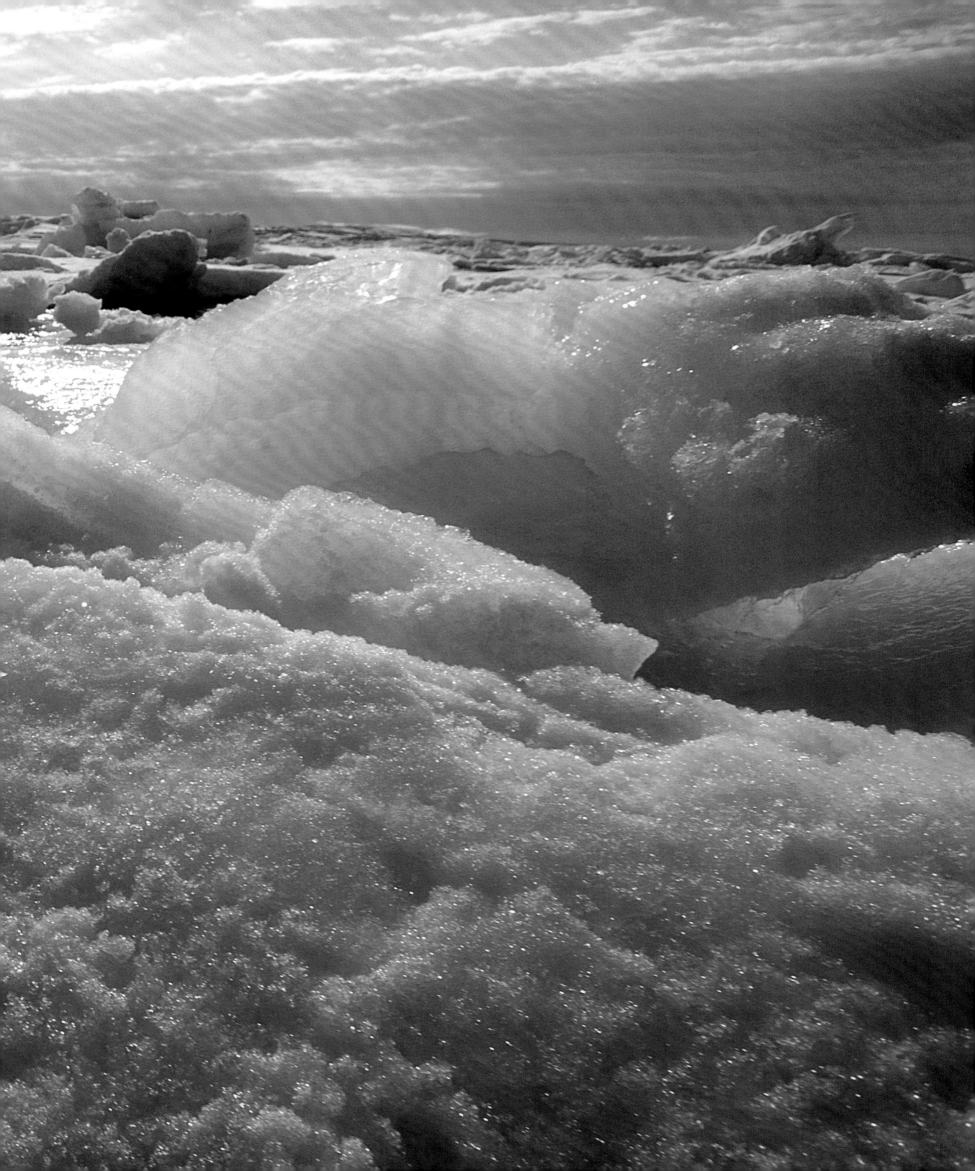

breaking ice

Ice comes from water. Water comes from ice. The midnight sun glazes the vast frozen ocean, this reservoir of cold at the top of our planet. Summer is approaching, and the sea ice starts to dissolve. In some areas it happens quickly; the ice breaks up into drift ice and retreats north. In other areas it takes weeks, or even months; the ice slowly melts and unites with the cold water.

The North Pole ice cap is now an island of ice. In summer, it shrinks, its edges recede north—and so does life. The polar bears and seals travel with the ice, out far into the ocean, following the grounds and leads of frozen sea.

But from the south comes new life—birds, beluga and humpback whales, even orcas—to feed in the rich waters of the cold, open expanses of the Arctic Ocean, especially along the edges and in the cracks within the drifting ice.

Every year, however, the sea ice melts and breaks up earlier, and re-forms later, and summer in the Arctic becomes longer. The ice recedes farther north with each summer, making it more difficult for polar bears to reach. This results in more polar bears being trapped on land. For many months they are forced to fast, waiting for the next winter, and the ice it brings, to return. If this trend continues, the consequences could be disastrous; the melting of the Arctic sea ice puts the polar bear at risk. Scientists predict that by the middle of this century, in summertime the Arctic Ocean could be devoid of ice. If the ice vanishes, where will the life dependent on it go? The marine ecosystems of these northern latitudes are fragile, and completely dependent upon an ice-covered Arctic Sea.

The evidence is here and it is unmistakable. Humankind is tipping the balance of nature. Global warming is a reality, and scientists agree it is strongly influenced by human activities. The Arctic is its ground zero; it is time to make some vital choices and to take action. Ten of the warmest years on record, globally, have occurred during the last fifteen years. When our climate changes too fast, life is threatened. A world, a beautiful paradise of white, will collapse.

Sea ice, the very definition of the Arctic, is dissolving. If summer continues to intrude on winter, the season of winter as we know it could disappear.

Is there a future for snow and ice, and the species dependent on it?

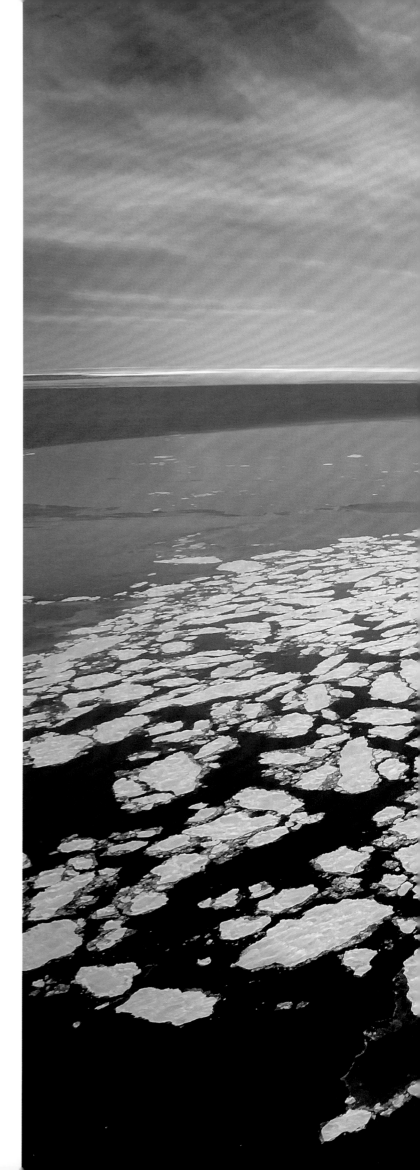

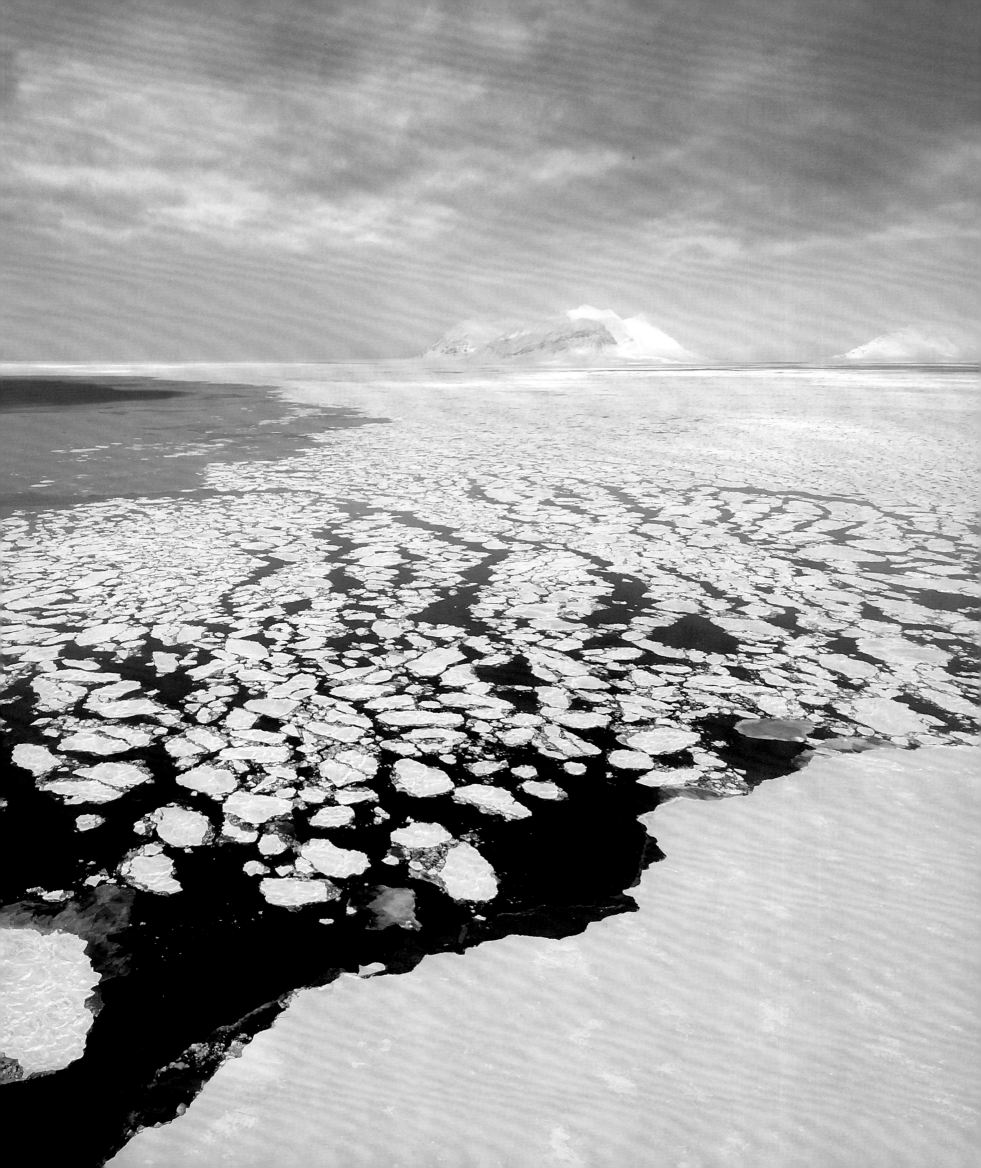

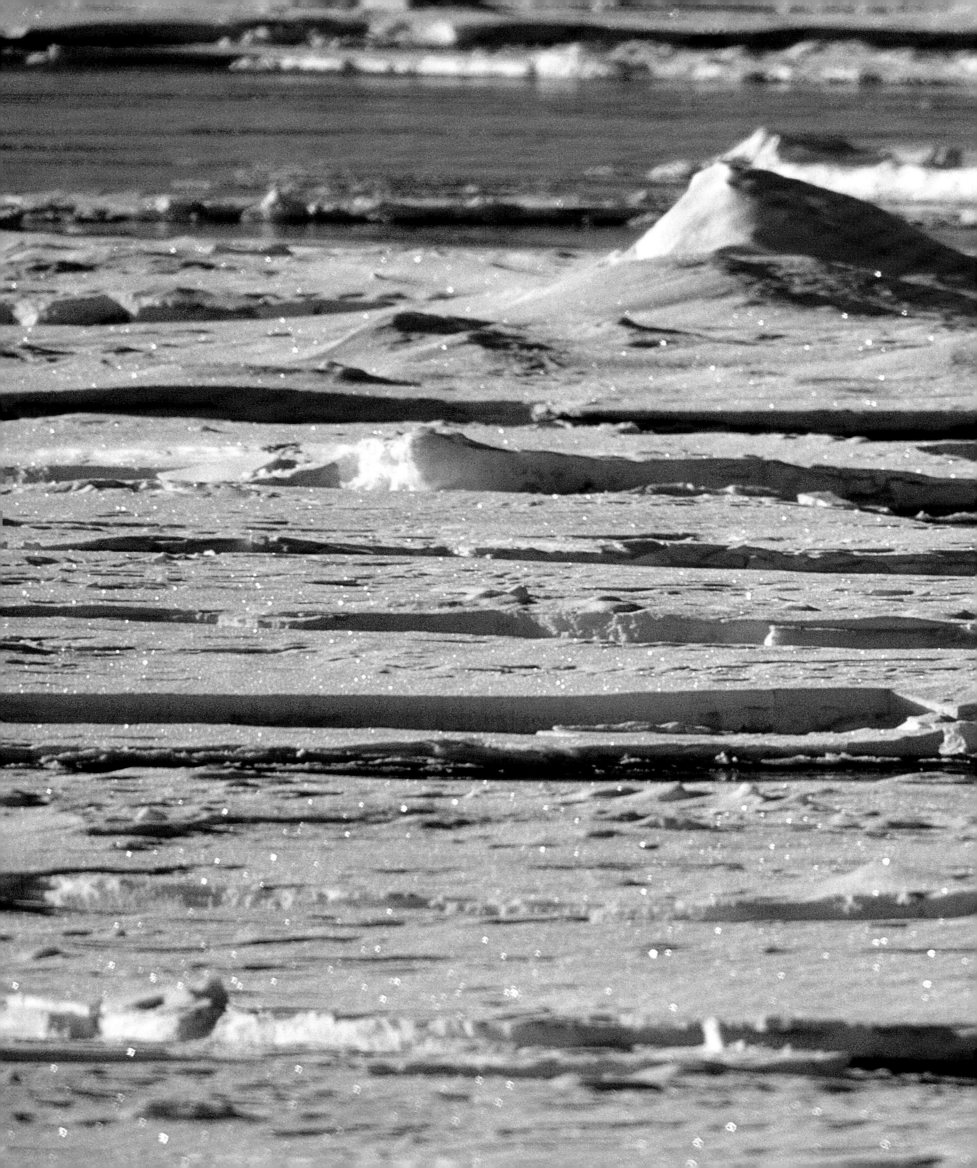

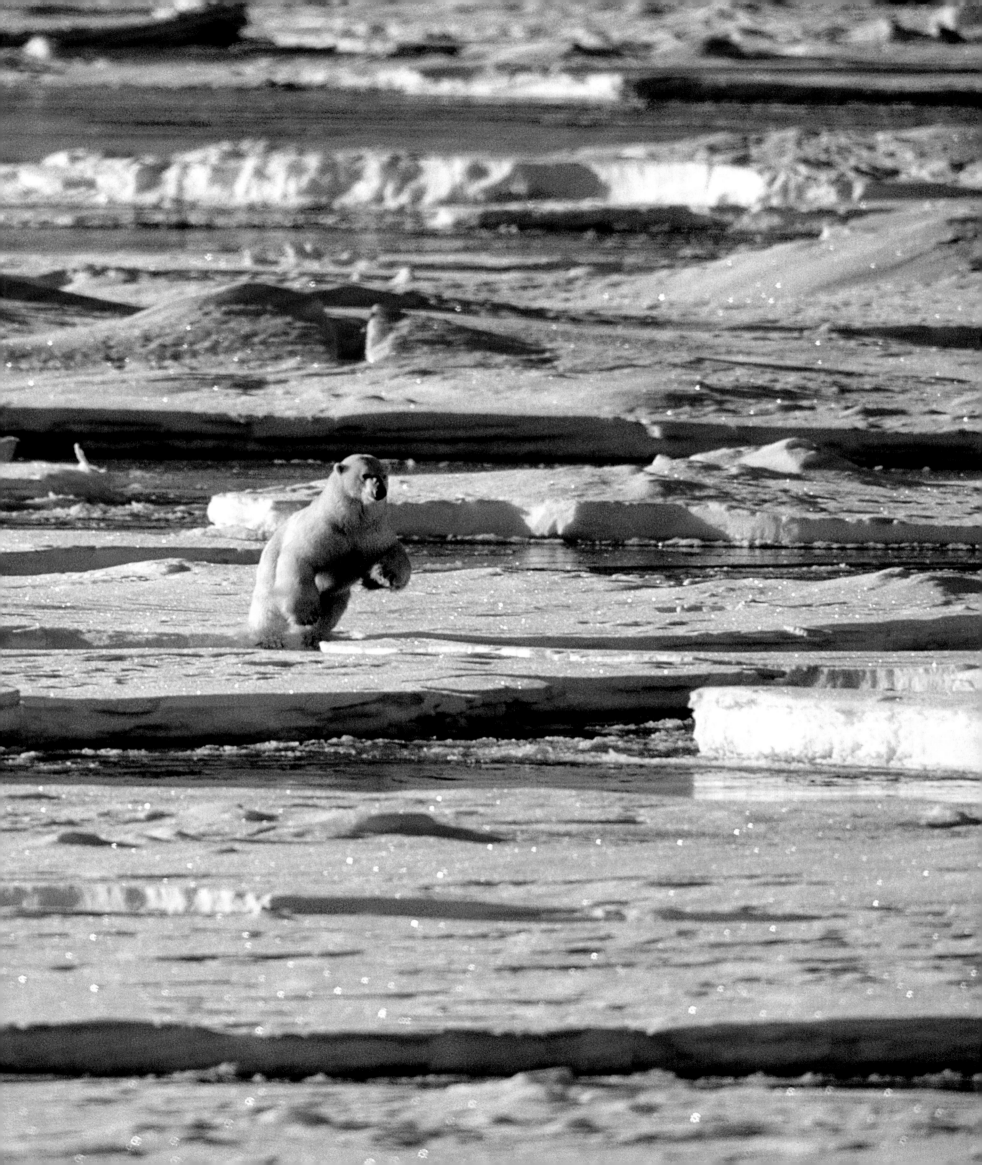

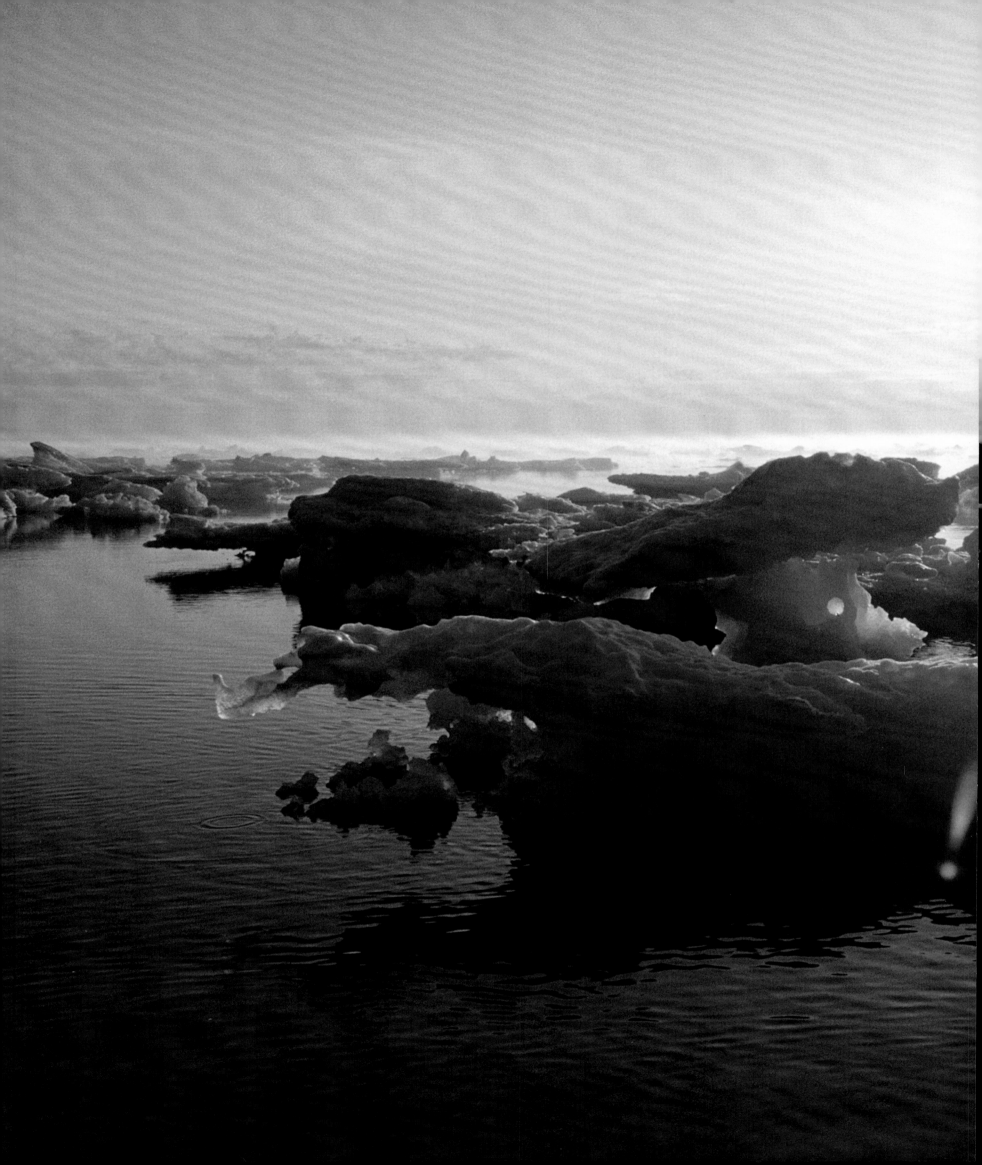

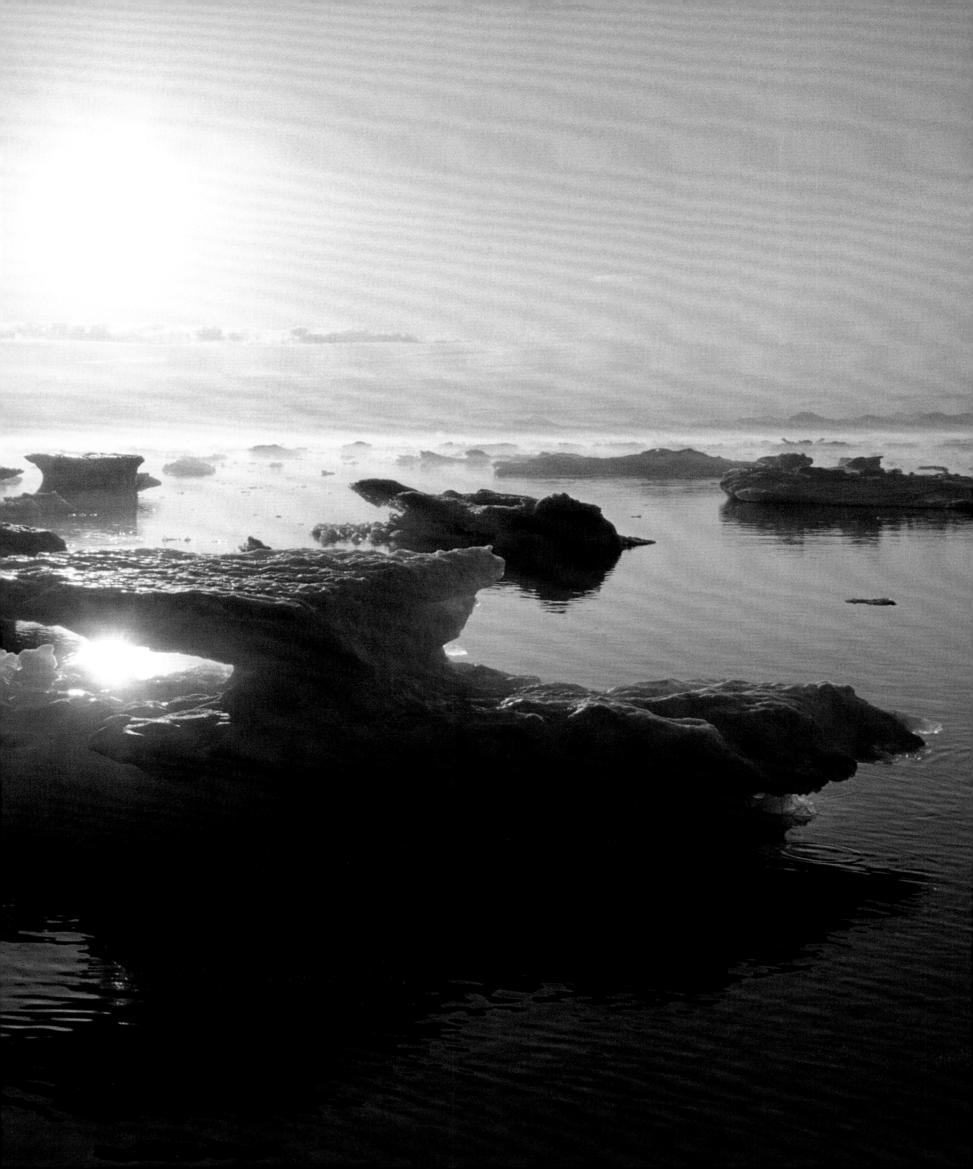

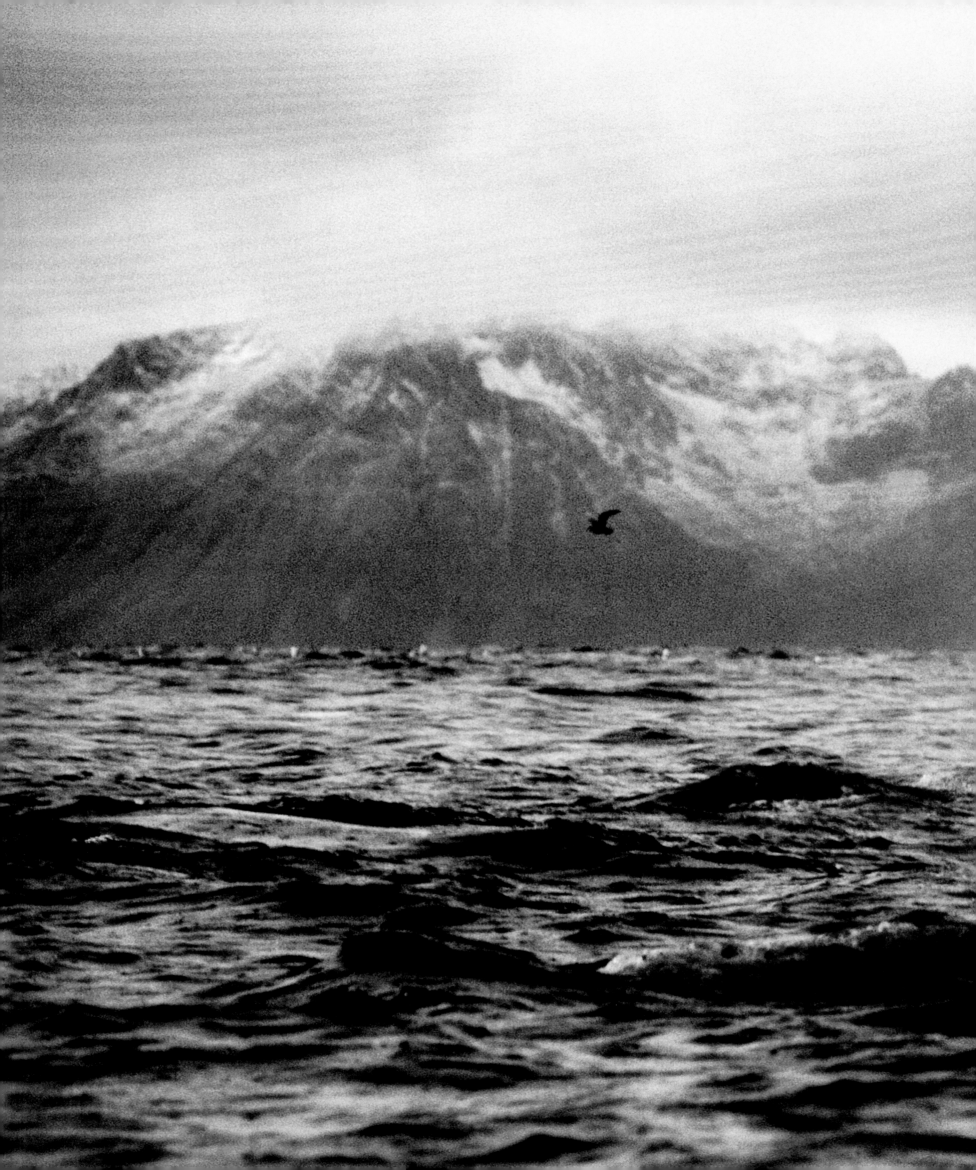

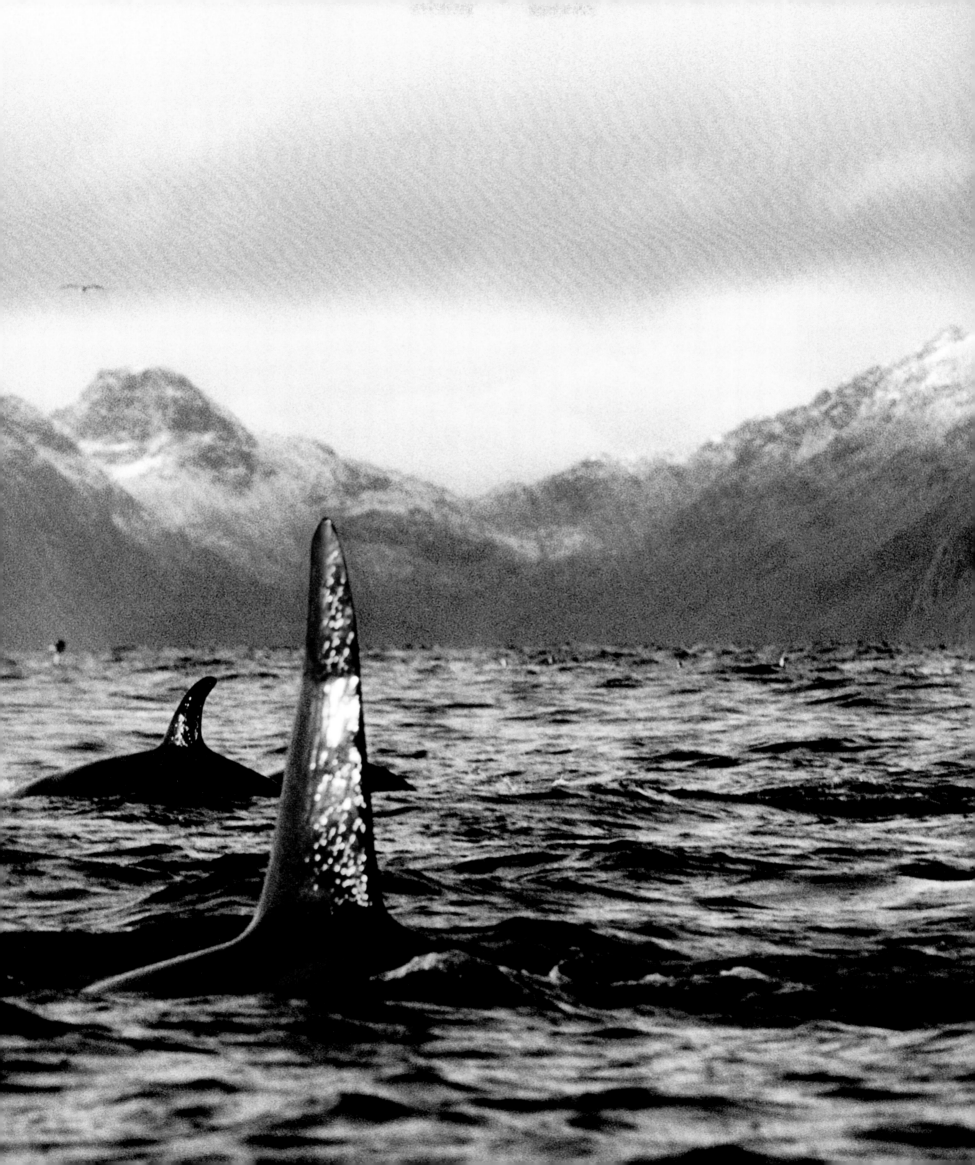

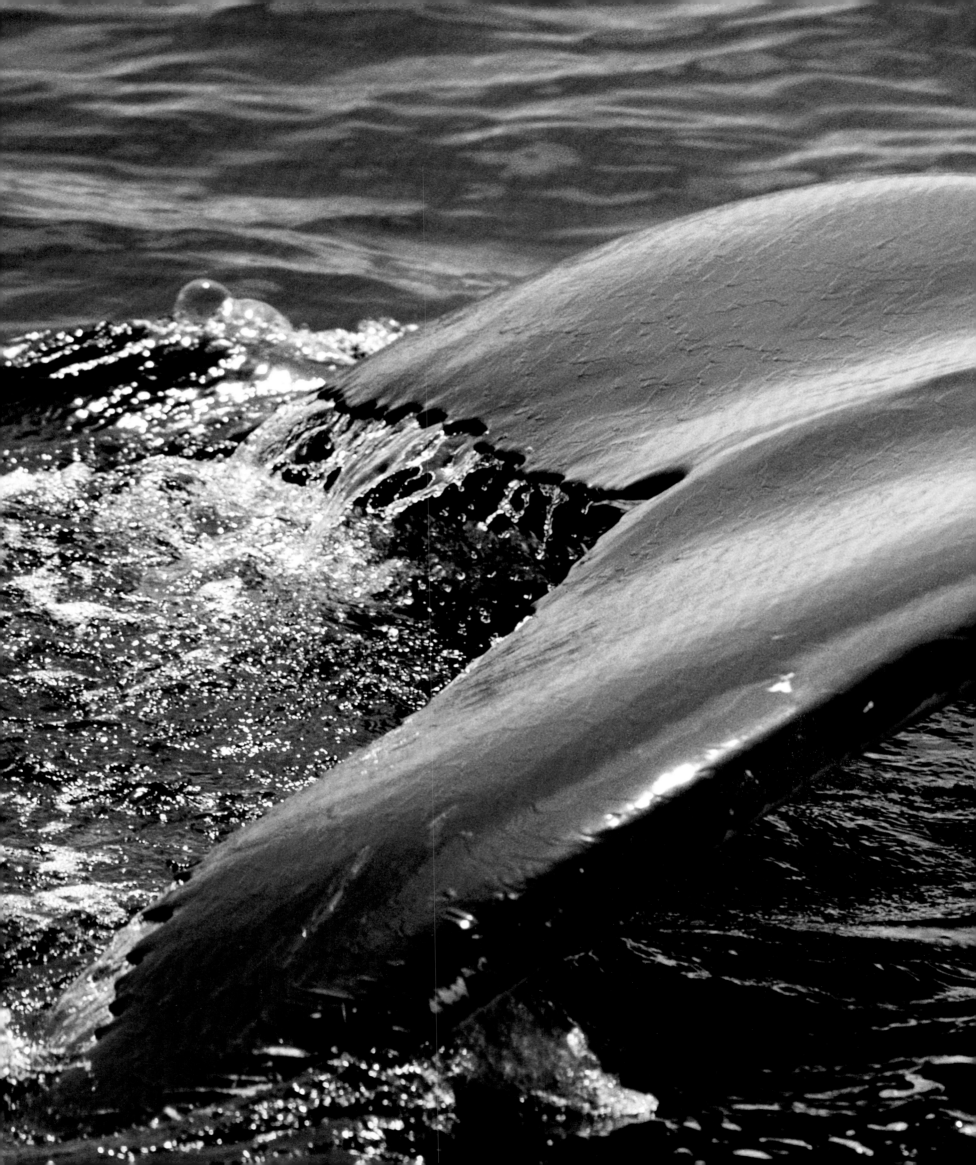

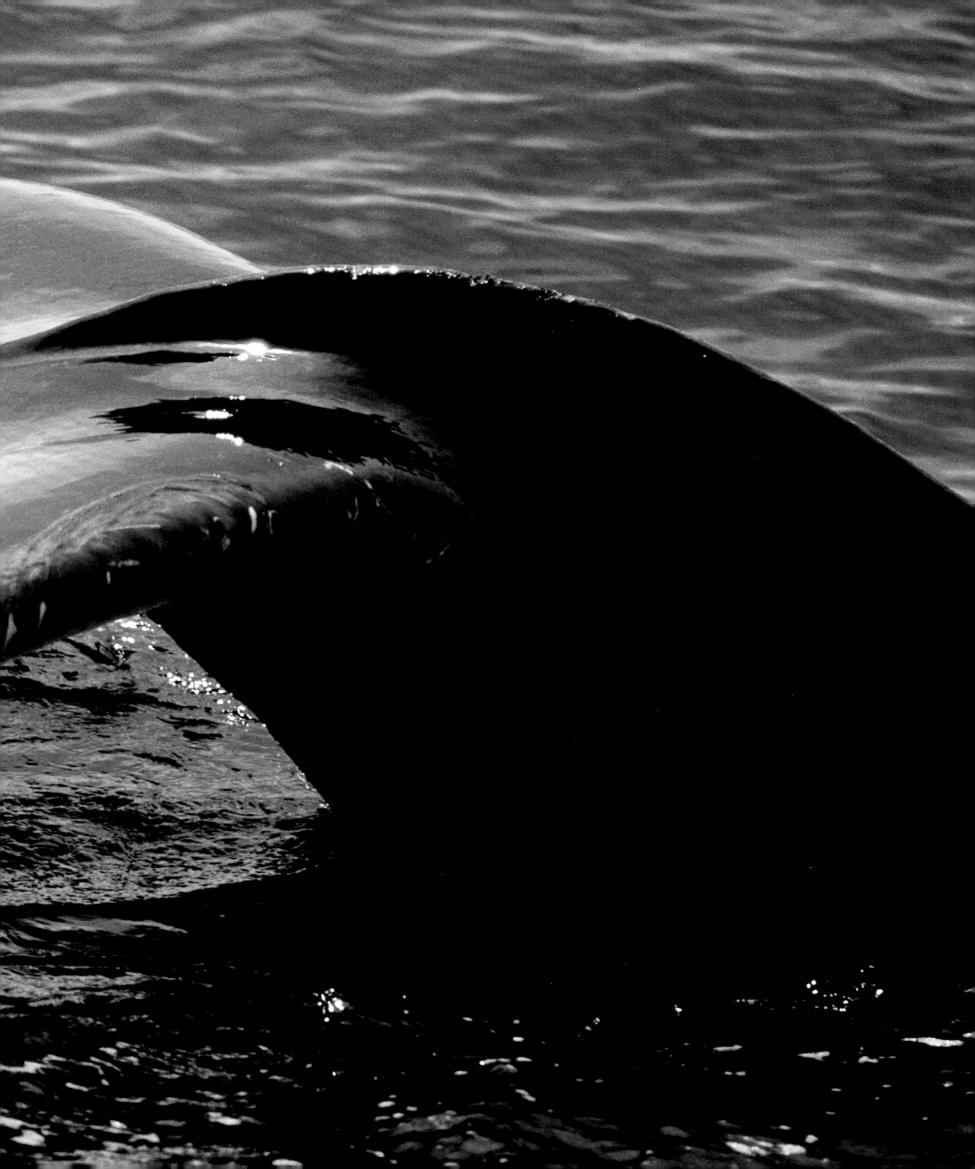

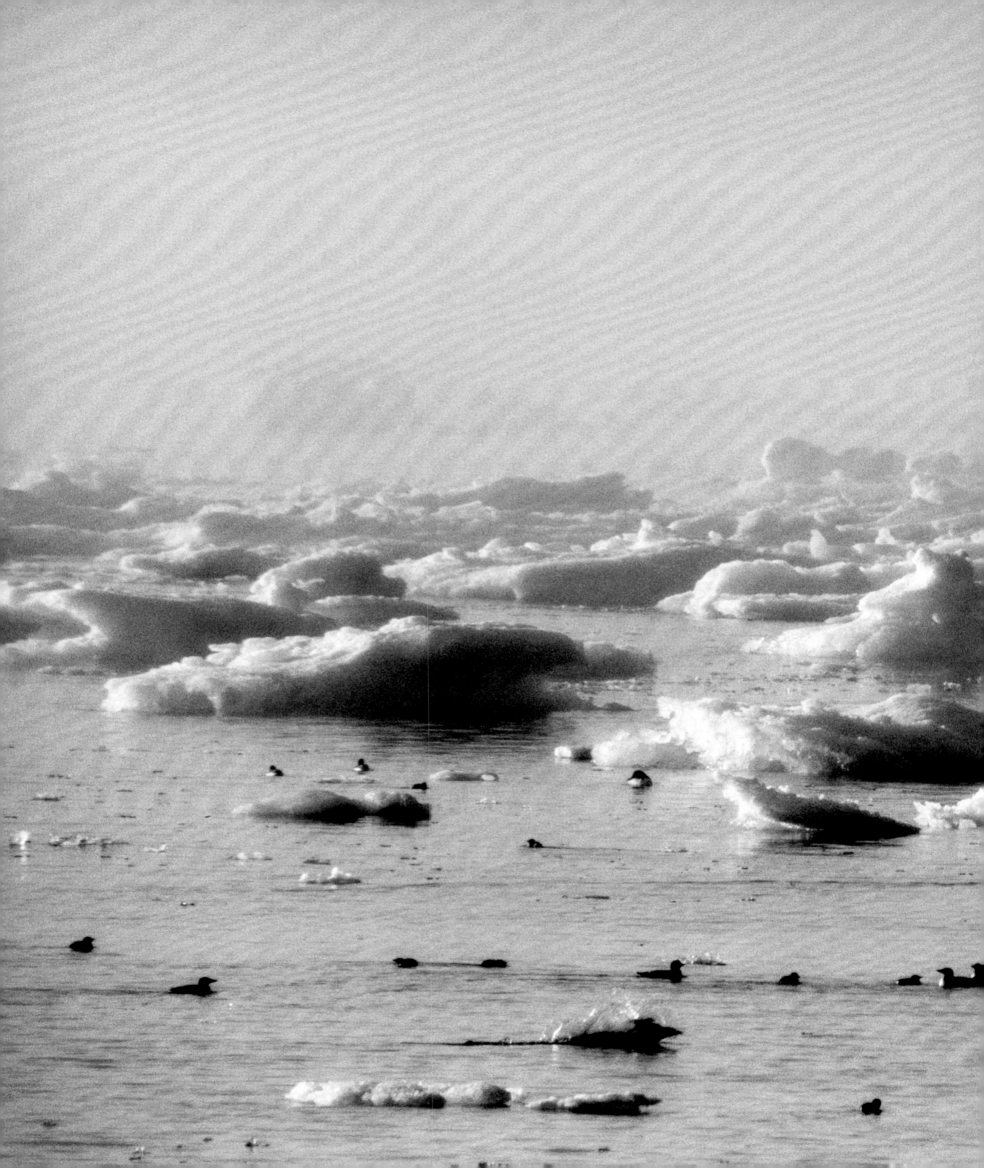

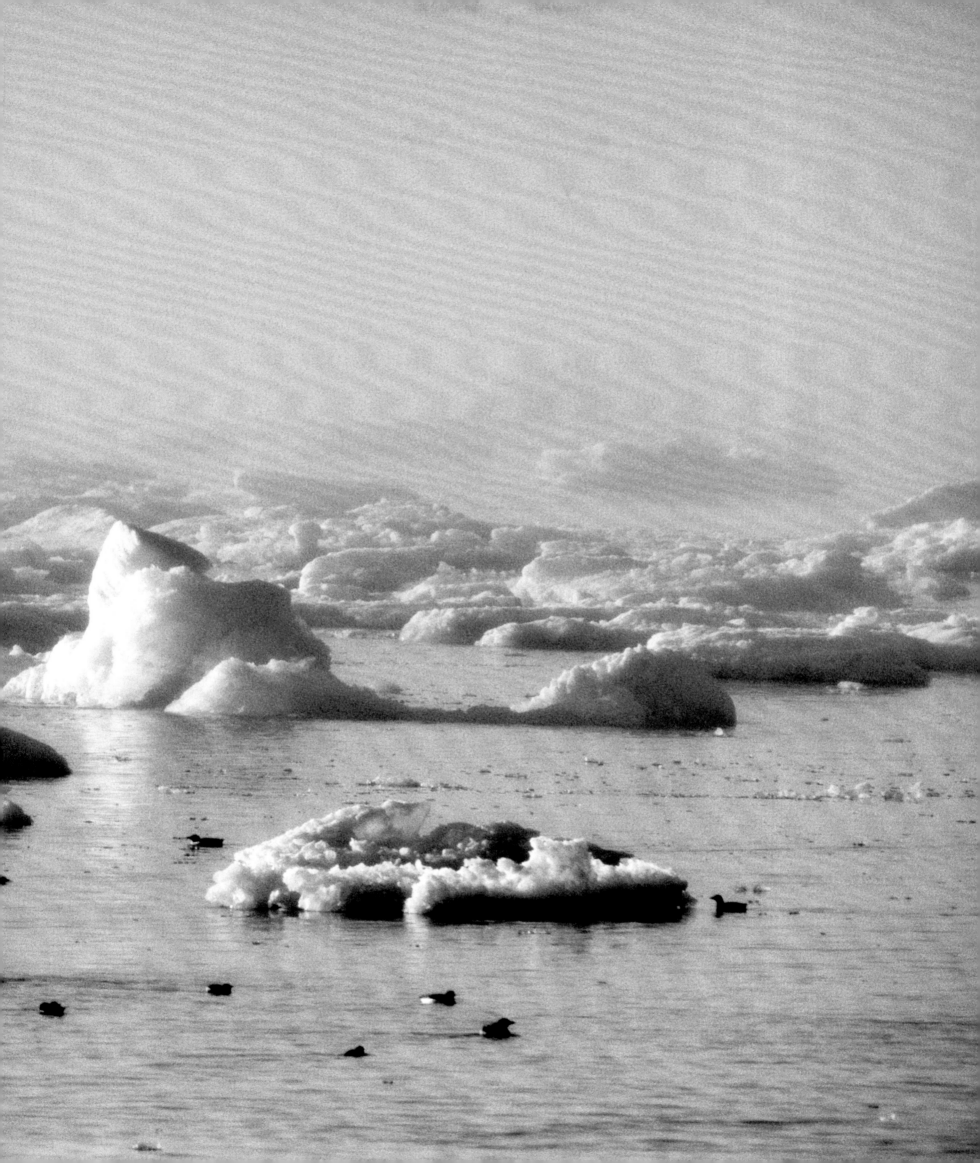

life from above

From the first days of summer, when the sea ice starts to break up and the snow-covered tundra thaws, new life appears. One season ends and another begins. The coastal plains and tundra turn green, and millions of birds—little auks, guillemots, sandpipers, ptarmigans, geese, and many other species—land on the high latitudes of the high Arctic to breed along the cliffs and land bordering the Arctic Ocean. When the birds arrive, so does summer.

Some have traveled very far—like the Arctic tern, who flies between the poles. Summer in Antarctica, then summer in the Arctic, the tern embarks on a journey of over ten thousand miles between the seasons.

The birdlife fertilizes and facilitates the sparse vegetation that is exposed in summer. This makes life possible for land-living mammals such as lemmings, reindeer, and musk oxen. Without the birds, the summer tundra of the high Arctic would be a desert of stone, a wasteland devoid of life.

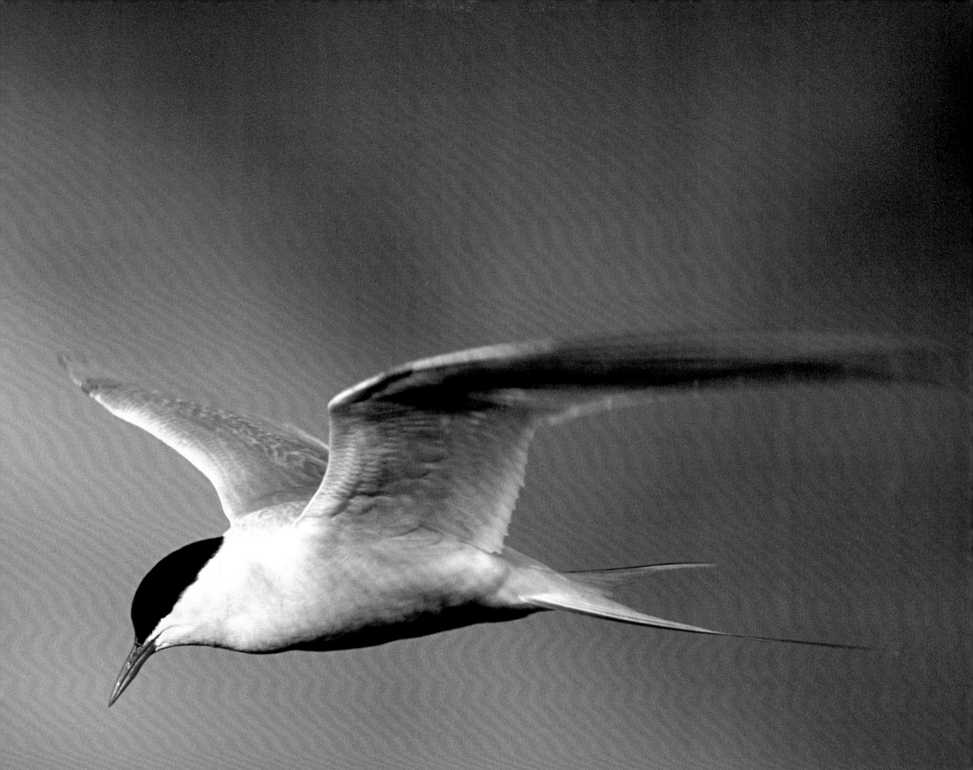

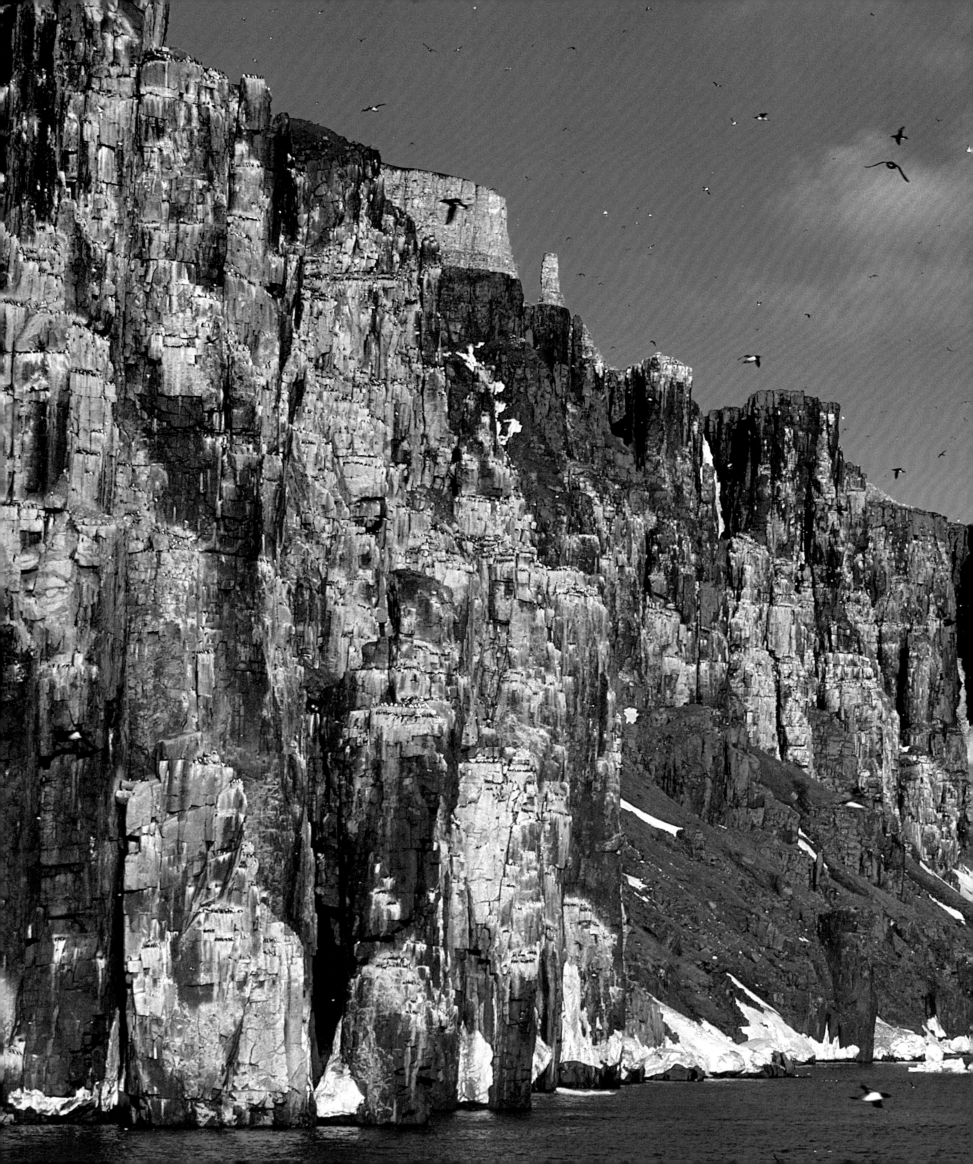

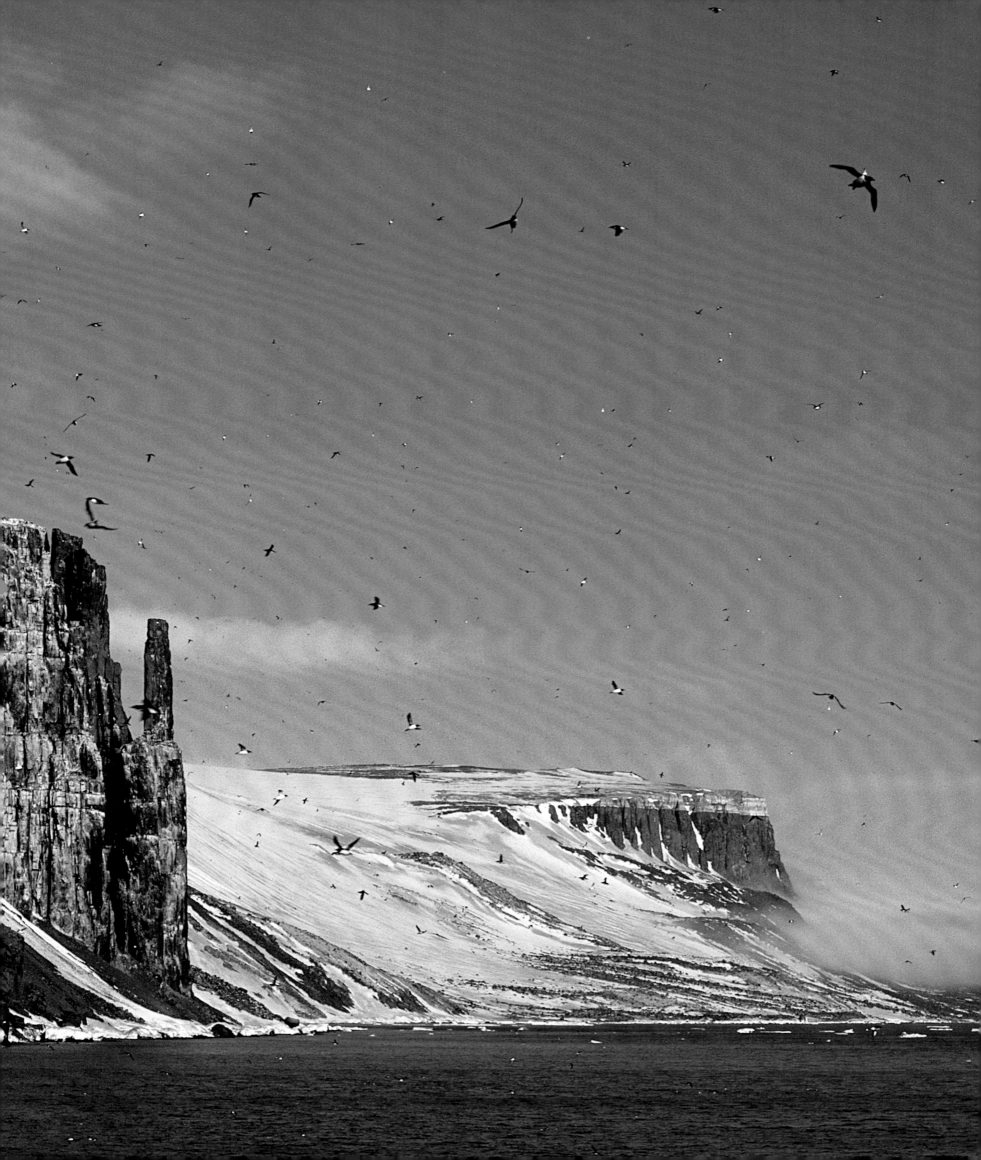

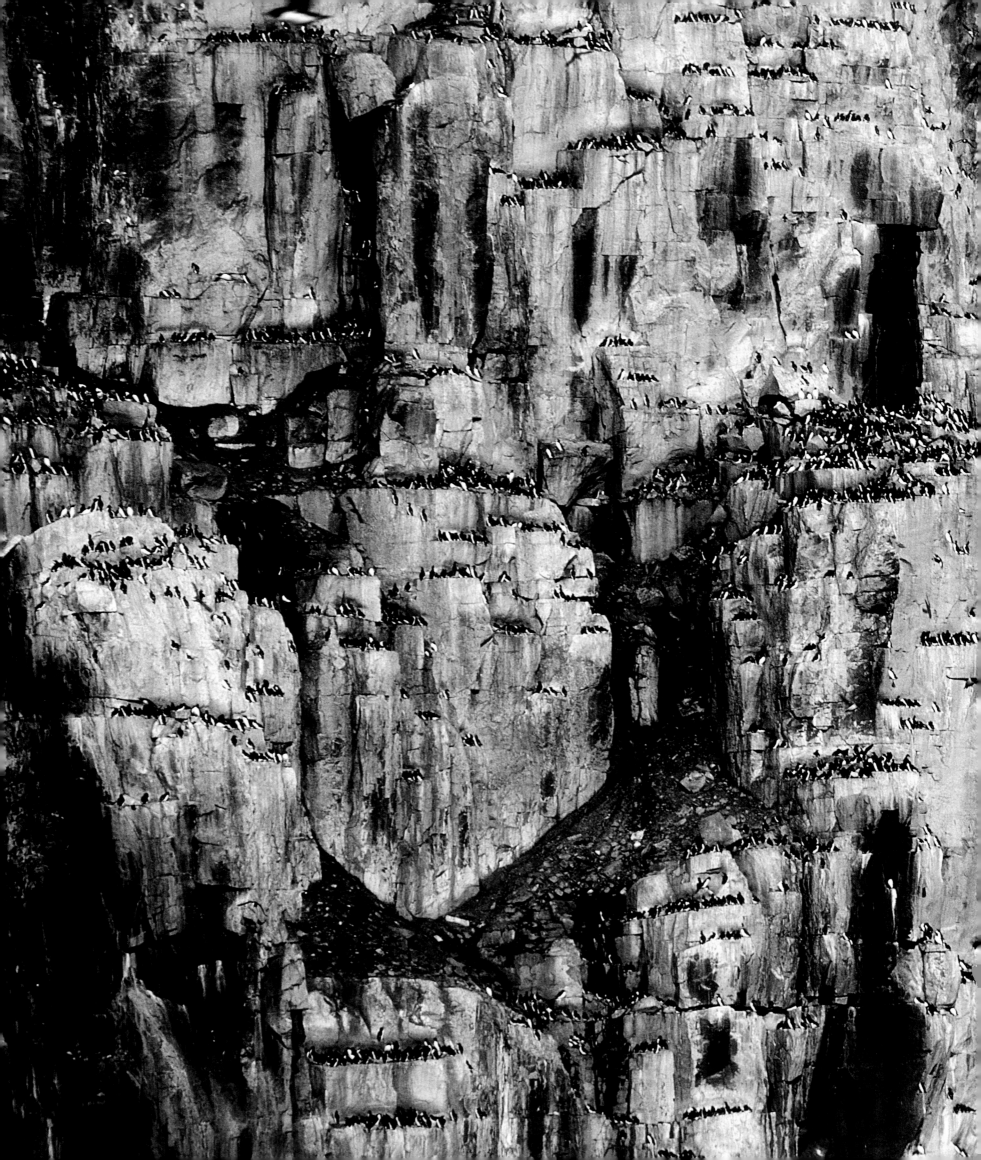

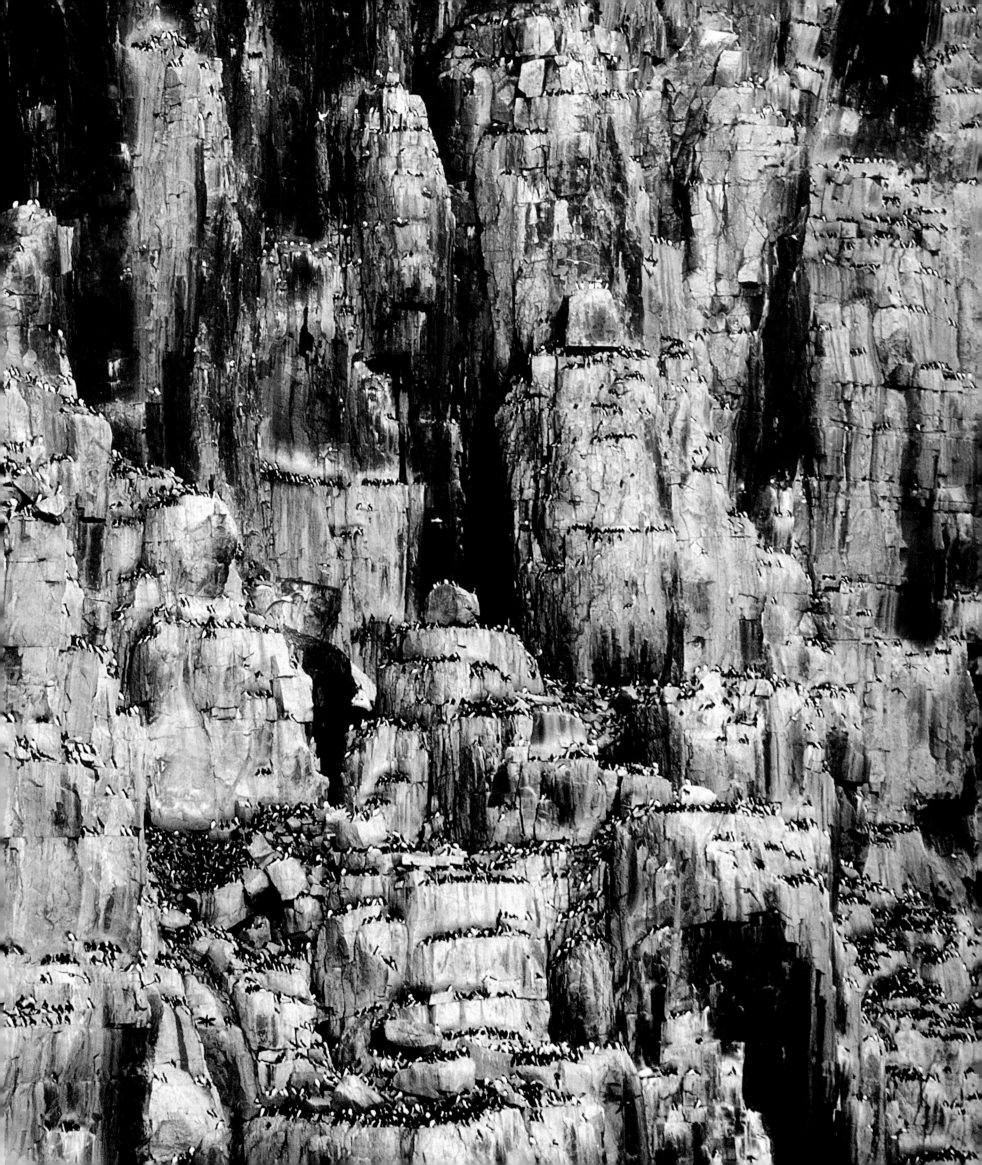

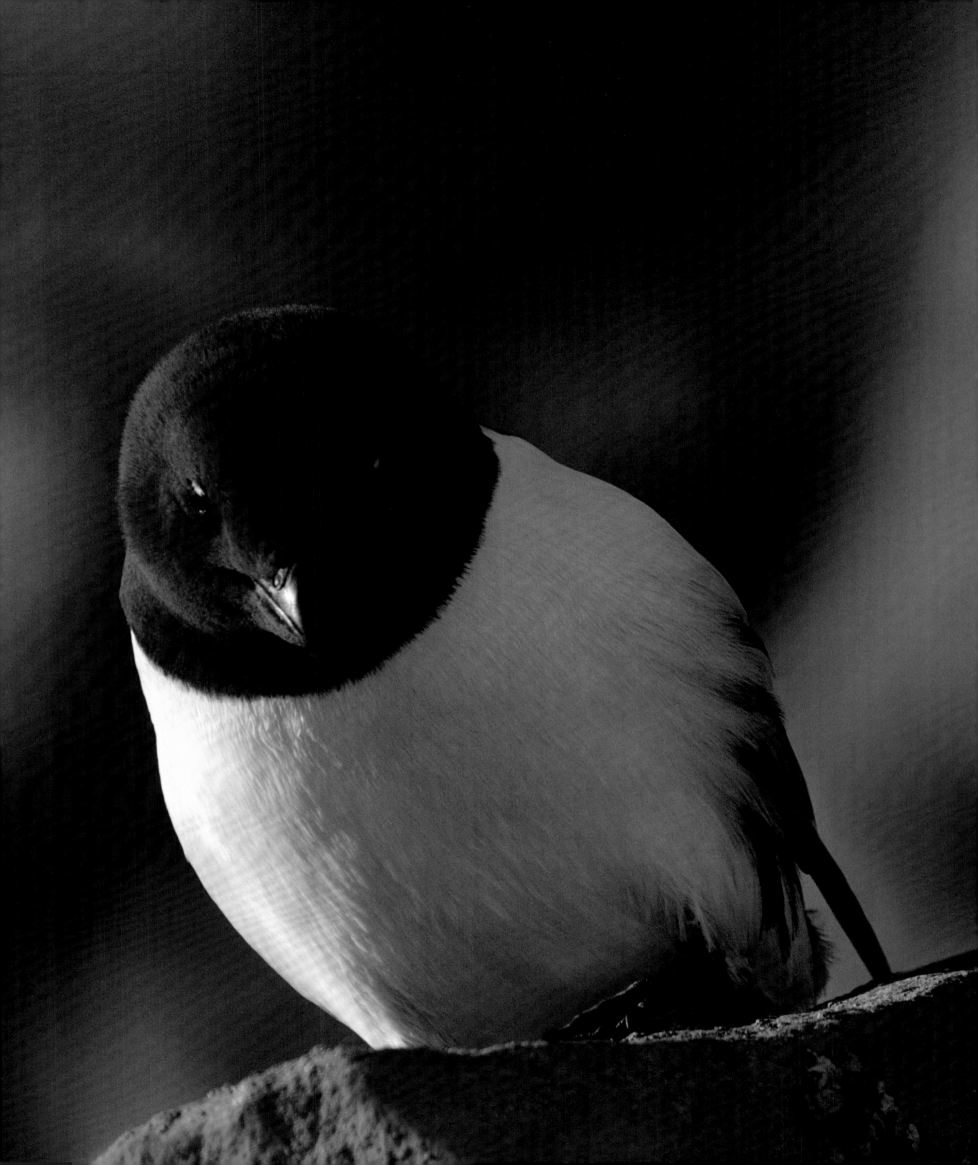

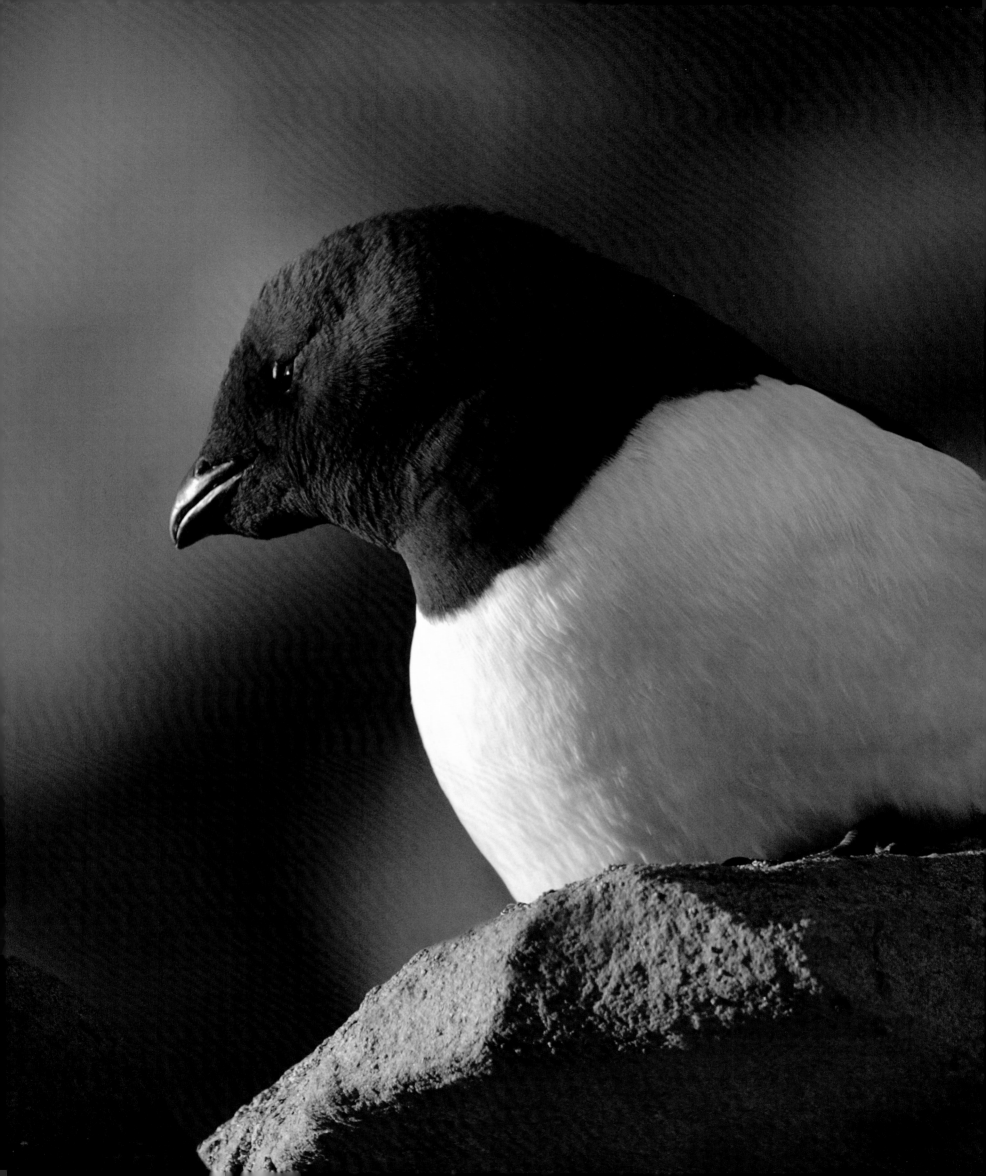

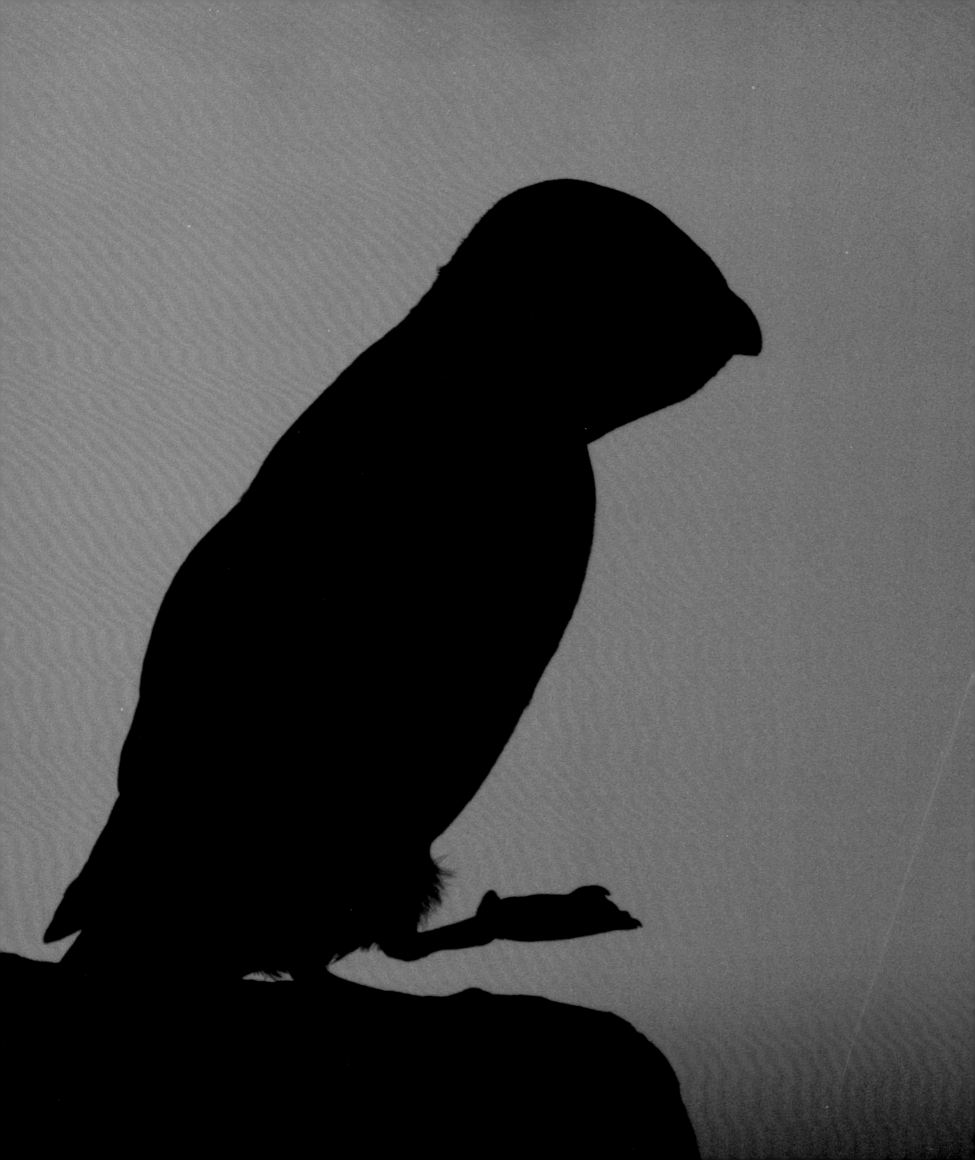

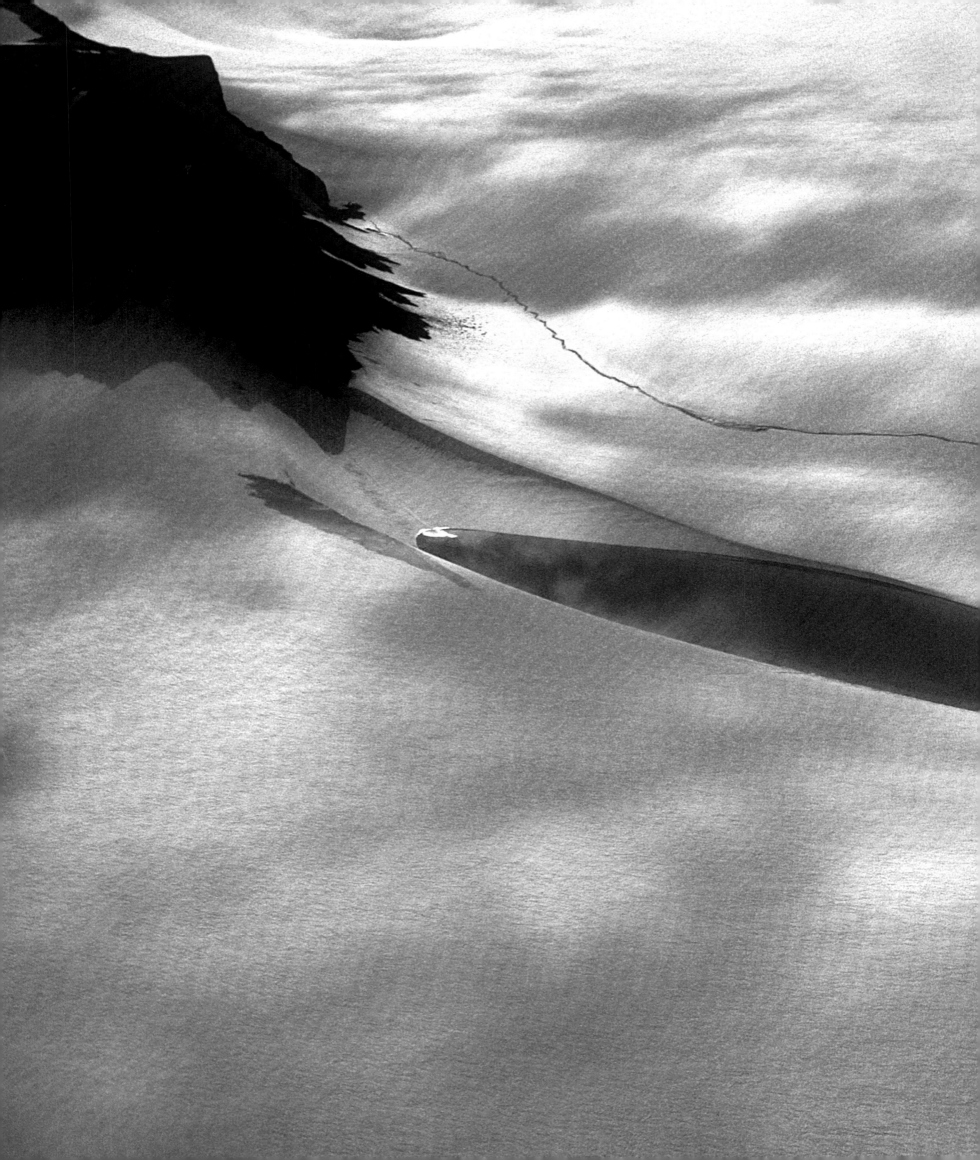

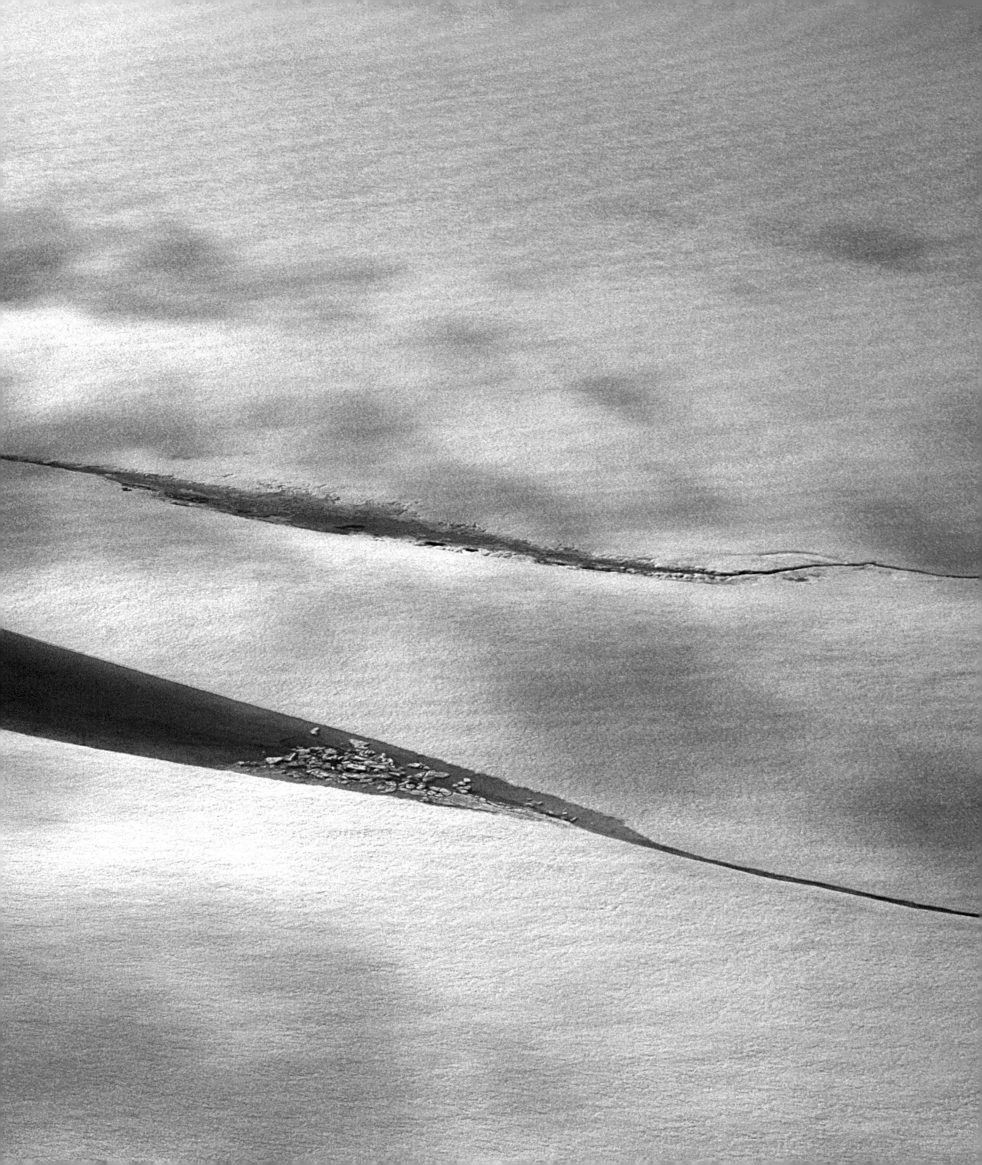

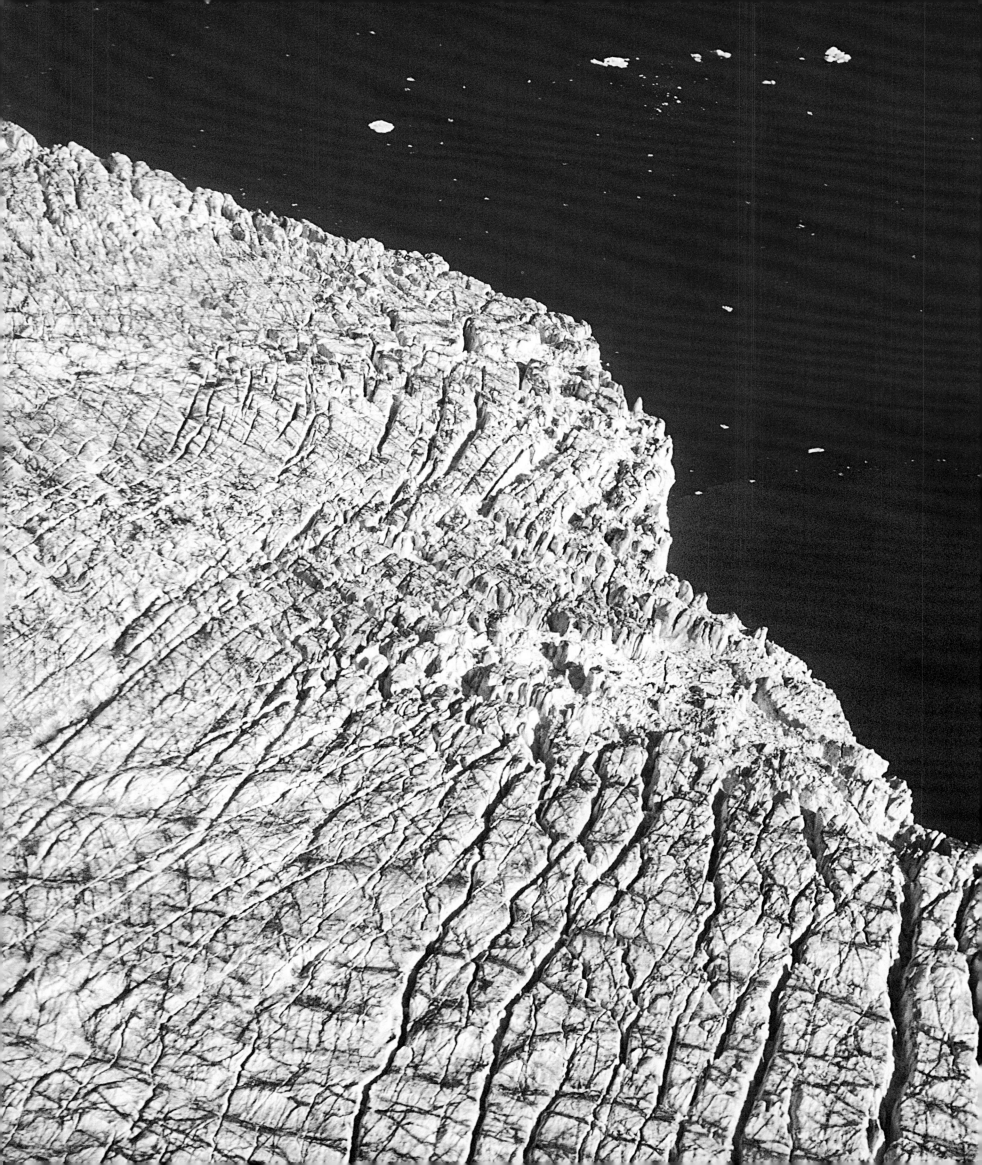

ice alive

Like a river of ice, the glacier runs from the mountains, through wide valleys, down into the sea. The massive, rugged front of the glacier is calving; huge blocks of ice hit the water below. Streams of meltwater run through the glacier, and water pours from portals at its front.

It is midnight, but full daylight. On the ice floes of the open fjord in front of the glacier, birds and seals are at rest. A white-beaked dolphin leaps out of the water, playing and feeding. A polar bear swims toward a seal resting on an ice floe; the seal seems unaware of the danger closing in. As it nears its quarry, the bear dives to hide itself. A few feet from the seal, it leaps out of the water, striking its target with its paw, but the seal quickly jumps off the floe, just in time to rescue itself.

Temperatures have risen above freezing. The landmasses of ice, the glaciers, come alive; constantly moving back and forth, they are sculpting the land beneath. Like architects of earth, some glaciers flow several miles per year, with more snow and ice being added at their source, and ice dropping off their front.

Throughout history, ice has sculpted roughly one-third of the earth's landmass this way. Coastal glaciers, which reach into the sea, break up in front during summer, filling the fjords and sea with icebergs and floes.

Like a living being, the glaciers give and receive. During winter they gain mass through the snow that falls on them, and during summer they lose mass through melting and calving of ice blocks at their fronts. It is a balancing act resulting in growth or retreat.

Three-quarters of the earth's freshwater is in the form of ice. Glaciers, snow, and sea ice work as our planet's own air conditioner; they reflect the sun's rays back into space. As our climate becomes warmer and the ice melts, more solar energy is instead absorbed by open water and land areas, and this energy is transformed into heat, which further warms the planet and leads to ever more melting of snow and ice.

Most glaciers have been retreating since the middle of the nineteenth century. However, during the last two decades global warming has greatly accelerated their retreat. As this trend continues, the future of cold is becoming uncertain.

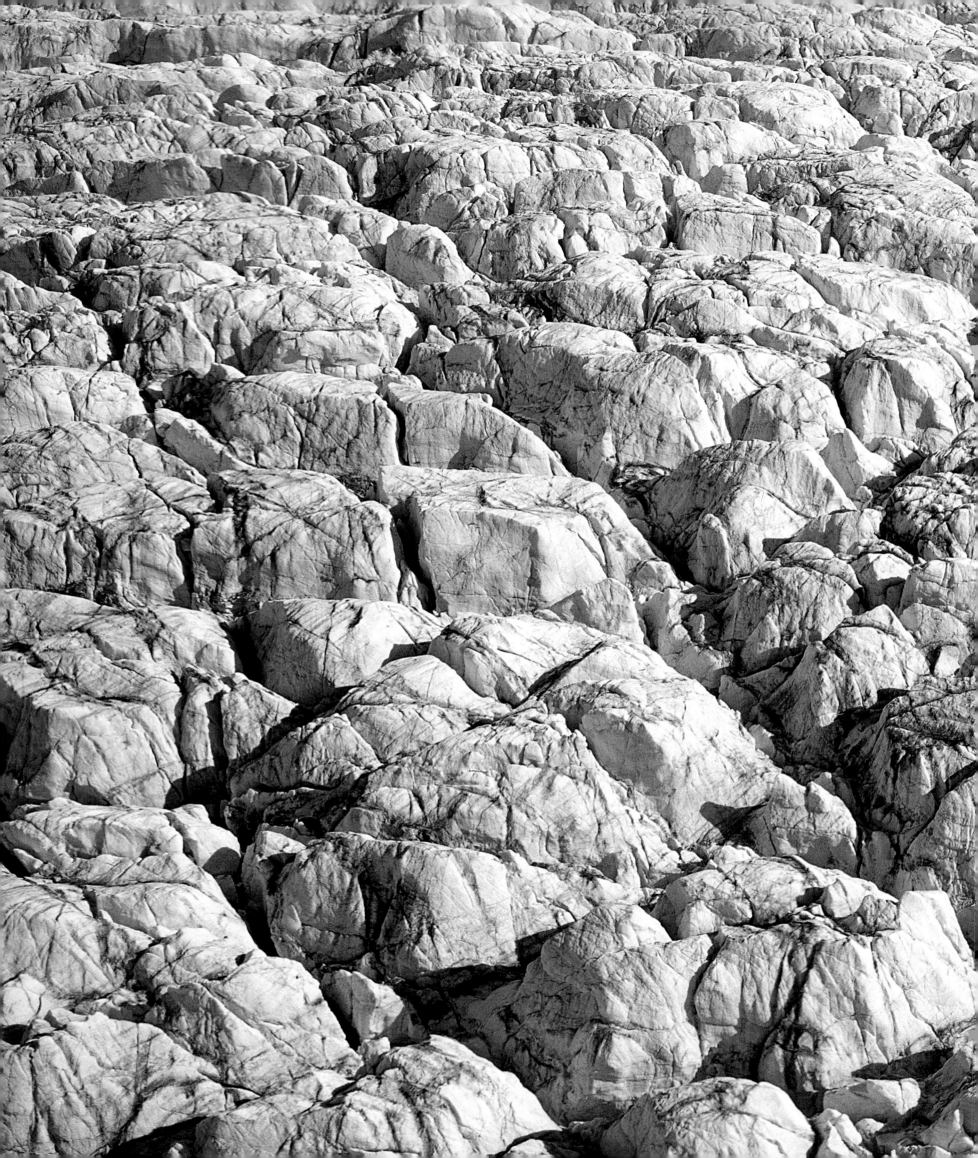

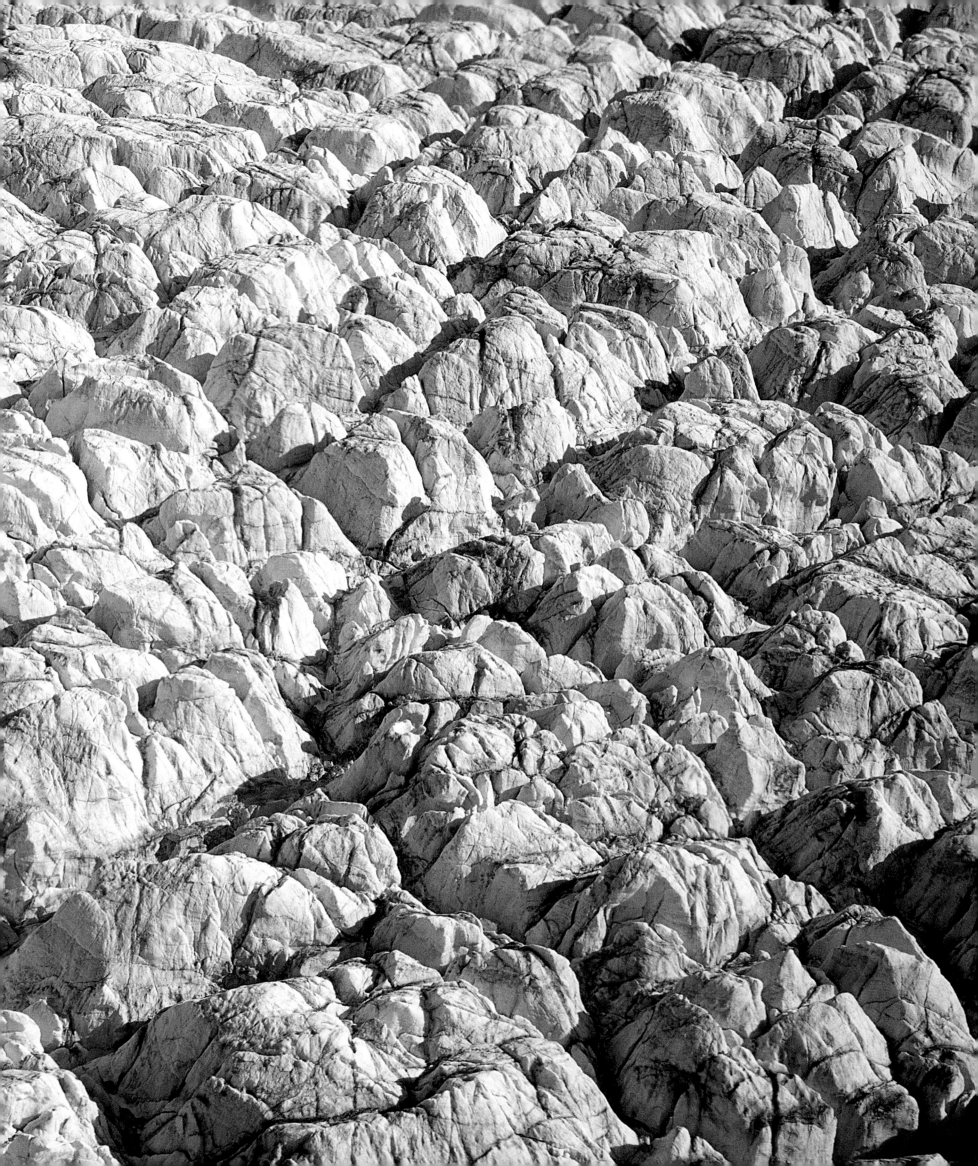

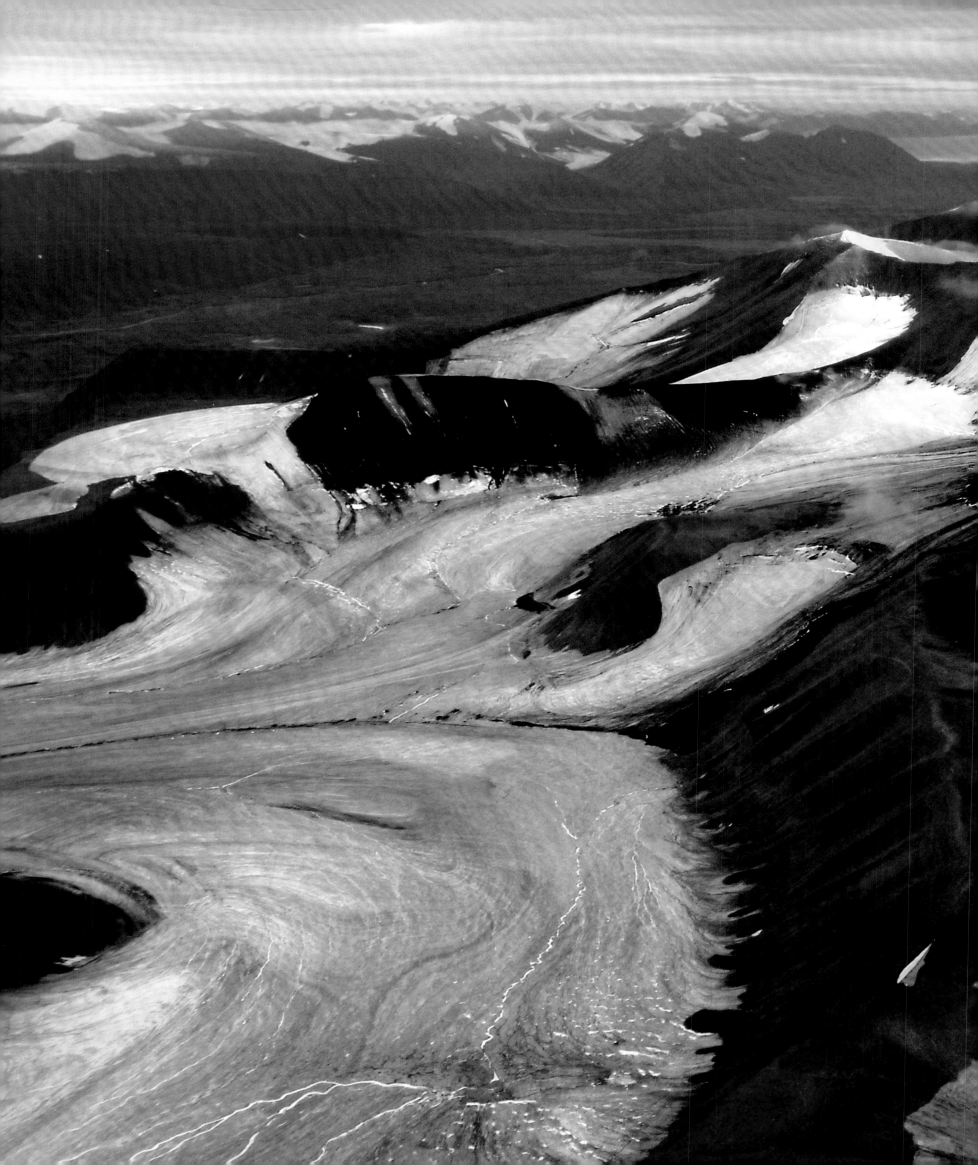

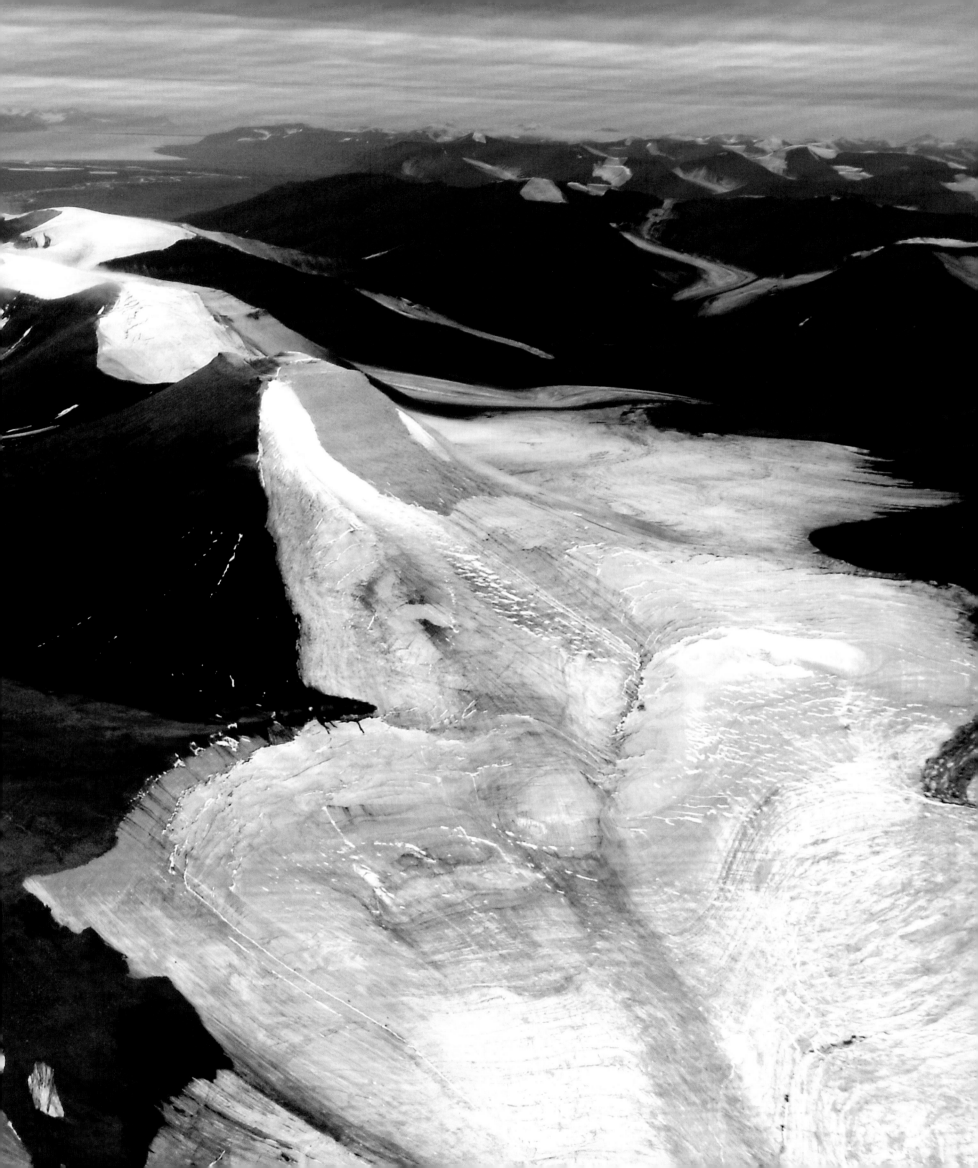

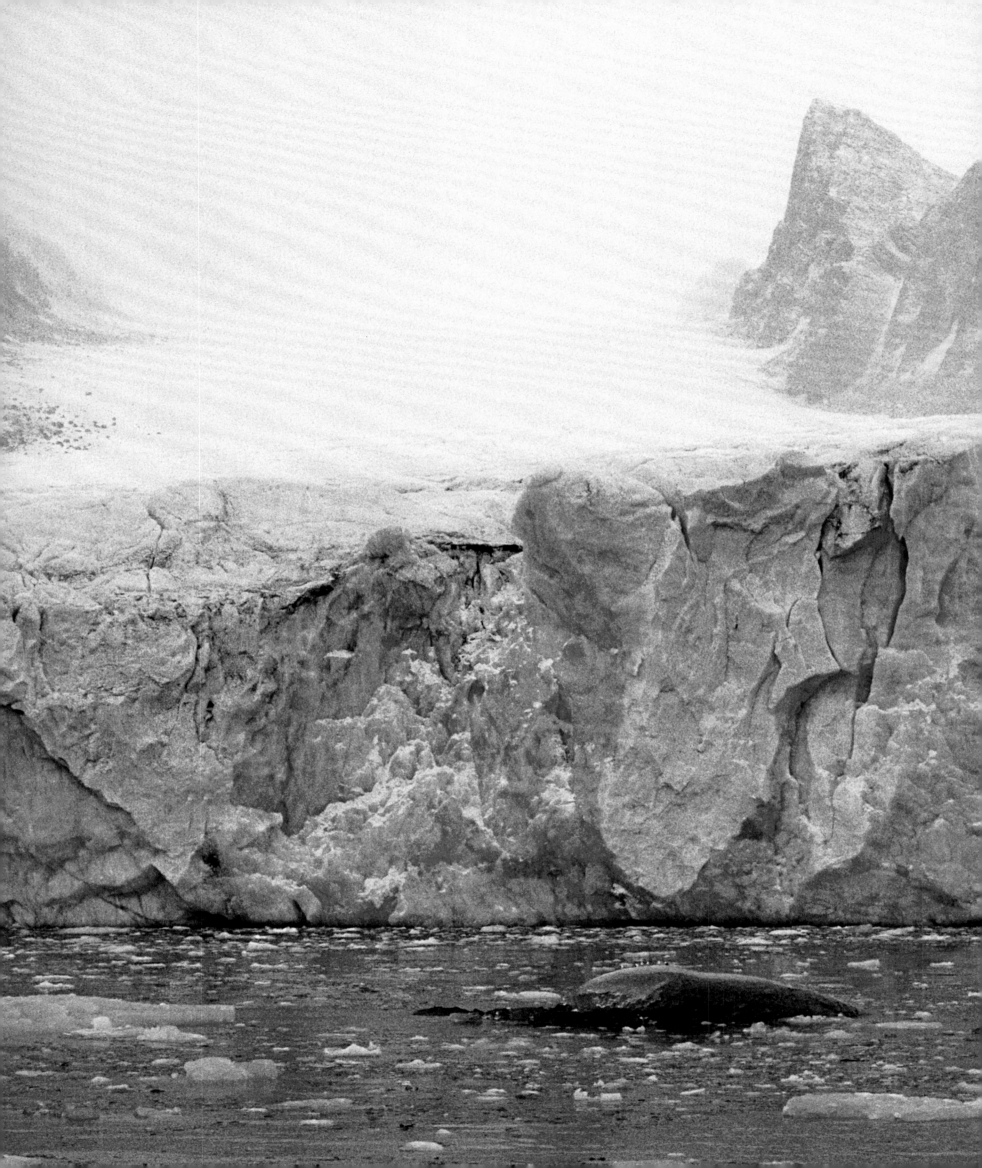

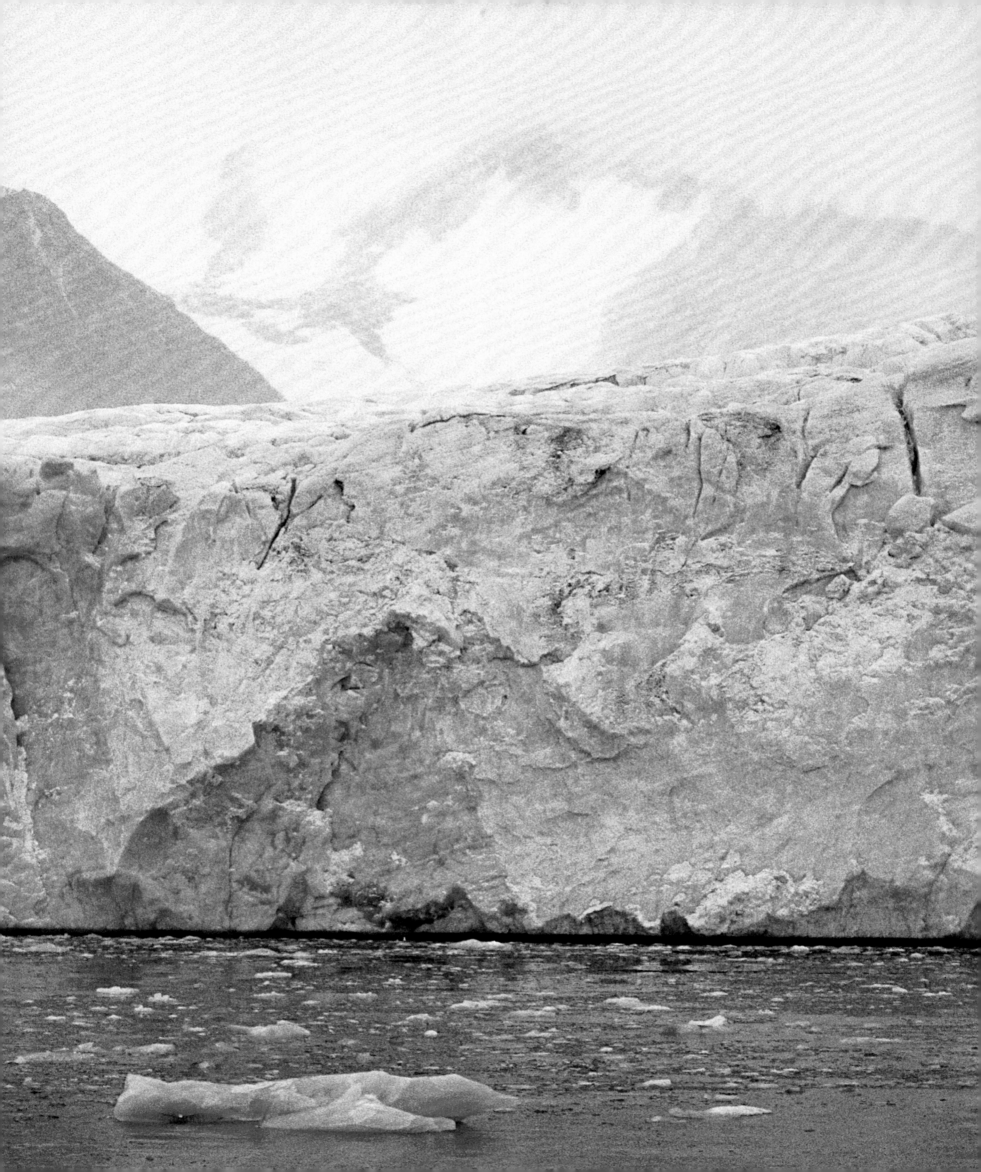

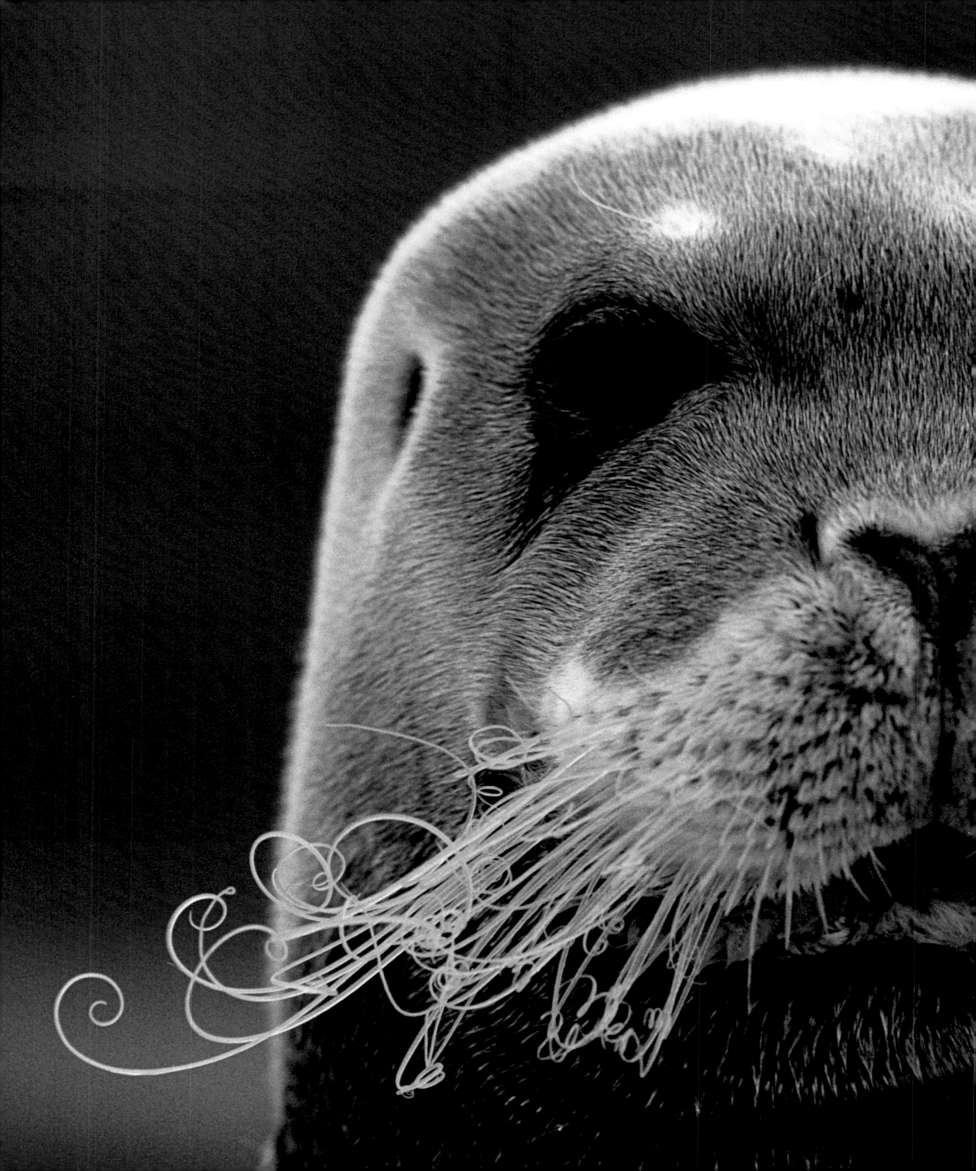

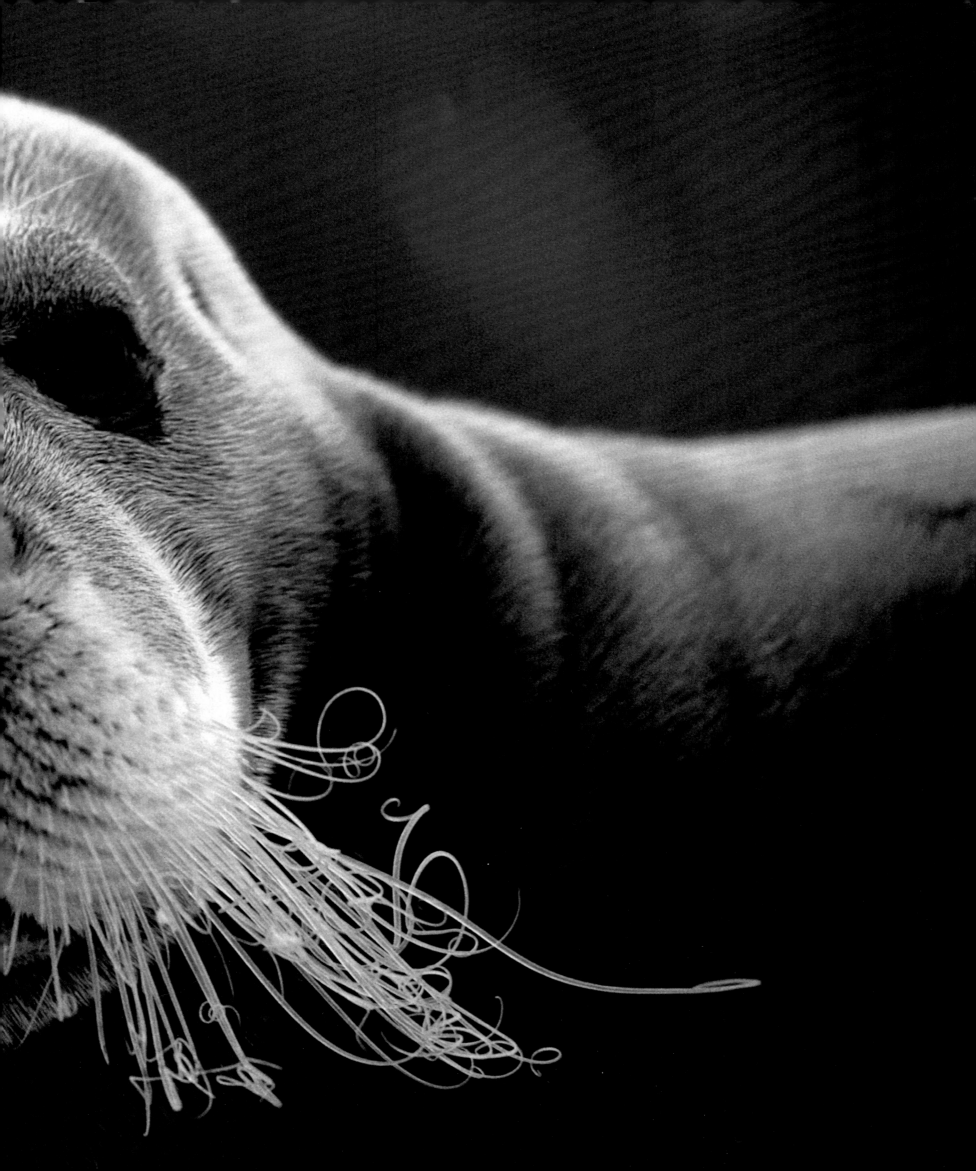

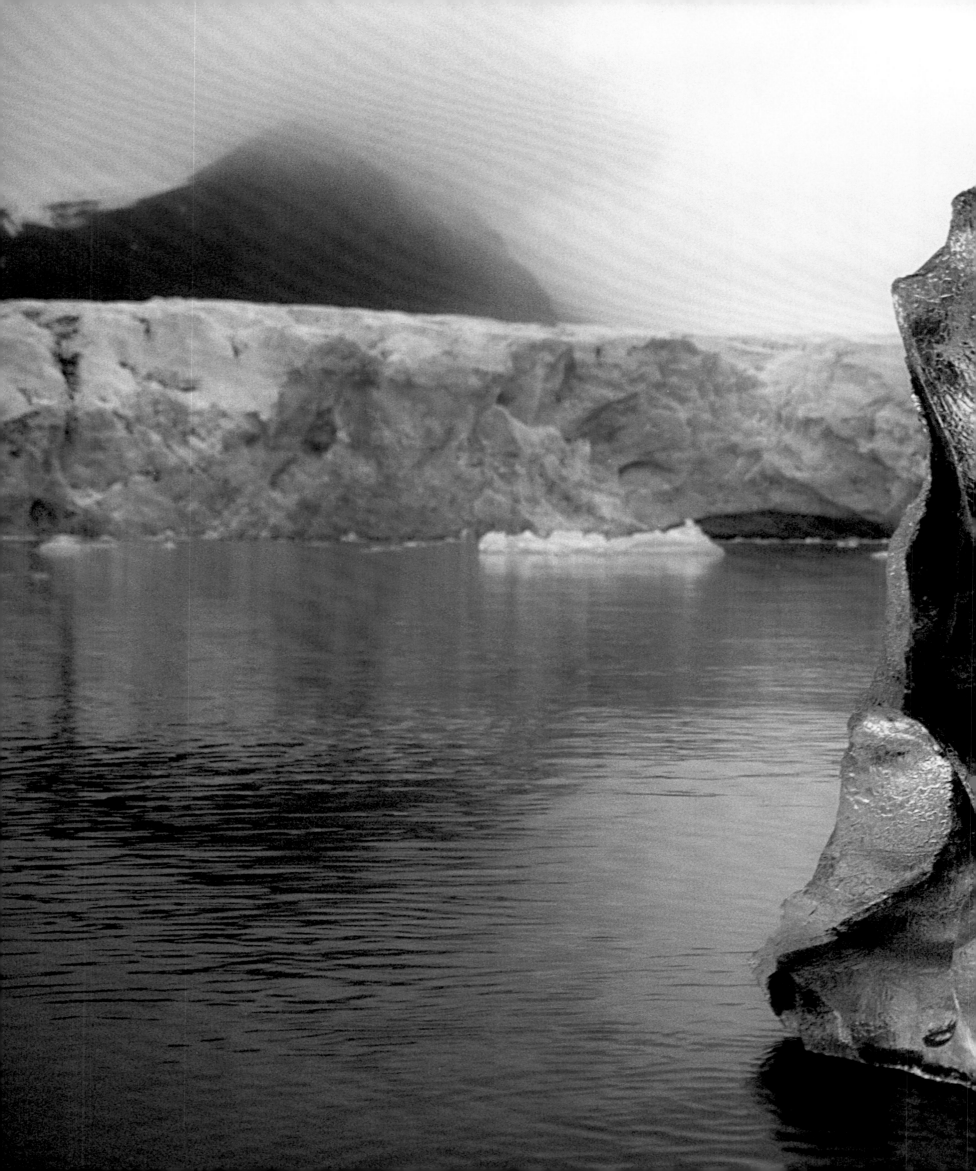

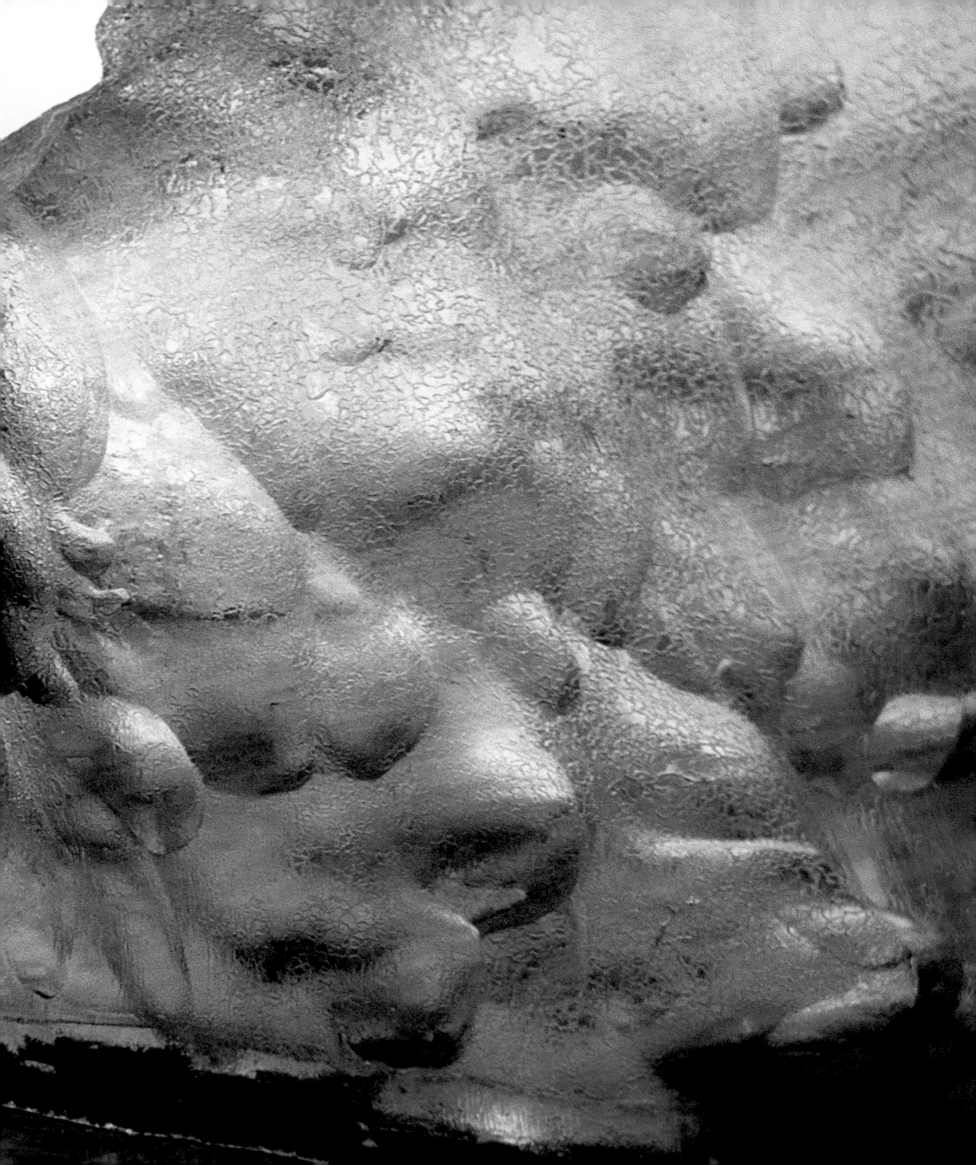

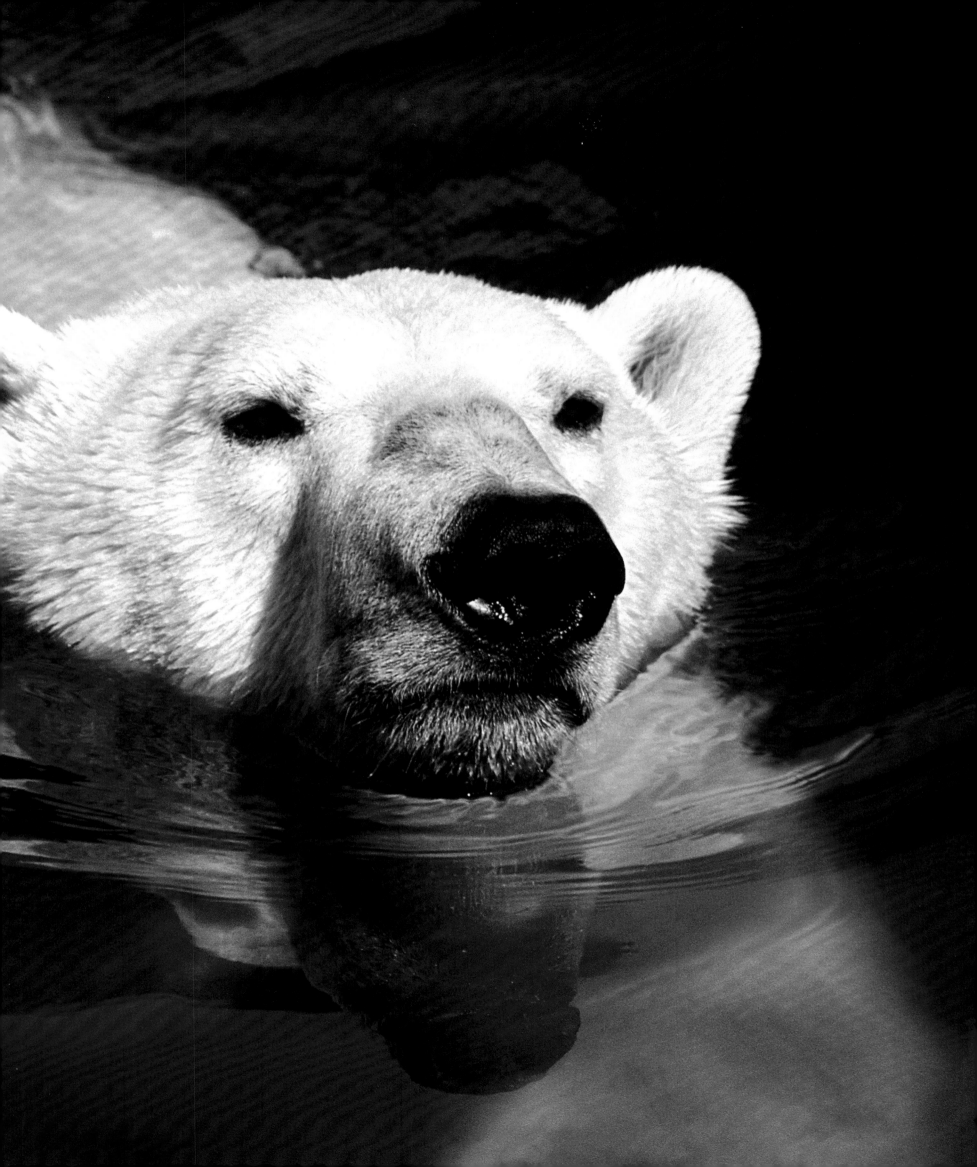

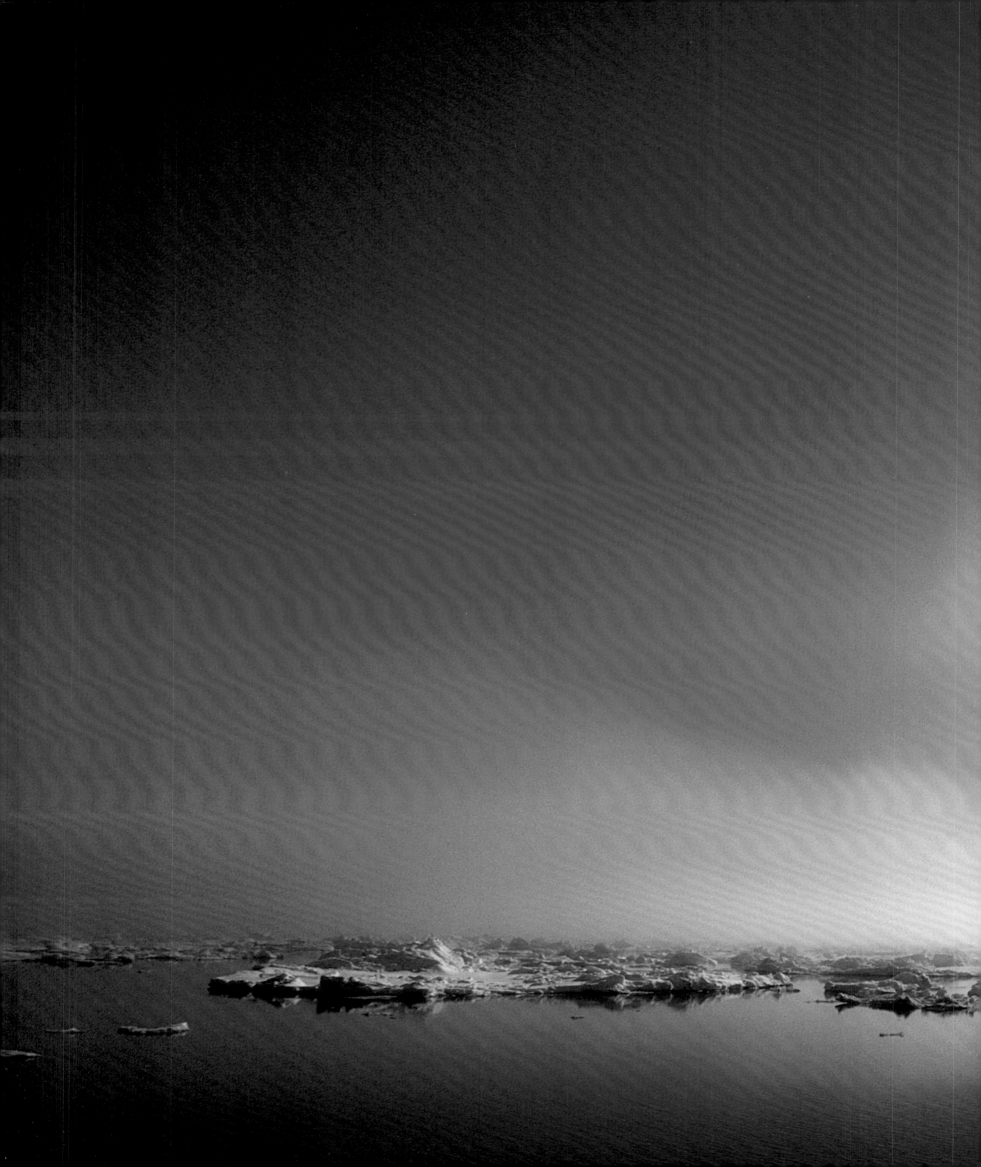

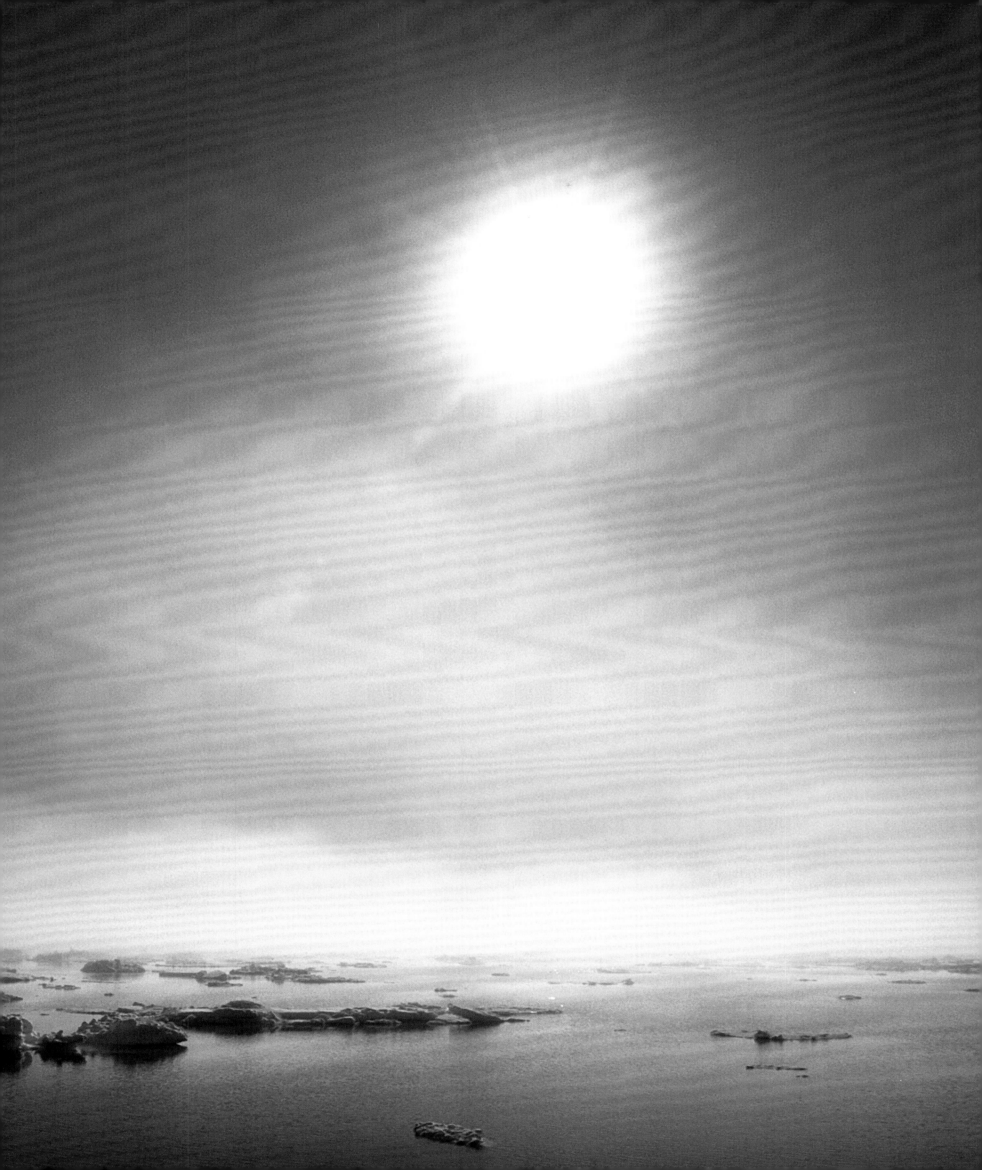

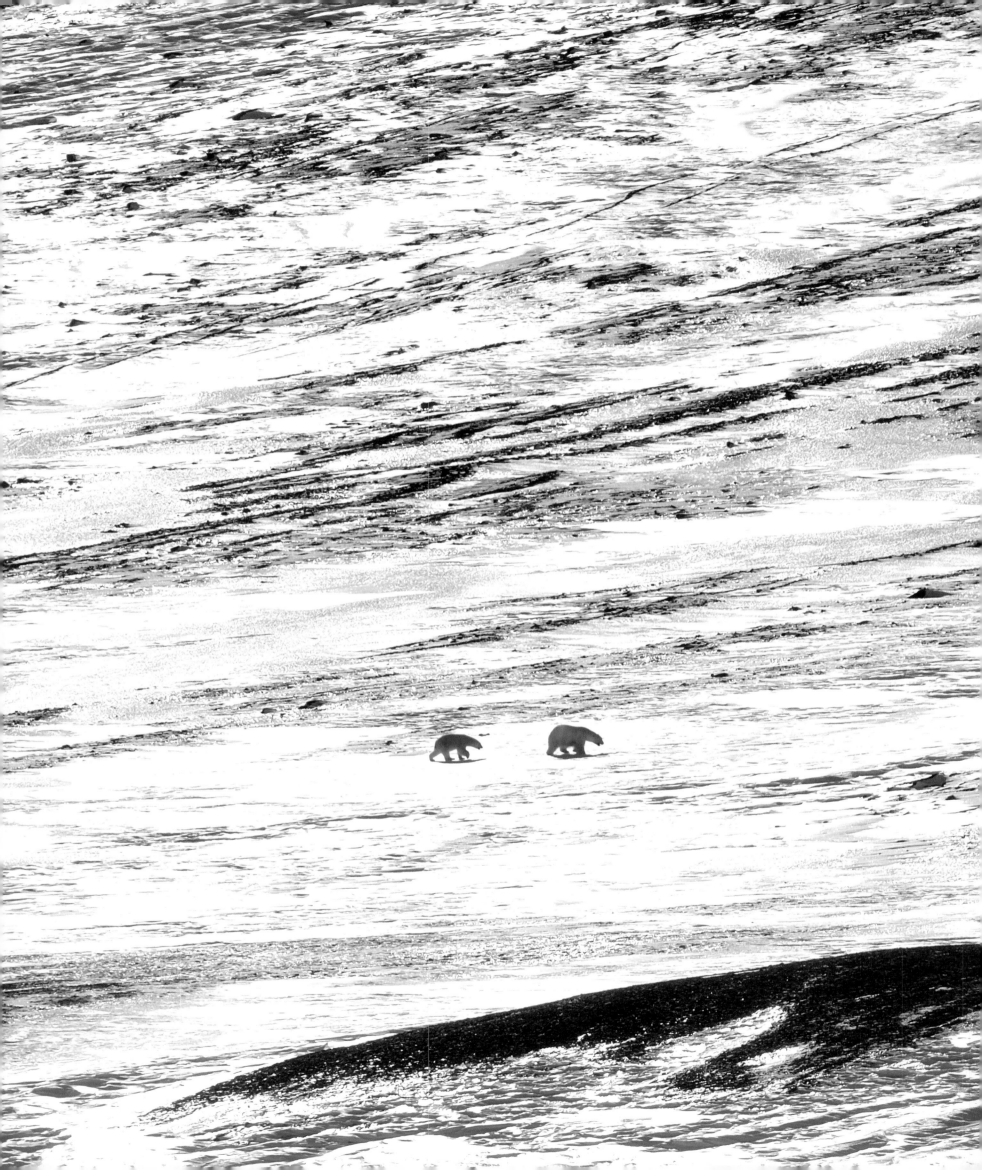

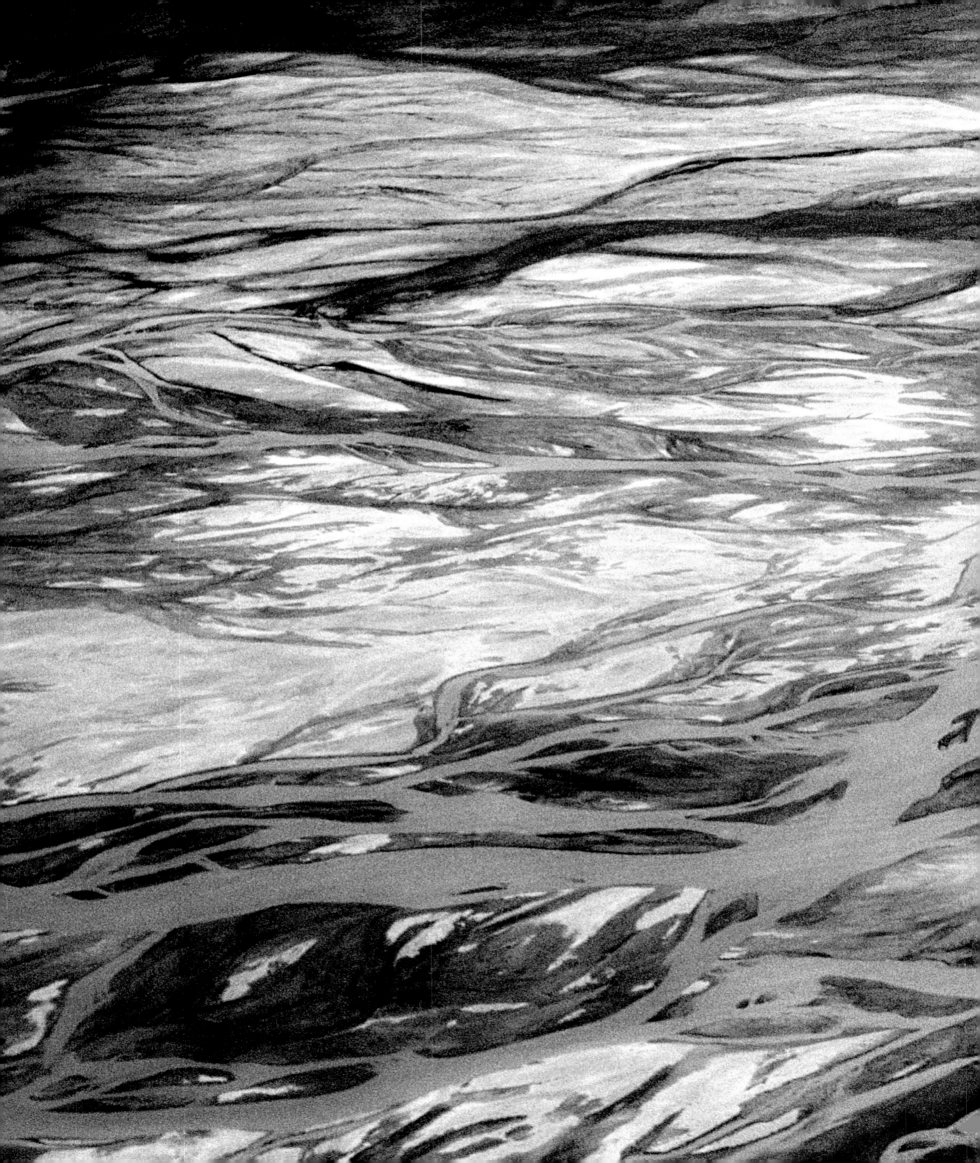

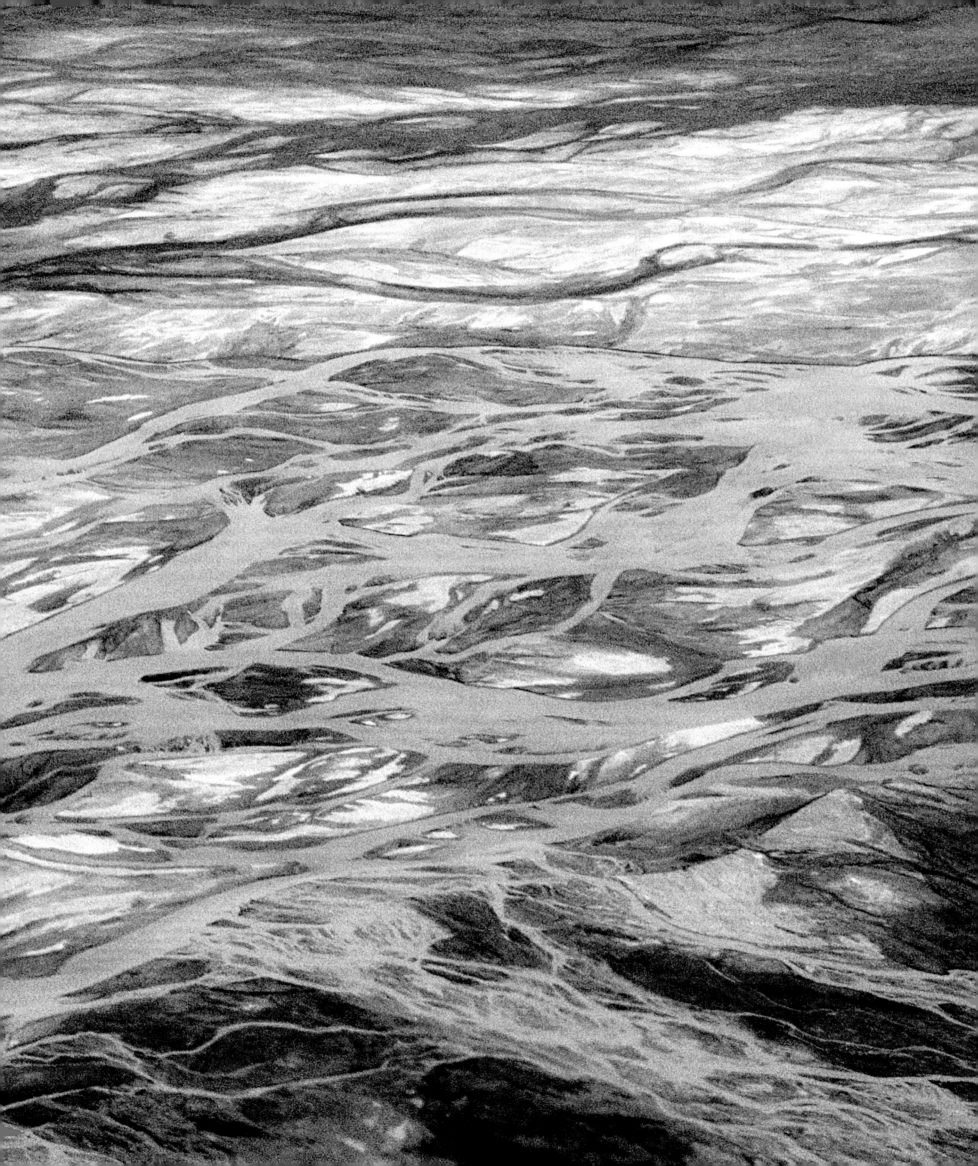

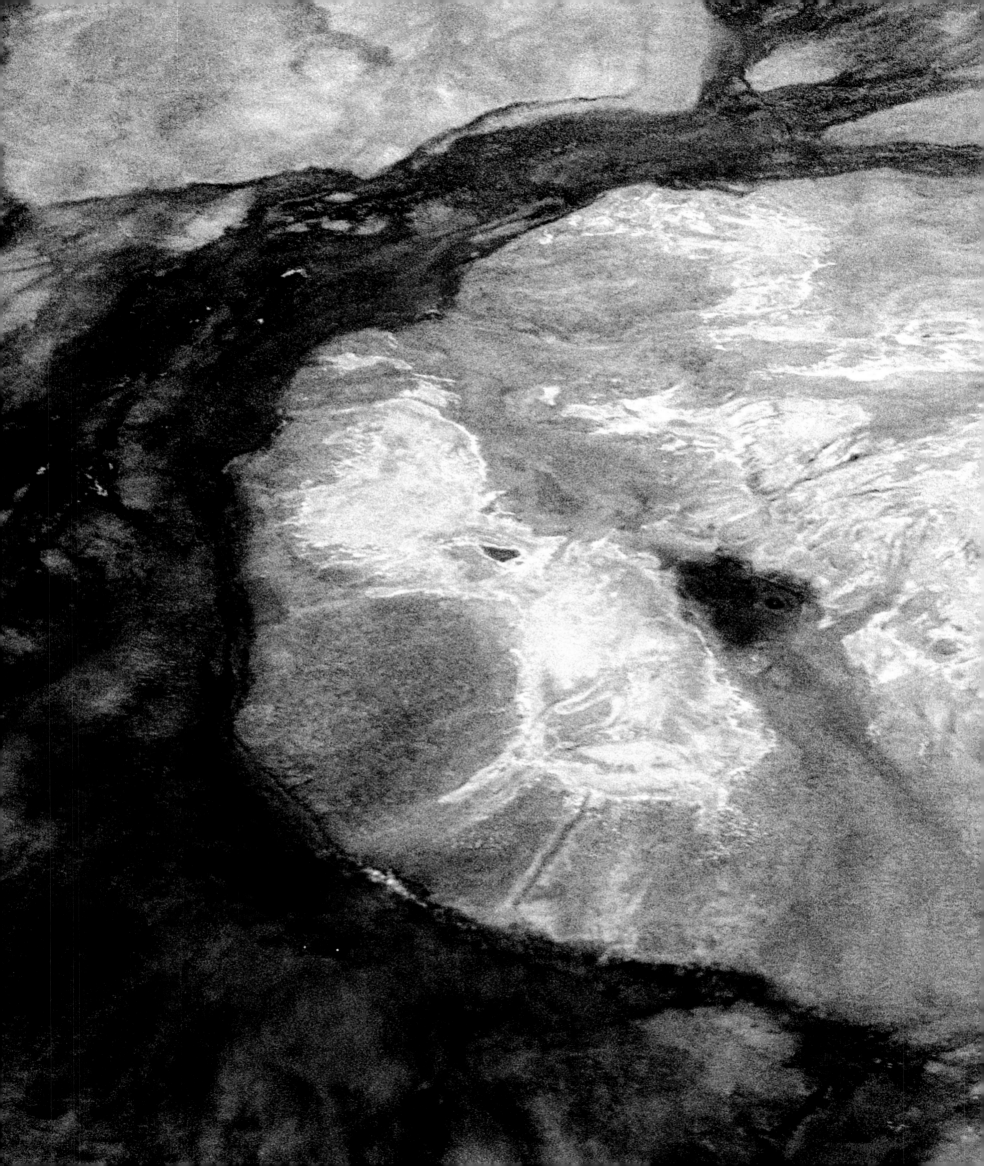

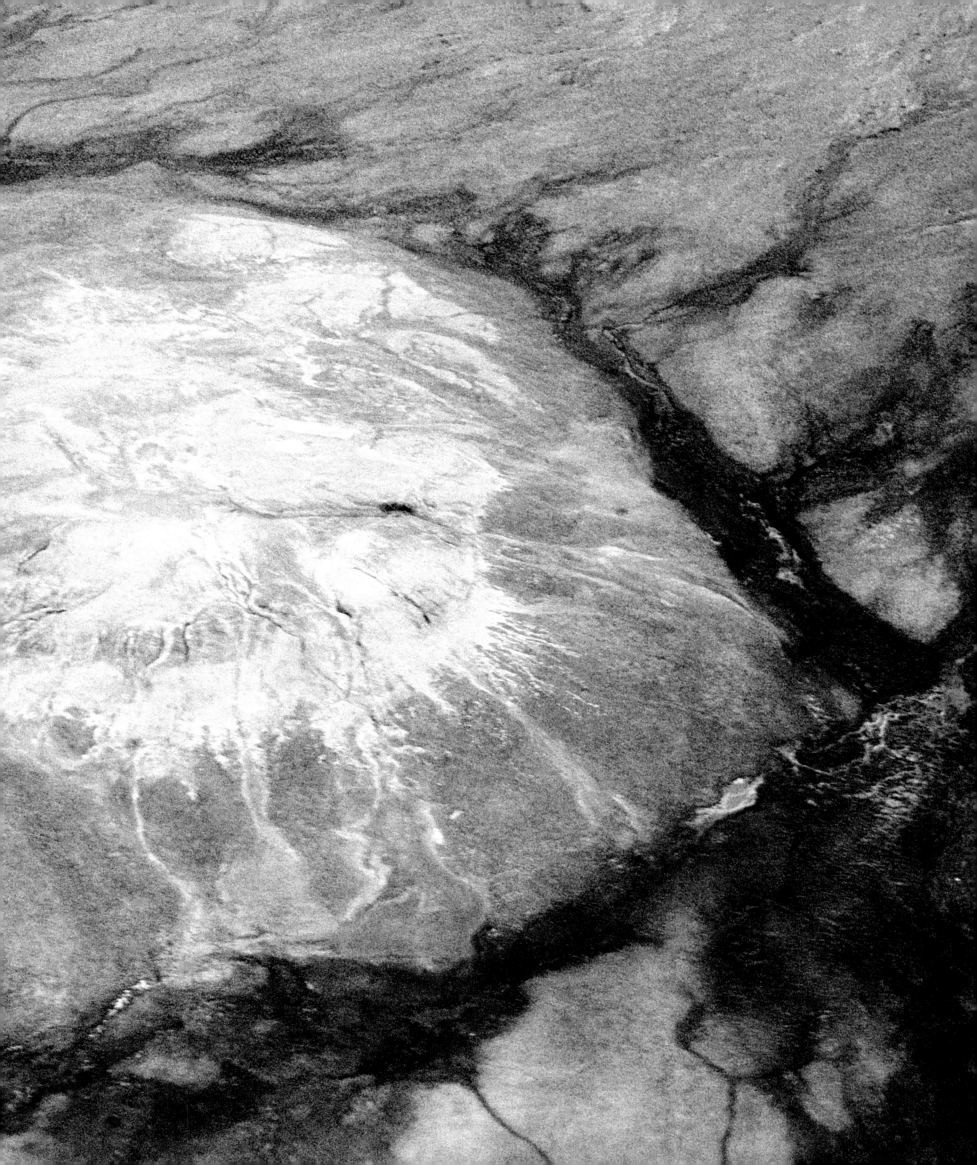

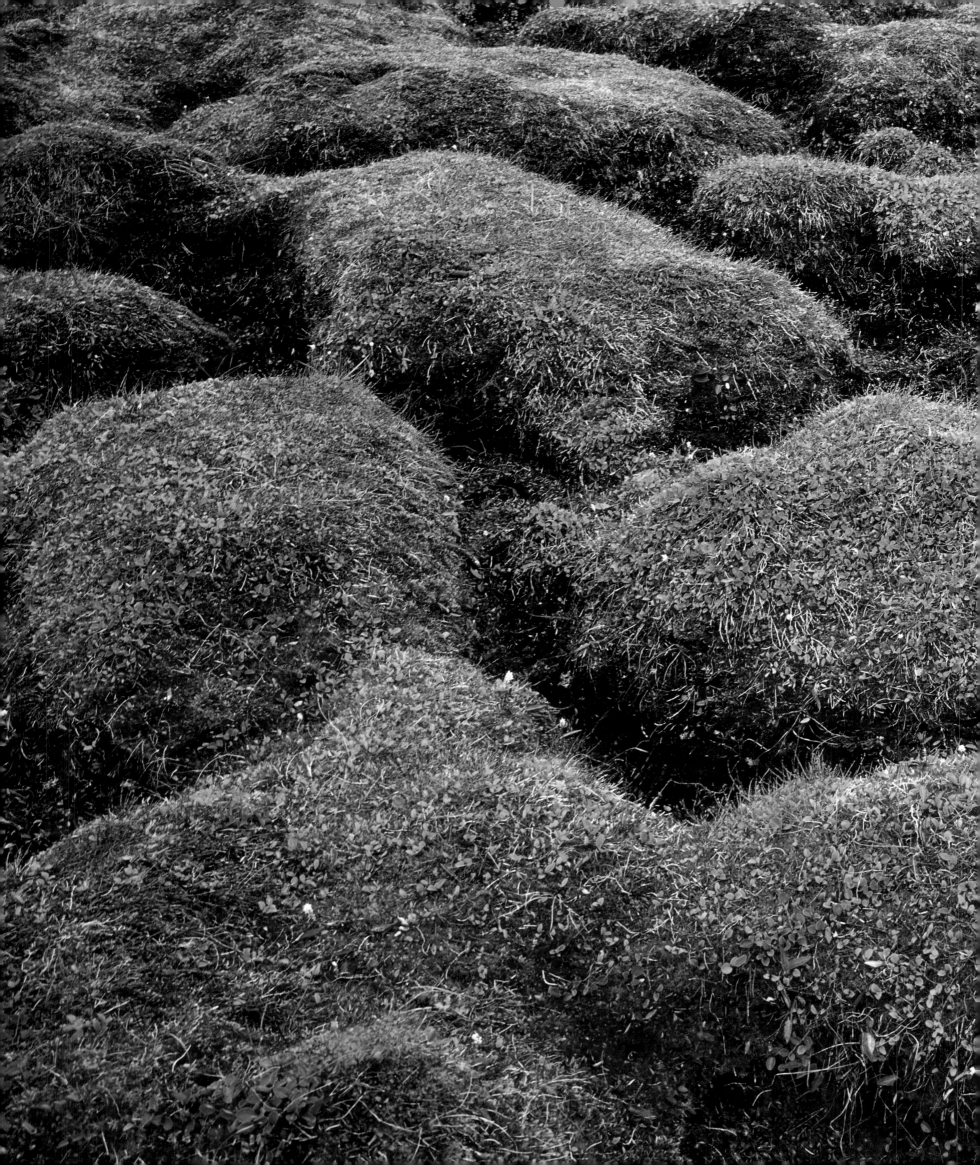

thawing ground

Open water, clear sky, and bare ground. When the snow melts and the waters are free of ice, a new world appears.

A herd of reindeer comes down the valley. The reindeer make the most of summer, eating almost constantly; for most of the year, the ground is covered in snow and ice, making access to food difficult—even impossible. A flock of barnacle geese lands, having flown hundreds of miles over open water to breed and feed on the thawing tundra.

With the help of the midnight sun, sparse Arctic flora blooms during the short summer. Moss, lichen, and sun-seeking flowers color the valleys and tundra. The vegetation is fragile and grows slowly. It is nurtured by the short, snow-free summer with permanent sunlight, but inhibited by the long winter, the permafrost, and the long polar night.

In some areas, the summer flora is so dense and colorful it is difficult to imagine that the same landscape was all Arctic white only a month earlier, and will be again very soon. The Arctic summer is short but, where the flora grows, intense.

The permafrost—the layer of earth that remains frozen—descends far down into the ground; only the top few feet thaw in summer. But with global warming, permafrost is thawing faster and deeper, disapearing permanently in some areas—and the landscapes of the Arctic are changing drastically. The frozen soil acts as a watertight bed for lakes, and a thawing ground will pull the plug on many of them, endangering plants and wildlife dependent on lakes and wetlands for their existence. Landscapes will change; whole vegetation systems will vanish. New species of plants will appear. Some will thrive, but Arctic vegetation as we know it will be gone. Birds will have to find new territories and other animals face new, perhaps impossible, conditions to overcome.

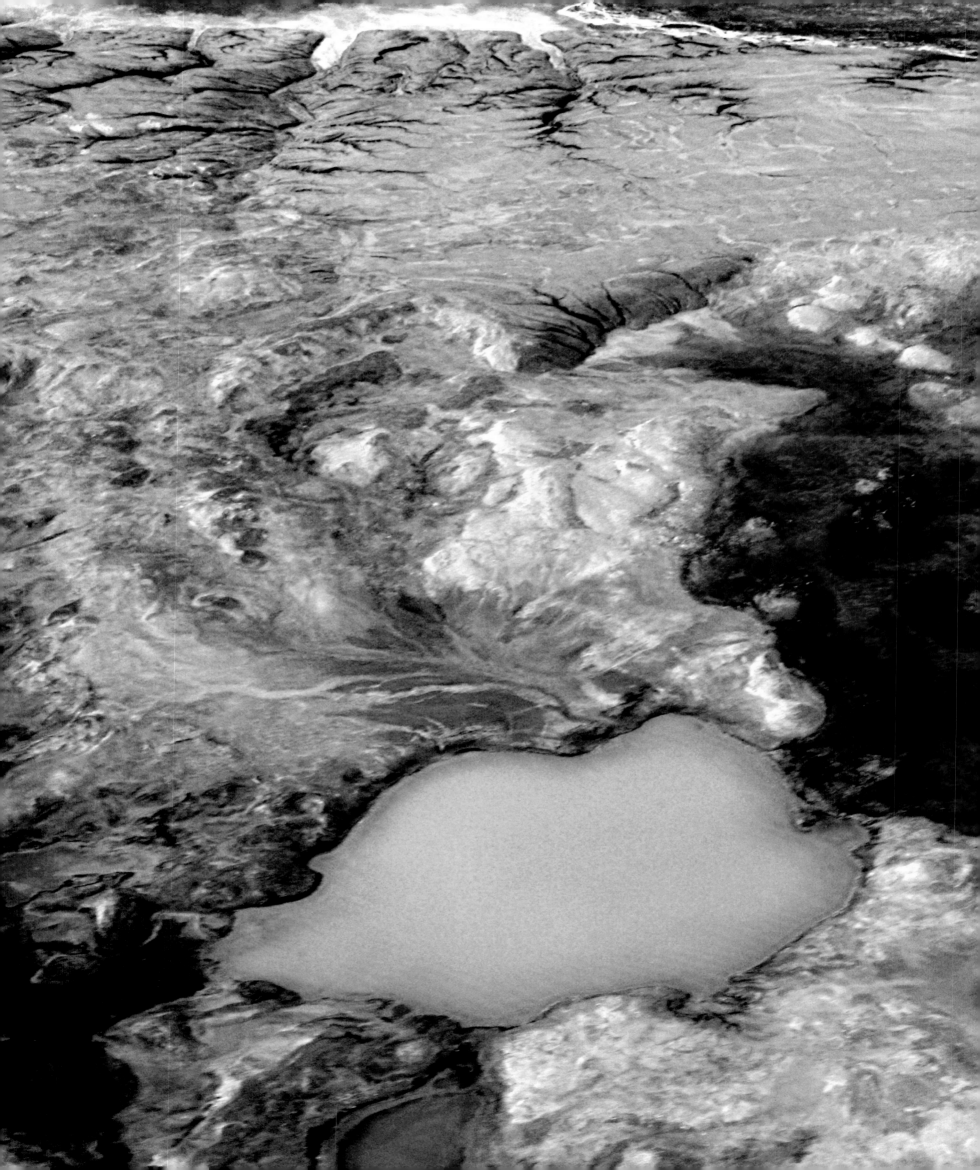

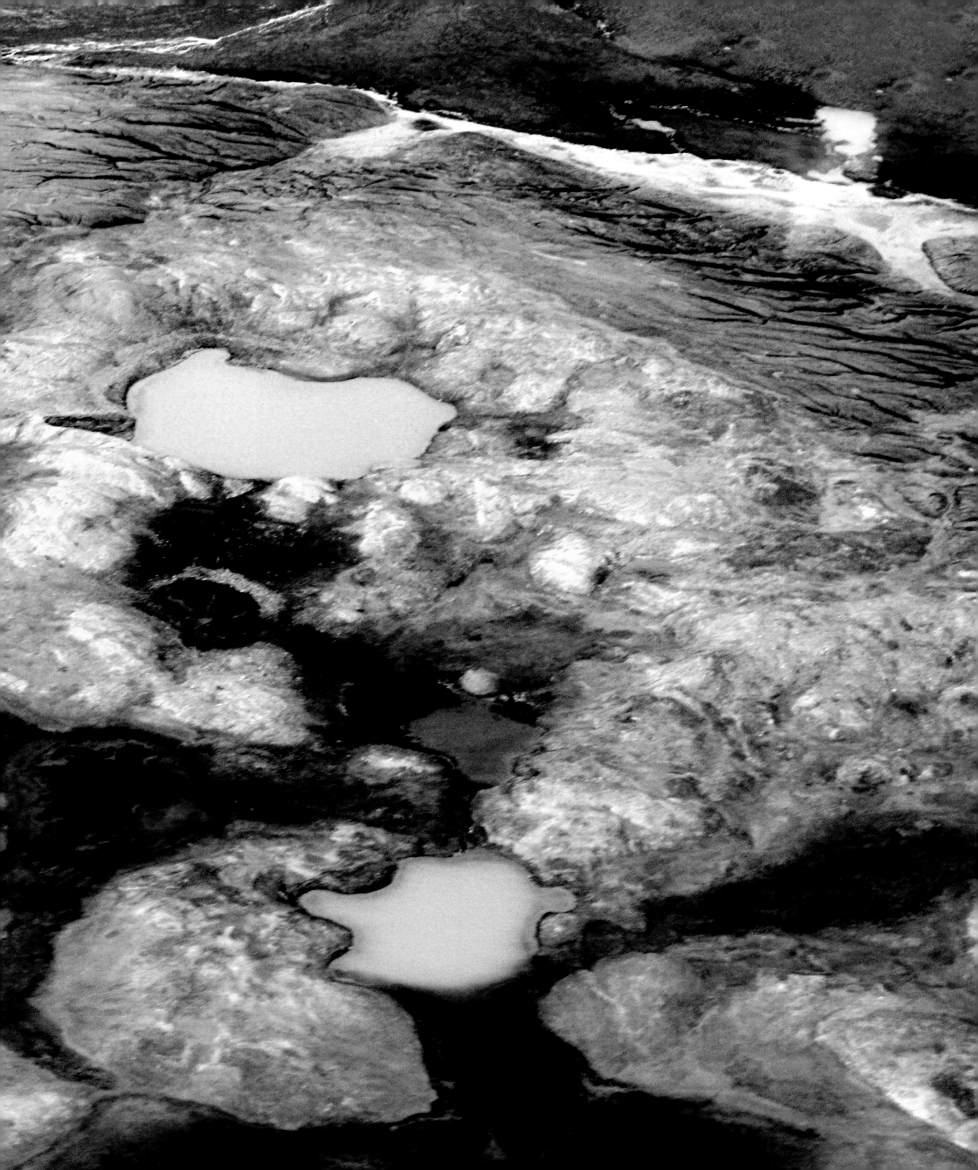

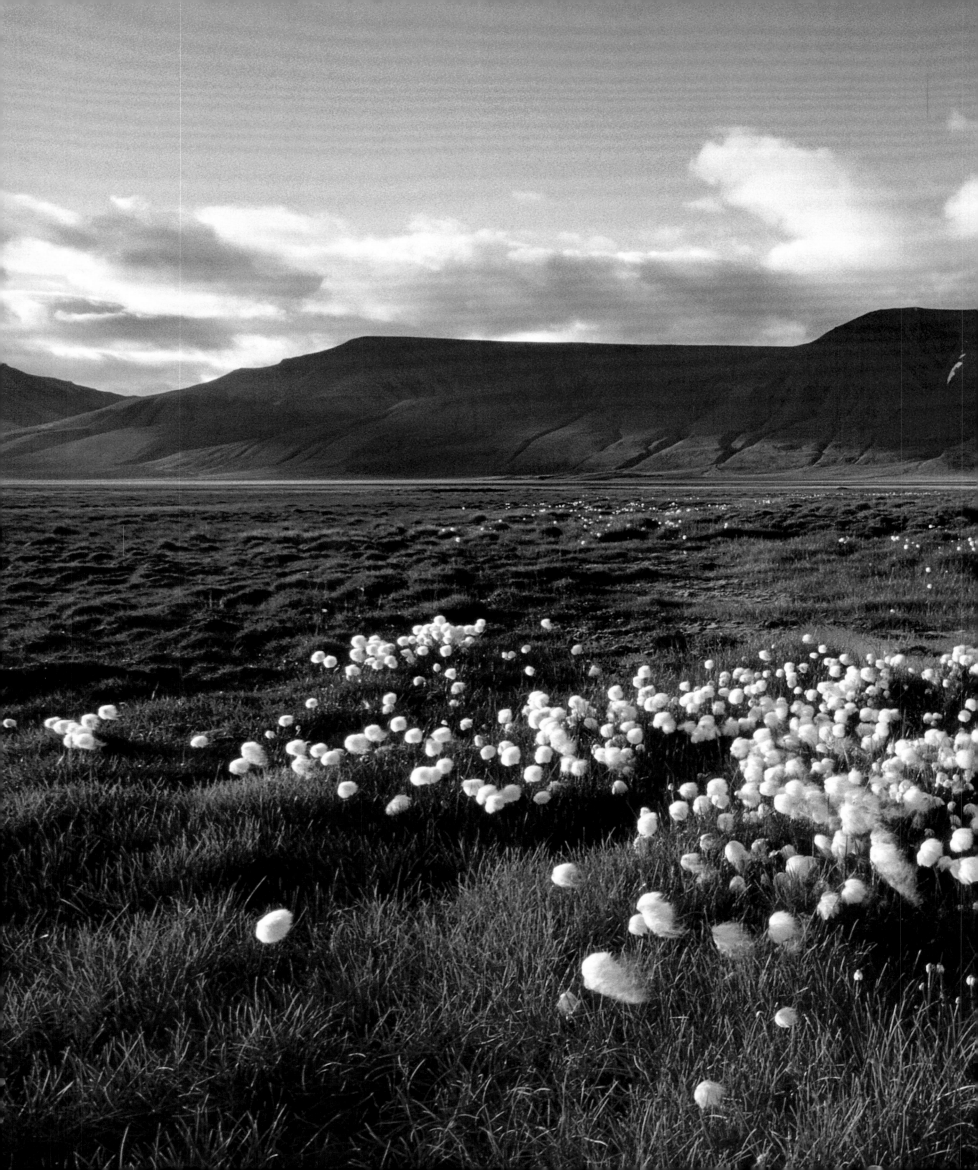

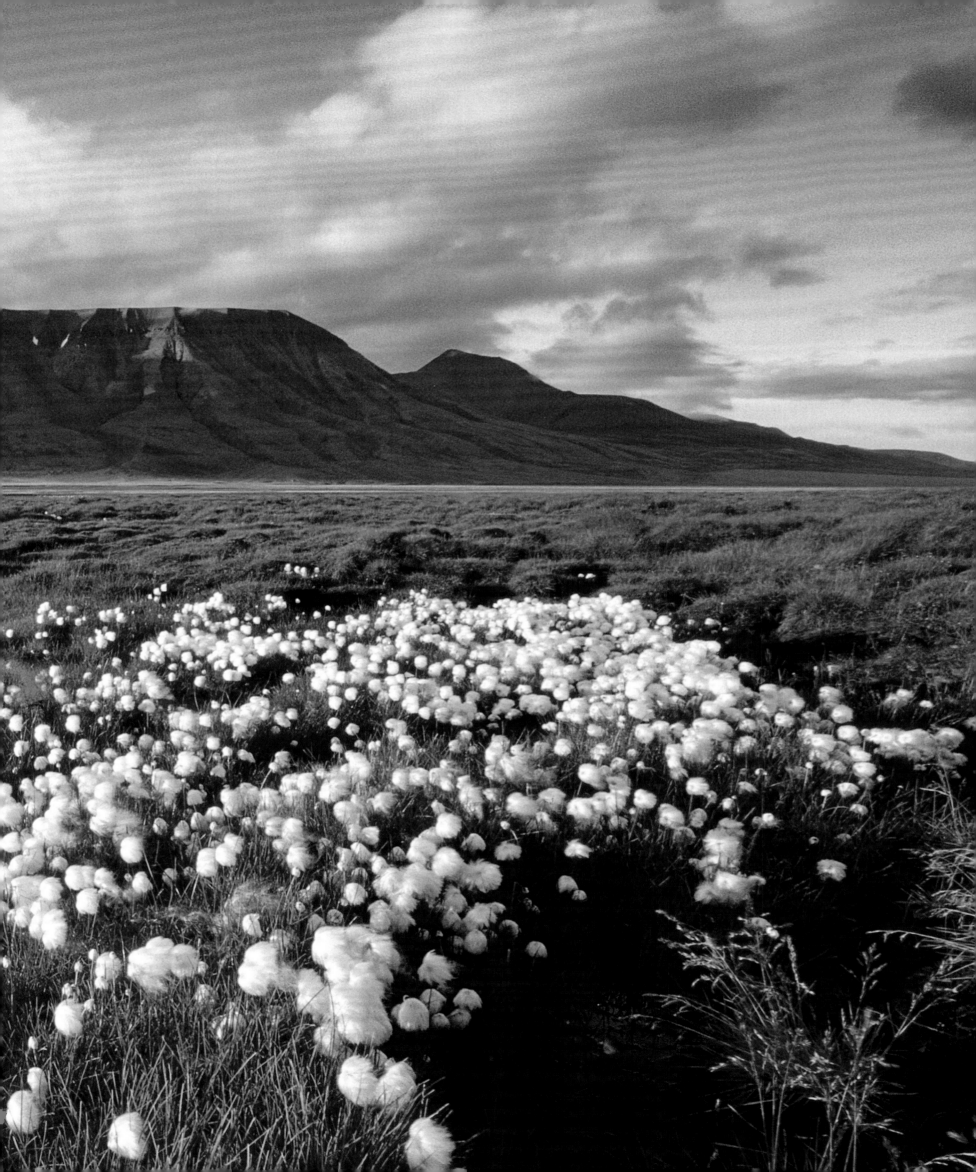

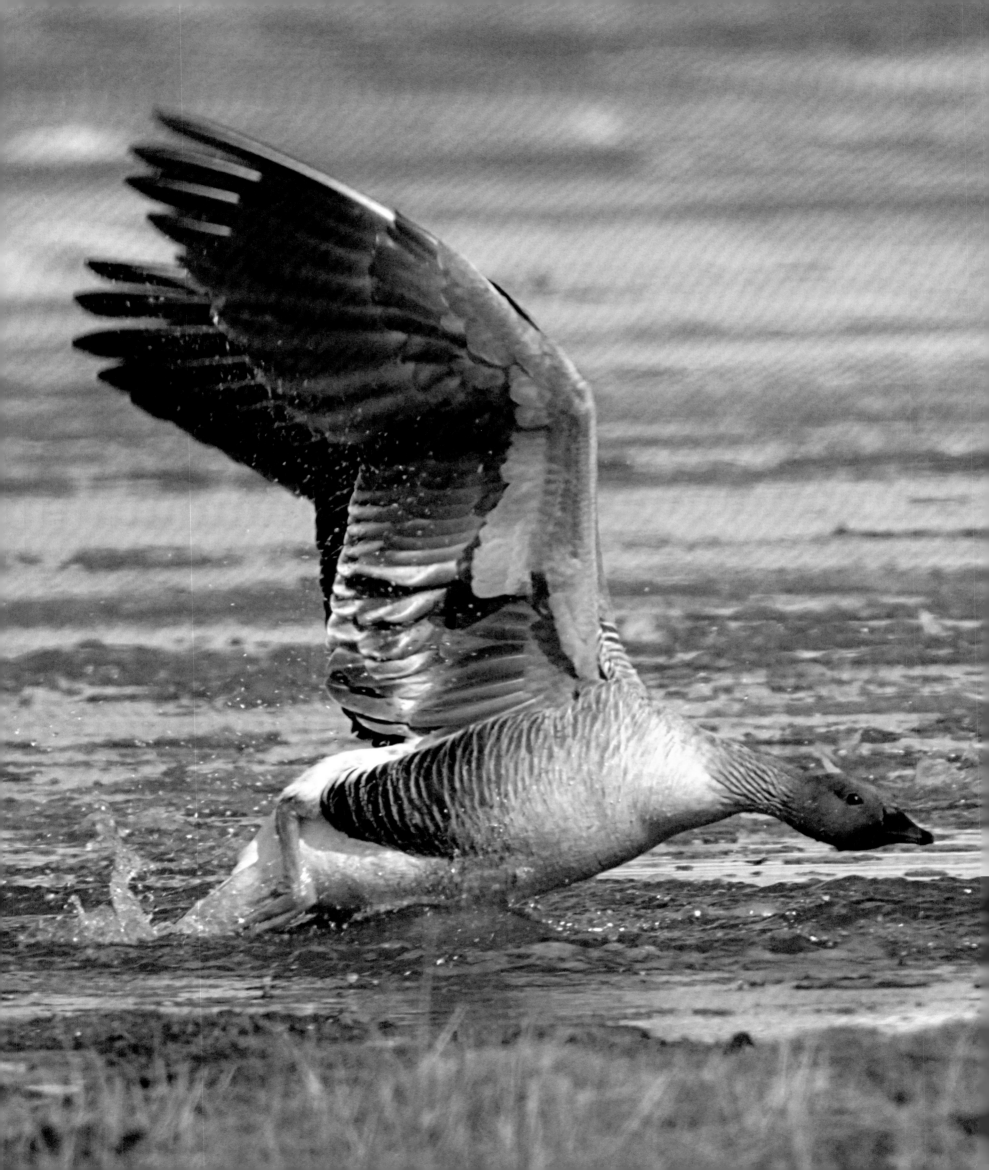

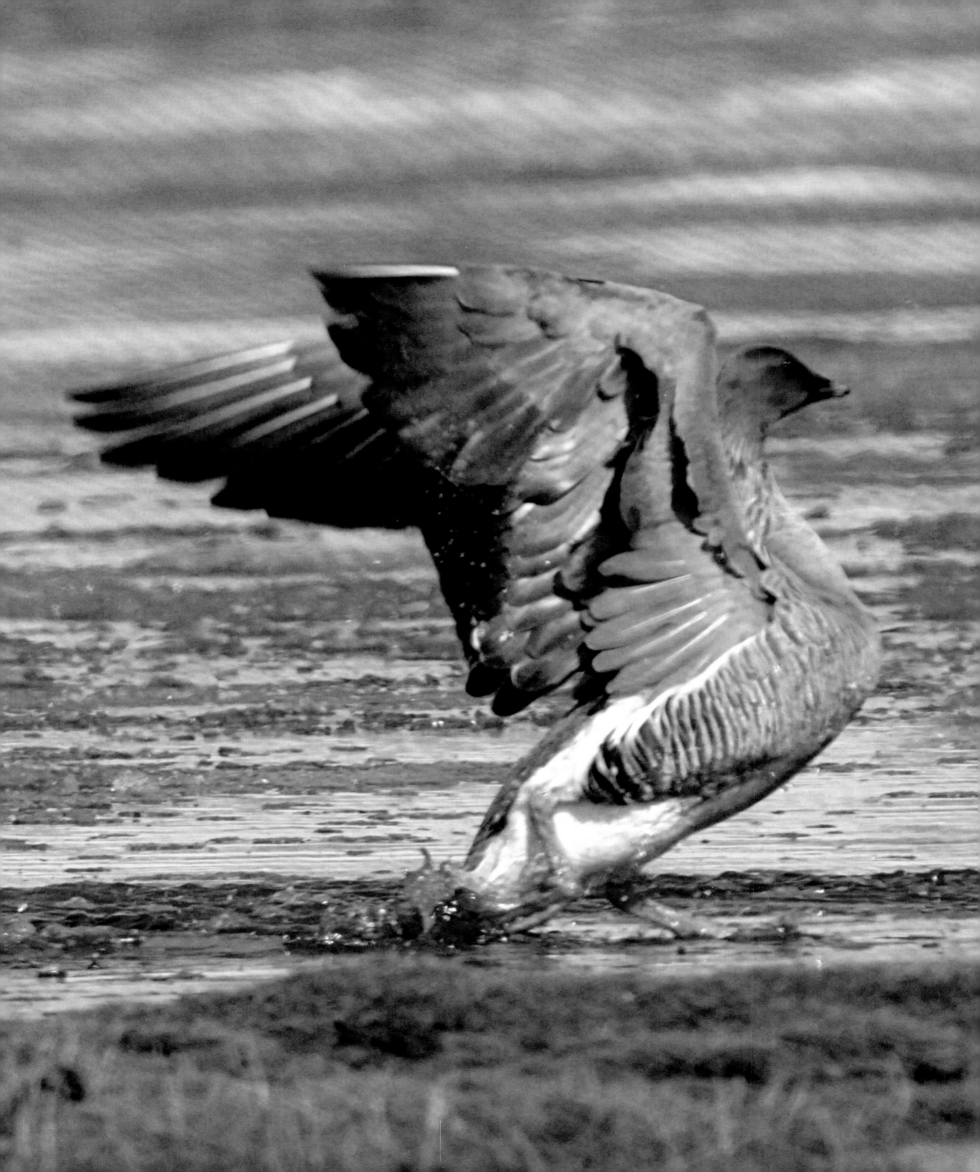

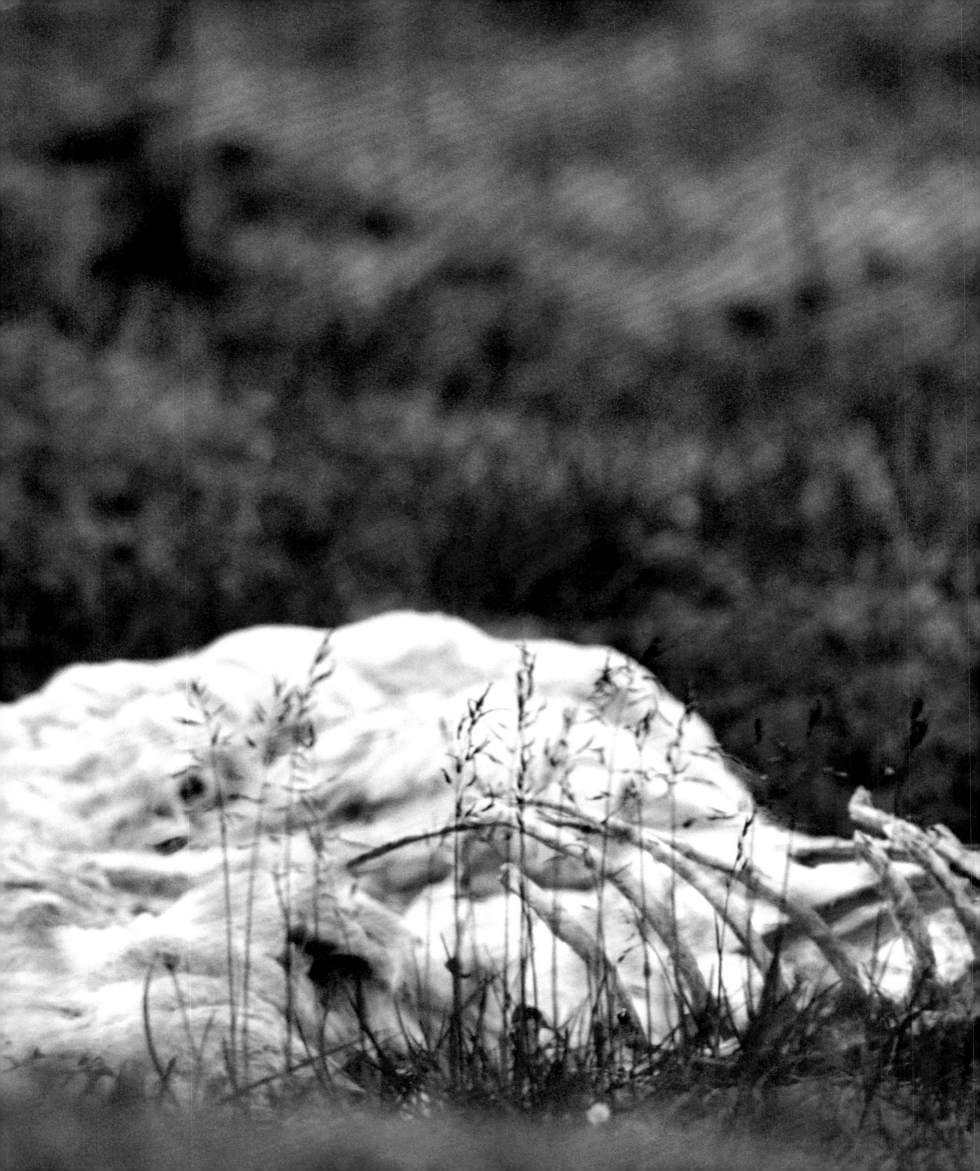

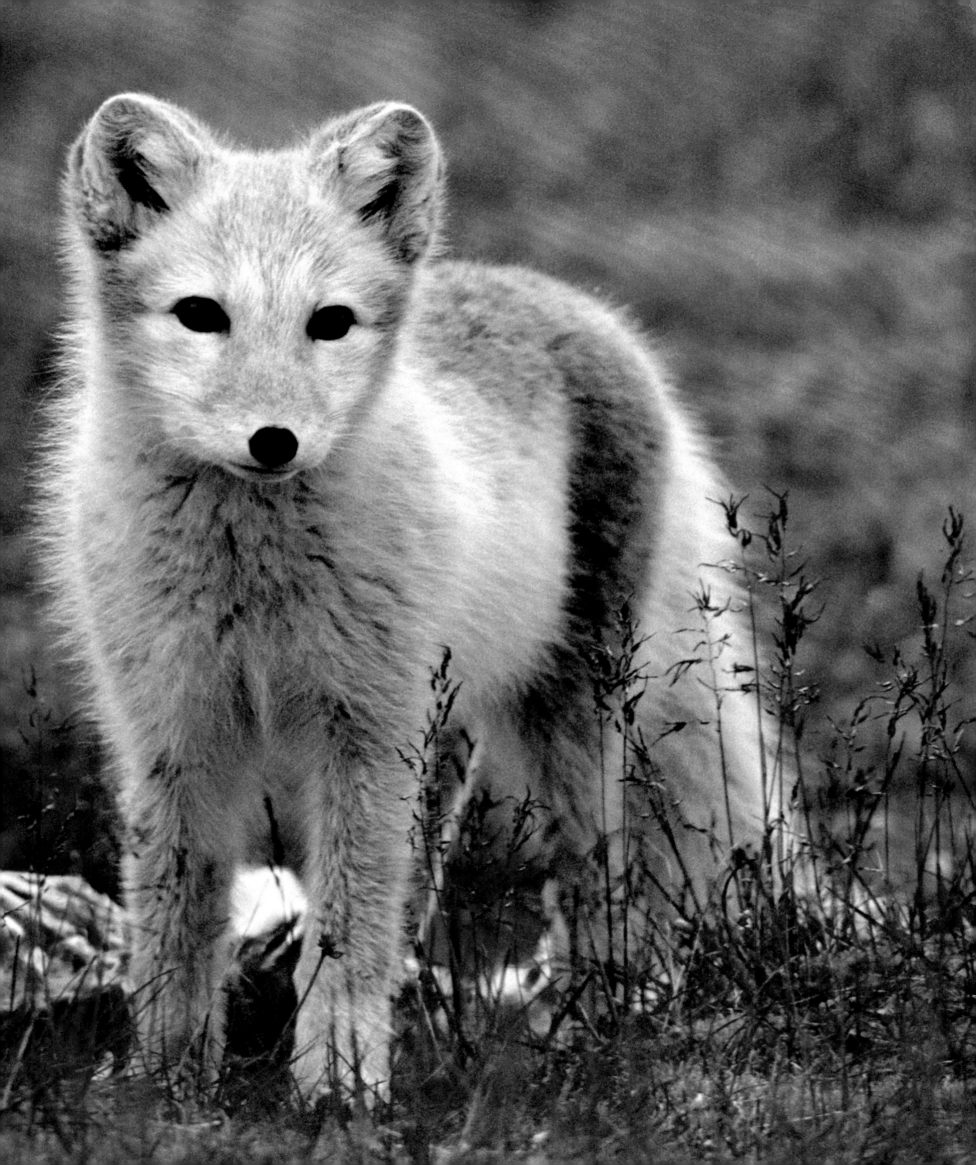

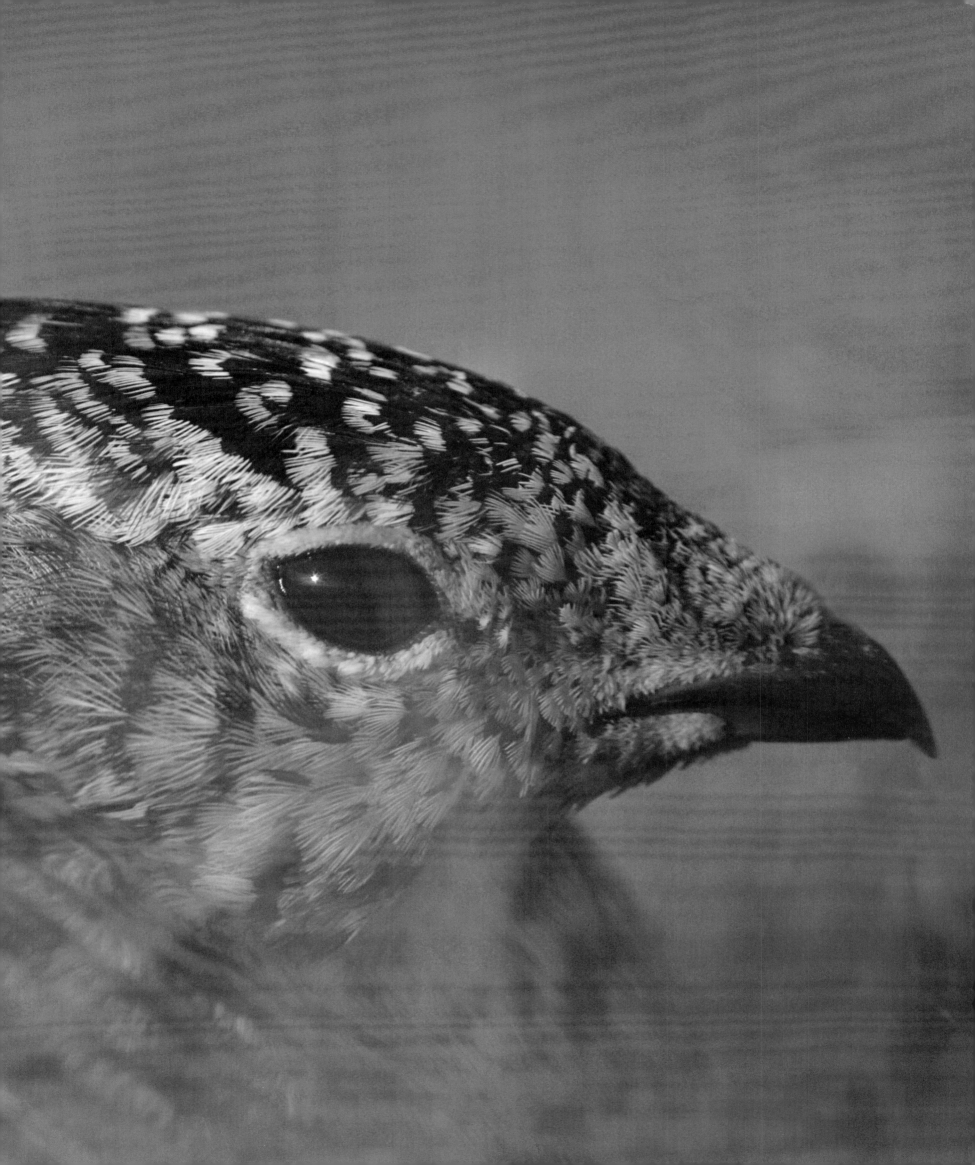

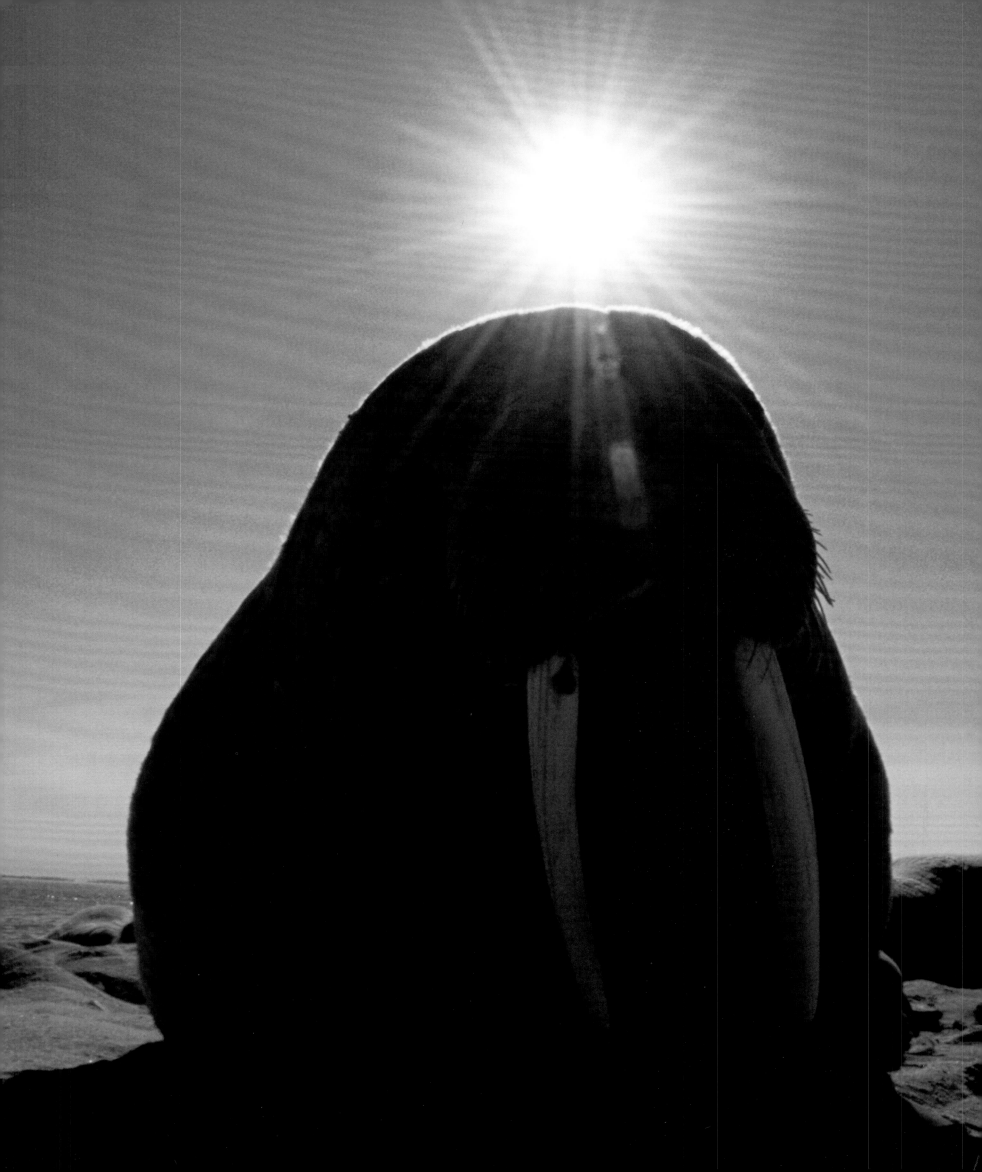

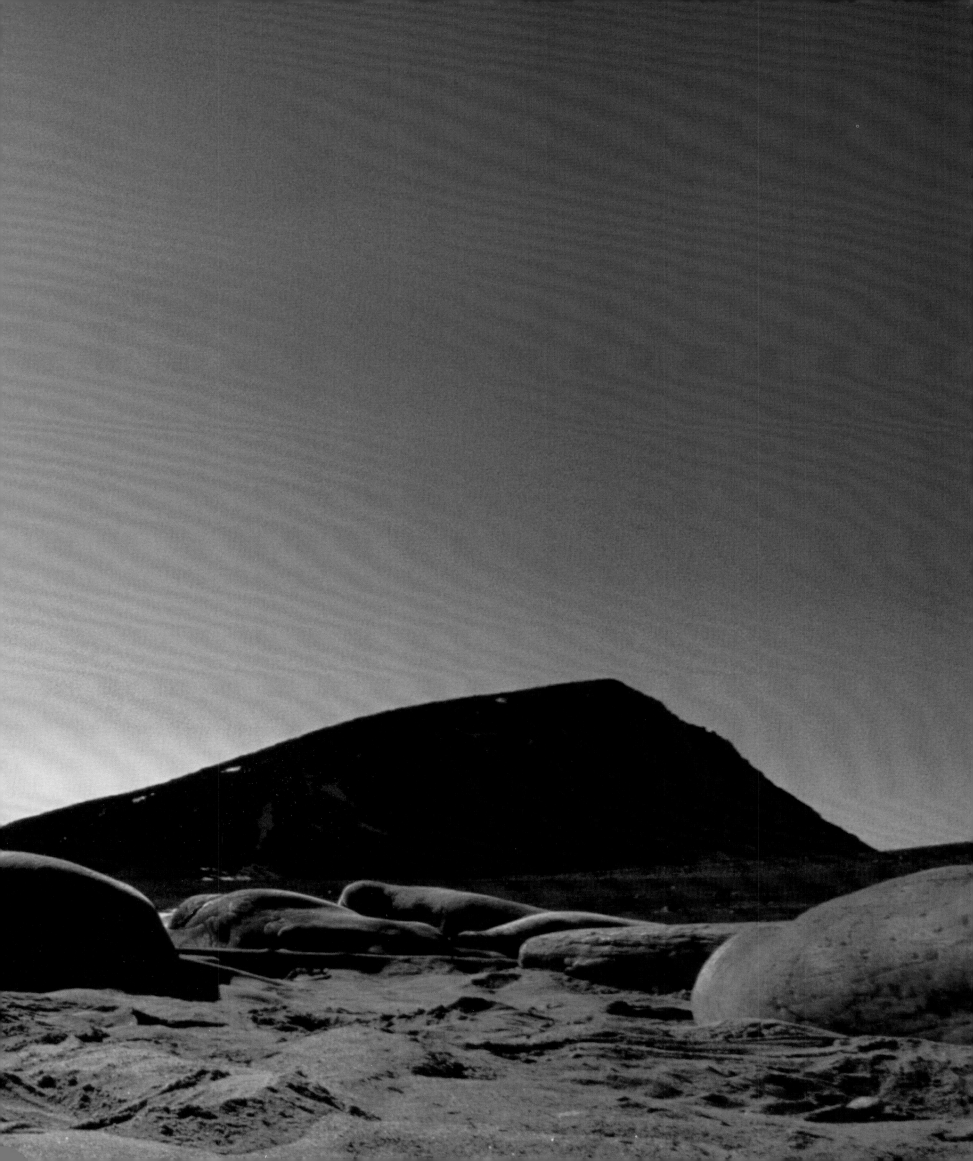

tooth walker

The remote island at latitude 80° north is surrounded by open drift ice. The skies are clear, and the midnight sun offers warmth and comfort to a herd of walrus that lies on the sandy beach.

The walrus is a social animal, often found in large numbers onshore and on ice floes, resting. A big male can weigh more than three thousand pounds, and its ivory tusks can reach beyond three feet in length.

On land and ice, the walrus is slow and disadvantaged, but as it crawls into the water to feed, it is graceful and lithe as a dolphin. Diving down to two hundred feet to find food on the seafloor, it can eat thousands of clams at a single feeding.

The walrus needs to be near open drift ice, as it uses the ice as a platform for resting and breeding. With warming conditions and thinning ice, however, life for the walrus becomes a greater challenge. It cannot dive as deep as seals can. It lives on shellfish—clams and crabs—and needs access to the seafloor.

Its Latin name, *Odobenus rosmarus*, comes from the Greek "tooth walker," as the walrus often uses its tusks to pull itself up on the ice. It is a giant of the past, the walrus; the oldest fossils date back more than ten million years.

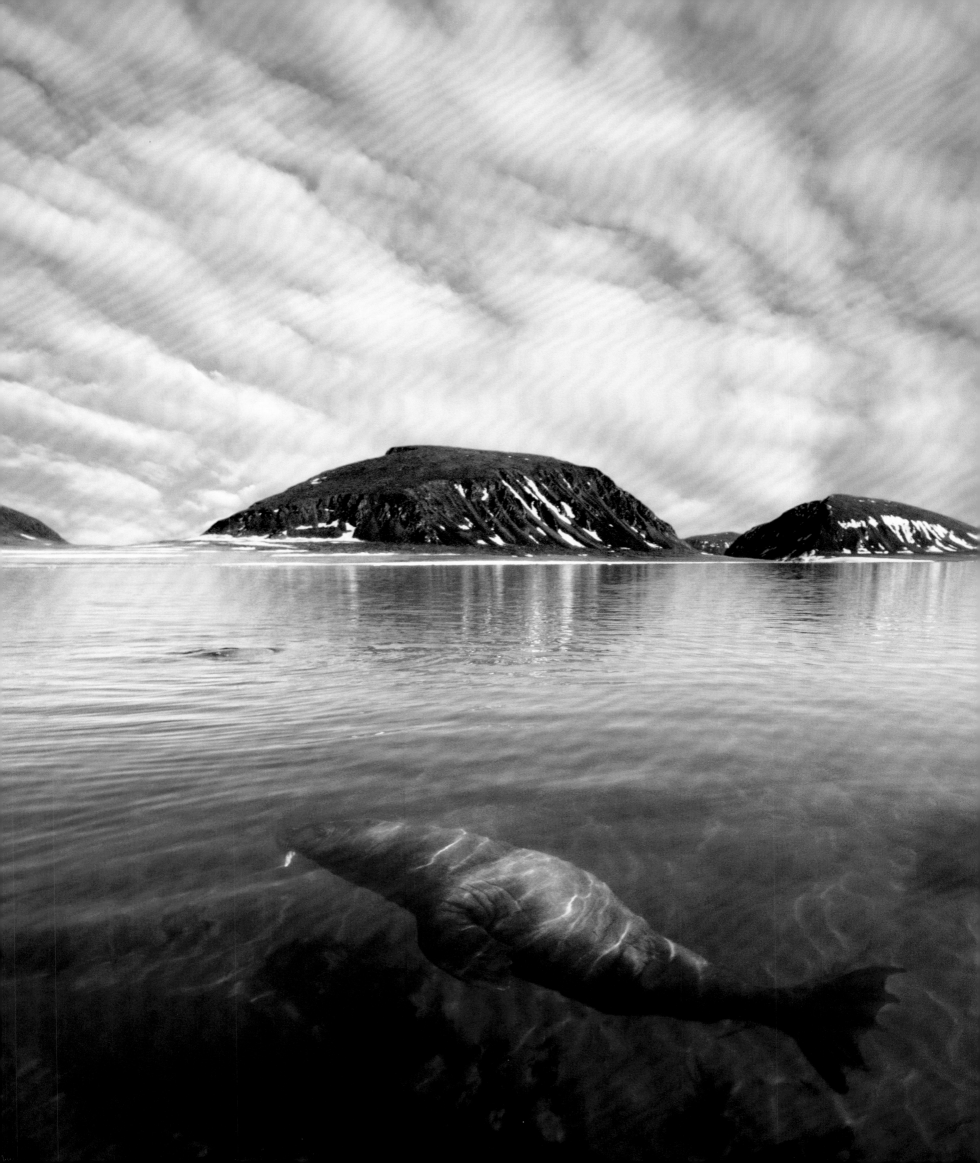

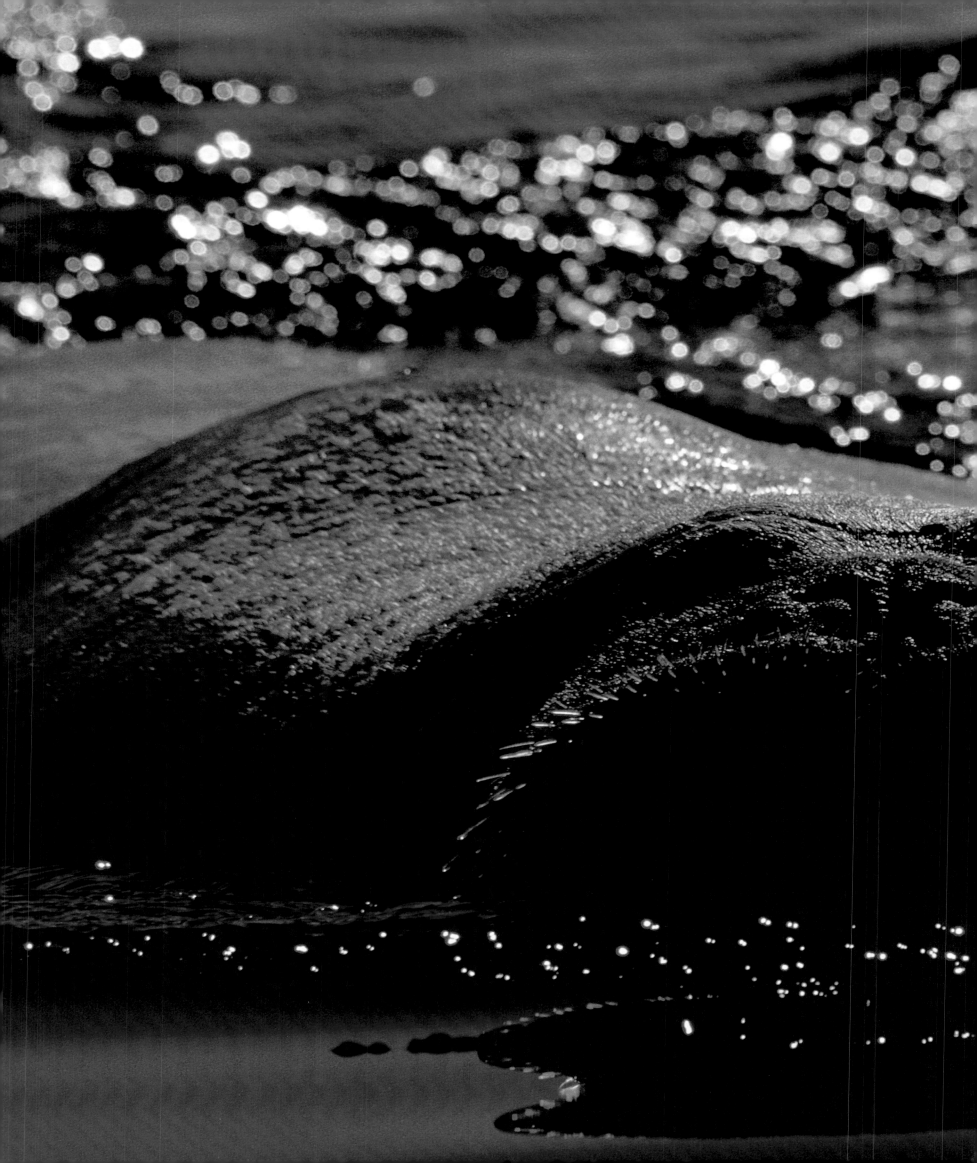

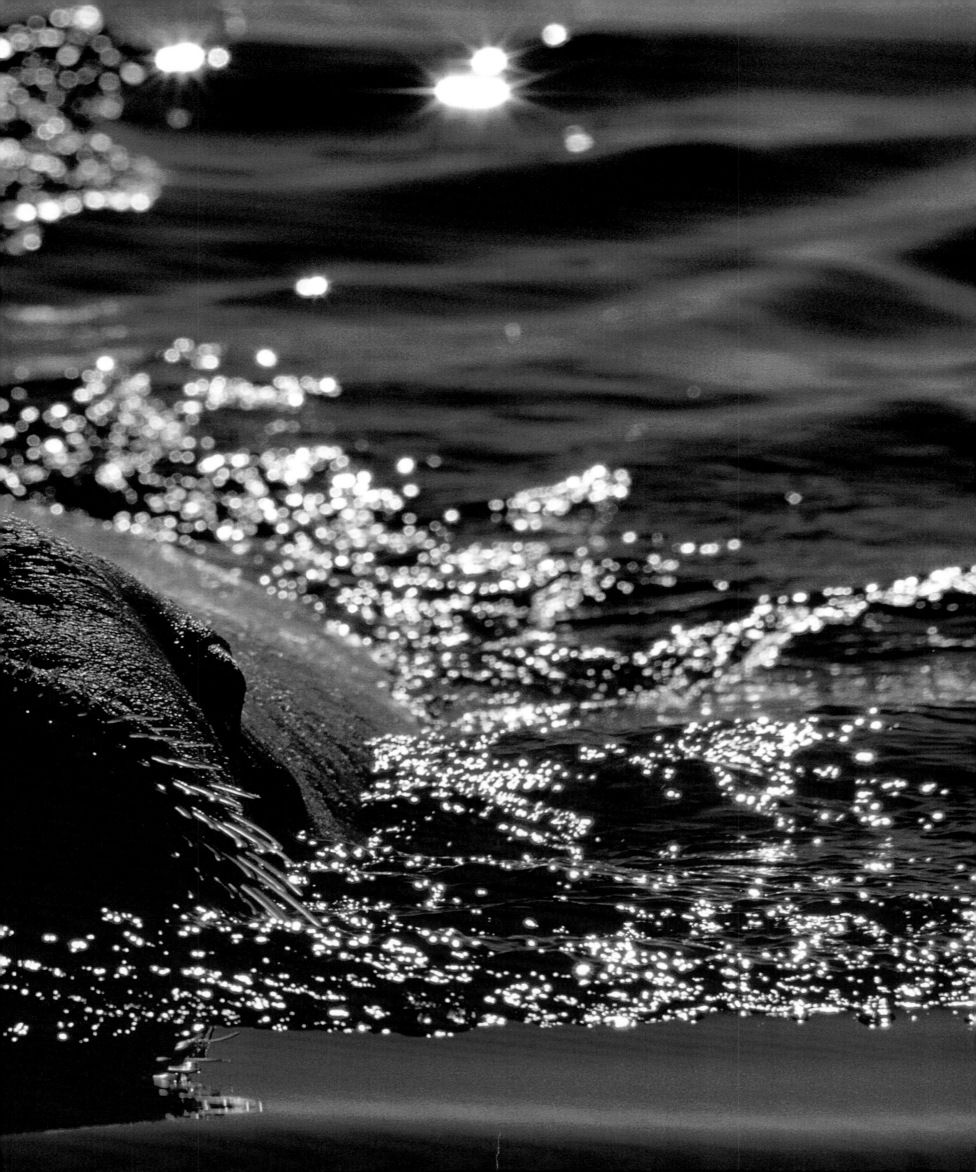

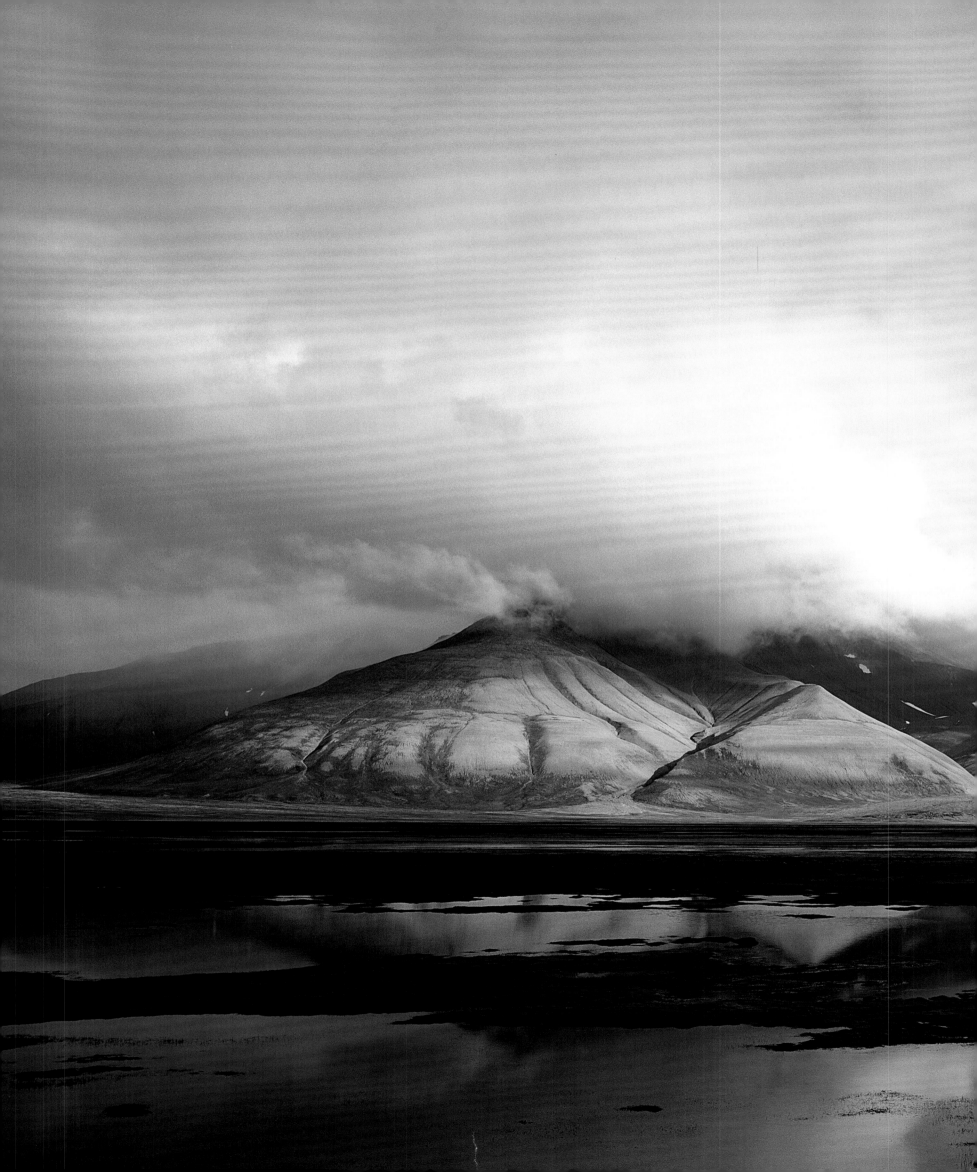

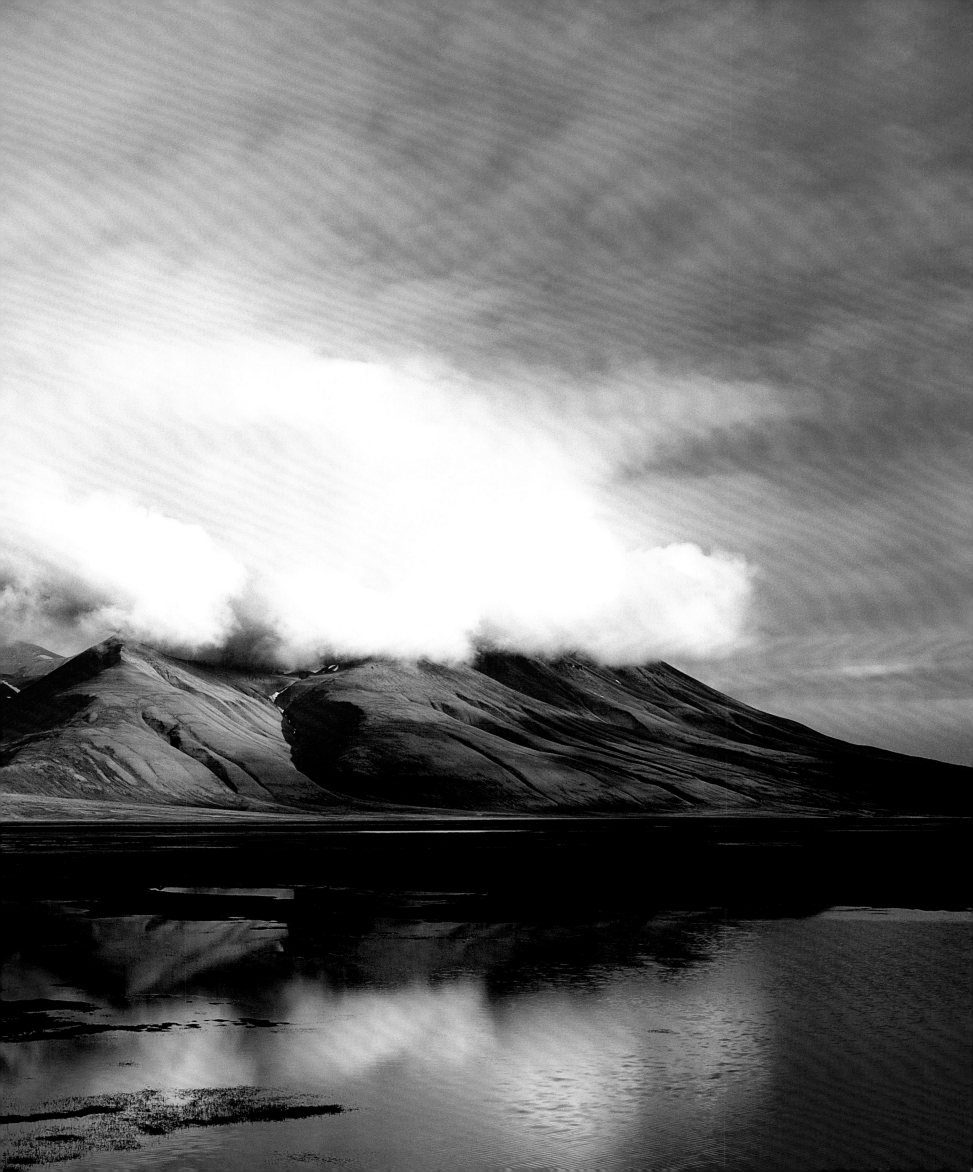

future

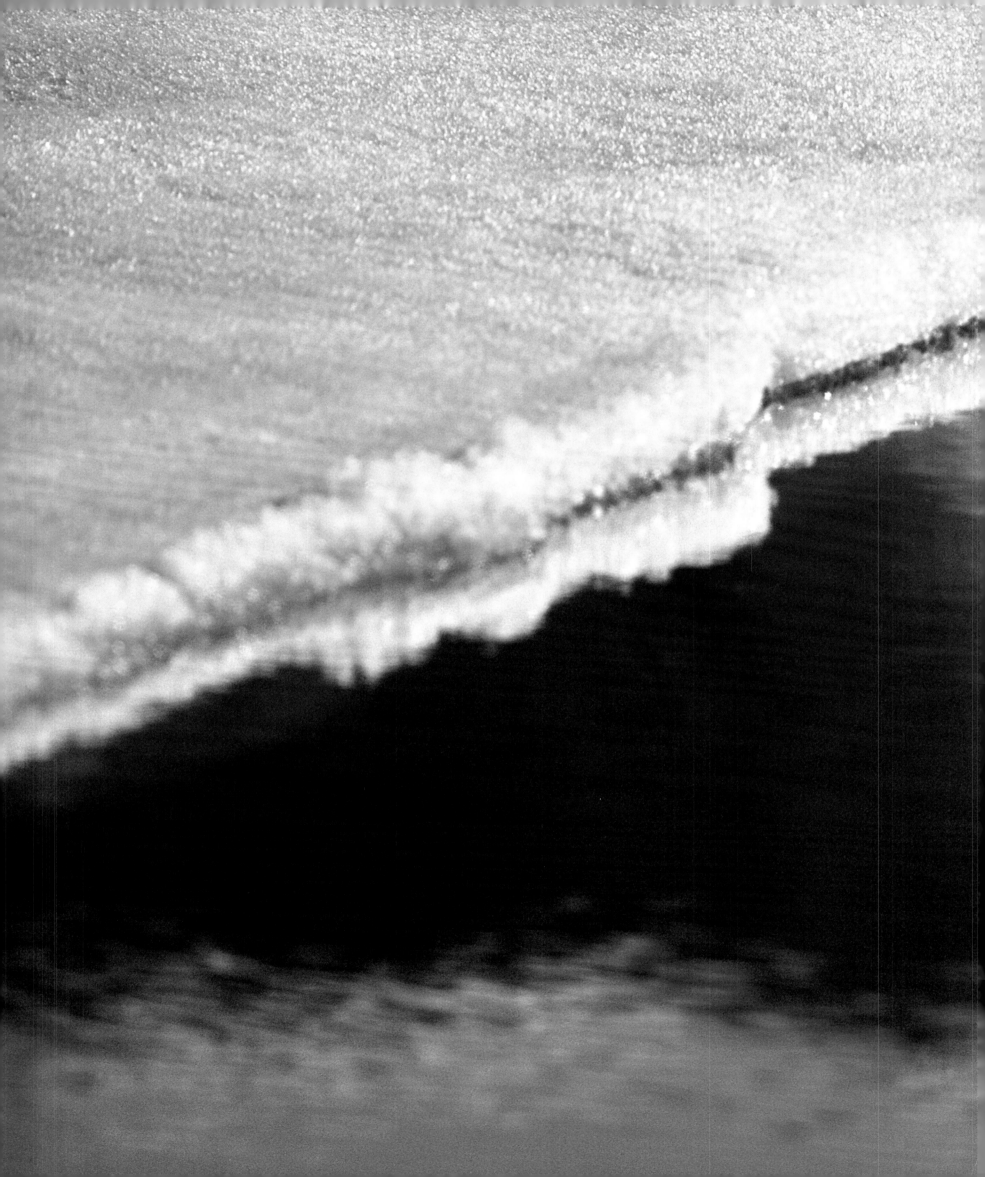

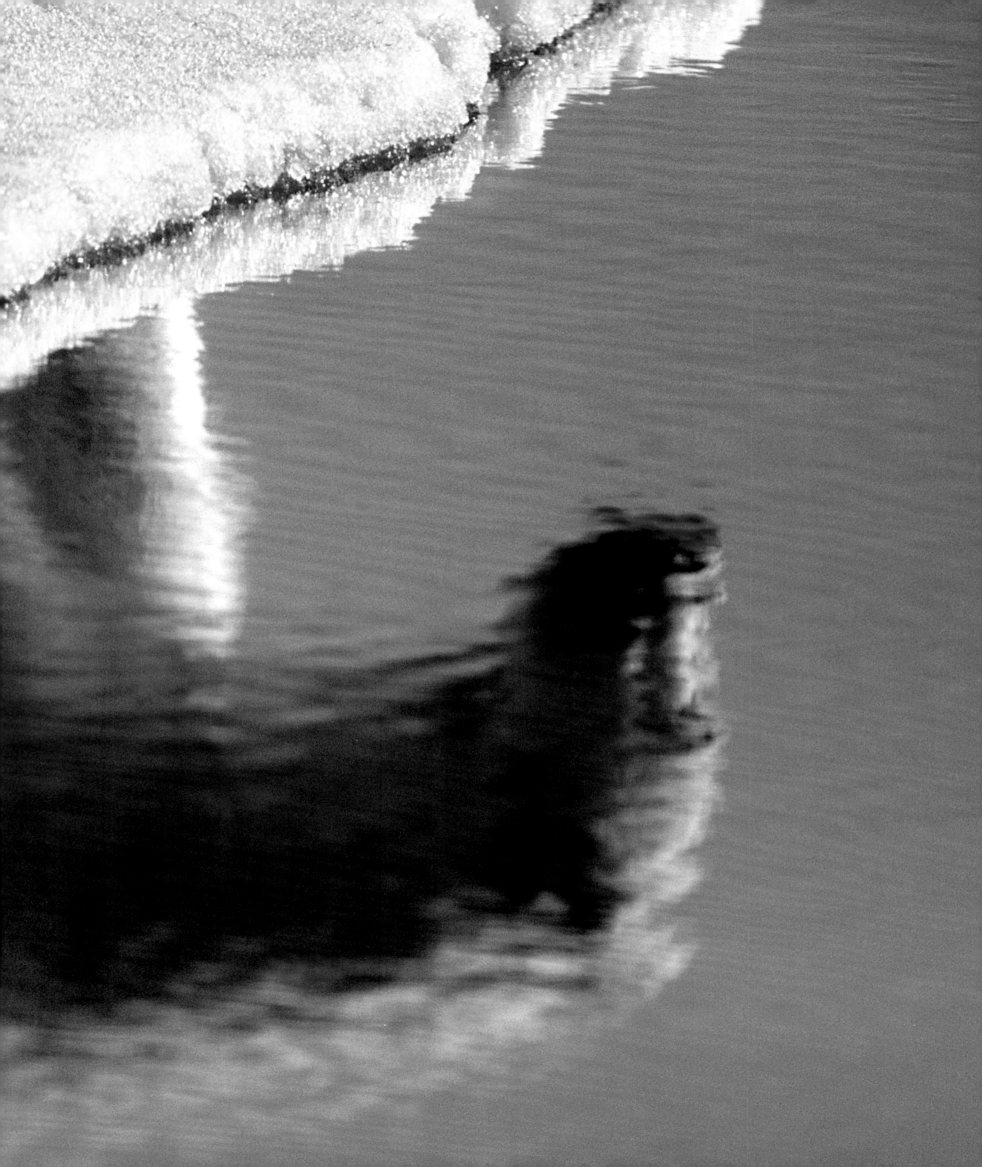

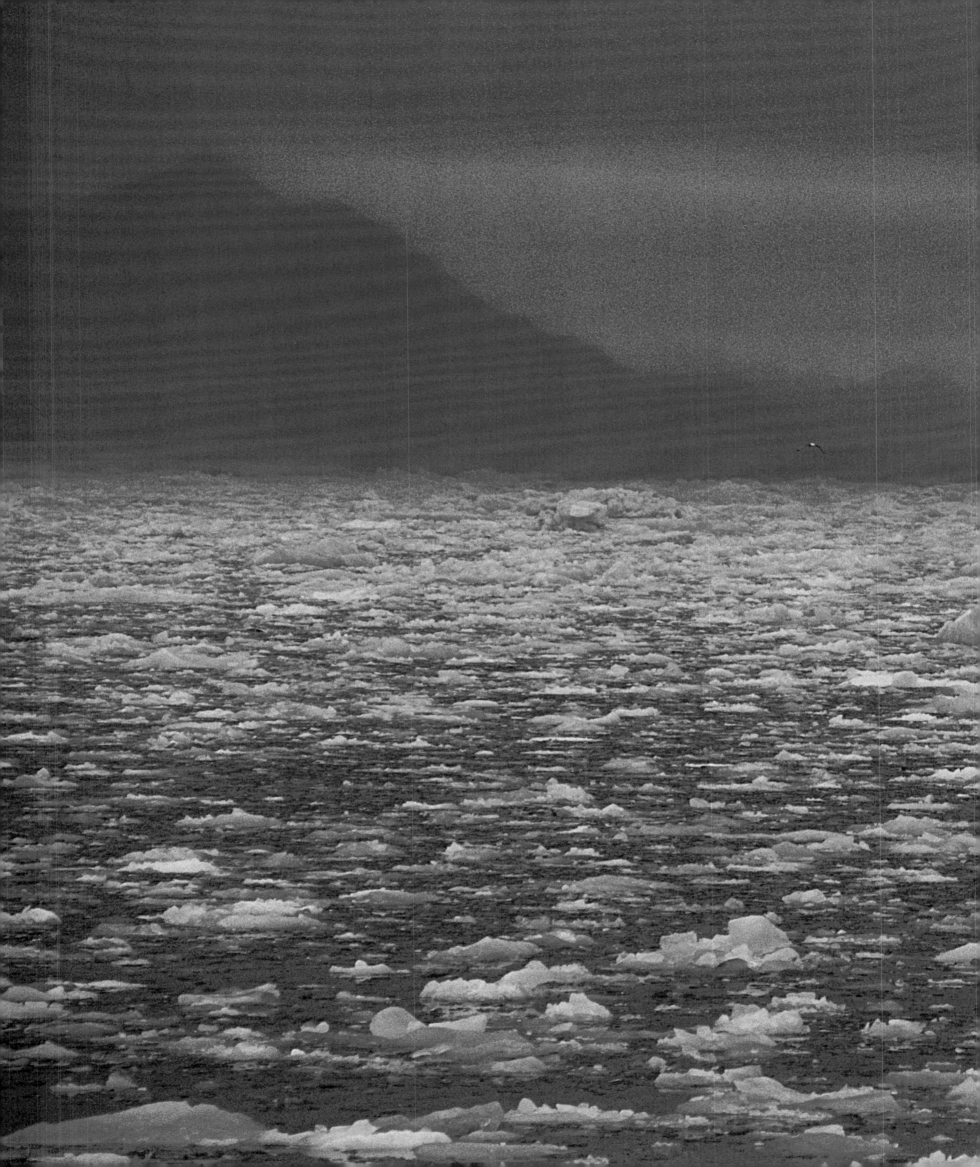

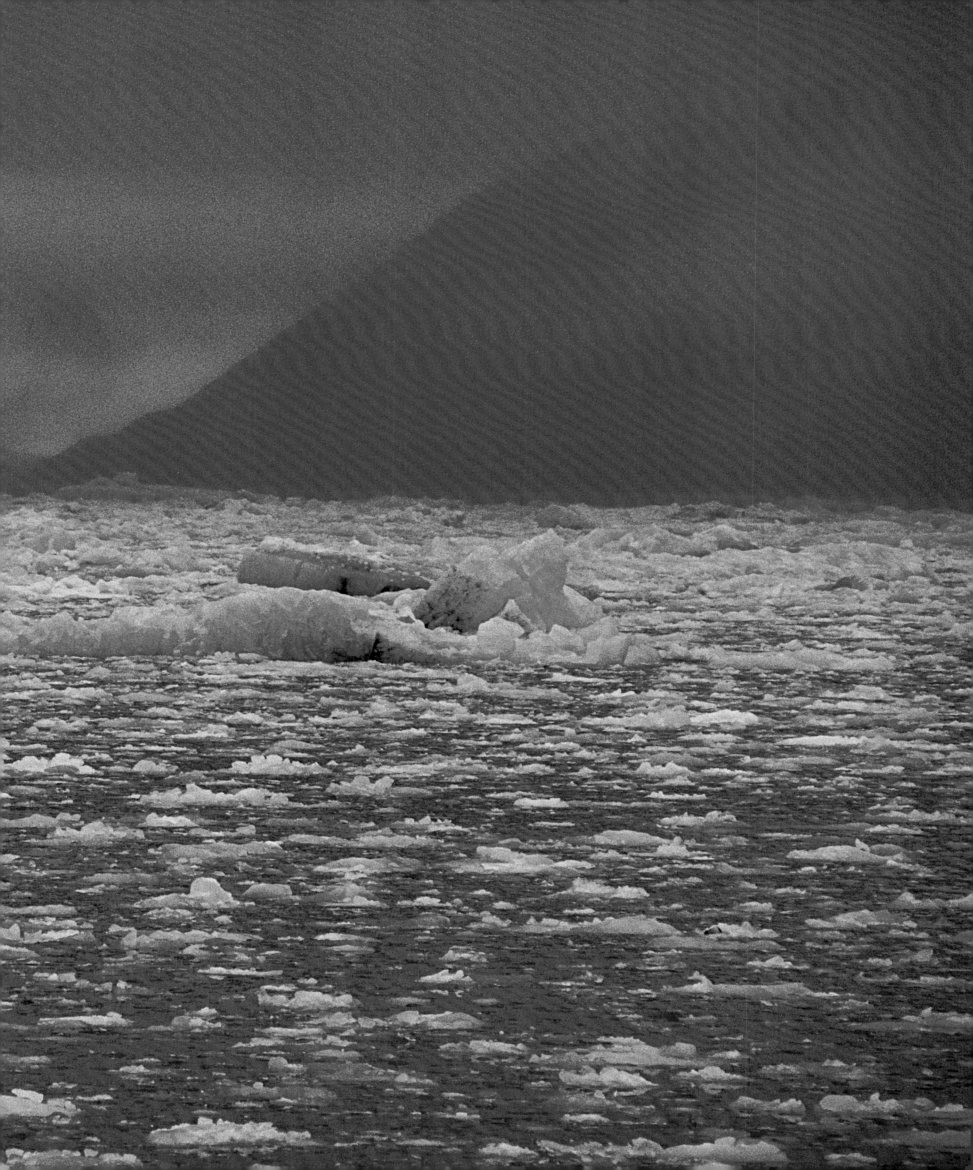

Arctic meltdown

The Arctic, a region frozen by definition, differs greatly from other parts of the world and plays a key part in our global climate system. It is colder here than in regions farther south; the main reason for this is that the sun's rays hit the Arctic at a sharper angle—a slant. With sea ice covering the Arctic Ocean and neighboring seas, gigantic glaciers and ice caps spreading over wide landmasses, vast areas of frozen ground and permafrost, the Arctic needs a stable and cold climate in order to persist.

With global warming and rising temperatures, dramatic changes are expected in the future. We are facing serious threats, not only to the polar regions but to the entire planet. Global temperatures are reaching levels unseen in recent history, and the fastest and most severe climate changes are happening in the Arctic. In the past few decades, average temperatures have risen almost twice as much in the Arctic as in the rest of the world.

The earth's relatively warm surface temperatures are the result of a natural phenomenon—the greenhouse effect. It is what makes life on this planet possible. Without it, our average temperature would be far below freezing. Gases in our atmosphere, such as water vapor, carbon dioxide, methane, and ozone, allow radiation from the sun to pass through to the earth's surface, where a large part of the radiation is converted to heat as it meets and is absorbed by dark surfaces. However, these same gases stop this heat from escaping back into space. Under normal circumstances, the natural composition of the atmosphere ensures that there is a natural balance between incoming solar energy and the heat that is reflected back into space. With higher concentrations of greenhouse gases, however, this balance is threatened.

The burning of fossil fuels, such as oil, natural gas, and coal, releases carbon dioxide and other greenhouse gases into the atmosphere, resulting in higher concentrations of these gases than normal. These higher levels of gases prevent excess heat from leaving the atmosphere, and result in climate warming.

When our main source of heat was the burning of wood, we gave back carbon dioxide, which was absorbed by the trees. But since we began burning oil and coal, we have been emitting gases that are not a natural part of the system. These fuels, buried deep underground, come from plants and animals that lived millions of years ago. Today, the earth's plants and forests can only bind a small part of the greenhouse gases we emit. Extremely durable, these gases will be circulating in our atmosphere for thousands of years to come.

As global temperatures continue to increase, climate changes will accelerate. For the Arctic region, a warmer climate has potentially devastating effects. The temperatures there are rising more than in the rest of the world, resulting in a reduction of the sea ice extent and thickness, thawing permafrost, and rising sea levels. A melting Arctic will in turn boost global warming and affect our global climatic system further.

There is clear evidence of this change. Ice cores taken from glaciers in the Antarctic and Greenland, as well as other places, provide scientists with information on how our climate was in the distant past.

Examination of these old records shows that the speed and pattern of the current warming is unusual, and largely a result of human activities, including our emissions of greenhouse gases.

Sea ice and oceans

Sea ice is an important factor affecting the climate system. It impacts the way solar energy is reflected and the way heat and moisture is exchanged at the ocean surface. It also influences the dynamics of ocean currents. The sea ice, glaciers, and snow-covered ground of the polar regions work as a reflector; almost all the radiation from the sun that hits its surface is reflected back into space as light, without turning to heat, which would get trapped in the atmosphere. This helps to keep the polar regions cold. When the sea ice, glaciers, and snow melt, however, the effect is reduced. In the summer, radiation from the sun is absorbed by the sea; it is later released as heat, resulting in an acceleration of the warming, or what is called a negative feedback loop. During the last three decades, the sea ice extent has shrunk by approximately 8 percent. The Arctic sea ice has also become thinner, in some areas by up to 40 percent, and these trends are accelerating.

The system of ocean currents in the North Atlantic, and the interaction between currents, is important to our global climate. The Gulf Stream brings large amounts of warm water from the southern oceans near the Gulf of Mexico northward, where it helps warm Europe. As it reaches its northernmost extent, where it meets the ice and cold water of the Barents Sea, the water cools, and sinks deep. It then flows back southward close to the ocean floor, and rises again near the equator to complete the cycle. This system is known as the Great Ocean Conveyor Belt. It transports millions of tons of water every second, and is key to our global climate, as it transfers heat throughout the oceans. Our oceans and atmosphere, storms, and low pressure systems help maintain a balance in temperatures by transporting heat toward the poles. The melting sea ice and glaciers, currently so excessively affected by global warming, feed the salty Arctic Ocean with large amounts of cold freshwater, however, which can disrupt the important balance and dynamics of the Conveyor Belt, and the global circulation of air and ocean water could be dramatically affected.

Ice on land

Glaciers exist on all the continents of the world, even Africa, but most are found near the poles. They require very specific and cold conditions, preferably heavy snowfall in the winter and cold summers. This ensures that the glaciers do not lose all the mass they gain in winter by melting or calving in the summer. The pressure of its weight is what causes a glacier to move. Valley glaciers flow down valleys, and continental glaciers, such as those in Greenland, flow outward in all directions from the middle. Movement caused by gravity is a result of internal change in a glacier. It can make it deform and spread out, and by doing so, move. Movement caused by sliding is often a result of a thin layer of water at the base of a glacier. This water

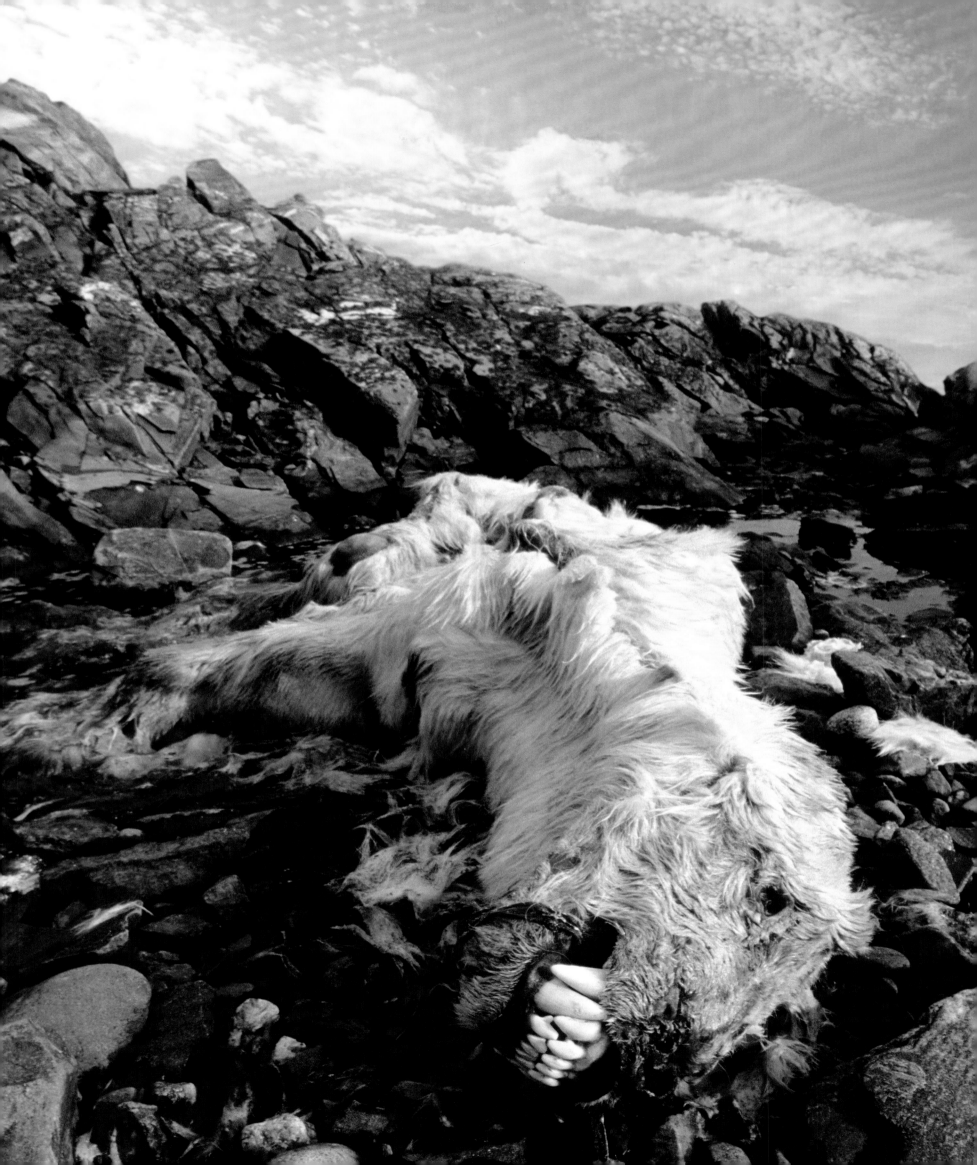

comes from the melting of the glacier itself, or has been transported down through cracks and channels in the ice. Meltwater in the glacier can accelerate the melting further, and the water that reaches the bedrock below can cause the glacier to move faster toward the sea. As the glaciers and their meltwater unite with the sea, the global sea level rises.

Moving glaciers are an indicator of change, and this is one of the reasons scientists study them. Long-term studies of glaciers around the world clearly show how they react to variation and change in our climate. Comparing recent glacier activity with historical records gives us a greater understanding of long-term processes and climate change.

Frozen ground

In the Arctic, most land surfaces consist of frozen soil, sediment, and rock. Permafrost exists where the heat of summer does not reach below the top layer of ground. Permafrost can be dry ground, or it can contain ice. It can be completely covered in snow or completely bare.

Permafrost soil contains vast amounts of frozen vegetation and animal remains—all of which are full of carbon. This carbon has often been locked away and hidden underground, frozen, for thousands of years. When global warming thaws the permafrost, the carbon escapes, increasing the levels of greenhouse gases in the atmosphere and accelerating global warming even further. Scientists see this as a dangerous circle.

In many areas the permafrost reaches deep into the ground, up to thousands of feet; even with global warming it would take many centuries for it to disappear completely. However, the areas containing the highest ice content, which easily thaw, are often found near the surface, and negative consequences are already visible there. When we lose the permafrost, we lose the stable base on which the land-based ecosystems of the Arctic are totally dependent. But perhaps equally important, we also further disrupt the global climate system.

Ice-dependent life

Polar bears are the world's largest land carnivores. They are completely dependent on sea ice as a platform to hunt for their primary food, ringed seals. During summer, polar bears that become trapped on land eat nothing, or very little, while waiting for the next winter and frozen ocean. With a longer ice-free summer, polar bears are moving to land earlier in the season, with fat reserves that may not be enough to survive until the next winter. If the summer sea ice of the Arctic disappears completely, which it is projected to do by the end of this century, it is unlikely the polar bear will survive as a species.

Ringed and bearded seals, among other seal species, are also dependent on sea ice for survival. They give birth and nurse their pups on the sea ice, use it as a resting platform, and hunt for food under it. Many seals create breathing holes and build shelters under the snow on the sea ice to protect themselves and their pups from cold weather and predators. Decreasing sea ice reduces the habitat of many seal species. With the ice breaking up earlier in the season, mothers and pups may also face premature separation, leading to higher death rates among pups.

Hundreds of millions of birds migrate to the Arctic every summer. As the tree line moves north and the summer landscape of the Arctic changes, important areas for breeding and nesting will disappear. The seasons are changing, and the birds' arrival in these northerly latitudes may not always coincide with the availability of insects.

Walrus need access to sea ice, as well as shallow waters, as they feed on the seafloor and cannot dive as deep as seals can. When the edge of the pack ice moves to deeper waters, walrus must swim long distances to reach their feeding grounds.

Sea ice is crucial for many animals. It is a hunting ground for polar bears, a place where walrus and seals rest and breed, a spot where Arctic foxes find food in winter, and reindeer and caribou can migrate. Melting sea ice in the Arctic means big problems for many species. The expected future reduction in ice and the shrinking, or even disappearing of habitats will likely drive some ice-dependent animals to extinction.

Future climate situation

Past, present, and future levels of greenhouse gas emissions and our climate's reaction to these emissions will determine the degree to which human impact causes the climate to change and temperatures to rise.

In 2007, the United Nations Intergovernmental Panel on Climate Change published the most important report on climate change thus far. Twenty-five hundred scientists from 130 countries worked for six years to compile the report, and it is a distinct warning to policy makers around the world. Radical international measures are necessary; otherwise, the consequences for our planet will be disastrous.

What we do now to limit the effects of global warming will have limited short-term impact. However, what we do now and in the next ten to twenty years will have a very profound effect on our climate for the longer term.

The effects of global warming are impossible to predict with absolute certainty. But scientists are producing ever-more reliable scenarios for the future. Using the scenario with the lowest emissions and the least warming results in a prediction that the earth will warm more than twice as much this century as it has in the past. The warming of the Arctic region will be even more dramatic, up to four times the global average, and the summer sea ice of the Arctic Ocean is likely to disappear completely by the middle of this century. The melting of the ice caps will accelerate, and as a result, sea levels will rise drastically, causing flooding and potentially forcing hundreds of millions of people from their homes. Extreme weather patterns, storms, forest fires, and many other effects of a warming climate will become more common.

If we do not act soon to stop this trend, future generations will pay a high price, indeed. Now is the time to act.

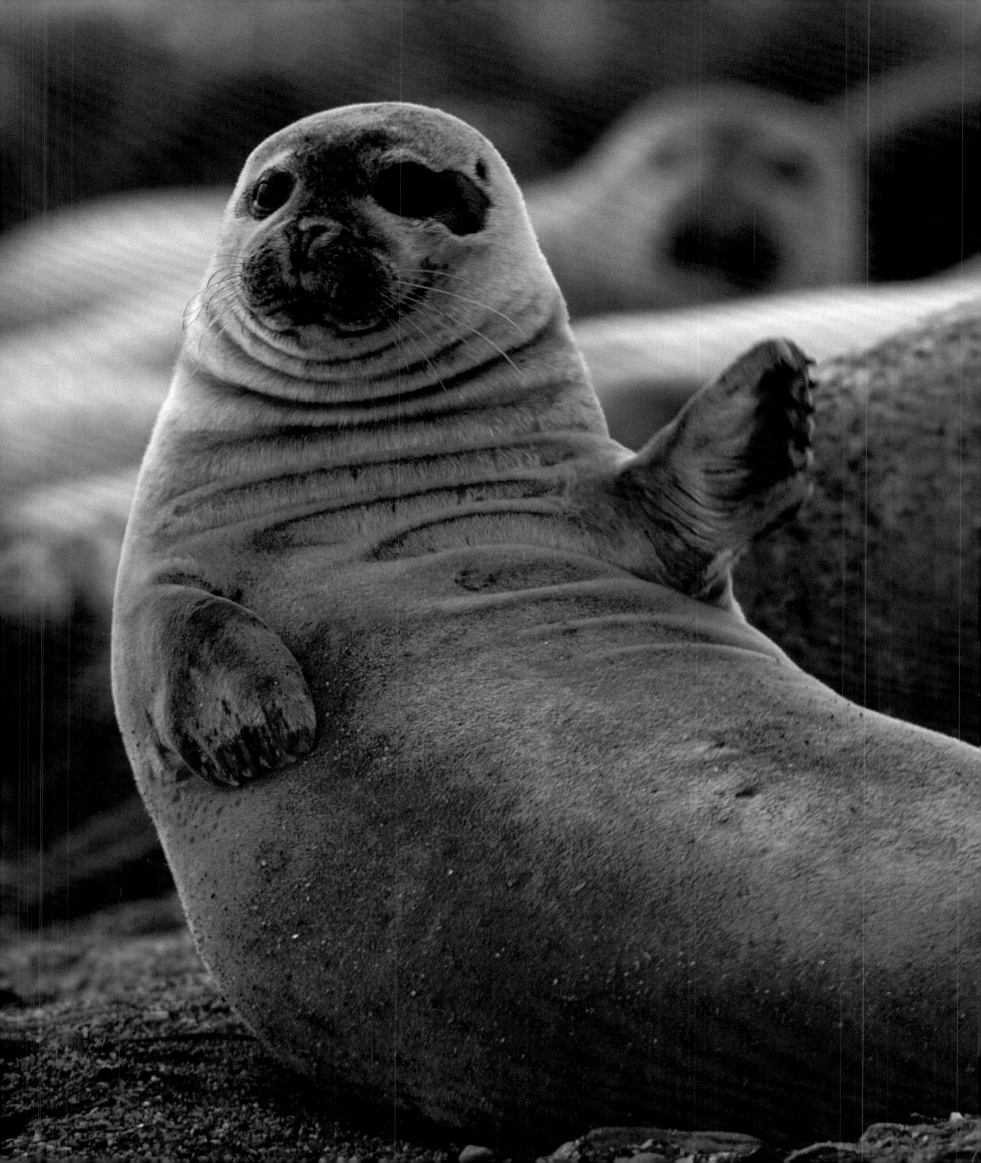

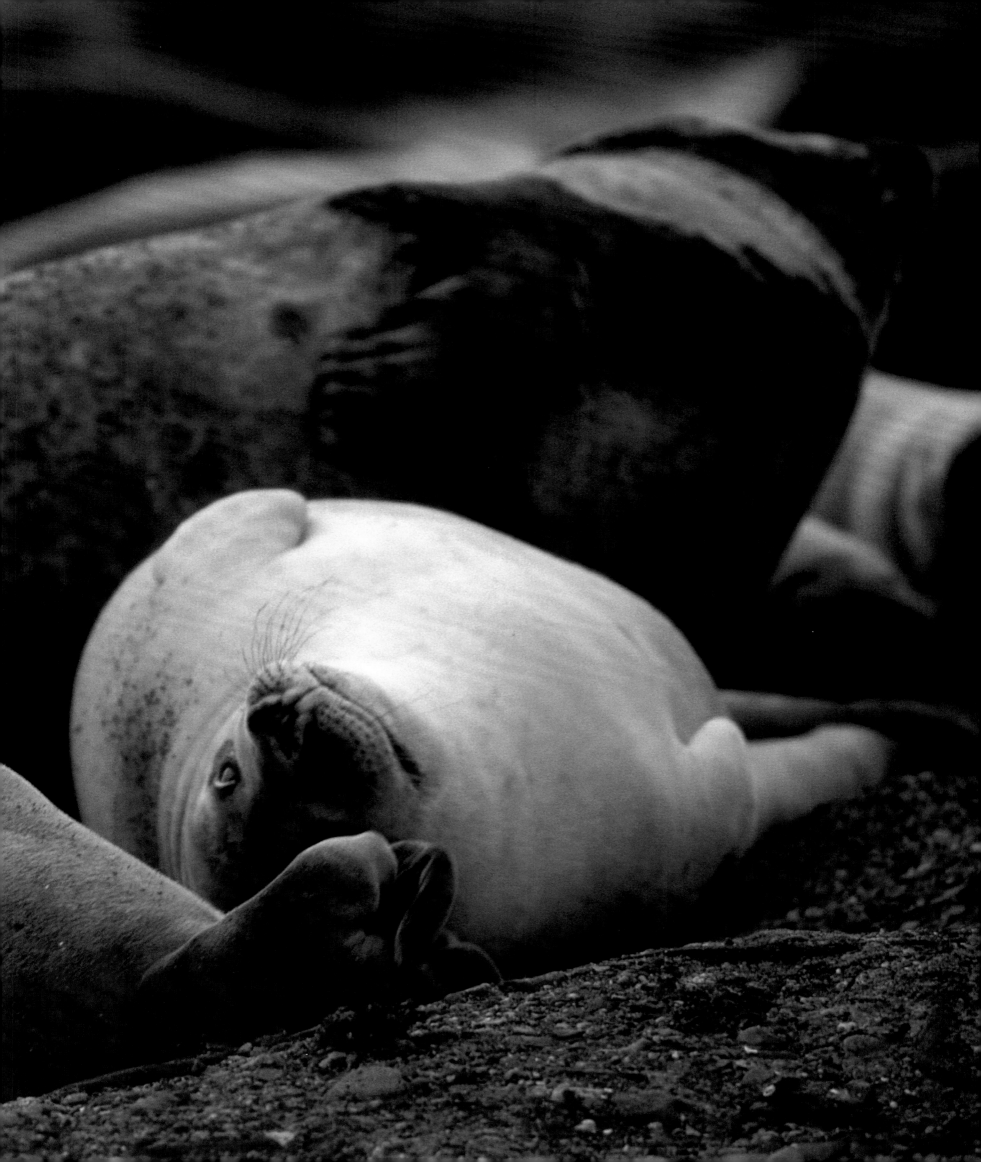

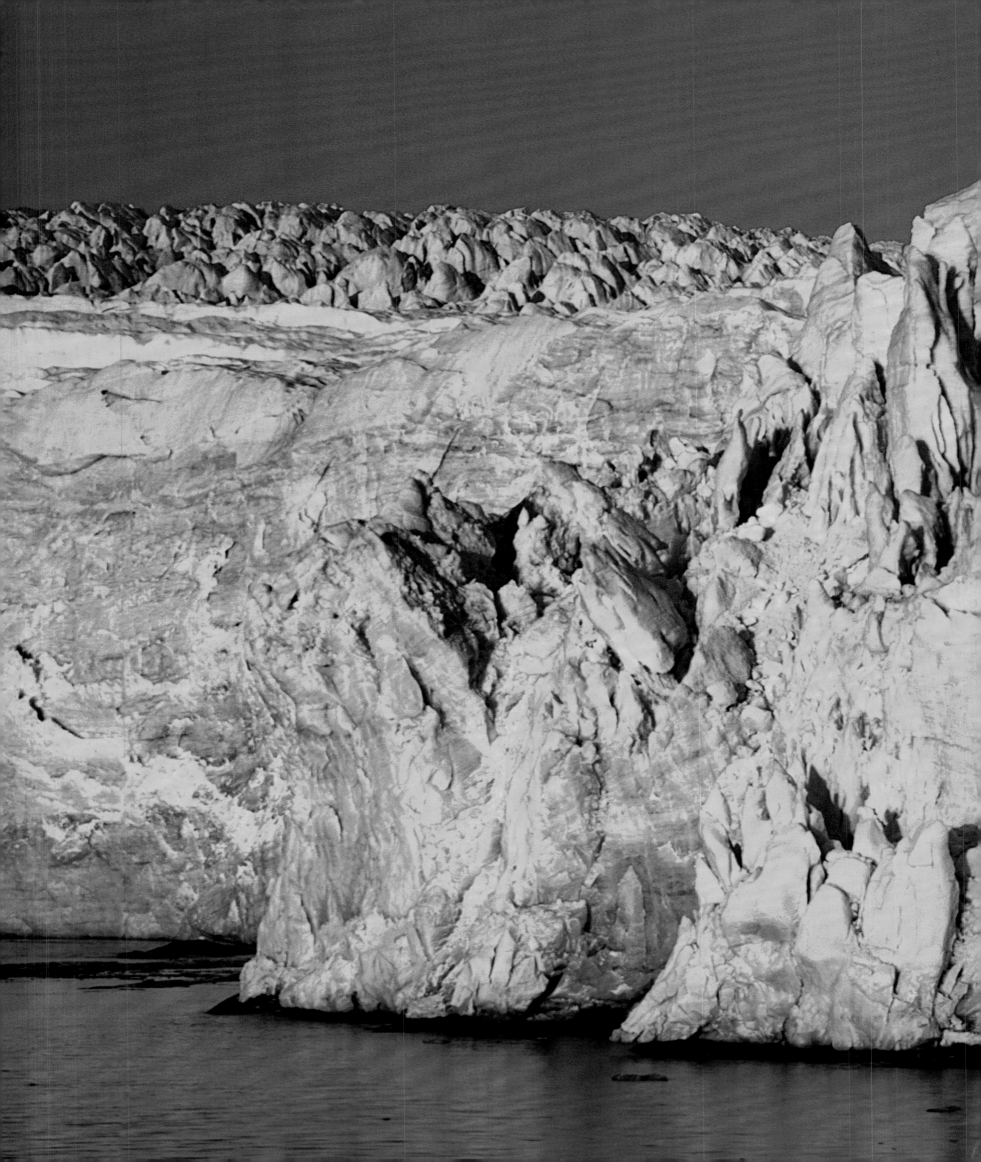

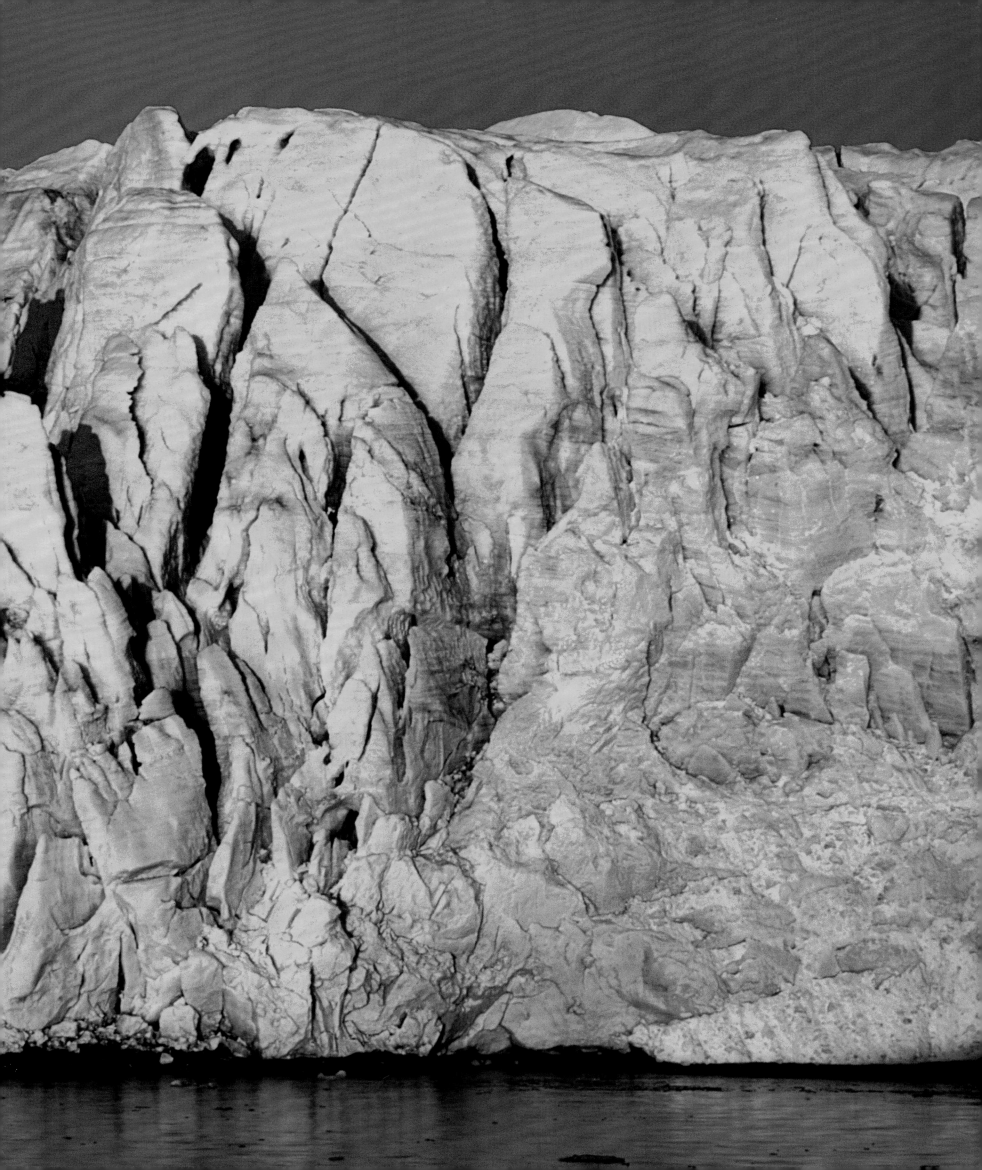

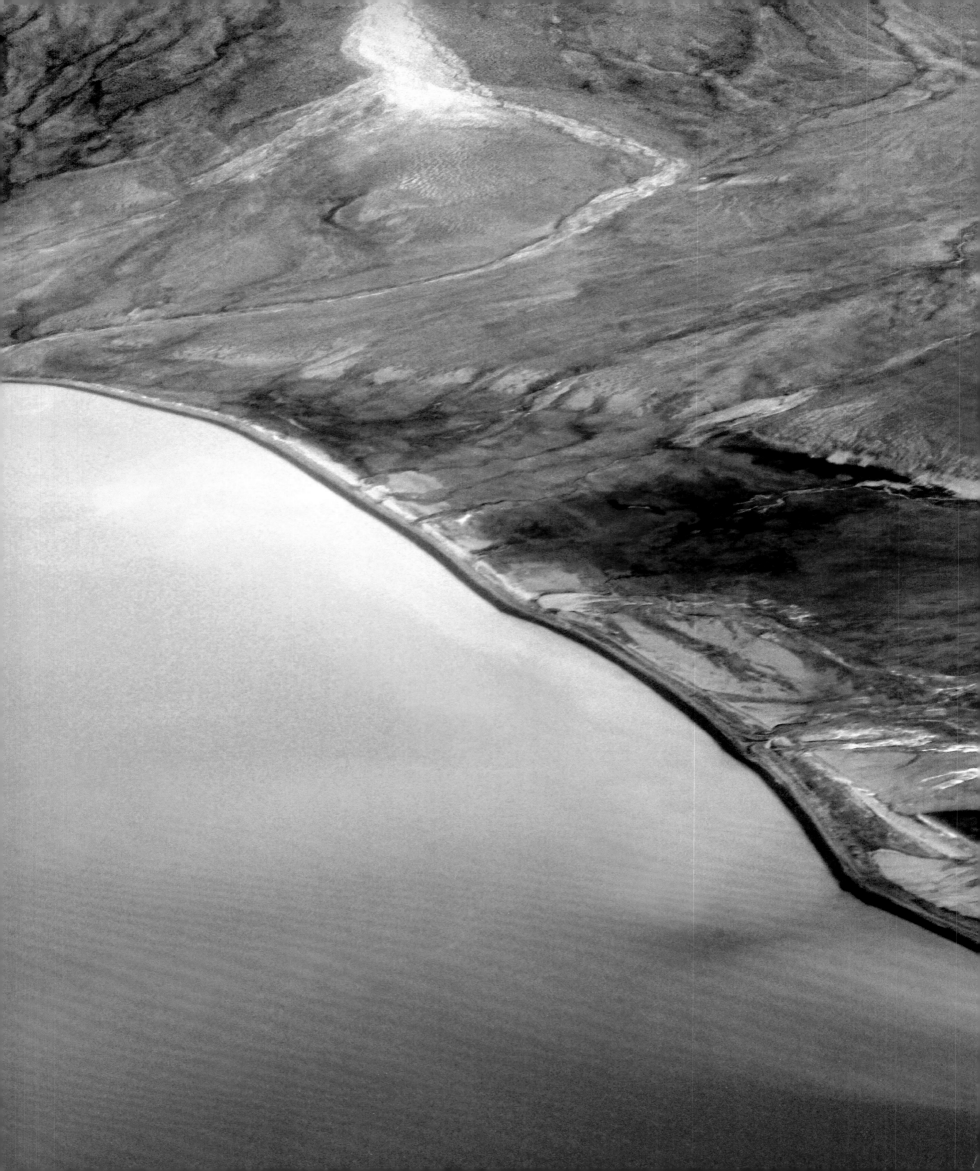

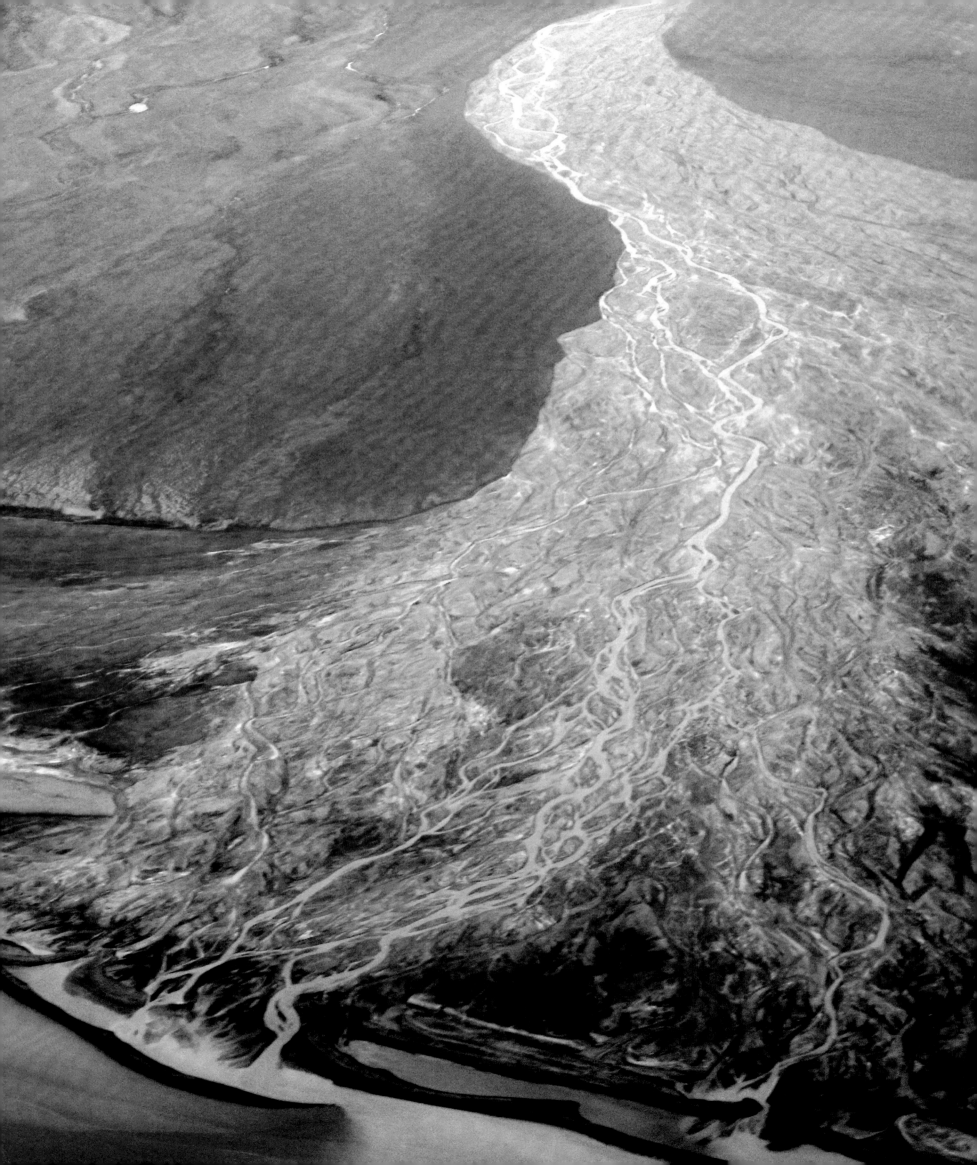

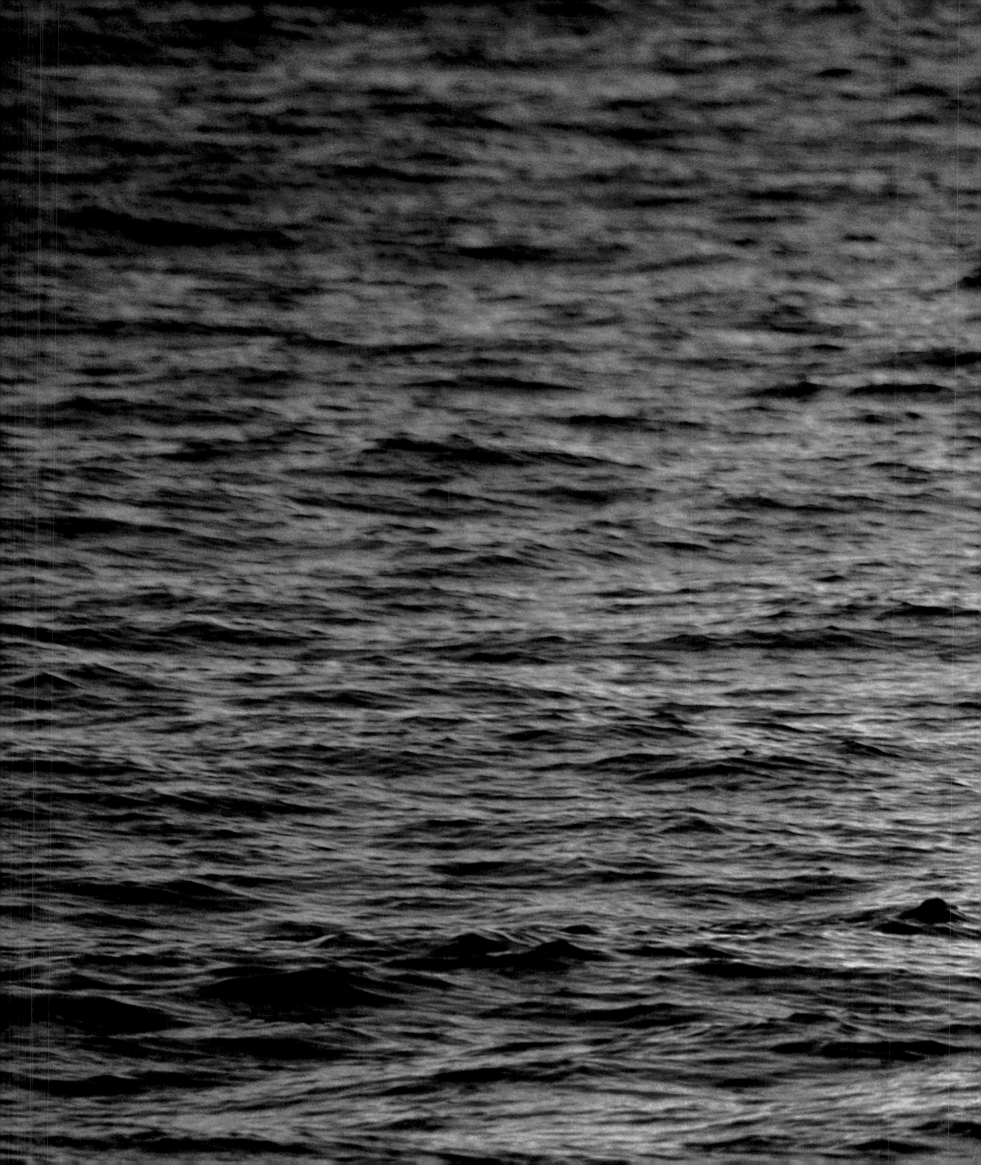

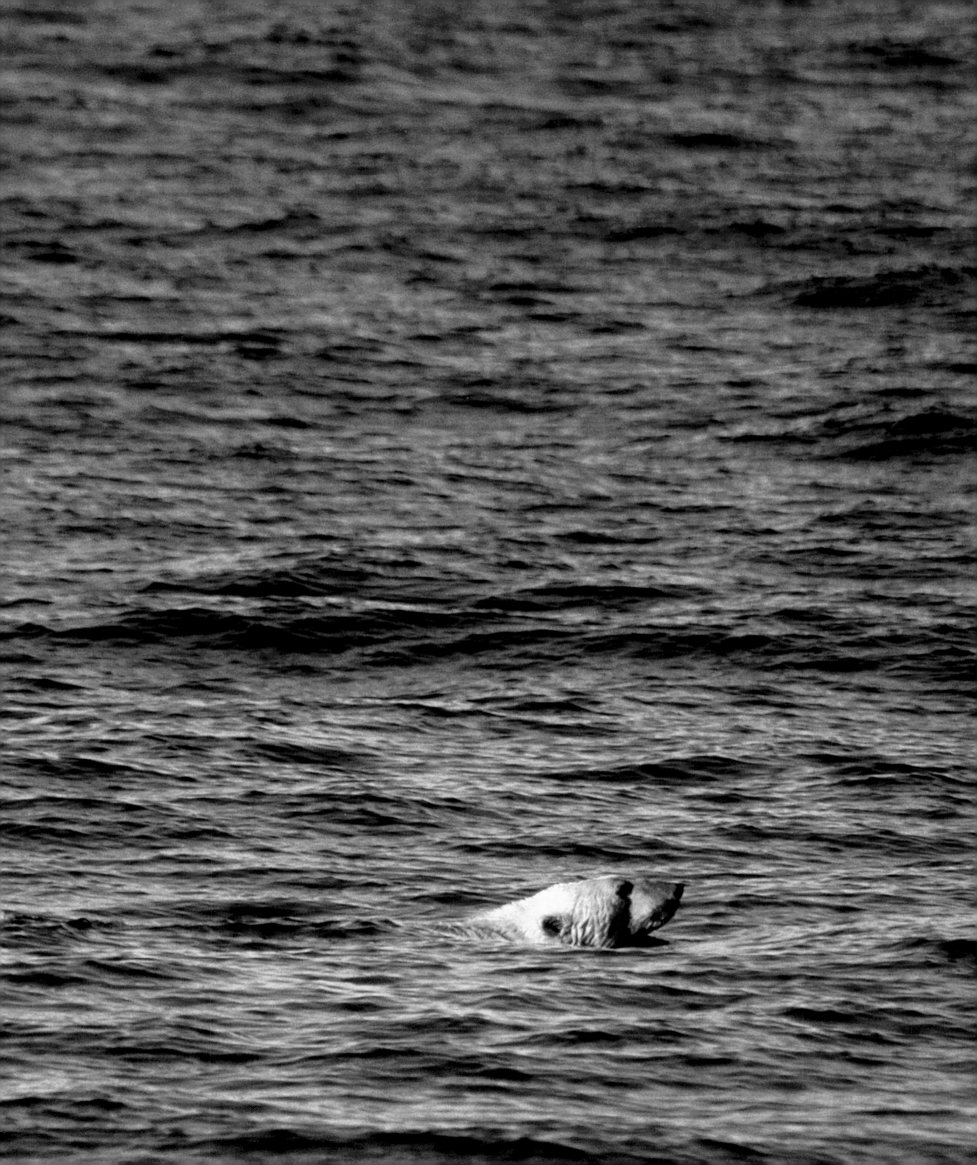

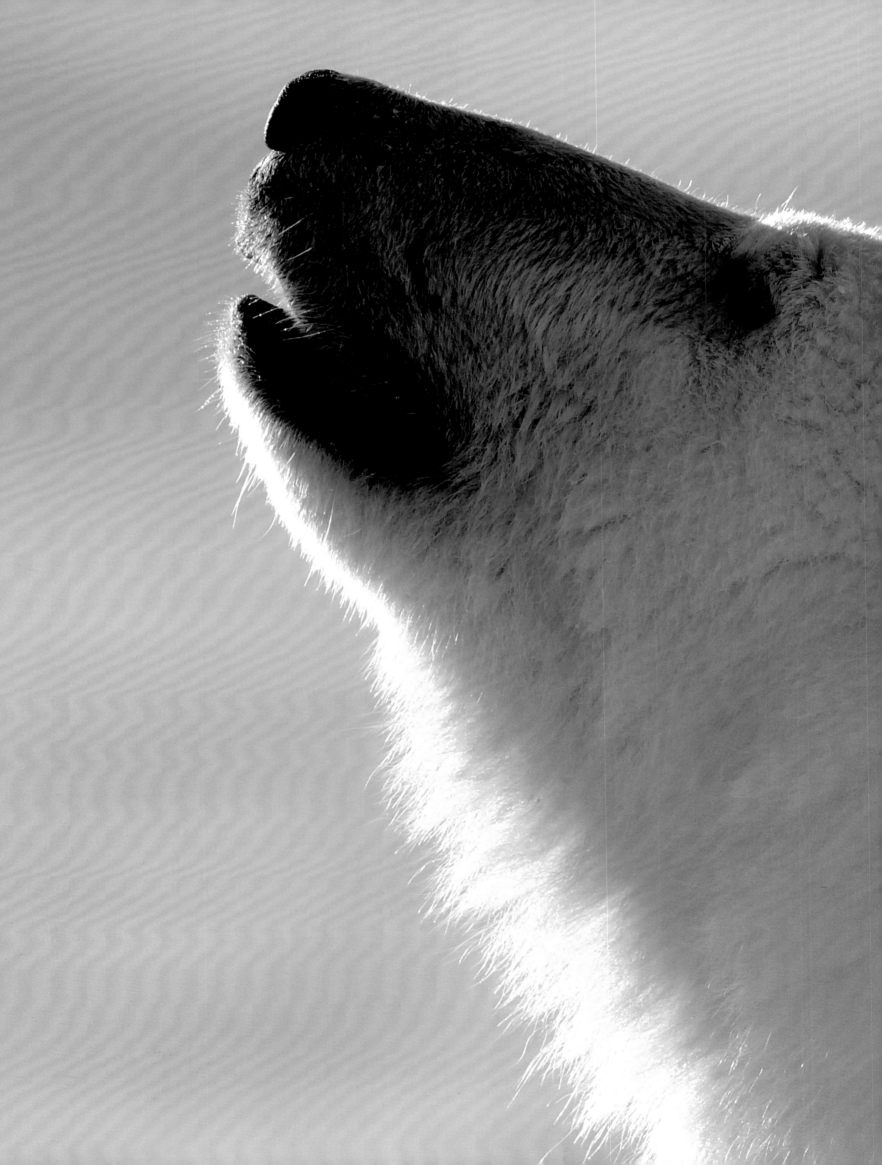

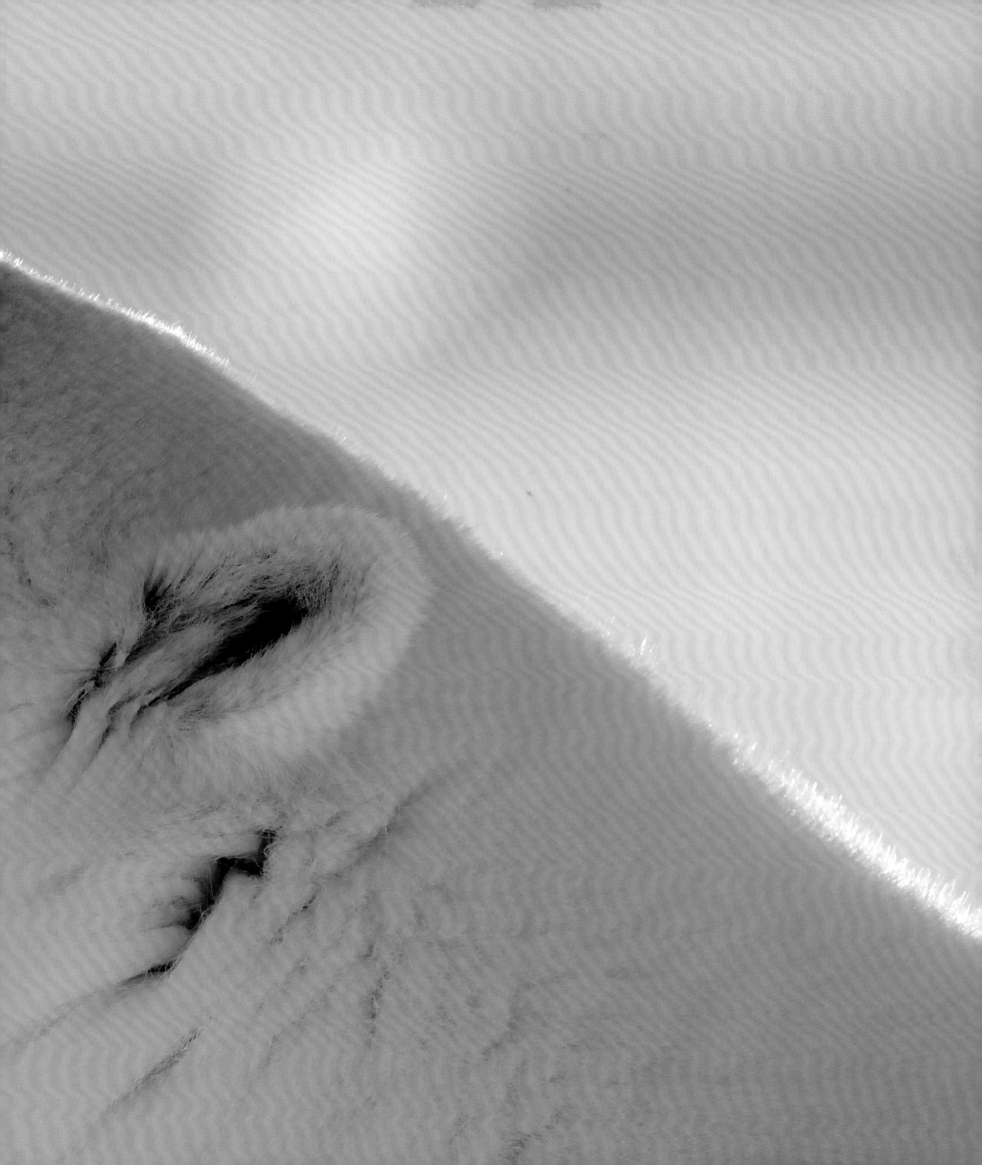

work on ice

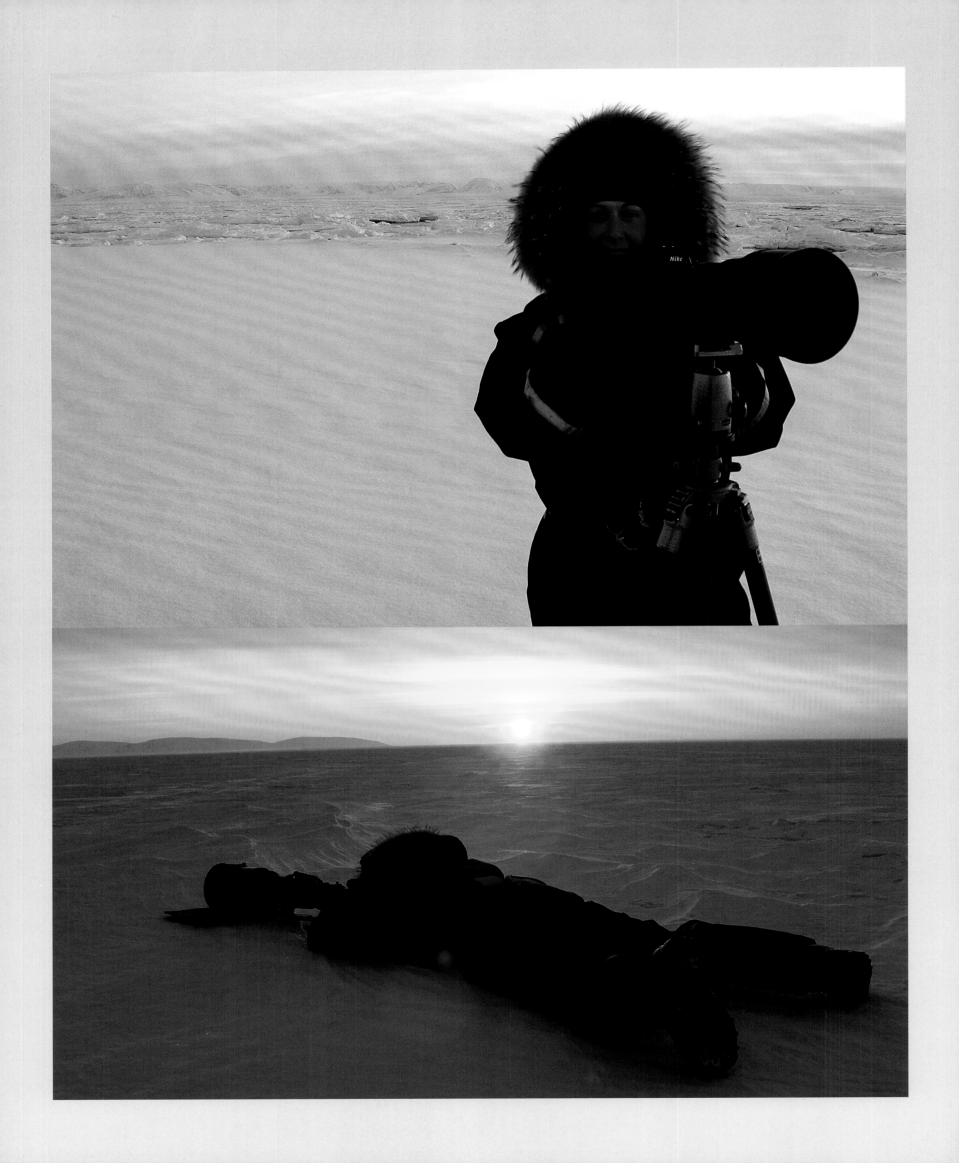

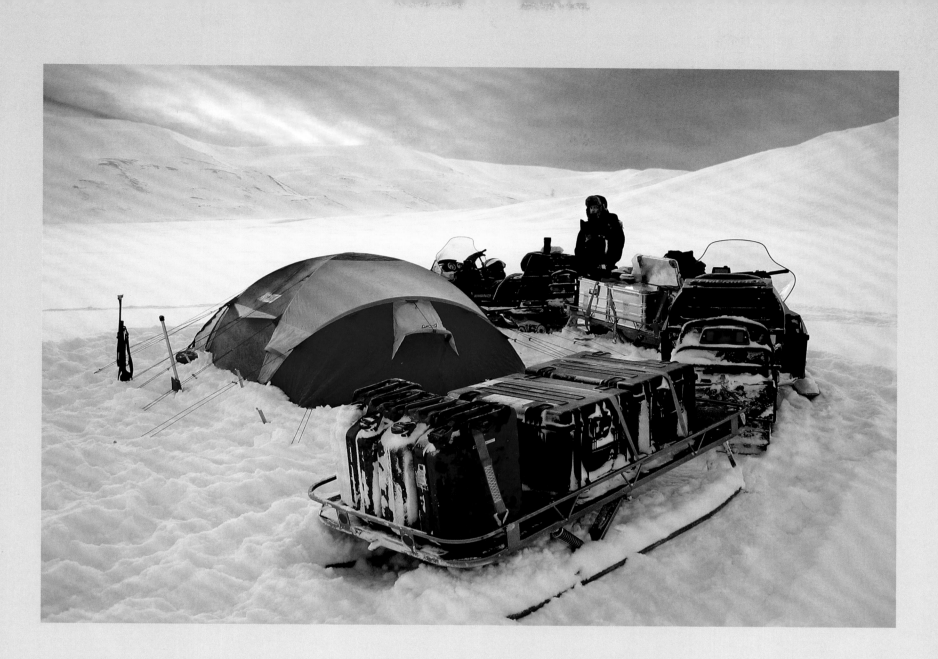

In 2001 we embarked on our first expedition for this project. Since then we have spent more than a thousand days in the field. It has been a few years of plenty of hard work, some blood, a lot of sweat, a few tears, and tons of laughter. We are humbled by the privilege of getting to know the Arctic, this wild, white world, so deeply. We sincerely hope that, through this book, we have been able to share some of this privilege with you. Our goal with *Vanishing World* has been to produce a witness's report on the state of the earth from its summit.

The most difficult task of all, perhaps, has been to compile this book. We have had to choose among memories of sunsets, seasons, wildlife encounters, and whiteouts. Experiences of a hundred lifetimes, life-changing experiences from the pack ice and tundra, compressed into five years, and those years compressed into the pages of this book.

Although Mireille is the photographer and Fredrik the producer, working in the high Arctic is a huge workload, and we share it equally. The planning of a long winter expedition takes months. This takes place at our base in civilization, Stockholm, Sweden. Logistics, including snowmobiles, helicopters, and air cargo. Equipment, such as satellite communications, weapons for self-protection, clothing, and all camera gear. Daily checks of ice conditions, and specific

planning of where to go in order to document what. All this is done together. We are each other's left foot and right hand. Who handles what depends on the mood of the day. Planning for a long expedition is like preparing for war. Once we embark on a new mission, leaving civilization, or our helicopter drop-off spot, with thousands of pounds of equipment, it probably looks like we are going to invade a country. Nothing could be further from the truth.

To fully grasp and communicate the complexity of the scenery and wildlife we are documenting, we work according to the notion that nature needs time. And nature doesn't take direction, so getting the shots Mireille is looking for often requires a great deal of patience. Getting the right shot from the right angle with the right light can sometimes take months.

We always collaborate closely with scientists in various fields, whether we are working with glaciers, polar bears, birds, or whales. We often follow research in the field, and the expertise of scientists gives us a solid foundation of knowledge. Our goal is not only to entertain and evoke feelings, but also to visualize difficult and complex questions and make them easier to grapple with. The fantastic support of the many scientists we collaborate with is one of the backbones on which we base all of our work.

Photography

For a photographer, the greatest challenge is probably to photograph white on white. Or black on black. The high Arctic offers both, and just about everything in between. Sometimes all this in just one day.

The camera cases we take on an expedition hold Nikon D2X and F6 camera housings, a wide range of Nikon lenses (up to 600 mm), plus teleconverters. Mireille uses steady aluminum and carbon fiber tripods from Gitzo, often paired with a Wimberley gimbal head. We use portable hard drives to store all digital material and carry a stock of slide film, mainly Fuji Velvia and Provia. Some of the images in this book were also taken with a Mamiya 7 II medium-format camera.

Just as we have evolved over our years on the ice, so has technology. To start with, Mireille's photography was all done with film, with robust and reliable Nikon F5 housings, which still work like a dream. At the beginning of the project, Mireille tested a number of different digital cameras; however, none were up to par with the F5 and traditional film. But then came our great partnership with Nikon Europe, the Nikon D2X was released, and things started to change. One concern about using digital cameras was how the technology would cope with the cold. This has not been a problem. The main problem with Arctic conditions as far as camera gear goes is taking care of all the batteries and keeping them warm. Sure, a lens or two has cracked on an extremely cold day, but for the most part, the camera equipment seems to enjoy the work as much as we do. However, a fully charged battery can wear out in just a minute if exposed to the wind and cold.

Most of the work Mireille does now is done using the D2X; some is done using film and the F6. In certain situations and settings Fuji Velvia film still surpasses digital.

Isolation

To cope with the cold of the pack ice, we have to make sure we are equipped and clothed for the worst-case scenario. We often have to deal with extreme conditions and situations. With the chill effect, temperature and wind have often produced effective temperatures of -110°F. But with time you become one with it. After a long spell in the field, on the ice, in the snow and cold, you are a part of the system. Adapted. The extreme becomes your norm.

The Arctic tundra and pack ice is a lonely place. Our expeditions for this five-year project have often lasted months. One year, 2003, we spent ten months more or less nonstop in the field. Spending a thousand days, and then some, in total isolation with someone is special. We know each other's poker faces, and all those bad jokes. We hear each other's thoughts and communicate without actually speaking. Isolation can be the greatest gift or the biggest punishment. We have sought the isolation, and will continue doing so. The feeling of being one with nature, when the only sound is that of the high Arctic wind, is bigger than life and cannot be described in words or even in photographs.

Isolation at its extreme comes when a long-lasting snowstorm hits the area we are in. We have sometimes had to spend weeks in our camp, barely able to go outside, except to do some digging so as not to become buried in the snow or lose our snowmobiles. In a severe snowstorm, you can barely see your hand in front of you. When it is as bad as it can get, the only thing to do is to sit tight and be patient.

Everyday life in the field is a lot of work. To get water we use glacier ice when we can find it; otherwise, snow. Cooking, doing the dishes, staying clean, and using the toilet—routine tasks that go without saying in civilization—become a huge part of daily life in the field and take up many of our waking hours.

Interaction

What is perhaps most rewarding about our work is getting to know the wildlife so intimately.

Our first close encounter with a polar bear could not have happened sooner. It was on the north tip of Spitsbergen during the initial night of our first winter expedition. After driving all day and all night over glaciers, high mountains, and what seemed like eternal screw ice through the sixty-five-mile-long fjord of Wijdefjord, we stopped at an old trapper's cabin to eat and rest. Built from Siberian driftwood in the late 1800s, the seventy-square-foot cabin didn't fit more than a stove, a table, and a bunk bed. Its only tiny window was nailed shut with wooden planks to keep polar bears out. We had a meal and lay down to rest. Fredrik was on the top of the bunk bed, a coffinlike space with only a foot of air up to the ceiling. Suddenly we were awakened by a polar bear on the roof. The ceiling sunk under its weight, almost breaking Fredrik's nose. The bear was trying to smash through the cabin as if it were ice and we were seals. A few minutes of complete chaos followed, with the bear trying to get in from all sides, attacking the walls and window. After a way-too-close face-to-face confrontation outside the cabin, and a flare-gun shot between the bear's legs, we were able to scare it off. As the bear ran away, we realized that although it had missed us for dinner, it had at least gotten something to eat. The leather seats of our snowmobiles were chewed up, totally demolished. We had a long winter thereafter, with rather uncomfortable driving. And the bear probably had a few days of indigestion. No winner there.

Since that first meeting with a polar bear, we have met hundreds of them. The first bear was a hungry and aggressive young male, and they are usually the ones that can be unpredictable. Around the camps or cabins we stay in, bears are a part of everyday life. One winter we had about thirty bears investigating our camp in just one week, four or five of them coming up close every night. We then discovered there was an abandoned and still-open bear den only a hundred yards up the hillside. Its smell was a magnet for all bears passing by. Polar bears are like human beings. They are all different, individuals. One thing most of them have in common is that they are very curious. The world they live in is all ice and snow. If they see or smell something that doesn't belong there, which they are able to do from many miles away, they want to investigate and see what it is.

The polar bear is regarded as the most dangerous land-living predator on earth, if we count ice as land. Inuit elders say that a polar bear can hear your thoughts. "Don't think ill of the bears," they warn, "for that might make them angry." A polar bear about to attack

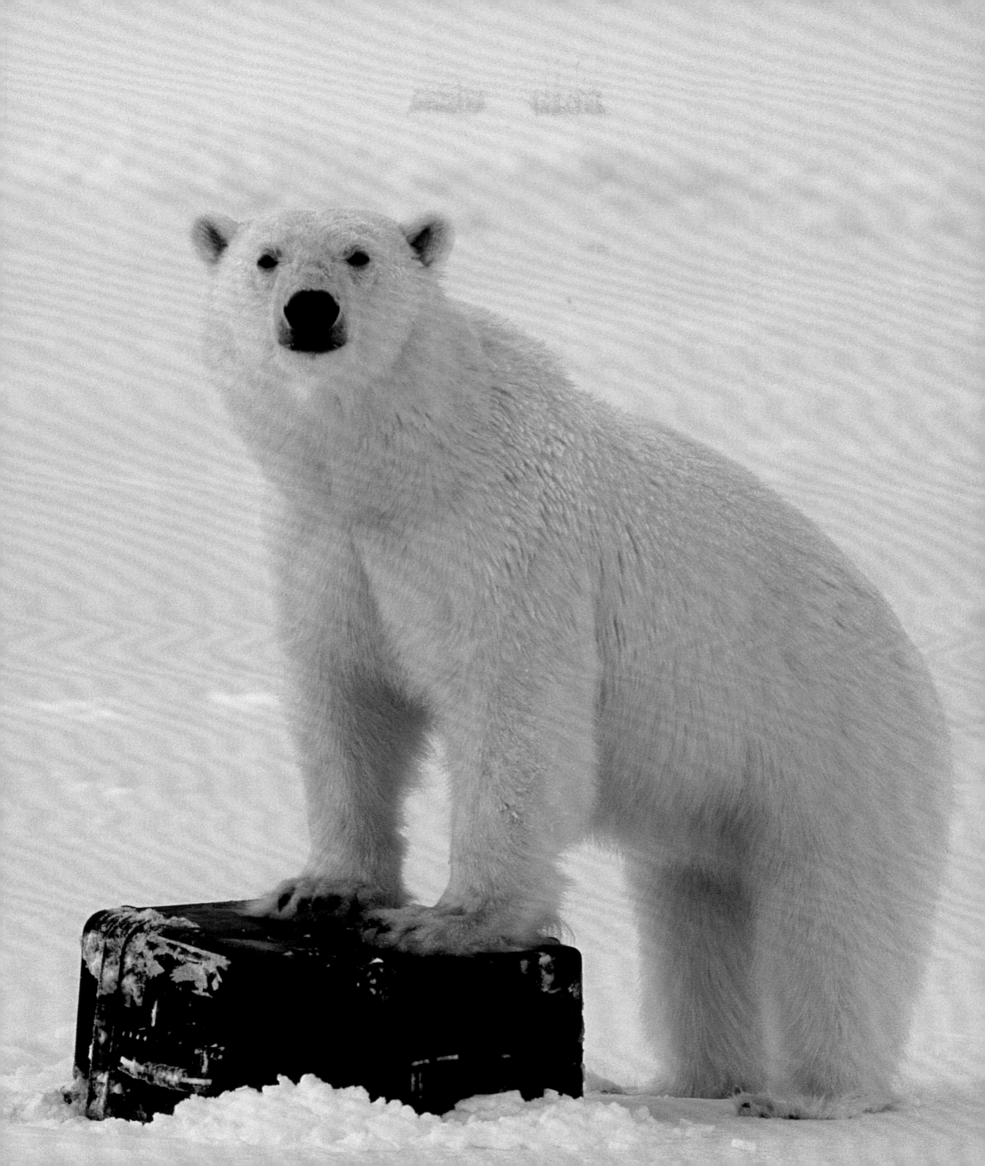

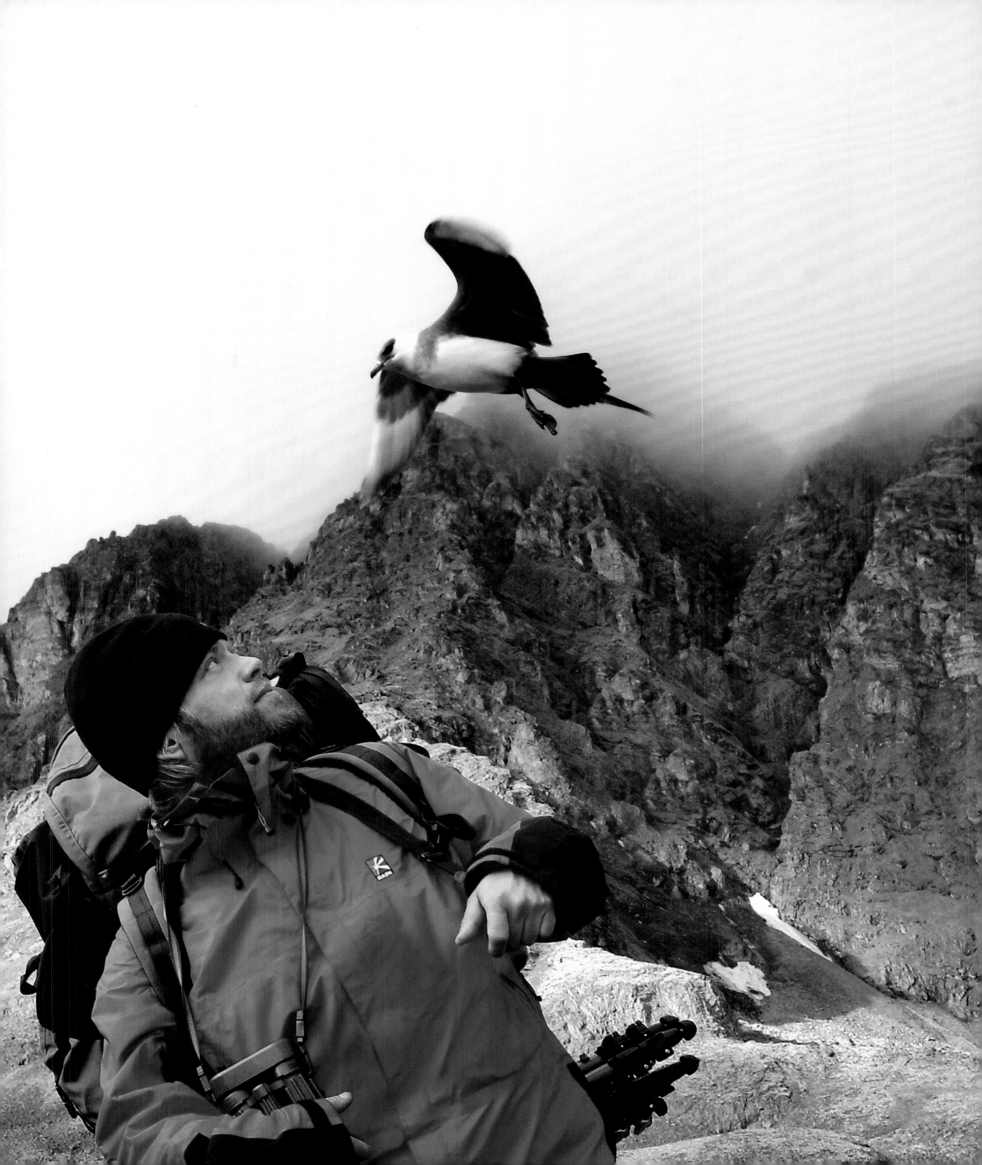

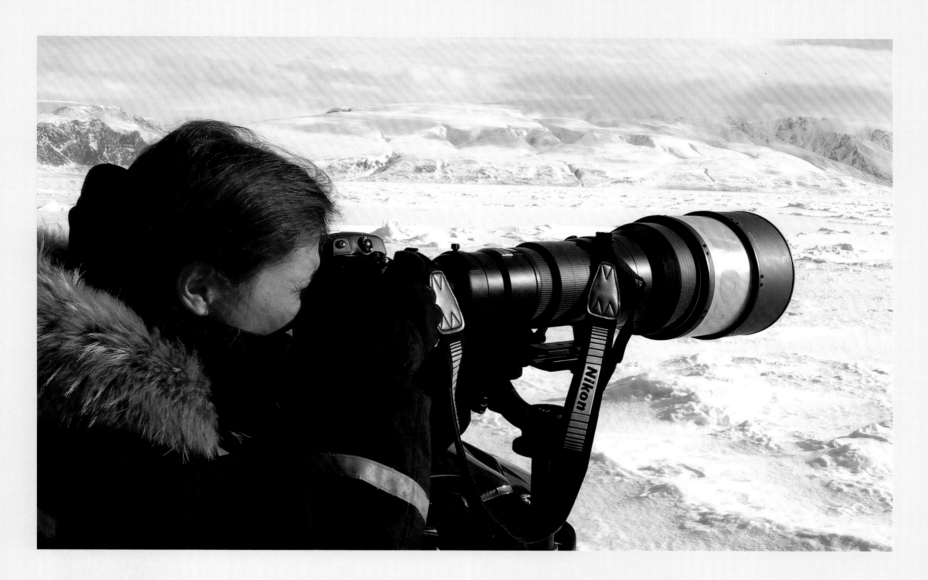

hisses and snorts to show aggression, lowering its head. When it attacks, it can reach a speed of thirty miles per hour. So it is important to be able to read a situation and what might happen, before the polar bear does.

Through our experiences and many encounters, we have learned a lot about how to live and interact with the white bears, how to read their behavior and act accordingly. But we have also learned from others, such as Dr. Nikita Ovsyanikov, a polar bear scientist who works on Wrangel Island, in the eastern Russian Arctic. One aspect he studies is the social life and behavior of polar bears. For many years, he has walked among the bears unarmed, except for a long stick, which he uses to scare bears that come too close. We would not consider going out in the field unarmed, but Nikita's way of thinking has taught us a lot. He says that to be able to study the animals as they truly are, you cannot disturb them in any way. You have to become one of them, and act just as they do. For wildlife photography in other parts of the world, it is common to hide. But it is completely impossible to hide from a polar bear. It will discover you many minutes and miles before you discover it.

We have had many interesting meetings with wildlife. Such as the one with two Arctic foxes, one blue and one white, who were fighting each other over territory; our campsite seemed to be the castle of their kingdom. We are used to being awakened by polar bears, but here, the two foxes were sitting outside every night, bark-ing at each other like dogs. This resulted in some great photographs, but very little sleep.

Another time we had followed a polar bear, a big male, for more than two days. Just as the bear had finished eating its latest kill, from far away, and running like it was the Olympics, came a little fox. The bear left, and we felt it was time to leave our friend the bear and look for new things. After we packed our gear and started driving, the fox ran after us. For the whole day and night, as we continued working over a vast area on the pack ice, the fox followed us, completely unafraid, always sitting very close, constantly observing us. In winter, some foxes follow polar bears to feed on the leftovers of seals. This fox obviously thought we had killed that seal it came across earlier and was waiting for us to make the next kill. Eventually it got bored, walked up to an open bag of exposed film that was lying on the ice, grabbed one of the rolls, and ran off. Fredrik, with ten layers of clothing, size 15 boots, and a heavy rifle on his back, ran after it in the deep snow. After a few hundred yards of shooing and throwing gloves and everything in his pockets after the fox, Fredrik finally got it to let go of the film.

That is one thing we have learned—all animals are individuals, quite different from each other, and many of them even have a sense of humor. And some are thieves.

On winter expeditions the two of us tend to work alone in the field, with no assistants. Working with wildlife, less is definitely more.

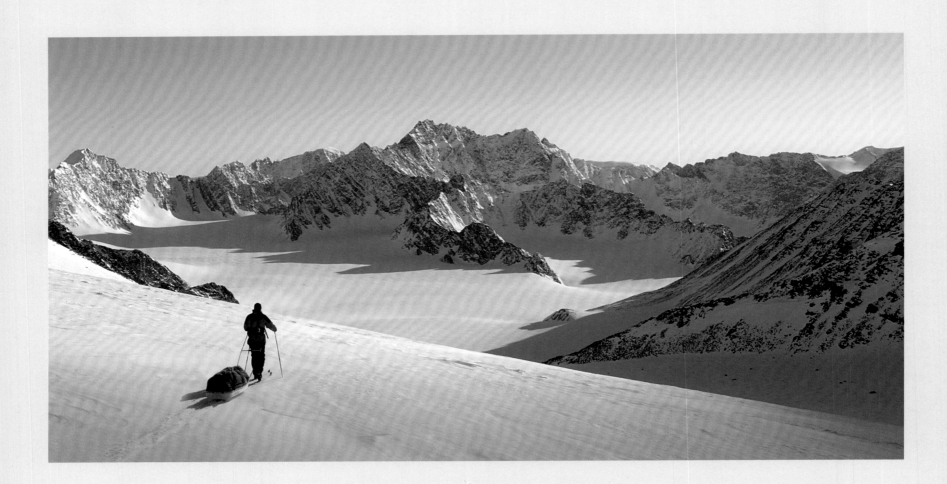

The bigger and louder you are, the smaller your chances of getting close to and acquainted with the animals. Our objective in photographing wildlife is to work with it as undisturbed by our presence as possible, in its true environment. We always work in the animals' own environment, and if they show stress or any signs of being disturbed we never, ever pursue them.

Travel

Traveling around the high Arctic is an endeavor in itself; it involves snowmobiles, dog sledges, skis, and helicopters. And a lot of walking. Our expeditions often take us hundreds of miles from the nearest settlement. Passing over glaciers full of crevasses and pack ice that breaks up all around you can be risky. But with experience comes knowledge, and the ability to read the conditions ahead. It is all about analyzing the potential risks and, most important, always being prepared for the worst. It is really true that conditions can change in the blink of an eye. A nice sunny day can turn into complete mayhem when you least expect it. We have been fortunate, and have gained a lot of experience through the years. But accidents do happen.

One time, driving back to civilization after a three-month expedition, we had our first, and to this day only, serious accident. As we were driving up a hill, looking for a spot to take a break and have a meal, the ground beneath Fredrik's snowmobile suddenly disappeared. There was a twenty-foot-deep crevasse that had been hidden by a thin layer of snow. Fredrik crashed into it and landed with the nose of the snowmobile straight down. The sledge behind carried almost a thousand pounds of camera gear and gasoline, and

it landed on his shoulders. Fredrik's back broke in a couple of places, and his left forearm was crushed. After a helicopter rescue operation, extensive surgery, and half a year of rehabilitation, we got back on the horse again. There is a lot of metal in Fredrik now. If airport security was a hassle before with all that camera gear and film, we now try to show up at check-in earlier than ever.

Each and every photograph in this book is associated with a memory, some sad, but almost all happy and warm. What we did, where we were, the events that led up to the photograph, and what happened thereafter. A five-year-long film that will play in our hearts forever. Life on ice is a warming of the heart, an awakening of the mind and cleansing of the soul.

We have a passion for this frozen world. It has become our territory, and we will continue exploring it for years to come. We are now in the midst of field documentation for several additional book projects, which will see the light of day in the coming years.

Vanishing World is not a testament. It is not the final document of this wild, white paradise. We do not think disaster has to strike before the world will turn its attention to the crucial issues the earth faces. We refuse to believe that trends cannot be turned around and people's minds changed. Although we hope this book can be seen as a plea for thought, we do not expect our work to change the direction of humankind. But if one single person comes to the realization that we all need to take action to preserve not only the polar regions, but our planet, we will have succeeded. We hope that person is you. For our part, this is merely the beginning. Our polar journey continues, and we would love to have you with us.

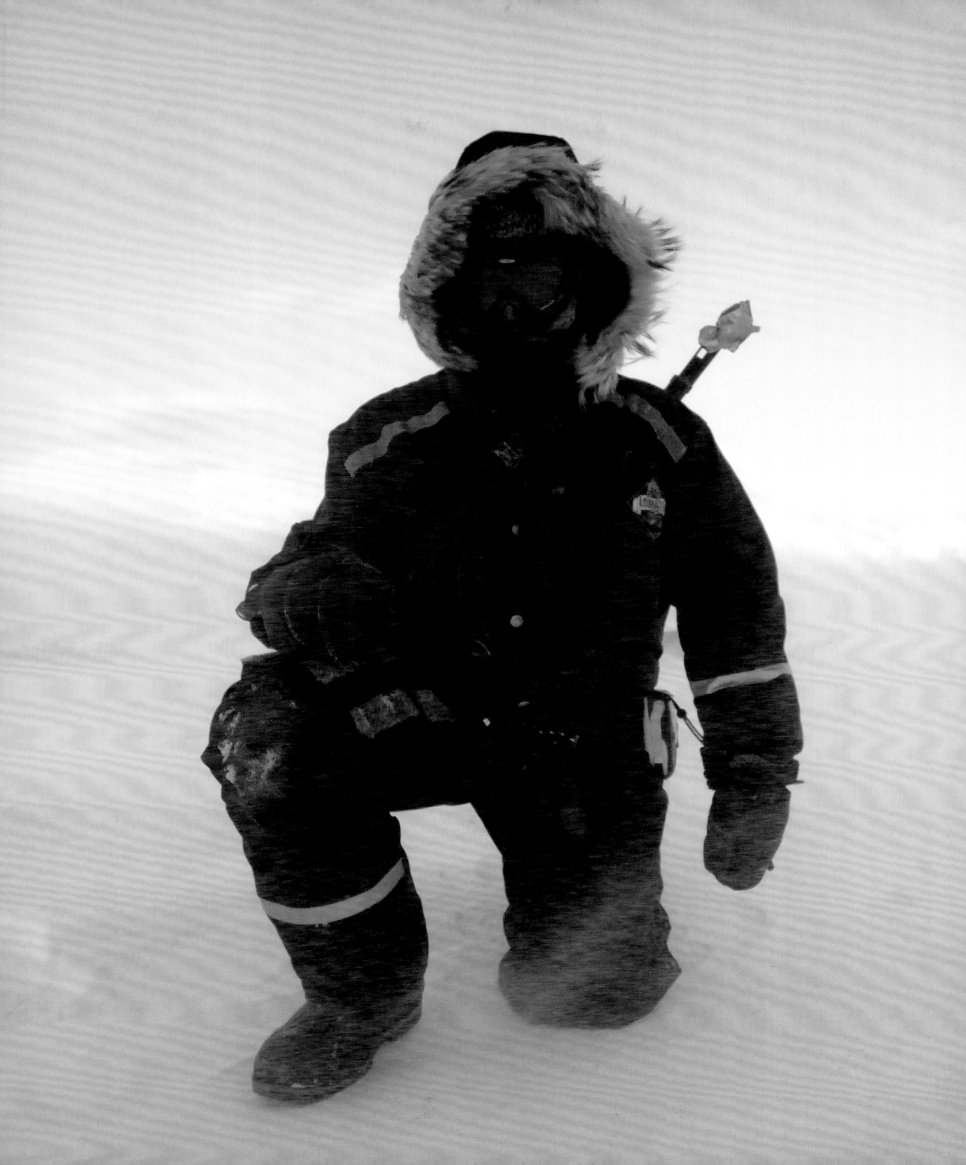

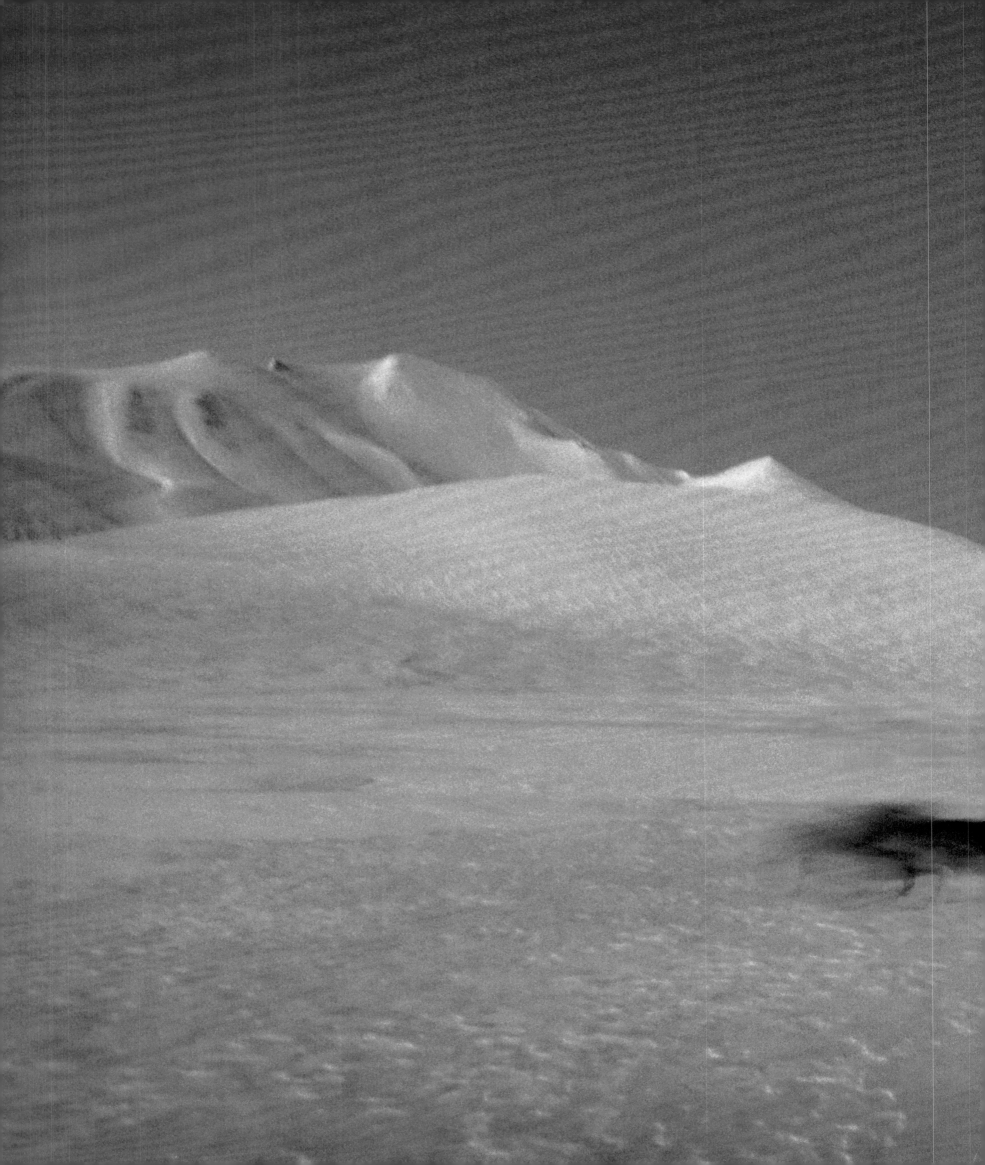

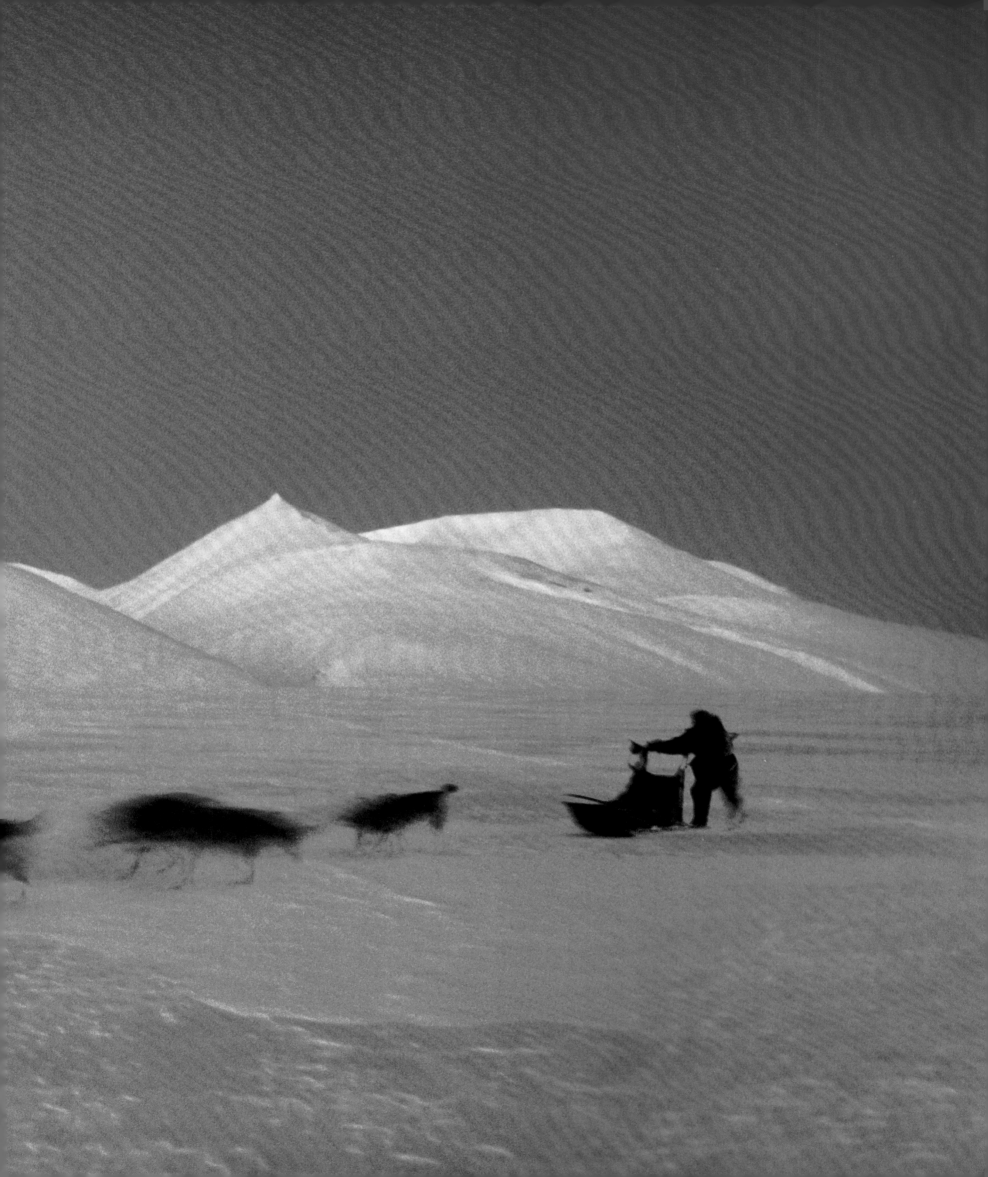

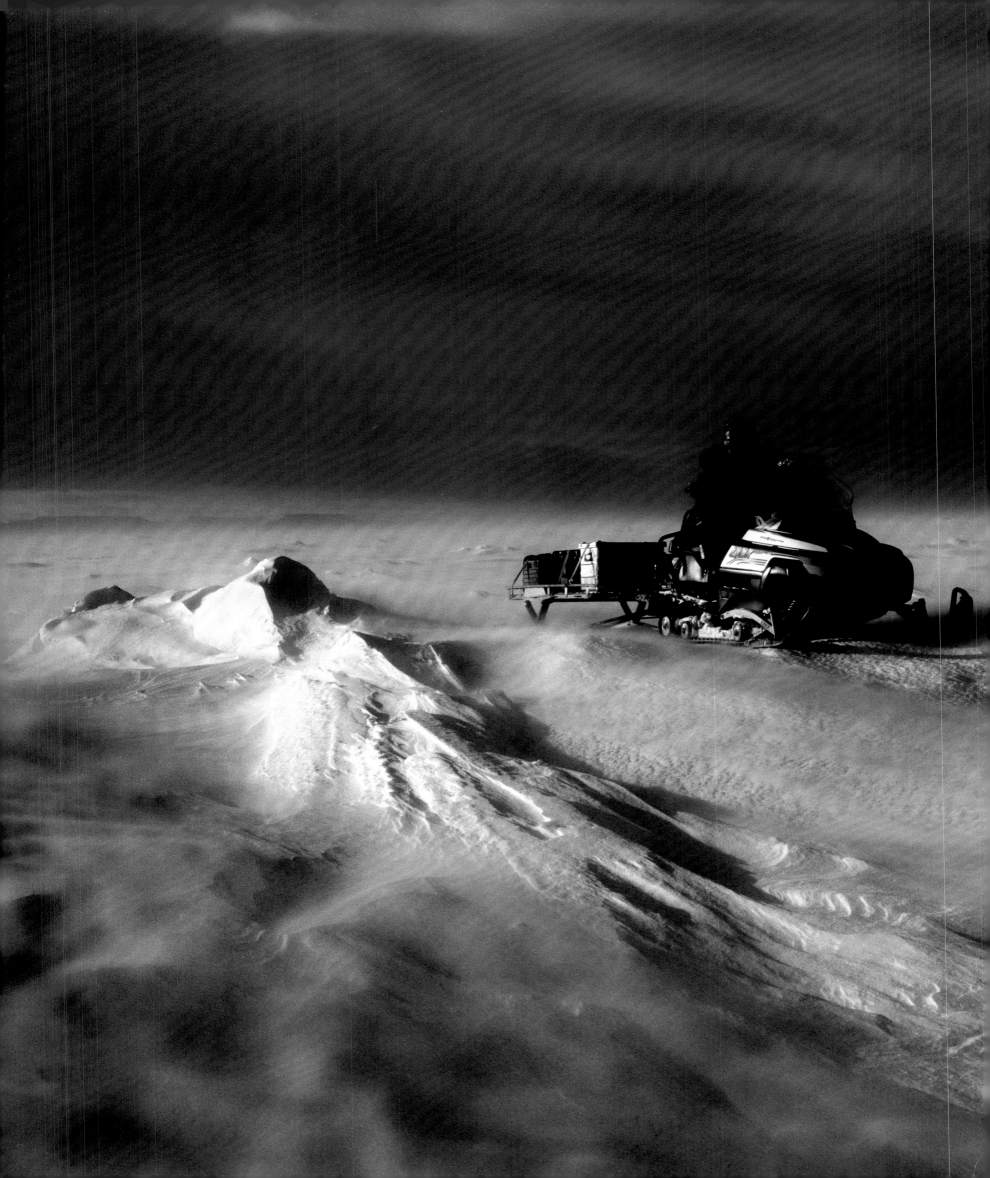

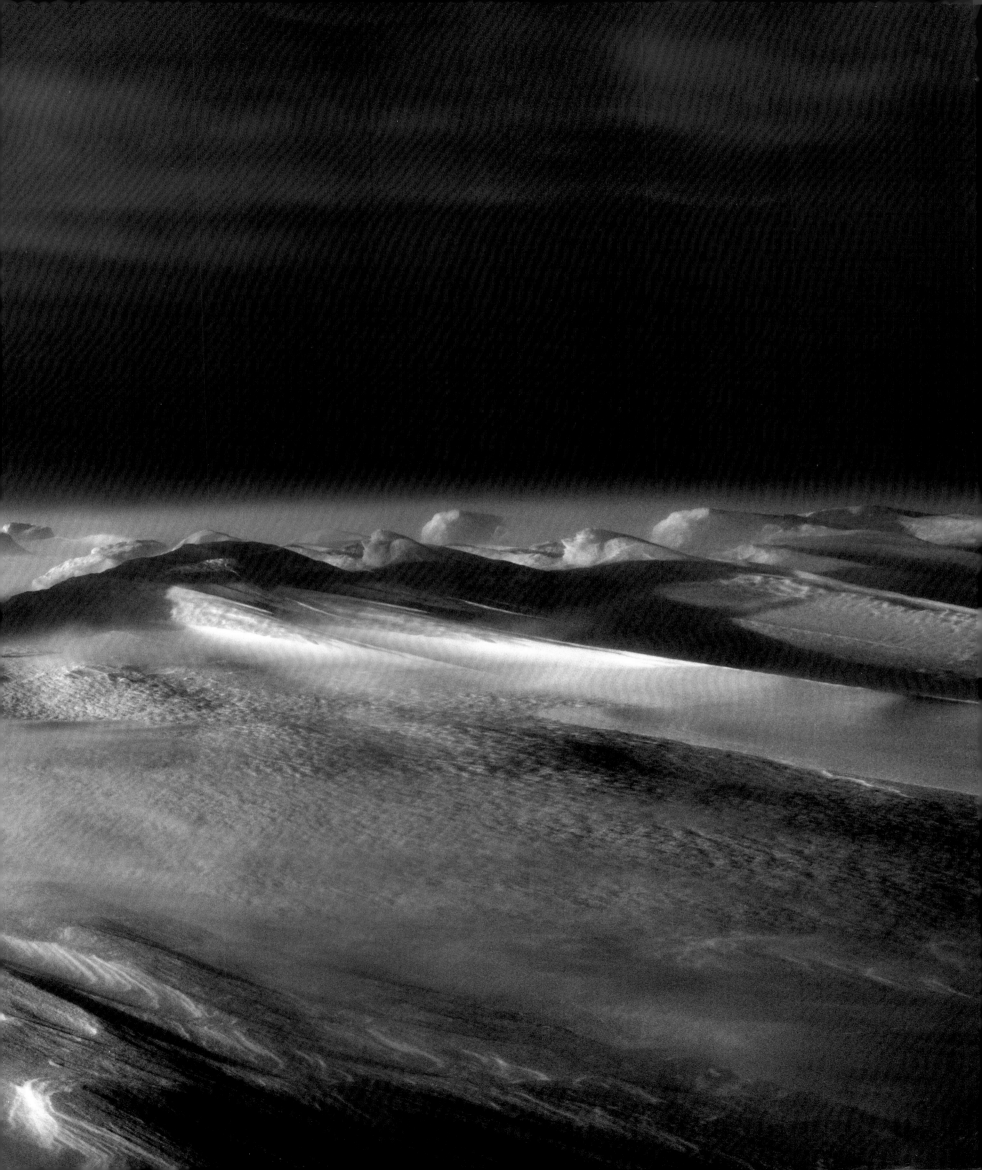

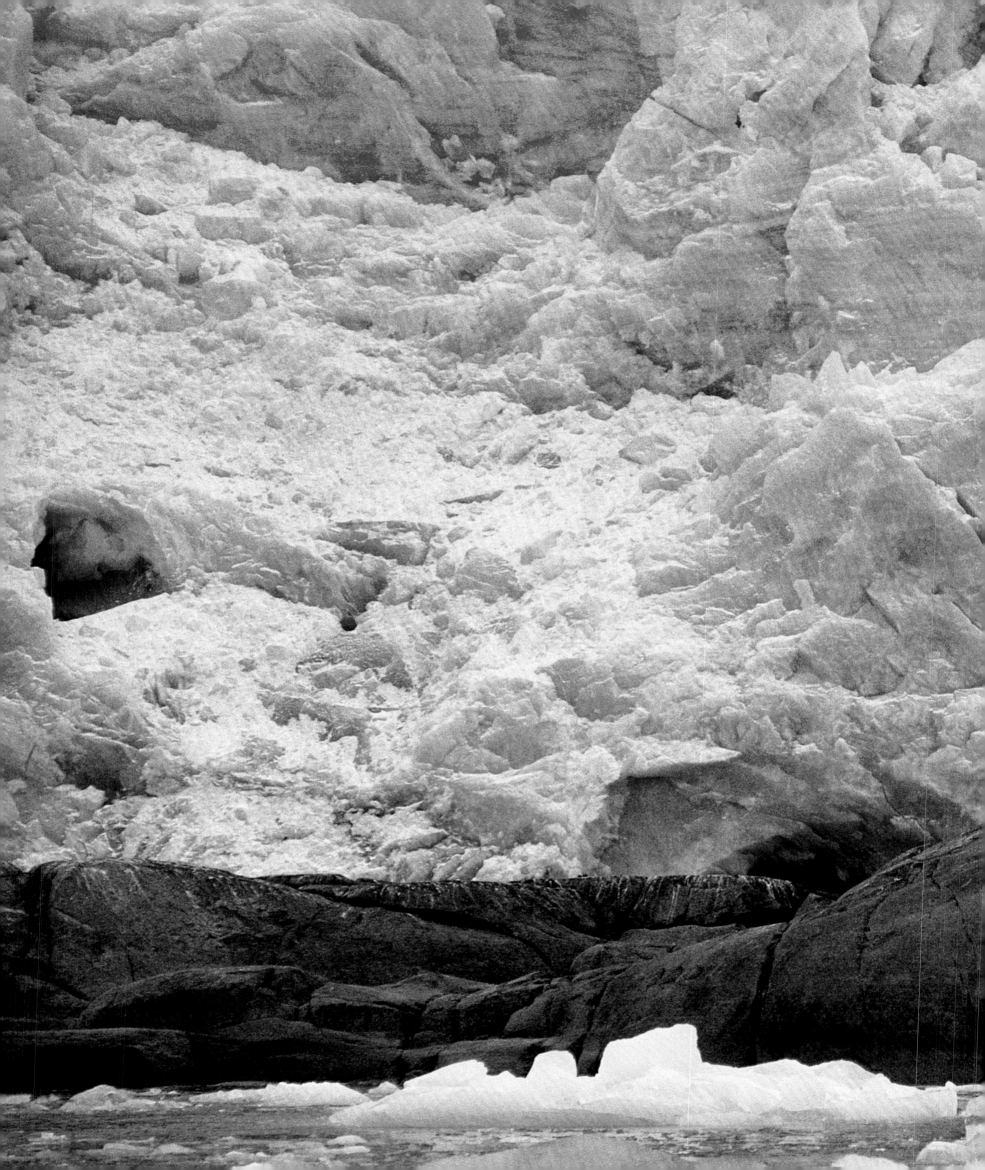

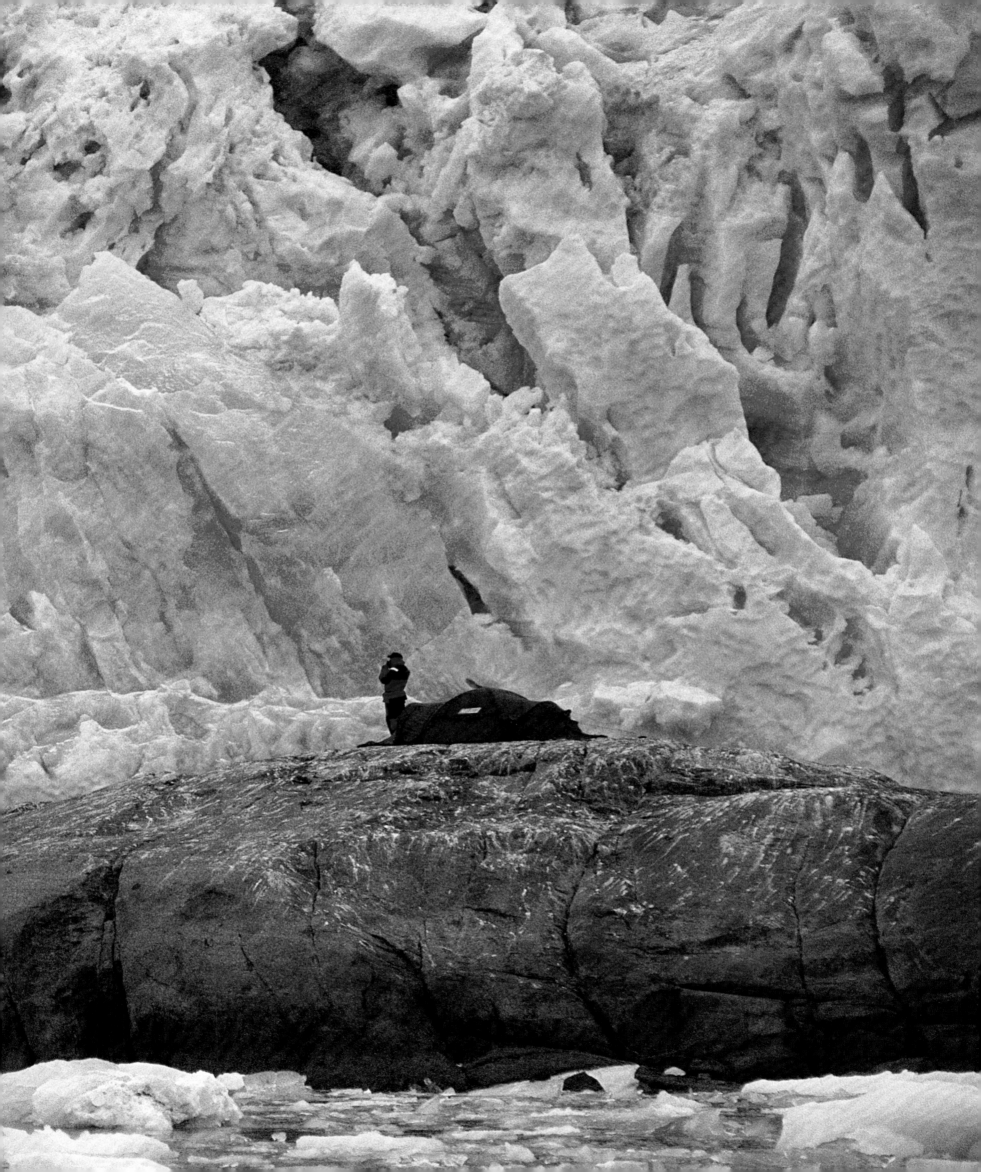

make a difference

We are wearing out our planet's resources. Emissions of carbon dioxide that accelerate the warming of our climate, pollution of air and water, and reduction of the ozone layer; and oil spills, deforestation of our rain forests, flooding due to rising sea levels, and various human activities are having a negative impact on life on planet earth. Now is the time to change direction, and to do that, we all have to be involved.

Not a soul on earth can hide from global warming. It could be the biggest threat humankind has ever faced. We all have the power to make a difference. Small changes in our everyday lives—using fluorescent lights at home, driving less, using less water and less electricity, and choosing environmentally friendly products—are among the many ways to make a difference as individuals.

We can also make a difference together.

WWF International
Av. du Mont-Blanc
1196 Gland
Switzerland
Phone: +41 22 364 91 11
www.panda.org

WWF United States
P.O. Box 97180
Washington, DC 20090
Phone: +1 202 293 4800
www.worldwildlife.org

WWF Arctic Programme
Kristian Augusts Gate 7A
0130 Oslo
Norway
Phone: +47 22 03 65 00
www.panda.org/arctic

International Polar Year
IPY International Office
High Cross, Madingley Road
Cambridge CB3 OET
United Kingdom
Phone: +44 1223 221 468
www.ipy.org

Polar Bears International
P.O. Box 1097
Occidental, CA 95465
www.polarbearsinternational.org

Natural Resources Defense Council
40 West 20th Street
New York, NY 10011
Phone: +1 212 727 2700
www.nrdc.org

National Wildlife Federation
11100 Wildlife Center Drive
Reston, VA 20190
Phone: +1 800 822 9919
www.nwf.org

Stop Global Warming
15332 Antioch Street, #168
Pacific Palisades, CA 90272
Phone: +1 310 454 2561
www.stopglobalwarming.org

Worldchanging
www.worldchanging.com

The Kyoto Protocol
www.unfccc.int

acknowledgments

We offer our thanks to our families and to all the friends, scientists, companies, organizations and individuals who have helped us during the past five years. Without you, this project would not have been possible.

Our sincere appreciation goes to our families, who have believed in us and supported us throughout this project—especially Maud Hedén, Vera Granath, Christian de la Lez, Christian Jansson, and Matilda Andersson.

Many thanks to Karl-Erik Wilhelmsen, Arild Hermansen, Ann-Edel Hansen, Johan Berger, Jørn Hansen, Kine Stiberg, Stein Woldengen, Marta Slubowska, Mary-Ann Dahle, Tommy Sandal, Endre Solbakken, Kjell-Reidar Hovelsrud, Anders Lindseth, Karin and Anders Stensson, Morten Rekstad, Sveinung Lystrup Thesen, Oddvar Midtkandal, Stig Odinsen, Jurek Rozanski, Anders Hjelmblad, Johan Skåntorp, Bonnie Roupé, Jason Thompson, Fredrik Dahlberg, Veijo Pojohla, and Geir Vatne.

We also want to express our gratitude to Dario Castiello, Robert Cristina, Will Kraus, Gabriel Brånby, Adam Brånby, Per Nordgren, Steve Gingrich, Marianne and Bo Landin, Eva Schröder, Craig Hastings, Jill Conrad, Knut Løvstuhagen, Tone Karin Hesle, Soili Saunamäki, Laura Palmer, Hans Irgens, Joakim Südow, Fredric Ståhl, Elena Marchetto, Dagfinn Onarheim, Annika Öhberg, Håkan Sköld, Birgitta Wetterlind, Mats Kiviniemi, Jan-Olle Molander, Peter Burman, Kent Grankvist, Per-Magnus Sander, Katarina Salén, Ralf Holmström, Sara Hörnfeldt, Carsten Webering, Jörn Homburg, Mattias Johansson, Terho Lahtinen, Melissa House, Mats Ekman, Magnus Eclundh, Terje Eilertsen, John-Einar Lockert, Ellen-May Indahl, Linda Reese, and Alexander Bierwald.

Working in the Arctic is demanding. Only the best equipment and logistics are good enough. Without the fantastic support of our partners, our life on ice would be impossible. Thanks to Nikon Europe, BRP Norway, Lynx Snowmobiles, SAS Cargo, Carl Zeiss, Gitzo, Fuji Film, Wimberley, Mamiya, Iridium, ACR Electronics, Explorer Cases, SAS Braathens, Woolpower Ullfrotté, Rukka, Sorel, Bask, Baffin, Canada Goose, Meindl, Sporthaus Moxter, Hestra, Alfa Sko, Helsport, Scandinature, Energizer, Telemar Scandinavia, Molanders, Tura Scandinavia, Scandinavian Photo, Diabolaget, Primus, Grabber Warmers, PolarQuest, M/S Origo, Svalbard Snøscooterutleie, Spitsbergen Travel, Procordia, Drytech, Asnes Ski, Acapulka, Suunto, Ortovox, C2 Safety and Petzl. Thanks also to the Norwegian Polar Institute, Lufttransport, and Airlift.

On behalf of all polar bears, we wish to thank scientists Andrew Derocher, Jon Aars, Magnus Andersen, and Christian Sonne.

A special word of thanks goes to Roar Pedersen at BRP, Yvonne Schaefers at Nikon, and Ulla Leijon at SAS Cargo. Your continuous support throughout this project has made all the difference.

Lisa K. Digernes and Kenneth Swezey at Cowan, DeBaets, Abrahams & Sheppard: we are very grateful for your expertise and support.

Neil Hamilton, Magnus Sylvén, Stefan Norris, and WWF.

Deborah Aaronson, Steve Tager, Michael Jacobs, and all our friends at Harry N. Abrams.

Thank you all,

To contact the authors:
Nova Photography & Media
P.O. Box 7219
S-103 88 Stockholm
Sweden
E-mail: info@novaphotomedia.com

Nova Photography & Media specializes in photography and film in the polar regions.
We produce books, fine prints, posters, calendars, films, and exhibitions.

We donate a portion of all proceeds to conservation programs.

For more information, please visit our Web sites:
www.novaphotomedia.com
www.vanishingworld.net

All photographs by Mireille de la Lez except pages 248, 250, and 255 by Fredrik Granath.

Library of Congress Cataloging-in-Publication Data

De la Lez, Mireille.
Vanishing world : the endangered Arctic / photography by Mireille de la Lez ; text by Fredrik Granath.
p. cm.
ISBN 978-0-8109-9464-5
1. Arctic regions—Pictorial works. 2. Arctic regions—Description and travel. I. Granath, Fredrik. II. Title.

G610.D45 2007
577.0911'3—dc22
2007015607

Printed and bound in China
10 9 8 7 6 5 4 3 2

HNA
harry n. abrams, inc.
a subsidiary of La Martinière Groupe

115 West 18th Street
New York, NY 10011
www.hnabooks.com